The Mastery of Nature

The Mastery of Nature

ASPECTS OF ART, SCIENCE,

AND HUMANISM IN THE

RENAISSANCE

Thomas DaCosta Kaufmann

PRINCETON UNIVERSITY PRESS · PRINCETON, NEW JERSEY

Copyright © 1993 by Princeton University Press
Published by Princeton University Press, 41 William Street,
Princeton, New Jersey 08540
In the United Kingdom: Princeton University Press, Chichester, West Sussex
All Rights Reserved

Library of Congress Cataloging-in-Publication Data
Kaufmann, Thomas DaCosta
The mastery of nature : aspects of art, science, and humanism in
the Renaissance / Thomas DaCosta Kaufmann.
p. cm. — (Princeton essays in the arts)
Includes bibliographical references and index.
ISBN 0-691-03204-1
1. Renaissance. 2. Art, Renaissance. 3. Architecture,
Renaissance. 4. Science, Renaissance. I. Title. II. Series.
CB361.K36 1993 92-6169
700'.9'024—dc20 CIP

This book has been composed in Bembo with Centaur Display

Princeton University Press books are printed on acid-free paper,
and meet the guidelines for permanence and durability of the
Committee on Production Guidelines for Book Longevity of
the Council on Library Resources

Printed in the United States of America
1 3 5 7 9 10 8 6 4 2
(pbk.) 1 3 5 7 9 10 8 6 4 2

To

my teachers at Collegiate,

and to their memory

Contents

List of Illustrations

Preface and Acknowledgments

Ⴛ

IN A DEBATE held at a meeting of the Renaissance Society of America in 1990, Anthony Grafton offered a witty description of the role of acknowledgments in prefaces of books of the Renaissance. Along with currying favor, Renaissance authors used their prefaces to establish the ideal genealogy and audience for their books. In so doing, often they thanked numerous people, including the names of many who had never read their work.

I can nevertheless hope that in invoking this description here, I am not naming fictive readers, including Tony Grafton himself. Several friends and scholars have actually read parts of this book and otherwise given specific pieces of advice and information: their names are sprinkled throughout the text. More general acknowledgments that appeared in the initial versions of some of the essays in this book should also be repeated. Chapters 2 and 4 specifically acknowledged Sir Ernst H. Gombrich and James S. Ackerman, with A. I. Sabra additionally thanked in Chapter 2. For Chapter 3, my knowledge of Hoefnagel's poems on Dürer was initially due to M. Lee Hendrix, who most generously called my attention to them and suggested that I might be interested in studying them. Similarly, Robert Lindell generously informed me about two of the documents that are discussed in Chapter 5, and even supplied me with copies of them. Chapter 6, and the original version of the essay here presented as an excursus to Chapter 4, gained from critical readings by David Quint and Tony Grafton. Professor Grafton also offered careful critiques of the Introduction and Chapter 7, and most recently reread and made comments on the text of the entire book. Still more important, perhaps, he joined David Quint in encouraging me to assemble the essays and to consider publishing this book as a whole.

In various places and at various times I have also discussed many of these essays with Margaret Carroll. R. Bruce Livie helped with editorial work on the initial publication of Chapter 4.

I should also like to recall members of audiences who heard some of these essays initially as lectures in Zurich, Vienna, Berlin, Bratislava,

Brno, Baltimore, Malibu, and Princeton, and who by their questions helped to sharpen some of the arguments or make corrections.

I am grateful to the readers for the Princeton University Press, Professor David Knight of the University of Durham and Professor Walter Gibson of Case Western Reserve University, for several useful suggestions. Similarly, I would like to thank the arts editor of the Press, Elizabeth Powers, who gave a critique of the introduction.

Virginia Roehrig Kaufmann has been closely involved in the forming of many of these essays. We have discussed to my profit many of the ideas presented here at various stages of their development. She has also contributed her own critiques to them. Finally she is the co-author of Chapter 1, which she has generously agreed to have republished here.

While the Introduction and Chapter 7 have been written for this book, the other essays will have appeared elsewhere previously. Chapter 1 was published in *The J. Paul Getty Museum Journal* 19, 1991, pp. 43–64; Chapter 2 appeared in the *Journal of the Warburg and Courtauld Institutes* 38, 1975, pp. 258–87; Chapter 3 was published in the *Jahrbuch der Kunsthistorischen Sammlungen in Wien* 82/83, 1986–1987 (published 1989), pp. 163–77; Chapter 4 was published in the *Zeitschrift für Kunstgeschichte* 39, 1976, pp. 275–96, and the Excursus, ibid., 48, 1985, pp. 117–23; Chapter 5 was forthcoming at the time of writing in the *Jahrbuch der Kunsthistorischen Sammlungen in Wien*, 1992; Chapter 6 appeared in the *Leids Kunsthistorisch Jaarboek* 2, 1983 (published 1984), pp. 179–207. I am grateful to the editors of these journals for permission to reprint these articles.

I have corrected, amended, occasionally rearranged, and otherwise edited previously published materials in the effort to present a coherent and correct text and to avoid redundancy. While these essays remain substantially as they appeared originally, in several instances I have also made reference to works published subsequently to the earlier versions of chapters 2 to 6 and of the excursus to chapter 4, insofar as they bear directly upon my own arguments or raise central points of interpretation. Similarly, I have also slightly reshaped texts to respond to specific critiques. Otherwise I have made no further effort to bring these essays systematically up to date.

I am grateful to the Spears and Publications Funds of the Department of Art and Archaeology for granting financial assistance toward the preparation of this book. Susan Lehre helped place earlier publications on disk; Shari Kenfield again ably assisted in obtaining photographs and permissions.

In preparing this book for publication, I am mindful that it contains interpretations that may evoke diverse reactions. There thus come to mind some words of Seneca (*Naturales Questiones* VII: 30), an author who

figures in these pages—words that were also well known to Johannes Kepler, another important figure here. "Many things that are unknown to us the people of a coming age will know. Many discoveries are reserved for ages still to come, when memory of us will have been effaced. Our universe is a sorry little affair unless it has in it something for every age to investigate."[1]

The introduction to this book traces some of my own path into scholarship; in dedicating it to earlier teachers still, I am thus also thinking of those who will in turn come after.

Princeton, New Jersey
September 1991

The Mastery of Nature

The Mastery of Nature

❦

PARADIGMS AND PROBLEMS

ARTISTS from the fifteenth to seventeenth centuries carried out a "conquest of reality." Through the discovery of techniques of pictorial illusionism and new media, including the mastery of perspective and oil paint, they gradually developed means to achieve an ever more convincing imitation of the natural world. The history of pictorial naturalism in art can be traced from Masaccio and Van Eyck to Caravaggio and Vermeer.[1] During the same period there originated a new theory and history of the figural arts, one that evolved from Ghiberti and Alberti to Bellori and Sandrart.[2] This literature both characterized and contributed to what was often regarded as the growing visual mastery of nature in art.[3]

At the same time the bases were laid for a "new science" that was to flourish in the seventeenth century. From the fifteenth century on, investigation of the world of nature became increasingly empirical, eventually rejecting the precedents in magical and other occultist practices out of which it grew.[4] Reasoning based on correspondences supposed to exist between the qualities of men and matter was discarded. Instead, principles of mathematical analysis came to be employed, especially in astronomy and mechanics: these led to the creation of a new cosmology and a new mechanics.[5] Hence a practical knowledge also resulted, with a new technology, that enabled men not merely to understand, contemplate, or emulate nature but to have power over it.

These at least were some commonplaces in thinking about the early modern era in Europe when I was introduced to these subjects in the late 1960s and early 1970s.[6] At that time a paradigm had been formulated that directed research in several fields of study of the humanities. In the grand overview of Erwin Panofsky, but also in the opinion of many other scholars, the Renaissance displayed a cultural unity. Compartments dividing artist and scientist had broken down during this era. In Panofsky's view, as science turned empirical, art turned systematic and theoretical: the result was a practice based on theory, and a theory based on practice. The

invention of perspective in art on the one hand and of the microscope and telescope in science on the other marked the limits of a period of synthesis in which approaches to nature complemented each other: accomplishments in art and science mutually assisted each other's advances.[7]

But these commonplaces concealed many complications. What were the precise stages in these historical developments? While there was a general sense of the way in which art and science worked together, details needed to be filled in to complete the picture. It was easy to see how art and science might intersect in the work of someone then considered a "universal man," such as Leon Battista Alberti or Leonardo da Vinci. But how much other evidence was there for this process of decompartmentalization, and why did it occur? How exactly did art and science otherwise work in tandem during the period that was identified with the Renaissance? Why should they have parted company in the seventeenth century?[8]

It was moreover unclear how this picture could be reconciled with an older view of the Renaissance. The growth of naturalistic art and natural science could be regarded as exemplifying "the discovery of the world," as the Renaissance had been characterized since Jacob Burckhardt.[9] But the determination of their connection with other significant aspects of the early modern era, which Burckhardt had also described and which continued to motivate scholarly studies in the mid- and late twentieth century, proved more troublesome.

Considerations of the relation of empirical science and mimetic art to the "revival of antiquity" made the problem clear. One reigning dogma maintained that humanism had had little to offer to the development of a "new science." Classical culture had been literary, and as such it had little to contribute to a knowledge that could offer mastery over nature.[10] An extreme articulation of this position even held that in its reverence for and revival of classical letters, Renaissance humanism actually impeded the development of a "new science" based on experiment and observation.[11]

The relation of humanism and classically inspired art to naturalism posed similar problems. If Leonardo had cultivated a naturalistic art that approximated natural science, he himself was aware of the problem that he could be styled a "man without letters" (*omo sanza lettere*).[12] Although scholars did not take this notion literally, it remained difficult to associate humanism with Leonardo's accomplishments, just as it was hard to discern its effect on the marvels of Netherlandish painting from the fifteenth to the seventeenth centuries. The formulation by art historians like Panofsky of the conception of "classicism" could accommodate a mimetic goal to a classical ideal.[13] But by the 1960s historians were becoming increasingly interested in other aspects of art—in Italian painting just as they long had been in comparable features in northern painting—that could neither be easily related to this ideal, nor for that matter to the traditions of humanism. Indeed, Giovanni Pietro Bellori, the epitome of classicist art theory,

had treated Caravaggio as the antithesis of an art that emulated the antique, and this critique could be extended to many other "naturalistic" painters.[14] A related situation may account for the effort of some scholars of Dutch seventeenth-century painting to tie seemingly naturalistic still life, genre, and landscape paintings, and portraiture as well, to humanist traditions of the Renaissance by emphasizing their association with emblems.[15]

These were but some of the many problems that faced students of the culture of early modern Europe. Other categories of the older, Burckhardtian paradigm presented similar difficulties. What, for instance, was the relation of the "discovery of the world and of man" to the life of society and festivals, which had also been treated so eloquently by Aby Warburg?[16] How could these activities be set in the context of social relations and practices that also came to interest historians from the 1960s? How indeed could making works of art that imitated nature or, on the other hand, carrying out scientific investigations of the natural world be related to another phenomenon that had long been discussed by historians of politics and diplomacy—the establishment of the modern state?

Not only had these subjects been researched by generations of scholars in Europe and America, but in the 1960s they were intensely debated. An argument about the character of Renaissance civic humanism[17] had parallels in discussions of other aspects of Renaissance culture, including the relation of art to society. Could the new naturalism of the Renaissance really be regarded as a product of bourgeois humanism?[18] Along with the reevaluation of the relation of ideas to society in the Renaissance, attention was, in fact, increasingly being directed to the importance of the courts. A considerable amount of scholarship was thus generated on court ideology and imagery and their place in the "festivals of the Renaissance."[19] Perhaps most elusive, it also remained to be determined how ethical or religious beliefs, another concern of Renaissance studies since Burckhardt and Warburg, could affect artistic production and scientific exploration.

To a student turning to this period, an abundance of areas thus lay open for investigation and interpretation.[20] The essays on art, science, and humanism in the early modern era collected here represent some of the results of responses to these questions. Conceived for a variety of functions and occasions over the past two decades, and often stimulated by individual discoveries, they nevertheless should be read in the context of a continuing consideration of these larger issues.

Basic to all the following essays is the assumption that no single line of inquiry, fostered within one traditional field, can lead to satisfactory answers to the kind of overarching questions that have been posed for cultural history, of whatever variety, in the last third of the twentieth century. At the same time these essays offer particular solutions to these problems, involving specific studies that often originate in art history but open onto general questions.

This approach has no doubt also been shaped by personal circum-stances and experiences. Not only traditions of scholarship but also edu-cational institutions and programs encouraged its development. Under-graduate work in cultural history and graduate work in intellectual and cultural history made it seem natural to relate the concerns of art history to broader issues. The impact of the Warburg Institute may in particular be seen to have left its mark here.

The Warburg Institute, where at the begining of the 1970s I was in-structed in Renaissance studies, had been founded initially to stimulate *Kulturwissenschaft*. Two dicta of Ernst Gombrich stand well for the credo of that institute as it had evolved under his direction half a century later: "There are no disciplines, only problems"; and (a paraphrase of Ernst Kris) "Everything is always much more complicated." Although Gom-brich had himself contributed to the definition of the paradigm in ques-tion (the "conquest of reality" is his phrase, and a study of theories of light in Renaissance art and science stimulated by a suggestion on how to focus on the development of illusionism is the source for an essay here), the course in Renaissance studies was not intended just as an introduction to this point of view, but to open new perspectives on the past. Conse-quently subjects such as French Neoplatonism, hermeticism, and astrol-ogy were introduced along with seemingly less arcane fields.

The Warburg Institute's pedagogical ideal at the time was even larger in scope, aiming at more than the encouragement of new approaches or the reconsideration of old ones: its goal was to develop an ability to turn with confidence to the texts of the past. As Michael Baxandall was ele-gantly demonstrating at the time, many kinds of sources could be read for insights into the "visual culture" of a society.[21] Various ways of reading images and texts were stimulated to develop the kind of familiarity with the culture of the past that would allow an interpreter to discharge many different kinds of meaning from any one document.

At the Warburg, moreover, the continuing presence and stimulus of Frances Yates indicated ways in which hitherto ignored or insufficiently examined corners of the past, such as the hermetic tradition, might reveal clues to changes in systems of value or thought. Yates suggested that previously unexplored areas might yield fruitful results: she pointed to the way that connections might be made between the activities involved in the manufacture of objects or images and the processes of intervention in the natural world that characterize science. Yates also pointed to court patronage as a possible link between art and science.[22]

In the early 1970s, among disciplines established in the United States, the history of art appeared to be most accommodating to the study of this kind of cultural history. Works of art seemed to offer an especially rich deposit of cultural meanings, or "social relationships," as Baxandall put it. At Harvard, where training was still centered on works of art and

artists, other ways of approaching the interconnections between art, science, and society were suggested. At this time J. S. Ackerman was investigating the interrelationship issues of art and science[23]: the concern with nature painting, represented here by several essays touching on Georg Hoefnagel, can be related to Ackerman's seminar on naturalism in the Renaissance.

Just when I was considering a topic that might bring together all these different concerns, the appearance of R.J.W. Evans's magisterial *Rudolf II and His World* seemed to present a much needed focal point.[24] Evans provided access to a previously misunderstood, even ignored milieu, a court in which the visual arts, humanism, the occult, and natural science all flourished. Here there seemed to exist just the historical situation in which the arts and sciences could be seen to develop together. In Evans's vision of Prague c. 1600 appeared many of the interconnections that might help lead to insights into the resolution of some of the larger issues of Renaissance cultural history. Moreover, since Rudolfine Prague seemed to lie on a historical cusp, it also offered clues for understanding the transformation of Renaissance culture into that of the next epoch.

In the most insightful review of Evans's work, Frances Yates indicated areas where his treatment of "Prague mannerism and the magic universe" suggested further research and interpretation could be productive. Not an art historian, Evans had had to rely on earlier work in the field instead of his own research. Yates called his discussions of "mannerism" and "baroque" "a temporary lapse into rather second-hand generalizations after the splendidly high levels of his original scholarship."[25] Evans had described the demise of this "mannerist" world in Prague, without recognizing the problems involved in using this notion as an interpretative tool.[26]

Johannes Kepler did not appear much in his pages, although Kepler's discoveries and publications may well be the most significant cultural achievement of Rudolfine Prague. It is surely remarkable that both Kepler and Tycho Brahe, who along with Galileo Galilei were the most outstanding scientists of the day, were both active at the imperial court. Yates noted that "a great problem for the future is to elucidate the steps by which the magical universe lost its magic and gave way to the mechanical universe. And here the world of Rudolf II must contain many of the clues. It was, after all, the world which Kepler chose to work in."[27]

The world of art and science in Rudolf's Prague thus seemed a field wide open for research in the history of art and the history of science. Many of the present essays derive from research on Rudolfine Prague, which I thought provided a special key to understanding larger issues in European cultural history. But before larger cultural historical questions could be addressed, much more groundwork in art history needed to be done.

Much more than the applicability of the term "mannerism" (though I concerned myself with this problem, too)[28] needed to be established be-

fore a research program in the relation of art, science, and culture could be implemented. First, it was necessary to understand the role of art in the service of the court as something other than a mere pastime or refuge from politics. It was, in fact, possible to relate ceremonies, festivals, and collecting at the Habsburg court to pan-European categories that Yates and other scholars had elucidated. This theme directed the topics of my dissertation[29]: it figures in several of the essays here as well. These studies suggested that the interests and connections of Rudolfine Prague were not to be limited in space or time, but led back to investigations of earlier periods, as suggested in several chapters here, just as they pointed to research on other contemporary centers.

When I started my research, no satisfactory basic survey, not to mention catalogue, existed for painting in Rudolfine Prague, nor for any of the other visual arts there. There also was no satisfactory overview of its manifold aspects, certainly not that expressed by proponents of the concept of mannerism, which was hardly helpful for many of the newer kinds of Prague naturalistic painting, including the nature studies that are discussed in several of the essays in the present collection.

Art in Rudolfine Prague was also difficult to situate in either its direct historical or geographical context. At least outside of the region, not much was known in general about art in Central Europe (with the exception of the "Old German Masters" of Albrecht Dürer's time) in the early modern period. Most English-speaking students had heard little about it, and so when I went to do research in the region, I was all the more surprised, impressed, and stimulated to work on the numerous outstanding monuments from the fifteenth to eighteenth centuries that do survive. There existed then only very scant notions of other seemingly less accessible objects, artists' drawings of the period, and hardly any idea of what sheets could be found in the United States. Even the copious specialized bibliography that already existed for art of this area was hard to locate.

The path that has led to the composition of these essays has therefore been one with many detours. On the way have come two drawings exhibitions with catalogues containing substantial interpretative introductions, a catalogue raisonné with a synthetic overview of painting in Rudolf II's Prague, and an annotated bibliography with historiographic introduction of art in Central Europe.[30] These efforts are not merely ancillary to cultural history, but indeed an essential component of it: effective connoisseurship can be bound up with cultural history.[31]

The following essays on the relation of art, collecting, patronage, and science, treating the transformation of world views and symbolism, should also be regarded as case studies that complement these other efforts, alongside which they evolved. Despite their diversity, all the pieces presented here touch upon the general issues enunciated in this introduction.

All, moreover, may be regarded as responses to a single master trope: the mastery of nature. While "nature" had a large number of connotations in the early modern era, several conceptions of nature, meaning the general scheme of things, or the physical world, or ground of the cosmos, were basic in both art and science.[32] The essays here reexamine various of these themes.

The first essay, on the "sanctification of nature," deals with the question of why the mastery of a convincing illusion of nature should have become a goal for the visual arts to begin with. In particular, it touches on the origins of *trompe l'oeil* in manuscript illumination, which had previously been explained from formal or iconological premises. Instead, it suggests how a perspective informed by anthropology and history provides a way of seeing how motivations related to religious beliefs and practices may have contributed to the creation of illusionistic imitations of the natural world.

The second essay suggests how, once the imitation of nature became a goal for the visual arts, traditions of astronomy and optics were coordinated with writings on art in the conceptualization of responses to problems of pictorial illusionism. It traces the history of a particular question, that of shadow projection from the fifteenth to the seventeenth centuries. It shows how the perspective of shadows was first worked out in theory by artists and then became a subject for mathematicians, until this fruitful collaboration was severed in the seventeenth century.

The third paper returns to the question of the "nature of imitation," offering a close reading of an artist's poems that demonstrates the multiple connotations of this notion. These poems can be interpreted to show how naturalistic images can be related to academic ideals. They suggest how much more can go into the making of nature studies: humanist concerns about imitation, ethical attitudes gained from philosophy, and a moderate religious stance tending toward confessional and political compromise may all have been conjoined.

The fourth essay considers the metaphorical aspect of the mastery of nature. It starts from the discovery of texts that accompanied paintings to demonstrate how this conception informs the composition of seemingly bizarre images of heads formed out of naturalistic, seemingly still-life components. These pictures were actually "imperial allegories" that were metaphors of power over the world for a ruler. The excursus to this essay indicates some of the sources in classical literature, and humanist interpretation thereof, for the imagery of a surprising portrait of a ruler composed of fruits. It thus suggests the special manner in which classical texts were employed, raising the contrast between a modern invention and its ancient source.[33]

The next essay presents a program for a ceremony by a court astronomer who was also a humanist and poet, in which a ruler's mastery was

celebrated with triumphal arches executed by artists collaborating with that writer. This chapter offers a reading of a work by a self-defined "humanist adviser" that emphasizes not so much the political aspects of the ceremonial entry, a subject discussed elsewhere,[34] but the coordination and relation of art, poetry, humanism, astronomy, and technology. The program points again to the way in which ground could be prepared for "interdisciplinary cross-pollination" that could eventually bear fruit in many fields.

The penultimate essay interprets another text—a letter written by an artist to elicit the existence of an attitude toward art and technology. It is suggested that this letter reveals the existence of an approach that coincided with an attitude of his patrons. This "modern" attitude, in contrast with one of imitation of the ancients, is an aspect of the "mentality" of this milieu that might account for the encouragement of new technology, new scientific ideas, especially in astronomy, and new forms and genres of art also developed there.

The final essay returns to a reconsideration of the classic locus for the combination of art, nature, and science, the *Kunstkammer*. It reexamines the way in which collections could have a symbolic dimension that expressed a ruler's mastery of the world. It argues that the *Kunstkammer* was also implicated in a larger program that included scientific research, some of which eventually led to another view of the "mastery of nature," in the "new science." It is suggested that the "new science," in fact, grew out of the context that cultivated these collections, but ended up producing a view of the world that came to transform the very *episteme* that had informed their foundation.

Along with these major topics, certain subsidiary themes will be found throughout these essays. Several sorts of connections are suggested among astronomy, astronomers, and art. A moderate religious stance is found to be pertinent to the study of nature in a number of instances. And besides important patrons, especially in the Habsburg court milieu, certain figures—Dürer, Hoefnagel, Giuseppe Arcimboldo—emerge.

It cannot be claimed that these essays offer a comprehensive resolution to the issues this introduction has evoked. That remains for another, larger, and more concentrated account of the complicated interrelationships of art, science, humanism, and nature in the early modern period. Nevertheless, it is to be hoped that they offer glimpses of solutions on the way to that larger project. In the meantime, they may even stimulate others to reconsider questions that still seem essential for an understanding of the early modern era in Europe.

I

The Sanctification of Nature

OBSERVATIONS ON THE ORIGINS OF

TROMPE L'OEIL IN NETHERLANDISH BOOK

PAINTING OF THE FIFTEENTH AND

SIXTEENTH CENTURIES

One of the more remarkable phenomena in European painting of the fifteenth and sixteenth centuries is the development of *trompe l'oeil* illumination. As it first appeared in Netherlandish books of the late fifteenth century, painting of this sort creates the illusion that a bit of nature actually is lying on the page. As such, *trompe l'oeil* may justifiably assume a key place in the history of the imitation of nature in manuscripts. Although many circumstances surround the development of *trompe l'oeil* illumination, this chapter considers aspects of the problem that have been overlooked in previous discussions, suggesting how the mastery of this illusion of nature may have originated.[1]

This reconsideration proceeds retrospectively from an examination of one of the later products in the history of *trompe l'oeil* in Netherlandish manuscripts, the Bocskay *Schriftmusterbuch* illuminated by the painter Georg (Joris) Hoefnagel (J. Paul Getty Museum, Malibu; figs. 1–4).[2] The text of this manuscript was written in the 1560s. It is one of three such versions of what might be described as an elegant sampler or model book of various kinds of handwriting, including Hebrew, Latin, Greek, and other more exotic varieties of script (including mirror writing) that were presented to Emperor Ferdinand I Habsburg. Between 1594 and 1596 the Netherlandish painter, humanist, and poet Hoefnagel completed this manuscript for Ferdinand's grandson and successor, Emperor Rudolf II

1. Georg (Joris) Hoefnagel, *Flower, Fruits and Butterflies*,
Scribe, Georg Bocskay, *Mira Calligraphiae Monumenta*

Habsburg. This was the second such task Hoefnagel, whom we shall be
encountering frequently in these pages, had carried out for the emperor,
since during the immediately preceding period, between 1591 and 1594,
he had added decorations to another, similar codex written by Bocskay,
which now belongs to the Kunsthistorisches Museum, Vienna.[3] Rudolf II
was a very great patron and collector—one of the greatest in the history
of European art—and for him Hoefnagel made suitably splendid embel-
lishments.[4] At the end of the Getty manuscript Hoefnagel added his own
model alphabet with illuminations. He also intervened in the body of the

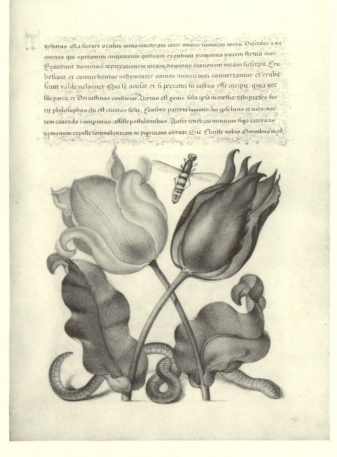

2. Georg Hoefnagel, *Tulips, Snake and Insect*, Scribe, Georg
Bocskay, *Mira Calligraphiae Monumenta*

text—and it is his additions that provide the point of departure for this
chapter.

At the margins and in the interstices of the texts of this manuscript
Hoefnagel has depicted various creatures of the natural world. The ob-
jects painted in watercolor and body color include plants, flowers, seeds,
nuts, insects, and even reptiles, such as snakes and lizards. These crea-
tures are depicted with great attention to detail. They are executed in rich
colors, fully modeled, and finely delineated with minutely applied brush-
strokes. Hoefnagel has painted them with an eye for all their peculiarities.

3. Georg Hoefnagel, *Cherries, Flowers and Butterfly*, Scribe,
Georg Bocskay, *Mira Calligraphiae Monumenta*

Many of the objects are shown with shadows cast on the page, so that the illusion is increased that they are three-dimensional objects set on the actual pages of the manuscript. The depiction of objects that cast shadows on the page is one of many tricks of *trompe l'oeil* illusionism that Hoefnagel used. Elsewhere he shows a plant with its stalk piercing the page, part of which is also depicted on the reverse (figs. 3 and 4). In its rich accumulation of naturalistic illumination and *trompe l'oeil* devices the Getty manuscript represents a distinctive accomplishment in Hoefnagel's oeuvre. It is also not an exaggeration to call this work a high point in the history of naturalistic illumination in manuscripts in general.

4. Georg Hoefnagel, *Stem*, verso of fig. 3

Although still found in a manuscript, Hoefnagel's miniatures consti-
tute one of the penultimate steps in the development of independent still-
life painting, that is, the depiction of still life as an independent subject in
full-scale easel painting. Some other miniatures by Hoefnagel from the
1590s form the next step, where representations of vases and insects,
flowers, and plants, though still painted on a vellum page, are freed from
any connection with a written text (fig. 5).[5] The depiction of nature in
these images already seems to exist as an independent form of representa-
tion. It was only a short step from this kind of depiction in miniature to
that of the oil painting on panel (or canvas) of the independent still life.
Indeed Hoefnagel is recorded in inventories of collections such as that of

5. Georg Hoefnagel, *Still Life with Flowers and Insects*. Monogrammed and dated 1594

the Archduke Leopold Wilhelm Habsburg as having made just these kind of paintings.[6] The Swedish scholar Ingvar Bergström long ago recognized Georg Hoefnagel's importance in this development, although no certain works of this sort by his hand survive.[7]

However, the first surviving paintings on panel by a Netherlandish artist are found in examples made soon after Hoefnagel's death, probably shortly after, if not in, 1600, by Roelandt Savery, as in pictures dated 1603 (fig. 6).[8] Savery, like Hoefnagel, was one of Rudolf II's court painters in Prague. A connection between these artists can be established, since Savery certainly knew Hoefnagel's manuscripts and used elements from them in his own paintings. This kind of book illumination therefore possesses further importance for the development of panel painting as well.

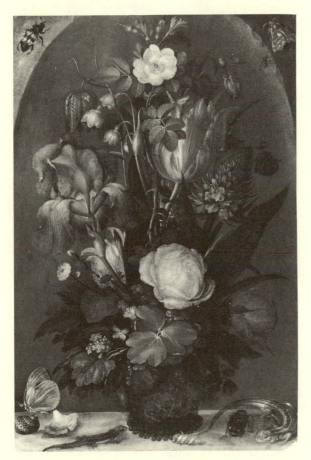

6. Roelandt Savery,
Still Life with
Flowers in a Roemer,
1603

There are many things to be said about Hoefnagel's manuscripts and also about the place of his work in the important development of the new genre of independent still-life painting.[9] In this chapter Hoefnagel's work serves as an apt starting point for the interpretation of an important feature of naturalistic illumination in Netherlandish book painting, beginning with a consideration of Hoefnagel's relation to tradition. For Hoefnagel's work may be regarded not only as one of the progenitors of the tradition of independent still life on panel but also, as long recognized, one of the last descendants of another long tradition.

Hoefnagel's intervened in the Getty manuscript by adding what can be seen as forms of *bas de page* and marginal illumination comparable to those found in medieval book painting. While previous scholarship has already pointed out some of the visual sources for Hoefnagel's nature studies,[10] here the concern is with the place of Hoefnagel's work in relation to the history of northern, and particularly Flemish, book painting. Viewing Hoefnagel in the light of this earlier tradition not only illuminates his own accomplishments but at the same time reflects back on certain aspects of illusionism in earlier manuscripts, whose tradition it culminates in certain regards.

Hoefnagel's work may be compared specifically to so-called "Ghent-Bruges" manuscript illumination of the late fifteenth and early sixteenth centuries. Several scholars have recognized that his paintings may be related to works associated with these Flemish manuscripts in their use of careful modeling and their still-life-like representation. Beyond Hoefnagel's personal origins in the southern Netherlands, similarities in the meticulous manner of painting, the presence of *trompe l'oeil* devices (such as cast shadows or stems slipped through fictive slits in pages), and naturalistic content in the marginal decoration point to Hoefnagel's connection with this tradition. Most important, it can even be demonstrated that Hoefnagel was directly familiar with actual examples of this sort of painting, since he added his own illuminations to already existing books of this kind.[11]

"Ghent-Bruges" illumination and Hoefnagel's painting are mutually relevant in that both contributed to the development of illusionism in manuscript painting. The three-dimensional modeling of vegetative and other forms of natural ornament in the borders of late fifteenth-century Flemish book painting carries further the transformation of the Gothic tradition of ornamentation with flourishes and interlaces, known technically as cadels, in the margins of manuscripts. Earlier in the fifteenth century painters of manuscripts in Italy, France, and the Low Countries had included depictions of flowers resembling living specimens in borders. A prayer book illuminated by Michelino da Besozzo from the beginning of the century is decorated with delicate vines that twirl around the text, together with flowers that are mostly identifiable. But many of

the flowers glitter with gold, are inappropriately associated with vines, and are laid out in a regular pattern that is closely related to the frame, so that they do not create a convincing illusion of nature.[12] In the famed *Très Riches Heures* of the Limbourg brothers made for the duke of Berry around 1415, the illusion of living flowers is enhanced by the presence of snails, which seem to have attached themselves to the flower stems. The flowers grow in more random patterns, like those found in nature, but they seem to be rooted in the frame of the miniature in an unlikely and unnatural fashion.[13] Like Michelino's, the Limbourg brothers' images of flowers serve a strongly ornamental function in that they are still physically linked to the miniature and thus lack a life of their own.

The Master of the Hours of Catherine of Cleves offers an altogether different collection of objects and presents them in a different way. Bird-cages, coins, fish, pretzels, eels, coins, a rosary (fig. 7),[14] detached heads, and even documents with their seals[15] are but some of the objects painted in the margins, where they are detached from the miniature and text, with which they have, at best, an ambiguous relation. They are also modeled so as to suggest their existence in three dimensions. Because of their independence from the text and miniature and their illusionistic rendering, they might seem to be close to the marginalia found in "Ghent-Bruges" manuscripts, but they share little in common, either in painting technique, subject matter, or meaning. Many of the objects in the Hours of Catherine of Cleves, such as the bird-cages, are not shown to size, and even those things close to their actual dimensions, such as coins, do not cast shadows so as to suggest they are actually lying on the page.

None of these developments can in any event be directly associated with the inventions of the illuminators from Ghent and Bruges. In these marginalia, which are the center of our interest here, Flemish masters initiated the use of such devices as cast shadows and the illusion of objects piercing the page or being attached to it by a thread or a pin. They also increased the number and kind of creatures illustrated, made even greater efforts at depicting their details precisely, and showed objects at close to their actual size. Together these efforts create the illusion that the objects depicted are actually lying on the page: they deceive the eye and can therefore properly be called examples of *trompe l'oeil* illusionism. Although similar devices are known in earlier panel painting, their appearance in these manuscripts seems to represent their earliest occurrence in manuscript illumination.

Despite the significance of "Ghent-Bruges" manuscripts for the history of pictorial illumination, there has been surprisingly little discussion of the reasons for its development. As Anne Van Buren noted in a review of the art-historical literature that she published in 1975, students of pictorial representation in Flemish manuscripts have concentrated on the

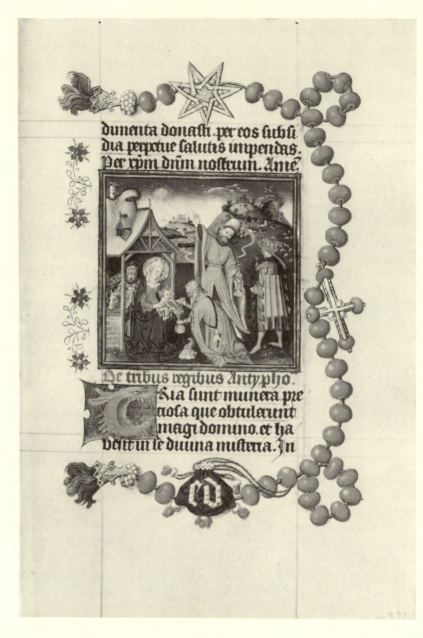

7. *Adoration of the Magi*, Hours of Catherine of Cleves, c. 1440

morphology of forms or on specific details in miniatures, not on the borders.[16] Then again some of the major hypotheses of the study of book painting involve the assumption that an inevitable decline set in with the fifteenth century. This was the view of Erwin Panofsky, who thought that the invention of perspective and its introduction into manuscripts doomed book painting,[17] and also of Otto Pächt, who argued that the introduction of spatial illusionism into book illumination meant that a "heavy strain was put on the artistic organisation of the page."[18] According to Pächt, the flat expanse of the page contrasted with the illusion of recession into depth.

Perhaps the most widely accepted interpretation remains that promulgated more than forty years ago by Pächt in his study of the Master of Mary of Burgundy, so named from his association with manuscripts made for this important patron, the daughter of the last independent duke of Burgundy and wife of Emperor Maximilian I Habsburg. Pächt argued that the Master of Mary of Burgundy "obtained a new lease on life" for book painting by unifying the way a page was seen according to a consistent point of view.[19] Consequently, this artist developed a three-part scheme of composition in which the margins of the page present objects such as flowers with all the tricks of *trompe l'oeil* that we know from Hoefnagel; the text is shown as writing on a page, and the main miniature, usually depicting a scene from the Bible or the lives of the saints, was painted as if it were viewed through an opening in the page, much as through an open window, in its own illusionistic space. In this scheme, which can be found in many "Ghent-Bruges" manuscripts (figs. 8–11), three qualities of illusion are presented in relation to one consistent point of view: the borders are depicted with objects shown as if they were in a space located in front of the flat surface of the page on which the text is written; the page with text occupies a sort of middle layer; then the miniature with its figural composition is depicted as if it were a scene occurring behind both the page and text.[20]

Van Buren remarked that as of the time of her article only Sixten Ringbom seemed to have doubted this explanation in print.[21] For Ringbom, the Pächtian interpretations was one made from a post-Cézanne (Van Buren says post-cubist) point of view. Ringbom doubted whether a fifteenth-century master would have perceived the decorative framework as neutral, or indeed perceived any conflict between planimetric organization and an illusion of space. For Ringbom the development of *trompe l'oeil* borders was rather "a perfectly natural extension of illusionism to the border," a result of the application of the artist's "skill on the decorative framework" that also relied on precedents in northern panel painting.[22] Clark Hulse has also criticized Panofsky's and Pächt's intrepretation of the development of spatial systems supposedly found in

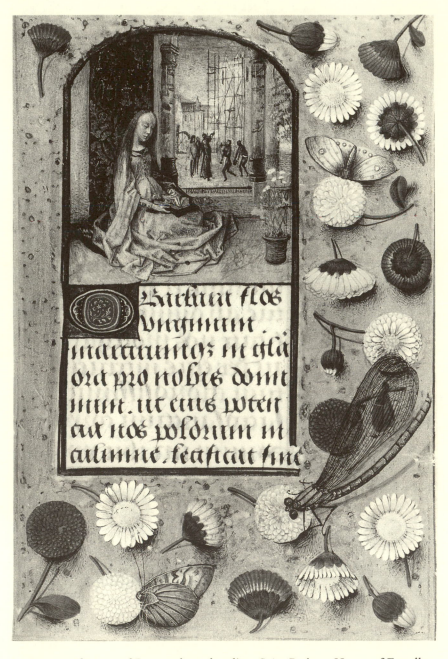

8. Master of Mary of Burgundy and atelier, *Saint Barbara*, Hours of Engelbert of Nassau, last quarter 15th century

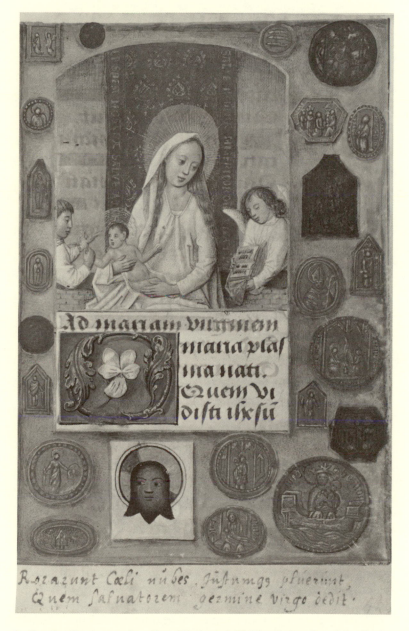

9. Sander Bening and atelier, *Virgin and Child and Angels*, with pilgrim
badges, holy images, and other devotionalia painted on the border,
Hours of Philip of Cleves (with epigram by Hoefnagel
in his own hand at the bottom), before 1483

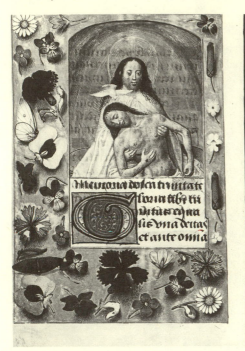

10. Sander Bening and atelier, *Throne of Mercy*, Hours of Philip of Cleves
(with poem by Hoefnagel in his hand at the bottom), before 1483

Netherlandish painting, represented by the work of the Master of Mary
of Burgundy, as "a retrospective construction of the modern scholar
seeking to defend the status of painting in his own century."[23] Van Buren
rightly said that under the sway of Pächt's analysis, aesthetics ruled the
study of the Master of Mary of Burgundy,[24] and hence, one may add, to
a large extent the study of Netherlandish book illustration. Since it also
ignores the question of the selection of objects found, and the reasons for
their appearance, Ringbom's analysis seems, however, no less "aesthetic."

But the existence, since its earliest appearance, of *trompe l'oeil* illusion-
ism in the margins of pages altogether lacking miniatures would indicate
that Ringbom's and Pächt's hypotheses are problematic. The three con-
stituent elements appear in various combinations other than the tripartite
arrangement described by Pächt. Even more frequently pages are found
with illusionistic borders and text but without a miniature (figs. 12–15).
There are also pages in which the miniature is shown not as through a
"window" but rather with the same sort of *trompe l'oeil* illusionism as the
border, whose fictive space they seem to share (fig. 16), or with no
marked recession into space (fig. 17). Miniatures depicted as if seen

11. *Saint Christopher*, with shells, pearls, and pilgrim badges painted to
seem as if pinned and sewn onto page, Book of Hours c. 1530

12. Master of Mary of Burgundy and atelier, text with *trompe l'oeil* border,
Hours of Engelbert of Nassau, last quarter 15th century

13. Text with painted flower depicted pinned onto page. Hours of Philip of Cleves, illumination by Hoefnagel

"through a window" are frequently found on pages that lack a text altogether but nonetheless have *trompe l'oeil* borders (figs. 18–20).

The system of representation in which naturalia are placed immediately next to a text that lacks a central miniature is most closely related to Hoefnagel's considerably later work (compare figs. 1–4 and fig. 12). Other illusionistic devices, such as the depiction of stalks of flowers or plants penetrating a page, appear in both the earlier "Ghent-Bruges" manuscripts and in Hoefnagel's codex (compare figs. 3 and 4 and figs. 21 and 15). It is therefore hard to accept an argument for a historical development that leads away from this type of bipartite page organization, since this type of presentation continues to be found at the end as well as at the beginning of the sixteenth century.

The relation of Hoefnagel's Getty codex to the "Ghent-Bruges" manuscript tradition thus throws open the question of historical evolution. Pächt's historical model implies a certain teleological bias, in which what may be called the supposedly more inventive stages of development are more highly regarded. Although Pächt thought that the "Ghent-Bruges" school had revived the tradition of manuscript illumination, his explanatory model still retained the conception that book painting had suffered a decline. He therefore argued that already with the later "Ghent-Bruges"

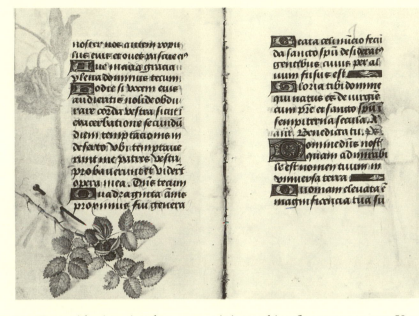

14. Text with pin painted to suggest it is attaching flower onto page. Verso of fig. 13, Hours of Philip of Cleves, illumination by Hoefnagel

manuscripts (those of the early sixteenth century), book painting no longer offered a suitable medium for the artistic ideas of the time.[25] But the obviously high quality of Hoefnagel's painting in the late sixteenth century, and his sophisticated and witty play with illusionistic devices, would seem to contradict the thesis that his work is a product of decline. Rather, the later temporal position of Hoefnagel's codex in the history of still life suggests that the outpouring of "energies," as Pächt put it, found in "Ghent-Bruges" manuscript illumination continued through sixteenth-century book painting right up to the seventeenth century.[26] The curve of naturalistic book illumination may be plotted in a different trajectory against the course of development of independent still-life painting on panels.[27]

The other major hypotheses that have been advanced in place of Pächt's and Ringbom's theses are no less questionable. Several scholars have offered the suggestion that there may be a relation between the objects represented in the margins and the miniatures or the text, or that the objects may have symbolic meanings.[28] Frank Büttner has attempted to connect the iconographic programs of the border decorations of late medieval manuscripts more closely to the textual content and miniatures.[29] However, when these examples are carefully examined, it begins to seem

15. Follower of Simon Marmion, text page and border with daffodil,
Book of Hours, c. 1490

unlikely that all the creatures and objects found in the margins of books
of the "Ghent-Bruges school" could be related to the text on the page,
any more than Hoefnagel's creatures could; in any case, this argument
remains to be demonstrated more convincingly. Similarly, the arguments
of Clark Hulse for a "spiritual rhetoric" that binds the miniature to the
framing elements in the work of the Master of Mary of Burgundy would
seem not to apply in many cases.[30] All of these proposals share the as-
sumption that the text, miniature image, and border are related, and that
the development of illusionism in the naturalistic margins and in the inte-
rior miniature are associated. Yet these connections also remain to be
proved and seem doubtful.

Whatever the merits these arguments nevertheless retain for explaining
what is undoubtedly a complex phenomenon, we would like to suggest

that the development of illusionism in the margins of books may be related to the function of these books. Like Hoefnagel's codices, the richly illuminated "Ghent-Bruges" manuscripts were made to be *Prachthandschriften*: they are splendid, precious items. Many of them were created originally for aristocratic patrons, such as Mary of Burgundy. Even when works are encountered that may have been made for the market, we can assume that it could only have been a very rich man or woman indeed who could have afforded to possess such books.

Even more important—and in this they are to be distinguished from Hoefnagel's Getty manuscript—illuminated "Ghent-Bruges" manuscripts can be associated with devotional practices of the late fifteenth and early sixteenth centuries. Many of them are books of hours or other works

16. Simon Bening and atelier, text with Coquille Saint Jacques painted on border, Book of Hours, c. 1500

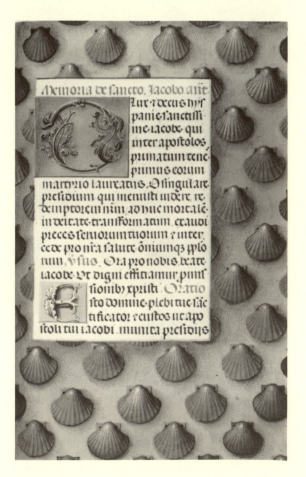

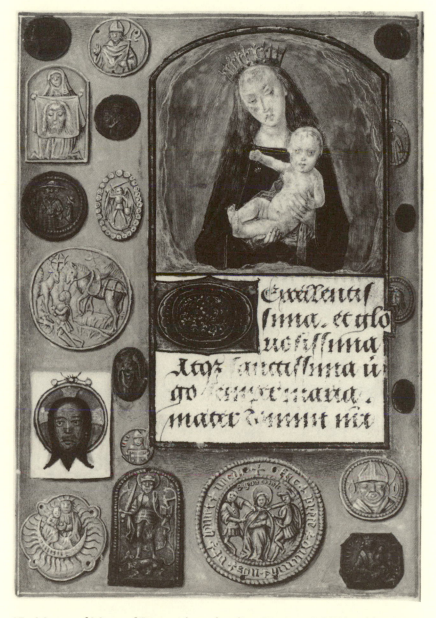

17. Master of Mary of Burgundy and atelier, *Virgin and Child*, with pilgrim badges, holy images, and other devotionalia painted on border, Hours of Engelbert of Nassau, last quarter 15th century

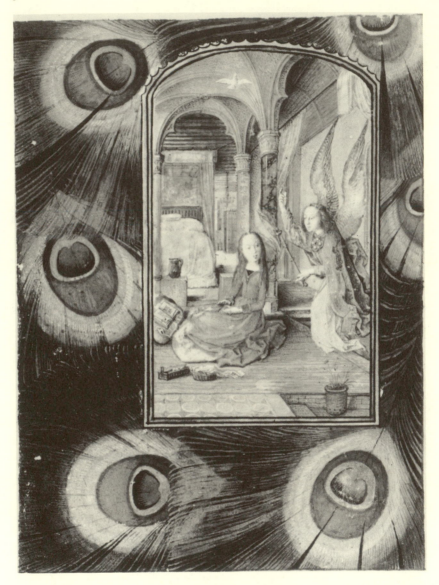

18. Master of Mary of Burgundy and atelier, *Annunciation*, Hours of
Engelbert of Nassau, last quarter 15th century

intended for private devotion. As such, they may be better seen in the context of personal piety. As with certain liturgical objects and ecclesiastical ornaments, the production of this kind of book in such a sumptuous form may have been considered appropriate for its devotional use,[31] at the same time that the work may also have demonstrated the owner's piety.[32] Since they were intended for private devotion, these books could develop "a considerable freedom in composition and contents."[33] And this applies to their decoration as well as to their texts.

Private devotion is one familiar aspect of the religious life of the later Middle Ages; pilgrimage, defined as a journey to holy places or shrines, is another. In fact, these two tendencies seem to have converged in books of hours of the late fifteenth century. As the researches of Kurt Köster

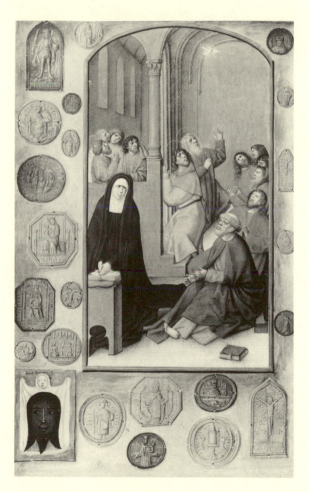

19. Sander Bening and atelier, *Descent of the Holy Spirit*, with pilgrim badges, holy images, and other devotionalia painted on border, Hours of Louis Quarré, c. 1488

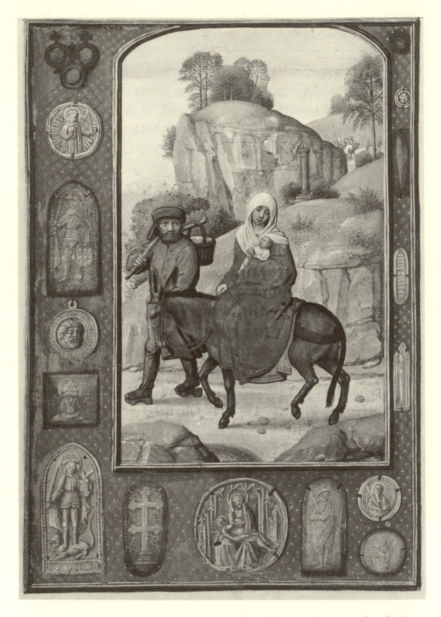

20. Simon Bening atelier, *Return from the Flight into Egypt*, with pilgrim
badges and devotional images painted on border, Book of Hours,
first quarter 16th century

BN Der Mertz hat xxxi tag.
Die monat hat xxx tag.
marcius.

iij	d	Albinus bischoff.
	e	Lucius mertrer.
xi	f	Kunigund iunckfraw.
	g	Adrianus martrer.
xix	A	Equicius Abt.
viij	b	Fridelinus beichtiger.
	c	Perpetua iunckfraw.
xvi	d	Thomas prediger
v	e	Piertzig martrer.
	f	Bekering magdalene.
xiij	g	
ij	A	Gregorius babst.
	b	Macedon priester.
x	c	Zacharias babst.
	d	Longinus martrer.
xviij	e	Cyriacus martler.
vij	f	Gertrut iunckfraw.
	g	Thimotheus martrer.
xv	A	Joseph.
iiij	b	Hubertthus martrer
	c	Benedictus Abt.
xij	d	Theoderus martrer.
i	e	Lirinus martrer.
	f	Paulus bischoff.
ix	g	Herkunding marie.
	A	Castalus martrer
xvij	b	Rupertus bischoff.
vi	c	Rogata iunckfraw.
	d	Eustachius Abt.
xiiij	e	Victor martrer.
iij	f	Balbina Iunckfraw.

21. Calendar page for March, Book of Hours, Ghent-Bruges, 1520–1530

have demonstrated, devotional books seem to have been taken on pil-
grimages. Köster has shown that they even became repositories for devo-
tional images and badges collected by pilgrims at the sites they visited.
These are evident in several well-known examples, found in some earlier
well-worn books of hours, some of which were made as early as the first
part of the fourteenth century.

Besides the evidence that wear provides for their frequent use, and
therefore for the personal significance they possessed for their owners,
some of these books have traces of additional functions and associations.
The habit of collecting pilgrim badges within a book goes beyond earlier
practices, such as attaching precious or holy objects to the cover of a
manuscript. The less precious objects with which we are now concerned
were collected and attached to the pages inside a book. Köster has shown
that this phenomenon was part of a widespread practice in which metal
pilgrimage objects and other small devotional images, pictures, and med-
als were actually sewn or pinned into manuscripts.[34]

Many of these objects can even be identified with the actual pilgrimage
sites to which the owners of the books in which they are found presuma-
bly journeyed. Significantly, the pilgrimage devotionalia found by
Köster and Joachim Plotzek[35] frequently appear in books of hours. When
their original ownership has been ascertained, the books most often prove
to have been made for the Burgundian dukes, members of their circle, or
their Habsburg successors, who are known to have made many pilgrim-
ages and whose piety is otherwise well demonstrated.[36]

For example, we find a devotional badge with the name Ferdinando
above the badge pasted in a book of hours from the beginning of the
fourteenth century: Ferdinando is the signature of Emperor Ferdinand I
(ruled 1558–1564), father of Maximilian II (ruled 1564–1576), and grand-
father of Rudolf II (ruled 1576–1612), Hoefnagel's patron (fig. 22).[37] This
juxtaposition of badge and signature suggests the emperor's personal
attachment to this pilgrimage image, and the practice is likely to have
followed of using the book in which the inscription appears as an object
of devotion while on pilgrimages. He probably acquired the badge be-
neath his signature at a pilgrimage site. In other books from the Burgun-
dian circle there are other examples of this practice: traces of medallions
and other images can, for instance, be found bordering the image of the
Virgin in the so-called Prayer Book of Philip the Bold, from the second
half of the fourteenth and the fifteenth centuries (figs. 23–24).[38] The prac-
tice continued into the sixteenth century; evidence can be found in the
Hours of Emperor Ferdinand I (fig. 25).[39] We have also discovered evi-
dence of a collection of pilgrim badges in an early sixteenth-century book
of hours at Princeton University (fig. 26). In this volume, the badges
were not sewn in, and there are no holes suggesting that they were pinned

in; rather, their impression on the folios on either side of where they were stored indicates clearly that they were simply inserted and probably present there from a very early time.[40] Moreover, the blank pages at the beginning of the manuscript seem to have been included for the purpose of containing such items. Thus the practice of collecting devotionalia at pilgrimage sites and of inserting them in books of hours seems to have continued even after these objects came to be depicted in the borders of such books.

This practice of inserting devotionalia and other images leads to a consideration of their relationship to devotional books.[41] Tokens gathered on pilgrimages became invested with blessing and efficacious powers. It is likely that the presence of holy images in devotional books is also an indication that these images, like the miniatures in the books themselves, were intended to inspire pious contemplation as well as to recall the memory of the pilgrimage itself and the holy image that was its goal.[42] Thus the process of recollection and inspiration that images facilitated seems to have provided an impetus for the collecting of devotionalia, in addition to the specific anthropological functions that they fulfilled, including the apotropaic, prophylactic, and talismanic uses that recent literature related to this question has examined.[43]

Some of the first "Ghent-Bruges" manuscripts with *trompe l'oeil* depictions in the margins imitate the very devotionalia, including painted crosses, religious medallions and plaquettes, pilgrim badges, and pilgrimage emblems that are found attached to the pages of earlier devo-

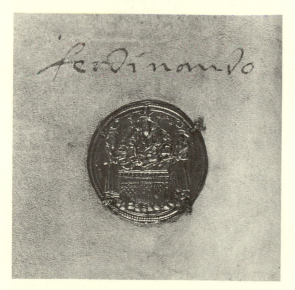

22. Pilgrim badge sewn onto page, with signature of Ferdinand I, Prayer Book of Emperor Ferdinand I (Hours and Psalter), North French, early 14th century

tional manuscripts. Köster has identified many of these painted pilgrim's badges with actual sites. He has also shown that these kinds of illustrations had appeared in manuscripts perhaps by the late 1470s, and they are known from many familiar examples of the 1480s, including the Hours of Philip of Cleves[44] (figs. 9, 10, 13, 14) and the Hours of Louis Quarré[45] (fig. 19). This tradition continued into the sixteenth century, when elaborate and detailed depictions of religious medallions are found, for instance, in a book of hours in the Gulbenkian Collection (fig. 20).

Depictions of pilgrim's tokens and many other types of devotionalia seem to have occurred exclusively in manuscripts of the "Ghent-Bruges" school.[46] The association of these manuscripts with pilgrimages is also made manifest by the appearance of scallop shells, the so-called *coquille*

23. *"Madonna on the Moon"*, Prayer Book of Philip the Bold, French, c. 1415

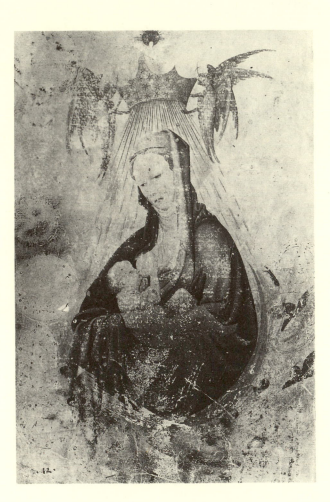

Saint Jacques, or *pecten Jacobaeus*, laid out on pages, as, for example, in a Munich book of hours by Simon Bening (fig. 16).[47] These shells are associated with the most famous pilgrimage, that to Santiago de Compostela in Spain; pilgrims to the site often wore the scallop shell associated with the saint. Furthermore, it appears that saints associated with pilgrimage journeys, such as Christopher, and others whose cults were the object of devotion at certain pilgrimage sites, such as Jodocus, Gertrude, Adrian, and especially James, are particularly numerous in the calendars and suffrages in some of these manuscripts.[48]

The objects were not intended to be merely symbolic.[49] A number of illusionistic details suggests rather that they were specifically meant to recall the objects carried or collected on pilgrimage, such as the shells

24. Köster's reconstruction of fig. 23 with the previous location of badges indicated

25. Pilgrim badges sewn onto page, Hours of Emperor Ferdinand I,
Flemish, c. 1520

26. Impressions left by pilgrim badges pressed into manuscript,
Book of Hours, Ghent–Bruges, c. 1500

attached to the pilgrim's hat or the devotionalia brought home. In some manuscripts, a painted hole can be seen in the top of the shell, or the shells are depicted pinned onto the page. (fig. 11)[50] These representations remind us of the presence in manuscripts of actual objects from pilgrimages.

When we find devotional objects painted in such a way that the artist's creation of an illusion suggests that they are sewn or attached with a pin to the page, we may ask if this particular sort of *trompe l'oeil* decoration does not, in fact, replicate an earlier practice of attaching precisely this type of object to a book. This intriguing possibility, first made in passing by Joachim Plotzek, has been the impetus for our research, based on his and Köster's observations, and our discoveries. We have compiled evidence that the *trompe l'oeil* images have their origins in the actual practice of attaching objects to the page.[51]

One piece of evidence strongly suggesting that *trompe l'oeil* images copy collections of actual devotionalia is provided by a comparison of the metal badges that were sewn around an image of the Virgin and Child in the fourteenth-century Hours of Philip the Bold (fig. 24) and the painted badges around the images of the Virgin in the Hours of Engelbert of

Nassau and the Hours of Philip of Cleves (figs. 17, 9). These examples demonstrate that images of the Virgin were popular places both for the addition of pilgrim badges and then later for their *trompe l'oeil* imitations. This practice may be related to the special devotion toward the Virgin, which is, after all, reflected in the popularity of pilgrimage sites devoted to her and is embodied in the very texts of books of hours themselves: a major section of each book is devoted to the hours of the Virgin.[52] Marian devotion may also be associated with particular aspects of illusionism in earlier books of hours, such as a page in the Hours of Catherine of Cleves, where probably the owner's own rosary, an object specifically connected with Marian devotions, is represented in the margins of a page containing a scene of the Adoration of the Magi (fig. 7). The relation of painted badges to pilgrimage is also suggested by their appearance around images associated with journeys, such as depictions of Saint Christopher (fig. 11) or of the story of the Flight into Egypt (fig. 20).[53]

Another very personal and private use of the earlier original manuscripts in which the actual pilgrimage objects were found suggests other possibilities for interpretation of *trompe l'oeil* imagery. Köster records that the prayer book of Emperor Charles V (ruled 1519–1558), Rudolf II's maternal grandfather, contained, in addition to pilgrim badges and devotional images, entries referring to details of family history. Besides these sorts of entries, in the book of hours made by artists of the "Ghent-Bruges" school c. 1520 for Archduke (later Emperor) Ferdinand I there are also family records and memorials, and even, in an envelope, a piece of the veil of his spouse, Anna.[54]

The presence of such personal memorabilia in such a large number of books of hours suggests a common custom of collecting and preserving a wide variety of such objects in devotional books.[55] This leads to a further hypothesis that other objects illustrated in manuscripts, in addition to the badges already mentioned, also may represent objects that had actually been preserved in manuscripts. *Trompe l'oeil* images of naturalia such as insects, flowers, and peacock feathers may represent items collected by the devout, together with the badges, during pilgrimages. Indeed, these objects are painted in the margins of the very same manuscripts in which *trompe l'oeil* pilgrim badges and other devotionalia associated with pilgrimages have been painted. For example, all of these naturalia appear both in the Hours of Engelbert of Nassau (figs. 8, 12, 17, 18) and the Hours of Philip of Cleves (figs. 9, 10, 13, 14).

Other scholars have already encountered flowers and insects pressed in books of hours, where they may been placed early in the history of the book, but they have not accounted for the presence these objects.[56] There is much evidence for the practice of collecting such objects in books from later times. Already in the sixteenth century in Italy botanists had begun

to collect dried specimens of plants and to place them into books, which are called *herbaria sicca*.[57] In an eighteenth-century German florilegium, both painted and real pressed plants appear, suggesting that a fictive image and an actual object were interchangeable in this context.[58] We may also recall the practice of pressing plants, flowers, and even insects into books that are of personal significance, a practice unconnected with botanical interests.[59]

 Scholars of illuminated manuscripts have hardly concerned themselves with the use of books for such purposes. Köster provides the notable exception: he systematically recorded the occurrence of actual pilgim badges in some devotional books, along with painted images of them. He did not, however, discuss the reasons why these objects were collected or replicated in books of hours, nor did he mention either collected or painted naturalia. It might even be said that art-historical and textual researches have often tended to neglect the objects preserved in books. Nevertheless, it is to be expected that if scholarship turns its attention more intensely to such issues, more objects may be found in books of hours. Contrary to popular belief, in illuminated manuscripts there was no separation of the sacred and what seems to us the secular realm. All things in nature might be considered to have belonged to the sacred.
 Much evidence exists that pilgrims brought back with them more than just tokens and religious images. The place of pilgrimage was regarded as a holy place, a bit of nature that had been sanctified by the presence of the divine. The association of the sacred with a particular place could be extended to the other objects, or other sites, including flowers, trees, caves, and ruins. We know that near pilgrimage sites, or other holy places, crosses and other devotional objects were left by the devout. Furthermore, in the fifteenth century, ceremonies of sacrifice, confirmation, and consecration sometimes took place at numinous sites such as crossroads, ruins, woods, rocks, sources, and fountains.[60] Among objects brought home from pilgrimage were not only holy oils or waters, tokens or other devotional images but also bits of earth, stones, plants, dust, and parts of the holy sites themselves.[61] These objects, like the pilgrim badges, could presumably stimulate devotion. The association of flowers with devotion is suggested by one of the key manuscripts under discussion, the Hours of Engelbert of Nassau, in images of both Mary of Burgundy (fol. 1v) and Saint Barbara (fol. 41r; fig. 8) at their devotions. In these images, objects that were aids to contemplation are depicted near the pious ladies. Mary holds and reads her manuscript, most likely a book of hours, beside a ledge on which lie several objects. Next to her is her rosary; beside it are two cut flowers, reminiscent of the very cut flowers that appear in a similar random fashion in the margins of the manuscript. Next to them is a

vase containing more cut flowers. If such flowers had affective powers, how much more would they have possessed if they had been collected on pilgrimage and thereby been sanctified by association with a holy locus or journey?[62]

As a recent study of medieval pilgrimages has stated, a pilgrimage, defined as a journey for a religious motive, is possession by means of religious behavior. In short, a pilgrimage is the sacralization of the space in which the pilgrim journeys.[63] According to this frame of reference, objects collected along the way gain significance through their association with the pilgrimage.

Returning to the depiction of such objects in *trompe l'oeil*, we would suggest that when we find pearls and other gems painted in books of hours, we might assume that they have a traditional association with holy images near which they appear. But other extraordinary objects, such as peacock feathers (sections of which are painted in manuscripts), flowers of outstanding character or beauty, herbs, and even insects (one thinks here especially of unusual or attractive specimens such as butterflies), might also have been collected on pilgrimages. It is possible that in addition to pilgrim badges and devotional images, some of the other objects depicted in the borders of illuminated manuscripts might also illustrate items brought back from pilgrimages, including remarkable forms such as butterflies and dragonflies (fig. 8, 12) and peacock feathers (fig. 18). Flowers or insects may not only have provided ample opportunities for artists to display their virtuosity and mastery of illusionism but also have been presented as copies of actual specimens collected while on pilgrimage.

Several particular aspects of the *trompe l'oeil* devices found in manuscript margins point to this possibility. Many items are painted in their actual size, with cast shadows that enhance their verisimilitude. Not only are flowers shown in borders; for the first time in manuscript illumination, they are depicted as if they had been cut or plucked. Flowers and insects are often shown as if they had been laid out flat on the page, even seeming to have been pressed between the leaves of a volume. Others are shown as if they had been attached or stuck through the pages, much like the practice demonstrable with pilgrim badges, which are depicted as if they had been pinned to the page. It also seems significant that attached flowers of this sort are found, along with the other naturalia already mentioned, primarily in "Ghent-Bruges" manuscripts, such as a book of hours in Vienna[64] (fig. 21) and another in Munich[65] (fig. 15). Though this sort of representation could become a fashion or provide a field for virtuoso display (like the depiction of the notorious fly who disports himself on the panel or page), we would suggest that much plant and flower material found in "Ghent-Bruges" borders might also have been inspired by the practice of collecting flora by pilgrims.

We can only speculate as to how this artistic practice originated. Perhaps the image itself was meant as a substitute for the actual object, in much the way that a badge stood for the actual cult image of pilgrimage seen by the pilgrim. Like the figural images often found in the same "Ghent-Bruges" manuscripts, the marginalia may even have been believed to partake in the power of the original image, especially if the representation closely resembled the original. Perhaps the *trompe l'oeil* images of pilgrim badges and of naturalia associated with pilgrimage could also inspire recollection and devotion. Their depiction in life-size *trompe l'oeil* would certainly have stimulated memory most effectively, and recollection of the experience of a pilgrimage would, in turn, certainly have stimulated devout thoughts. If the actual pilgrim badges and devotionalia, as well as pressed flowers and other naturalia, had earlier been collected as mementos that might aid memory and devotion, the painted versions could have performed the same functions, but with certain advantages; they did not damage the book the way that actual objects would have done, and a flower or insect, soon to wilt or decay, was more lastingly preserved by being painted than by being pressed between the pages of a book.[66]

To return to Hoefnagel, his manuscripts and the procedures they reveal provide evidence of natural objects being attached to illuminated manuscripts, but at the same time they demonstrate certain different practices. We may recall that several of the *trompe l'oeil* devices used by Hoefnagel suggest that flowers and plants were actually kept in the pages of books. Hoefnagel frequently employed the device of showing a flower, bud, or plant whose stem is depicted in such a way that it seems to pierce the page. In several instances in codices by the artist now in Washington, D.C., and in the Getty manuscript, the verso of the folio depicts the part of the plant that would have been seen on the reverse. Significantly these are shown as living, not dried, plants (figs. 3 and 4).[67] In the Hours of Philip of Cleves—a "Ghent-Bruges" manuscript in which there had already been depicted pilgrim badges, peacock feathers, and pages with jewels—Hoefnagel himself not only added *trompe l'oeil* devices, such as the flower seen from both sides of a page, but he also showed flowers and insects as if they had been pressed into the book. Hoefnagel's comments in this manuscript also indicate that he was familiar with other earlier Netherlandish works and was reflecting upon their artistic origins.

Another remarkable feature is found in the Washington volume known as *Ignis* (*Fire*), which contains depictions of insects; this feature suggests that Hoefnagel's manuscripts reflect earlier practices, as in the Munich, Vienna, or Philip of Cleves manuscripts. On several of the pages where insects are shown in the Washington book, the actual wings of the crea-

tures represented have been glued onto the page next to the body of the creature represented (fig. 27). On the one hand, the elision of painted and substantial form, of the fictive and real, indicates that this is a further step in the history of naturalistic illumination in which the use of illusionistic devices might be regarded as a display of wit. On the other hand, given Hoefnagel's ties with tradition, at the same time they also suggest that he was continuing an earlier practice.

In this regard, it is also important to consider that, with the exception of the Hours of Philip of Cleves, the decoration of which Hoefnagel completed, and the missal he illuminated on commission for Archduke Ferdinand (of the Tyrol), Hoefnagel's marginalia are not executed in manuscripts intended for private devotion. While the Bocskay codices in Vienna and Malibu contain some specimens of sacred texts, they are handwriting model books. And while the texts in the manuscripts of the *Four Elements* now in Washington are also in part derived from the Bible, they are incorporated into emblems. Although these works still possess some spiritual or rather ethical associations, they are not sacred in the manner of traditional books of hours.

Hoefnagel was working after the historical divide of the Reformation. For Protestants of the later sixteenth century, devotional books such as books of hours had ceased to be in use. Religious devotion was directed instead to reading the Bible. Theological texts, including the works of Luther and Melanchthon, became the focus of attention. One of these works was Melanchthon's *Loci communes rerum theologicorum*, his book of theological commonplaces. Its accumulation of biblical texts and theological doctrines in a certain sense replaced the Catholic prayer books, including books of hours.

It was often in copies of this work that a new form of book originated: the *Stammbuch*, known in Latin as *album amicorum* and in English as an autograph album. *Stammbücher* could be employed for family or personal matters, for example, to record family histories; earlier prayer books such as Ferdinand I's had performed this function, just as Bibles have in more recent times. Another more familiar use of *Stammbücher* was to collect the signatures and impressions of acquaintances and friends during travels. The fashion of keeping *Stammbücher* seems to have begun with students at Protestant universities, who for these purposes used extra blank pages that had been inserted into copies of the *Loci communes*.[68] Their travels did not take them, however, on religious pilgrimages of a traditional sort; it would be the signature of a worthy professor or theologian, not a sanctified piece of nature, that would have a place in such a book. Still, *mutatis mutandis*, books with religious associations retained their function as places for collections even after a time of confessional change. Eventually *Stammbücher* lost this connection, and the practice of

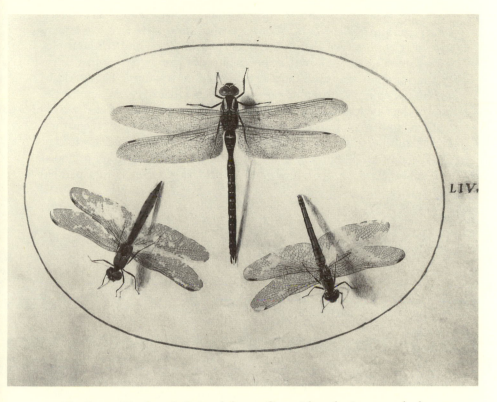

27. Georg Hoefnagel, Painted dragonflies with real wings attached,
Animalia Rationalia et Insecta (Ignis)

keeping autograph books became widespread among travelers and sedentary folk alike, among those with theological interests and those with
secular.

The development of this sort of book, with whose production Hoefnagel can also be identified, further helps to place his work within its
tradition. While Hoefnagel's confessional allegiance remains somewhat
unclear, he was most probably not a Catholic. When he went on trips,
and he was a frequent traveler, they were not holy pilgrimages. Instead
he went on voyages for discovery, information, and experience. The
topographical views he made on his voyages were not imbued with sacred significance. And the miniatures with naturalistic content that he
frequently made as *Stammbuchblätter* (entries in autograph albums) for his
friends were full of another philosophical and religious view of the world,
one that can be related to associations with humanists and interests in
natural history, political moderation, and religious eirenism.[69]

Despite the evident connections that scholars have pointed out between Hoefnagel and "Ghent–Bruges" manuscripts, there is, in fact, a considerable distance between them. Although philosophical and religious elements are no doubt still present in Hoefnagel's manuscripts, other interests increasingly motivate the artist's depiction of nature. The world of nature is beginning to be desanctified. With Hoefnagel, we are on the way to the development of the still life that is independent of sacred associations, to the investigation of matter and of the processes of the natural world considered as ends in themselves. We are approaching the world of the "scientific revolution" of the seventeenth century, which provided the foundations for the view of the world as a material, desanctified universe.

The Perspective of Shadows

THE HISTORY OF THE THEORY OF

SHADOW PROJECTION

THE PROJECTION of shadows is a problem that plagued artists and art theorists of the Renaissance. When the representation of the visual world of three dimensions again became a task for painting, the problem of representing light, and the shadow caused when an object impedes the path of light, became increasingly important. Shadows that overlie the objects creating them—the modeling shadows of painting—give the effect of relief. Shadows cast by one object onto another make the objects seem to stand out and help us to locate them in space. Cast shadows also give clues to the shape, direction, relative distance from the eye, and position of the source of light.[1]

To the artists and art theorists of the Renaissance, the proper depiction of shadows therefore held great interest. We have already seen in Chapter 1 how cast shadows contributed to the illusion of *trompe l'oeil* in manuscripts. Previously cast shadows had been used by Netherlandish artists such as Jan van Eyck (one thinks of the remarkable oranges in the Arnolfini double portrait [London, National Gallery]) and Robert Campin (as in the shadows created by the fire in the Hermitage Virgin and Child), as well as by Germanic painters such as Konrad Witz, for the creation of similar illusions of nature. From at least the time of Giotto, cast shadows were of no less interest in Italian art and art theory.[2]

The late sixteenth-century theorist Giovanni Battista Armenini thus states a commonly accepted opinion when he says that after the outline of a figure, *rilievo* is the most important part of a painting. But a correct impression of relief according to Armenini depends on placing the "larger lights" in accordance with the shadows they cause. Hence it necessitates a knowledge of different kinds of light and light effects, and implicitly of

cast shadows. It is necessary to know what kind of light comes from heavenly bodies, and what kind from artificial sources that painters employ when they want to represent *istorie* or *fantasie* of nocturnal scenes, and "capricious works and drawings which they often do when they want to let the world know the excellent artifice of their genius."

While such statements by Armenini, along with similar descriptions by Giorgio Vasari and Cristoforo Sorte,[3] may be signs of a Cinquecento vogue in the depiction of striking light effects, they also indicate a concern with ordinary day-to-day problems of the Renaissance painter's practice. Differences in perception, ambiguities in interpretation, questions of consistency and control all beset an artist or theorist who would attempt an empirical solution to the problem of the depiction of cast shadows, of shadow projection. First of all, perception of shadows is often inhibited. It requires a special effort of attention and the right conditions of illumination. Because the eye adjusts to the brightest light in the field of vision by dilating or contracting the pupil, in very bright daylight it may contract the pupil to a level where enough light is let in to see, but not enough to produce a perceivable contrast of light in what is observed to notice the difference between light and shadow.[4] Even where shadows may be perceived, differences in perception of brightness constancy mean that there is no uniform attitude that an observer will take to a cast shadow. One may look at shadows, into them, or through them.[5]

Consequently the representation of shadows in painting involves the use of conventions that are quite ambiguous. Experiments have shown that shadows can be perceived as blurs or spots in the visual field.[6] Thus although in paintings the shadows of objects are usually identifiable by other clues such as shape and color, they, too, can be interpreted ambiguously.[7] Clearly defined dark areas of color may be interpreted as superficial blemishes. Shadows may also be perceived as separate patterns or objects in a painting rather than as projected by illuminated bodies.

Consistency is another problem. To avoid painted shadows that look patched together from separate observations or seem completely illogical, Renaissance artists such as Piero della Francesca, in the cycle of the *Story of the True Cross* at Arezzo, adhered to the advice of the Trecento theorist Cennino Cennini in following the actual light of the space in which they worked.[8] Cennini's advice had been: "If, by chance when you are drawing or copying in chapels, or painting in other adverse situations, you happen not to be able to get the light off your hand, or the way you want it, proceed to give the relief to your figures, or rather drawing, according to the arrangement of the windows which you find in these places, for they have to give you the lighting. And so, following the lighting, whichever side it comes from, apply your relief and shadow according to this system."

But tracing shadows from the way they fall solves only part of the problem. For hour by hour, day by day, the sun changes its position in the sky, altering the length of shadows. To be absolutely consistent, the artist must choose the shadows that appear at one moment and return to paint at the same time of day whenever he picks up his brush. But even then the shadows may have changed—a misty or rainy day will alter their intensity. The more shadow-casting objects there are to paint, the harder the problem.

Renaissance artists developed a number of procedures to control the variation of light and shade. Cennini and Paolo Pino advised working in diffuse (*temperata*) light, which cuts down the visible difference between light and shadow.[9] But this method ran the risk of dissolving shadows altogether. Another practice that controlled the length of cast shadows was recommended by Leonardo da Vinci and is still followed today: the use of north light.[10] Still another was to make models. Vasari says that his contemporaries continued to use "rounded" models of clay or wax before drawing their cartoons in order to see shadows in sunlight; he says that Michelangelo had used models, and that the sculptor Jacopo Sansovino had supplied wax models for a number of painters.[11] Yet models placed in daylight become subject to the vagaries of sunshine.

The more sophisticated solution to drawing from models illuminated by a fixed light source is exemplified in an engraving of Baccio Bandinelli's "academy," which shows a group of students sketching sculpted models by candlelight. Many other studios followed similar practices: for instance, Carlo Ridolfi says that Tintoretto learned his art by making innumerable drawings by lamplight of *modelli* copied by Daniele da Volterra from the Medici tombs. Ridolfi also tells how Tintoretto used "to make little models of wax and of clay, clothing them with rags, and accurately investigating with the folds of the cloth the parts of their limbs. Sometimes he even placed them within little houses and perspectives formed of wood and cardboard, arranging small lamps at the windows, whence to see effects of light and shadow." The main disadvantage of this practice is that candlelight does not cause the same sorts of shadows as the sunlight in which painters normally work.[12]

The theory of shadow projection provided a satisfactory solution where practical experience could not. Renaissance treatises on art rationalized the study of shadows by providing conventions for the representation of phenomena that appear very irregular. By the end of the sixteenth century, discussions of shadows and shadow projection came to be assimilated into art theory alongside perspective. More than a book of Giovanni Paolo Lomazzo's *Trattato dell'arte della pittura, scultura, ed archittetura* is devoted to the subject of light and shadow. In his fourth book Lomazzo begins traditionally by describing the role of shadows in creating the ef-

fect of relief, later describing how different kinds of light produce differ-
ent kinds of shadow, including what he calls mixed shadow. In his fifth
book Lomazzo claims that the study of shadows constitutes an integral
part of perspective. Following what he says is the definition of the Greek
mathematician Geminos,[13] Lomazzo divides perspective into three "spe-
cies": optics, which corresponds to the *perspectiva naturalis* of the Middle
Ages; sciagraphy (*sciografica*), which corresponds to the *perspectiva artifi-
cialis* of the Renaissance; and the study of reflections (*specularia*). Accord-
ing to Lomazzo, "The second species, sciagraphy . . . considers shadows,
causes, principles, elements, differences, species, parts and essential pas-
sions, and reveals the causes of the variety of images of things that are
seen, by means of the distances far and near of the sites, above, below,
and in the middle. All of which reasons depend on the linear method of
grammica [i.e., *perspectiva artificialis*]. Sciagraphy then considers with the
same methods the shadows which objects project according to whether
the surfaces are high, low or wide."[14]

The aim of this chapter is to show the background against which Lo-
mazzo's statement is to be read, to demonstrate how cast shadows came
to be treated according to the rules of perspective.

ALBERTI AND HIS PREDECESSORS ON CAST SHADOWS

The first written discussion of *perspectiva artificialis* does not include any
lengthy mention of shadow projection. Leon Battista Alberti's treatise *De
Pictura*, the first classic Renaissance statement of the principles of perspec-
tive and also of the importance of relief, says very little about cast shad-
ows. They appear not to constitute a subject that would be of immediate
interest to a writer on perspective. Indeed, Alberti's failure to describe
shadow projection at length when discussing perspective suggests that in
the intellectual tradition from which his ideas were generated the study of
shadows was something apart. Consequently what Alberti does say
about shadows is worth examining as a key to the state of understanding
of his time; from it we can discover what might have hindered the devel-
opment of a theory of shadow projection.

In speaking of the "reception of lights," Alberti says: "Some are of
stars, such as the sun and the moon and the morning-star, others of lamps
and fire. There is a great difference between them, for the light of stars
makes shadows exactly the same size as bodies, while the shadows from
fire are larger than the bodies. A shadow is made when rays of light are
intercepted."[15]

Later Alberti states: "Quintilian believed that the earliest painters used
to draw around shadows made by the sun, and the art eventually grew by
a process of additions."[16]

Finally Alberti suggests a method for drawing the outline of a circle. "Perhaps a quicker way would be to draw the outline from a shadow cast by light, provided the object making the shadow were interposed correctly at the proper place."[17]

Instead of talking about shadows in terms of perspective, Alberti thus makes reference to a definition of different types of light, a classical allusion, and a practical way of drawing a circle (although the circle is shown in foreshortening).

Alberti's reference to Quintilian is to a story about the origins of painting that is also told by Pliny. In the legend, painting began when a Corinthian maiden outlined her departing lover's shadow on a wall. This legend, which seems to tie together the two meanings of adumbration, survived even when cast shadows seem to vanish during the medieval centuries; besides Alberti, Leonardo and Pino knew it.[18] And besides this legend there are also references in ancient literature to "sciagraphy." While sciagraphy is generally taken to be synonymous with scaenography and therefore to mean perspective, when Apollodorus is called ὁ σκιαγραφός, it may mean shadow painting; Apollodorus is said to have been the first to have found out the φθορὰν καὶ ἀπόχρωσιν σκιᾶς, a claim that cannot be simply equated with perspective.[19] But legends and classical references could never lead to a systematic theory of shadow projection.

Rather, Alberti's mention of the light of heavenly bodies suggests what provided much of the impetus for the theoretical study of cast shadows—astronomy. In astronomy the measurement of shadows cast by a gnomon was the means of recording the passing of hours during daylight as the sun passed through the heavens. The development of improved sundials, the invention of the concave σκαφή, already presupposed a fairly advanced knowledge of the projection of shadows.[20] So did the related use of measurements of the shadows in the determination of the procession of solstices and equinoxes that compose the solar year. By measuring the length of shadows cast by gnomons and reasoning from the geometry of similar triangles, an altimetric procedure employed by Euclid among others and said to date all the way back to Thales, astronomers attempted to determine the distance of the sun from the earth. Similarly by means of a sophisticated combination of shadow measurement and geometry based on the assumption that the sun's rays are parallel to each other, Eratosthenes managed to estimate fairly accurately the circumference of the earth, while Aristarchus made an attempt to measure the size of the sun and moon. Furthermore, the observation of shadows cast by the moon and earth by astronomers like Geminos accounted for the occurrence of solar and lunar eclipses.[21]

Ancient astronomy thus forged a fateful link between observation of cast shadows and geometry, a link that was to have important conse-

quences for both cosmographic and geometrical studies. These studies
converge in ancient discussions of problems related to astronomy that
involve the representation of three dimensions on a two-dimensional
plane. Ptolemy's *Analemma* offers a method of representing the different
points and areas of the heavenly sphere on one plane by means of orthog-
onal projection. His *Planispherium*, on the construction of the astrolabe,
solves the problem of explaining a means of representing the heavenly
sphere on the plane of the equator by stereographic projection, con-
structed from one point or pole.[22] Both these methods may have de-
pended upon shadow projection: there is both circumstantial and attested
evidence for this point. The principles of the *Planispherium* are to be ap-
plied in the construction of an astrolabe, an instrument that is intimately
connected with the examination of cast shadows in cosmographic con-
texts.[23] Moreover, later works of writers such as Biagio Pelacani da
Parma[24] and Nicephorus Gregoras[25] suggest that Ptolemy had used shad-
ows as a basis for his work on stereographic projection.

The first surviving document describing a method of shadow construc-
tion, however, occurs in a context related to ancient discussions of pro-
jective geometry. It may reveal another whole discipline in which cast
shadows played an important role. In his book on cylindric and conic
sections, Serenus of Antinöe defends the definition of parallel lines made
by the geometer Peithon in contradiction of Euclid. Peithon used lines
formed by shadows cast by columns to define parallel lines.[26] In his vindi-
cation of Peithon, Serenus tries to demonstrate that the shadow cast by a
parallelogram that is a section of a cylinder will be a parallelogram similar
to the section of the object, and that of a triangular section of a cone will
form a similar triangle.[27] He also remarks that the matters he is discussing
belong to optical theory, and that as a consequence they appear strange in
his own work; this discussion also has an odd echo in Alberti's treatise *De
Statua*, suggesting that it may have had a long, if hitherto unexamined,
afterlife.[28]

In ancient optics, however, one can find only a very limited discussion
of shadows. The divisions of "catoptrics" made by Geminos, and later
cited by Lomazzo when he wanted to include shadow projection in per-
spective, suggest that the study of shadows and their outlines may have
formed some part of optics.[29] But there is scant evidence to indicate that
Serenus's statement means that ancient optics included a developed idea
of shadows or shadow projection. The only surviving passage in ancient
optics in which cast shadows are specifically discussed is in the proof that
light proceeds along straight lines (κατ' εὐθείας γραμμάς): it is this context
that Serenus probably has in mind when he says that the matters he is
discussing belong to optical theory.

In the introduction to his late antique recension of Euclid's *Optics*, Theon of Alexandria argues from the phenomenon of light entering windows and from fires whose rays are the cause of illumination of and projection of shadows from bodies placed in their path. He says that bodies that project shadows equal in breadth to them are equal in dimension to the illuminating fires, since the extreme rays (ἐσχάτας ἀκτῖνας)—the rays coming from the extremes of the source of light—are parallel to each other and cannot converge to diminish the shadow nor spread to enlarge it, but the shadows will keep the measure of the body that impedes the light. Shadows larger than the bodies projecting them are caused by fires smaller than the bodies, and conversely shadows smaller than the projecting bodies are caused by fires that are larger. According to Theon, none of these things could happen unless the rays projected by the fire proceeded in straight lines. Theon then concludes his argument with a demonstration taken from rays of light proceeding through holes in one screen onto another screen parallel to it.[30]

There is good reason why cast shadows would be relatively important in astronomical contexts while they retained a limited role in optics. Among numerous ancient theories of vision, one held that vision depended on the extromission of visual rays from the eye, another that it depended upon the intromission of luminous rays coming from the object seen by the eye. Yet geometrically it makes little difference whether the visual rays or luminous rays are the cause of vision; the geometrical model, which Alberti also inherited, remains the same in either case. Hence the study of luminous rays as they act per se as the cause of shadows was not of much interest to optics. As Geminos indicates, the study of shadows was excluded from a narrower definition of optics, as distinct from catoptrics, optics being the science of sight. Even works on optics demonstrate that shadows were more a concern of astronomy. Euclid's only proposition relating to shadows, the eighteenth, is an altimetric procedure of astronomy. Likewise in the very passage in which Theon talks about cast shadows he uses notions that are close to those of ancient discussions of eclipses. Thus his notion that extreme rays determine the size of shadows is based on an assumption similar to that made by ancient astronomers when they ignore the penumbra of a shadow, assuming that shadows have clearly defined outlines.[31]

Down through the Middle Ages there is a distinction between the lengthy discussion of cast shadows that may occur in astronomical treatises and the cursory and repetitious one in optical theory. Arabic science developed a distinctive branch of astronomy called "the science of shadows," which was devoted to the study of "shadow instruments" (gnomons and sundials). This study was carried on by authors who

are called "authors on shadows," whose books, known as "books on shadows," are exemplified by a lengthy treatise by Al-Biruni: in the dedication to his treatise, Al-Biruni expressly leaves open the issue of intromission or extromission.[32] In his *Commentary on the Almagest*, Ibn Al-Haytham (Alhazen) also mentions that he has written a treatise on "the subject of shadows and all that relates of astronomical matters": this may be the work that Al-Haytham mentions in the listing of his writings, "A Book on the Shadow Instrument," namely, a treatise that was probably on sundials, like that by Al-Biruni, or by Ibn Sina, whose work he states was his direct source. Although it has been said about another distinct treatise by Al-Haytham, titled "On the Quality of Shadows," that, in studying rectilinear propagation of light and shadow, this work "must be regarded as belonging to the field of optics," Al-Haytham nevertheless also explicitly relates his investigations to astronomy, not to optics. In "On the Quality of Shadows" Al-Haytham calls cast shadows one of the foundations on which astronomy rests. He defines shadows, describes the different types of shadow of the Euclidean tradition, and further what we would call a shadow's umbra and penumbra, proving his arguments by geometry and experiment. Al-Haytham also demonstrates his awareness of the different contingencies involved in the study of the sun's rays from those of a fixed source like a candle, using them to describe a lunar eclipse, and accounting for the indistinctness in the edges of the sun's shadows that we actually perceive.[33] It would thus seem justified to say that in "On the Quality of Shadows" Al-Haytham also treats the study of the way luminous rays engender shadows as something separate from his other, independent, considerations of optics, the study of vision and visual rays, in which any similar extended consideration is absent.

Though Al-Haytham's discoveries anticipate much of the subsequent discussion of cast shadows, his work was not translated into Latin and remained unknown in the West during the Middle Ages; in contrast with his work, Western medieval optical treatises did little to advance an understanding of shadows. In the main, such important writers as Jacob Alkindi,[34] Roger Bacon,[35] Witelo,[36] and John Peckham[37] all repeat Theon's discussions of shadows equal to, smaller than, and larger than the lights causing them, a discussion to which the immense prestige of Euclid had been attached.

Early Renaissance writings on optics also belong to this tradition. For example, Lorenzo Ghiberti merely cribs from medieval treatises when he discusses shadows and repeats their definition of types of shadow.[38] Biagio Pelacani's *De Visu* or *Questiones de perspective* (sic), begun c. 1390, is likewise essentially a commentary on Peckham, whose work seems to have remained a basic handbook, if not a textbook, on optics throughout

the Renaissance.[39] The discussion of shadows in his eleventh thesis is an elaboration of Peckham's arguments and as such a restatement of much of the traditional optical argument.

Pelacani shows his originality, however, in combining the study of shadows, previously reserved to astronomy, with that of optics. Pelacani believed that "astronomy does nothing without optics" (*astrologia nulla fa senza prospettiva*): he thought that the study of astronomy depended on the study of optics and light.[40] Hence he included in his treatise on optics a discussion of cast shadows related to astronomical and altimetric interests. Included are a number of arguments involving triangulation, and finally a demonstration that "many other things can be deduced from shadows; how to find the height of the pole, and similarly the zenith . . . and the elevation of the equinoctial (circle) above the horizon and the hours of the day and of the natural (moonlit) night."[41]

At the end of his treatise Pelacani describes a still more remarkable procedure for the actual projection of shadows. Pelacani is trying to show how a number of "optical illusions" are produced, among which is the appearance of grapes with vines and other similar spherical objects inside a room. He solves the problem by reference to a method of stereographic projection using shadows. In a passage referred to above, he says he gets this method from Ptolemy. Whenever one wants to see the illusion of a sphere in a room, one must take the sphere and hang it in the middle of the room with a thread tied in an equinoctial circle. If one then places a burning candle very near the south pole, one will see, on the wall opposite, the candle, the sphere, and its "construction" in a plane. The same thing will occur if the eye is placed where the candle was.[42] Pelacani has thus succeeded in relating a procedure for planispheric projection to an optical problem. In fact, in his last statement he seems to be identifying luminous with visual rays, and the process of illumination and shadow projection with that of vision.

Yet Pelacani invented neither a theory of shadow projection nor one of perspective construction. And Alberti, who demonstrated perspective construction and may have been familiar with Pelacani, from whom he may have derived the notion of a "quicker" way to draw a circle in foreshortening, as well as the association of illumination and shadow projection with that of vision, did not describe a procedure for shadow projection in painting. Even if, in the passage in *De Statua* mentioned above, Alberti seems to follow Pelacani in the connection of illumination and vision, in *De Pictura*, where he describes perspectival construction, he did not demonstrate, hence seem to realize, the connection of perspective to shadow construction, nor did any of his contemporaries who wrote on perspective.[43] For the shadows that Pelacani and the astronomical tradition were talking about were real, not painted shadows. The next step in

the development of a theory of shadow projection had to be taken by a mind that combined not only a thorough knowledge of astronomy and optics but also a lively interest in applying them to the practical problems of painting shadows.

THE DISCOVERY OF A METHOD OF SHADOW PROJECTION IN LEONARDO AND DÜRER

Leonardo da Vinci was the first to undertake a systematic examination of shadow projection in relation to painting. Passages throughout his notes, and in particular his intended six books on light and shade, show that he had a lifelong interest in problems of shadow projection; he, in fact, seems to have understood that shadows could be projected according to the principles of perspective.

As is well known, Leonardo was familiar with some of the main works of the medieval optical tradition. From these sources he took his definitions of shadows, again distinguishing three basic types. He also derived from them several theories about the relationship of the shape and intensity of the shadow to its light source.[44]

Leonardo also had an interest in the role of cast shadows in astronomy. He was interested in the phenomena of eclipses; he said that since the earth is smaller than the sun, it casts a pyramid of shadow on the moon. He is also interested in what shadows reveal about the sun's size and distance from the earth. He seems to echo an argument made earlier by Roger Bacon when he comments on Epicurus's assumption that the sun was equal in size to the earth because columns cast parallel shadows in sunlight. He states that Epicurus was wrong because the rays of the sun and their shadows are not really parallel, but only appear to be so because of the sun's great distance from the earth.[45] Although this idea is essentially correct, Leonardo drew the wrong practical conclusion from it. He seems to have held to the mistaken notion that the sun can be regarded in practice as a point source of light; he states that every definite light is, or seems to be, derived from a point. Several of his drawings represent the illumination of trees or houses by tracing lines signifying solar rays toward a single point.[46] These representations betray a misunderstanding of a way of depicting the sun's immense distance from the earth, and consequently of the way its rays and the shadows it causes can be shown. This fundamental error compounded an error easily made in the description of different types of light source in medieval discussions of rectilinear propagation of light. It thus continued a basic confusion in the history of ideas of shadow projection.

Despite this mistake, Leonardo made a fundamental contribution to the development of a theory of shadow projection. In his mind, as in

Pelacani's, astronomy and optics were connected. On the same folio of his manuscript where he talks of the sun's rays, he makes notes on optics.[47] He describes the parallax distortion in the size of the stars as an effect of vision.[48]

Leonardo invested the medieval legacy he received from optics and astronomy with new meaning gained from his concerns as an artist. He believed that the illusion of *rilievo* in a painting depended upon proper distribution of lights and shadows, which in turn necessitated an understanding of the particular types of shadow that are projected in differing lighting conditions.[49] He examined and then stressed the role of cast shadows on colors. He observed the colors and shapes of shadows and those cast in towns, forests, and mountains. He even considered the motion of shadows through spaces that are not intercepted by any surfaces. All these theoretical interests are revealed in his painting.[50]

A folio in the Codex Atlanticus succinctly demonstrates the way that Leonardo linked artistic problems with a scientific approach in tackling the question of shadow projection (fig. 28). On part of this folio, he attempted to show the interior of a church in cross section. To help create the illusion of the interior space, Leonardo used shadows, just as Cronaca and Raphael and his school had used cast shadows in similar drawings. Such shadows would have helped an observer to understand the new genre of architectural drawing of interior views by giving an illusion of depth and making the different parts of the building seem to stand out from each other. But inconsistencies in early interior drawings like those by Cronaca show that there were problems facing an artist who wanted to use cast shadows in them. What conventions for showing shadows can one use? What are shadows anyway? On the same folio of the Codex Atlanticus, Leonardo seems to be grappling with these problems: there are other drawings of geometrical demonstrations of the way shadows are caused, cast on walls, and vary in intensity.[51]

In fact, Leonardo reached the conclusion that the answer to these and similar problems of shadows lay in an understanding that shadows played a part not only in optics, the *perspectiva naturalis* of the Middle Ages, but also in the artist's perspective, the *perspectiva artificialis* of the Renaissance. In the introduction to the outline for his proposed books on light and shadow found in the Codex Atlanticus he says: "Shadow is the obstruction of light. Shadows appear to me to be of supreme importance in perspective, because without them opaque and solid bodies will be ill-defined; that which is contained within their outlines and their boundaries themselves will be ill understood unless they are shown against a background of a different tone from themselves."[52]

From this basic understanding, Leonardo came close to taking the step of showing a practical method for projecting shadows according to the

28. Leonardo da Vinci, Sheet of Studies including Examination of Cast Shadows and Architectural Designs

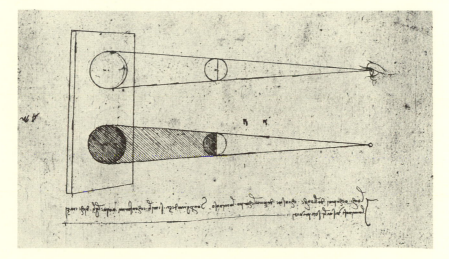

29. Leonardo da Vinci, Comparison of Vision with Projection of Shadows from a Point Source

newfound rules of artificial perspective. In Manuscript A he describes a procedure for making an "optical illusion" similar to that described by Pelacani, whose discussion of shadow projection he seems to have known. A candle placed by a small hole in a plate throws the shadow of an object, a circle in Leonardo's illustration, on a wall; the outline of the shadow is traced, and then the outline is filled in with shadow and highlight; when a person places his eye at the hole, he thinks he sees the object standing out from the wall.[53] In Manuscript C he gives a drawing that seems to reveal a grasp of the principles underlying Pelacani's and his own demonstrations. The drawing shows lines connecting to an eye a sphere and its image on a plane; beneath it is a candle illuminating an identical sphere, this time shaded, which produces a shadow identical to the circle just above it on the same plane in the drawing of an eye (fig. 29).[54] The eye is identified with the light. As Hans Schuritz first recognized, there seems to be here the kernel of the idea that the construction of a cast shadow that a sphere throws on a plane is in principle the same as the perspectival construction of the sphere.[55] Elsewhere in the same manuscript, Leonardo recognizes that shadows can be subjected to the rules of foreshortening.[56] From this point he could have concluded that they can be treated by perspectival projection just like anything else in a picture. To make the final practical step of demonstrating shadow projection according to artificial perspective, he would have had only to combine these various strands of thought.

Yet although some drawings in his extant manuscripts seem to illus-
trate a procedure for shadow projection, nowhere is a method clearly
represented.[57] What accounts for this lacuna?

Apparently Leonardo made new observations and became involved
with new aesthetic problems whose solution tended to contradict the
premises upon which he might have constructed a theory of shadow
projection. On the one hand, Leonardo had inherited a tradition of dis-
cussion from optics and astronomy that treated cast shadows in geo-
metrical terms, and thus held that the edges of shadows are clearly
defined lines, that cast shadows proceed in straight lines from the base of
the primary shadow, and that cast shadows form "pyramids."[58] On the
other hand, when after 1505 he began to study light and shadow outdoors

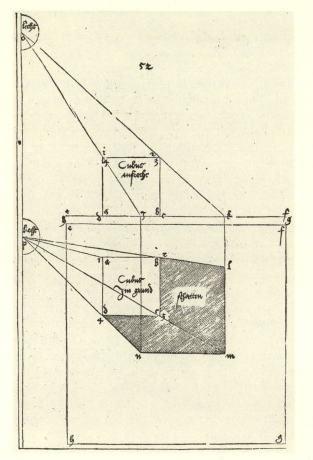

30. Albrecht Dürer,
Demonstration of
First Method of
Shadow Projection,
from [Die]
Underweysung der
Messung, 1525

under the *lume universale* of nature, in diffuse lighting conditions that obscure shadows, he noticed something about shadows' edges that might not be so immediately apparent when he looked at shadows projected by a fixed light source like a candle or by light entering through a window. As he says in a note datable to 1513, "Of the edges of shadows: some have smoke-like [*fumosi*] and ill-defined edges [*termini*], others distinct ones."[59]

This observation was coupled in Leonardo's mind with a number of aesthetic preconsiderations. First was his opposition to the use of outline in figural representation in painting. He states in Manuscript G: "The boundaries of bodies are the least of all things . . . wherefore, o painter; do not surround your bodies with lines, and above all when representing objects smaller than nature; for not only will their external outlines become distinct but their parts will be invisible from a distance."[60]

Added to this abhorrence of outline was the predilection he shared with Alberti and also later art theorists for smokelike (*fumosi*) transitions between light and shadow. Hence in his painting and theory Leonardo believed that outlining shadows would detract from the *dolcezza* of the finished work: "When you represent in your work shadows which you can only discern with difficulty, and of which you cannot distinguish the edges, so that you apprehend them confusedly, you must not make them sharp or definite lest your work should have a wooden effect."[61] Leonardo therefore found himself in a dilemma that he wrestled with throughout his later writings on cast shadows, as he says in a note of 1513 in the Windsor manuscripts: "What makes the outlines of the shadow vague and confused? Whether it is possible to give clear and definite outlines to the edges of shadows?"[62] If shadows have indefinite edges how can they be treated geometrically?

Leonardo struggled for solutions to the problems of outlines. In the Arundel manuscripts he says that the "outlines of objects will be least clear when they are nearest to the eye, and therefore remoter outlines will be clearer."[63] He relates the problem here to the eye's ability to focus on an object placed near it. Then in the Codex Atlanticus he relates the problem to the size of the light and the distance of the shadow from the object causing it. He states: "The greater the difference between a light and the body lighted by it, the light being the larger, the more vague will be the outlines of the shadow of that object. The derived shadow will be most confused towards the edges of its interception by a plane, where it is remotest from the body casting it."[64] Then Leonardo reexamines shadows cast by candlelight; this reexamination causes him to contradict a number of assumptions made in earlier expositions of shadow projection. He says that the shadow is not produced by the angle of the derived shadow but only by the body casting the shadow:

If a spherical solid body is illuminated by a light of elongated form the shadow produced by the longest portion of the light will have less defined outlines than that which is produced by the breadth of the same light. . . . And this is proved by what was said before, which is: That a shadow will have less defined outlines in proportion as the light which causes it is larger, and conversely the outlines are clearer in proportion as it is smaller.[65]

Again Leonardo seems to try to reason from what he has observed of shadows cast from candles:

A luminous body which is long and narrow in shape gives more confused outlines to the derived shadow than a spherical light, and this contradicts the proposition next following; a shadow will have its own outlines more clearly defined in proportion as it is nearer to the primary shadow or, I should say, the body casting the shadow; the cause of this is the elongated form of the luminous body.[66]

Here Leonardo is pondering over two distinct sorts of solutions to the problem of shadows' outlines. The one stresses the shape and size of the light source, the other the way the shadow is intercepted by a plane.

Leonardo chooses neither of these alternatives in his most coherent answer. Instead he emphasizes the role of the medium through which the shadow is thrown. He included observations of different kinds of light source he had made as a painter in his theory of light, distinguishing between "direct light," that of the sun, reflected light, light that passes through translucent bodies, and *universale* light, the diffused light of the atmosphere.[67] This last type of light is said to cause the indistinctness in edges of shadows:

The atmosphere which surrounds a light is almost like the light itself for the brightness and colour; but the farther off it is the more it loses this resemblance. An object which causes a large shadow and is nearer to the light, is illuminated both by that light and by the luminous atmosphere; hence this diffused light gives the shadow ill-defined edges.[68]

Surprisingly, Leonardo seems to have already come to this conclusion in 1492. Insofar as he means here that a diffused light creates shadows with unclear edges, and not what he says elsewhere when he speaks of particles in the air impeding the passage of rays of light and shadow, he gives one of the correct answers to the problem.

Yet paradoxically Leonardo's interest in the problem of shadows' edges limited his contribution to the discussion of shadow projection in terms of art theory. Because he both misunderstood the nature of solar illumination and did not realize that even a candle is not a pure point

source of light, he never achieved a more complete answer to the question of shadows' edges, which is also related to his use of *sfumato* as a painter. To have given a clear demonstration of shadow projection in terms of artificial perspective, he would have had to assume that the edges of a shadow were clearly defined, their path a straight one, their light source a fixed point. Or if he took the sun to be a source, its shadows would have to be considered the product of isometric projection by (for the sake of practical clarity) parallel rays. Yet these were all points that Leonardo was most unwilling to accept merely as assumptions while he puzzled over the limits of shadows and postulated different kinds of light source, including diffuse light. In fact, it was just these questions that he spent a considerable amount of energy pursuing rather than attending to the demonstration of how painters might construct shadows. This theoretical task remained for Albrecht Dürer to accomplish.

Where Leonardo had stopped, Dürer took the final step of demonstrating how to project shadows for the use of painting according to laws of perspective. In his *Underweysung der Messung* of 1525 Dürer follows Euclid's assumption that light travels in straight lines. Hence the edges of shadows are clearly defined: in the examples Dürer gives for both his methods, they are, in fact, circumscribed by straight lines. In Dürer's words: "Every light reaches in straight lines as far as its rays run. But if an opaque object is placed before the light, then the rays break off there, and a shadow falls so far as the lines of the light rays would have travelled."[69] The source of light is assumed to be a fixed point of determinable horizontal and vertical distance from the illuminated object.

Dürer's demonstration of shadow projection, in fact, formed an essential part of his discussion of perspective. A description of shadow projection was necessitated as part of the answer to the problem he posed in the *Underweysung der Messung* of how to show a cube in perspective with its shadow. Thus Dürer's first method of shadow projection proceeds according to the same principles as his first method of perspectival construction. He uses here a method similar to that which Erwin Panofsky called his *umständlichere Verfahren*.[70] He combines drawings of the elevation and ground plan of the illumination of an object into a third drawing in which the perspectival projection of the object's shadow is rendered "correctly." Dürer describes the projection of shadows from a die, which as a simple body can serve as an example for the procedure that one must also follow with more complicated bodies. The four lower corners of the cube are labeled *a*, *b*, *c*, *d*, the four upper *1*, *2*, *3*, *4*, and it is placed on a plane labeled *e*, *f*, *g*, *h*. The cube is shown in ground plan as a square whose corners are *1-4*, *2-b*, *3-c*, *4-d*, and then constructed in elevation as a square whose corners are *1-4*, *2–3*, *a-d*, *b-c*, upon a line parallel to lines *e-f*, *g-h*, labeled *e-h*, *f-g*. Then the points representing the source of light

are given *o* for the elevation and *p* for the ground plan, although they really represent (the location in the horizontal and vertical of) a single light, says Dürer, and are separated for "easier use." Lines signifying the rays of light are then drawn from point *o* through points *1-4, 2-3* of the square in elevation, ending in points *i* and *k*, and from point *p* in the ground plan through point *2-b* ending in point *l*, through point *3-c* ending in point *m*, and through point *4-d* ending in point *n*. Then lines are drawn connecting points *i* and *k* with points *l*, *m*, and *n*. The lines thereby enclosing points *l*, *m*, *n*, and connecting them with the edge of the cube as shown in ground plan demarcate the extent of the shadow in its length and breadth. The area between the cube and these enclosing lines is said to be the area of shadow (fig. 30).[71]

Dürer's second way of projecting shadows follows his *näherer Weg* in perspective.[72] It represents a combination in one diagram of the split method of the earlier procedure. A die whose upper corners are *1, 2, 3, 4* and lower corners are *a, b, c, d* is constructed by means of the *näherer Weg* according to "correct" perspective upon a plane *e, f, g, h*. A light source designated *o* is raised above the cube, and a line dropped from it to point

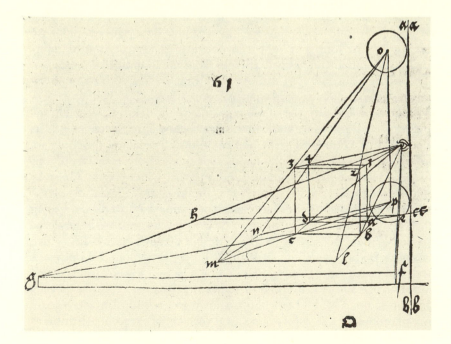

31. Albrecht Dürer, Demonstration of Second Method of Shadow Projection, from *[Die] Underweysung der Messung* (detail)

p, which one must conceive as being in the plane of the base of the cube. If the light is supposed to be farther away from the object it illuminates, it is moved higher up on the line *o-p*; if nearer, point *p* is to be moved farther away from the cube. Then straight lines representing light rays are drawn from point *o* through the upper corners *2, 3, 4* to where they intersect plane *e-f-g-h* at points *l, m, n*, and from point *p* through the lower corners *b, c,* and *d* to meet the other lines at *l, m,* and *n*. Then *dn, nm, ml, lb* are connected with straight lines (fig. 31). The outline that results circumscribes the shadow.[73] Dürer then illustrates the die with its shadow to indicate to the painter how it should look when shaded in (fig. 32); he says the same procedure can be followed for all objects, not just for cubes.

As Panofsky and others have suggested, Dürer's geometrical constructions of cast shadows derive from Leonardo or a Leonardesque source[74]; in Dürer, however, there are further complications. The first is caused by Dürer's connection of shadow construction with his *näherer Weg* in perspective. His first method of shadow projection had used a straightforward Italian plan-and-elevation construction. But his *näherer Weg* was his version of a different sort of construction, the distance-point procedure

Jn gleycher weyß wie ich den cubus in einn abgeſtolen gemel gebꝛacht haß / alſo mag mann alle coꝛpoꝛa die man in grund legen vnnd aufziehen kan/durch ſöliche weg in ein gemel bꝛingen.

Hernach will ich vnderweyſſen/wie man ein yetlich ding das man ſihet / vnd nit faſt weyt ſtet durch dꝛey ſeden meſſen/vnd dardurch in ein gemel bꝛingen mag.

32. Albrecht Dürer, Completed Procedure for Shadow Projection, from *[Die] Underweysung der Messung*

first published by Jean Pélérin (Viator), which he could have known in a 1509 Nuremberg edition. In Dürer's confused version the center point of the Albertian *construzione legittima* is moved over to correspond with the distance point of the object seen in perspective. While Dürer thus makes the two coincide, his *näherer Weg* has great practical disadvantages,[75] not the least of which is that it severely restricts (in fact doubles) the angle from which objects in a picture can be seen. These disadvantages may have kept him from using a consistent perspective construction in more than two pictures; they also may have kept him from showing cast shadows correctly even in engravings in which his perspective was consistent.[76]

Another more important confusion is evident in Dürer's completed illustration of shadow projection. While his text has assumed that the source of light is a single point from which all rays emanate, the illustration shows a sunlike disk. It is easy to see how someone who looked at this illustration after reading the text might think that Dürer had been demonstrating solar illumination and shadow projection. Whereas Dürer's demonstration of shadow projection was valid apart from his restrictive presentation of perspective—and his method of shadow projection could be separated from his perspectival system—it is not easy to discover that his method was not valid for solar shadow projection. Dürer himself, like Leonardo, may indeed have thought that it was valid to show the sun as a point source of finite distance. This mistake was to have a lasting effect upon later discussions of shadow projection; the influence of Dürer and Leonardo on sixteenth- and seventeenth-century theories of shadow projection was for ill as well as good.

The Influence of Leonardo and Dürer in Sixteenth- and Seventeenth-Century Theories of Shadow Projection

Leonardo's manuscripts were passed on and studied in a Milanese milieu for a long while after his death. The composition of the so-called *Treatise on Painting* evinces this interest, and the Codex Huygens, a mid-sixteenth-century treatise composed by Carlo Ubaldo from Crema, which is based on Leonardo's papers and contains both text and illustrations, shows the impact of the manuscripts. On folios 88 and 90 of the codex are indications of an elaborate study of shadow projection based on Leonardo but never carried out so systematically by him. This study seems a Leonardesque investigation made in response to aesthetic problems of the Cinquecento. On these folios are drawings that illustrate the projection of shadows by different sources of light. The first is labeled *Del sole. Per l'ombra dimostrazione*; it demonstrates the relation of the length of shadows cast by a human figure on the ground and on the wall of a building to the position of the sun as it passes through the heavens on

its diurnal route. The second is entitled *Della luna. Per l'ombra seconda dimostrazione*; it demonstrates the same relationship for the moon on its nocturnal route. In both, the shadows get longer as the sun or moon is nearer to the horizon. These drawings manifest an understanding of the basic problems of solar and lunar shadow projection—a problem not discussed by Leonardo himself—that shadows change with the position of these bodies in the heavens. The third drawing is entitled *Del foco. Terza per l'ombra dimostrazione*; it represents the other set of possibilities for illumination. It illustrates a fixed light source, a candle, that casts shadows on a wall. The shadows get bigger as objects approach the candle and move away from the wall. As might be expected from a manuscript in the Leonardesque tradition, the Codex Huygens has, however, no representation of a method of perspectival shadow projection.[77]

For this sort of practical information artists and writers on art theory turned to Dürer, whose written works must have served as convenient handbooks. Daniele Barbaro, for one, used Dürer extensively in his *Pratica della prospettiva* of 1568.[78] Barbaro's chapter on the "projection of shadows" is in the section of his treatise devoted to lights, shadows, and colors. Like Leonardo, in this section Barbaro says that a color should be blended gradually from its brighter to its less bright so that those areas struck by light do not appear separated as with lines from areas of shadow.[79] Like Armenini, he says that only one light should be placed above rather than below an object it is illuminating, since a statue lit from below and by many lights loses its relief and roundness.[80] Shadows make the color of an object darker and vary in density and darkness with the position of objects casting them and the type of light source. Shadows coming from the "eternal fires of heaven" are "almost equal" (*quasi pari*— a strange reinterpretation of Alberti) to the bodies casting them; those from "terrestrial fires" are larger.[81] Finally, like Dürer, Barbaro says that a light emanates rays in all directions, so that when an opaque body is placed in the path of the rays, it causes shadows to be projected; shadow projection should be taken from the height of the light. "Therefore whoever would want to measure correctly the length of shadows, should place the light in a determined place [*luogo determinato*] and from it make the lines fall like rays below it, and there put the boundaries [*termini*] of the shadow, which will be circumscribed by rays."[82]

Shadow projection makes things marvelously distinct from one another, as can be seen in the works of "two Brescian brothers"—the now-lost ceiling painted by the Rosa brothers in Santa Maria dell'Orto in Venice.[83] Barbaro's example of a method of shadow projection comes straight from Dürer, to whom he specifically attributes it. He gives Dürer's *näherer Weg* to shadow projection and illustrates it. He concludes, however, with a twist: "With good practice you can project every shadow, of

whatever body and shape you like, without drawing so many lines; and you can also determine the shadow of objects hanging in air cast upon distant planes, for which judgement and experience are needed."[84]

Down through the seventeenth century, writers on perspective learned shadow projection from Dürer, much as did Barbaro, using his method while avoiding the intricacies of his perspectival system. For example, Dürer is the only writer that the noted geometer Guidobaldo del Monte cites in his mathematical treatise on perspective of 1600.[85] In the fifth book of this treatise Guidobaldo reasons that the projection of shadows can be treated as another problem of projective geometry: to find out to what extent and how far shadows are cast on a plane by bodies lying in the way of light. It is assumed that the light is a point, and that the luminous rays proceed in straight lines from this point, that a plane be a certain distance from the light so that it intercepts that shadow, but the body casting the shadow not be equidistant from the light and from the plane. Given these conditions, Guidobaldo says it will not be difficult to find the boundaries of shadows.[86] He demonstrates this procedure for a cube (prism) by applying Dürer's second method of shadow projection, without, however, using his entire perspective construction system; he therefore also avoids Dürer's pitfalls. Guidobaldo then explains how the same procedure of shadow projection can be done by *ichnographia* (in ground plan), in other words a process like Dürer's first method. Next Guidobaldo demonstrates that shadows can be projected from other geometrical bodies by the same methods. He applies Dürer's second method to rectangular solids, cylinders, and cones whose bases are located on the plane; he then refines the method to handle more complicated questions like the projection of shadows from geometrical solids whose bases are inclined to the plane that intersects their shadow, and from spheres, concave cylinders, and concave hemispheres.[87]

But Dürer's method was not always used so correctly. In the second book of his *La perspective avec la raison des ombres et des miroirs*, Salomon De Caus takes Dürer's invention to its extreme application in art. De Caus first demonstrates how to represent in foreshortening a rod (*vergette*) and cube with the shadow appropriate to each by a combination of elevation (*orthografie*) and ground plan (*ignografie*)—Dürer's first method of shadow projection, which De Caus calls the easier if the longer procedure, to be employed when there are many different and irregularly placed bodies whose shadows one wants to depict.[88] Then De Caus demonstrates that *näherer Weg*, which he says "Albrecht Dürer teaches in his book on geometry."[89] After the demonstration of a number of artistic problems of shadow projection, De Caus's final problem is a tour de force of *trompe l'oeil*, showing how to "paint against the wall of a room a continuation of

the room with some figures and also to place shadows for everything that is painted in the room." He aims to represent an entire scene according to procedures of perspectival and shadow projection as a practical demonstration, since the great mass of painters is ill instructed as to viewpoint and shadow. First the perspective of the room is constructed by ground plan and elevation. Next the shadows are placed in the picture. A point of light is chosen in one of the windows of the room, either on the same side as the painted wall or on the opposite, made to coincide with the actual window of the room. From this source all the luminous rays are drawn, and the shadows laid in accordingly for the figures in the room:

> It suffices to draw three or four rays from the extremities of their bodies to the ground to know about where their shadows fall, because one cannot make the shadows of bodies composed of irregular outlines [*lignes courbes*] (as are the figures of the people) as exactly as those figures composed of regular outlines [*lignes droictes*].[90]

While De Caus at least recognized that there was no exact method for figures with irregular outlines, he did not realize that Dürer's method had other limits. His use of a point-source procedure for window illumination and shadow projection was questionable, to say the least. Only if the shadow's objects are very far away from the window and very small will they appear to be lit by a point source. If the light coming through the window is the direct light of the sun, then shadows must be cast as in sunlight. If the light coming through the window is the general light of the sky, then shadows must be cast as in conditions of diffuse light. In neither instance is it valid to represent the source of light as a point.[91]

In his popular book on perspective of 1628, Samuel Marolois also seems to have been misled by Dürer. In the third part, *Tractant des ombres*, Marolois relies on Dürer, whom he elsewhere calls a very excellent painter who had a very good knowledge of the art of perspective.[92] He uses Dürer's two methods of shadow projection to demonstrate how to cast shadows by projective geometry from various geometrical solids and other objects given a light and its height. Most of his illustrations adapt Dürer's convention for the light source, a sunlike disk with rays coming out of it.[93] In Marolois the ambiguity of the light is at its most intense, however. For Marolois clearly believed that any light source can be treated as a point. The introduction to the third part of his book says he will consider shadows

> which bodies exposed to light make, whether of the sun, of the moon, candle or something similar, which light is taken to be a single point, and its height is taken as a straight line perpendicular to the plane on

which rests the body of which one desires to have the shadow. Follow-
ing which as a general rule, lines will be drawn from the light and from
its base which passes through all the angles of the body, both on top and
those on the bottom, and where these lines intersect, the extremities of
the shadows of the body will be marked.[94]

While leading art theory to an understanding of shadow projection,
Dürer also led it into error.

CRITICISM AND CORRECTION: *SFUMATO* AND SOLAR
SHADOW PROJECTION

By the time of De Caus and Marolois, Dürer's methods had come under
attack. De Caus had already pointed out that his methods might not be so
appropriate for compound lighting conditions and complicated figures.
Others were to ask if Dürer's system took into account questions of the
outlines of shadows that Leonardo had raised, and if it were valid for any
other kind of light than that which may truly be considered a point, such
as candlelight. During the sixteenth century the question of shadows'
outlines had been restated by Armenini and Barbaro in terms of the
painter's *sfumato*. While the half-shadow of a candlelight can be ignored in
many circumstances, a point source, even when very small and at a very
great distance, cannot produce a critically sharp shadow because of dif-
fraction. Moreover, in most conditions of illumination the effects of scat-
ter and reflection interfere with the outlines of shadows; as Leonardo had
noticed, these phenomena are particularly evident in solar or diffused
light, in which the artist normally worked.

Artistic considerations also led to the attack on the other focus of
Dürer's theory. At a time when artificial light sources and *chiaroscuro*, as
in the art of Caravaggio, spread throughout painting in Europe, Karel
van Mander first distinguished point-source illumination as a property of
candlelight in his *Schilder-Boeck* of 1604. Describing different kinds of
illumination in his *Lehrgedicht*, he speaks about "candlelights: how one
shall depict them": ". . . the shadows must fall all over the picture from
the light as from a point." But van Mander also realized that candlelight
was not the most frequent source of illumination in painting; he stresses
that "candlelights [are] not very common things," and felt it necessary to
give examples of paintings where they were found.[95]

François Aguilon changed the discussion of shadow projection when
he took up these questions in his *Opticorum libri sex* of 1613. In the fifth
book of this work, entitled *De luminoso et opaco*, which is also directly
connected with painting since it was illustrated by Rubens, Aguilon dis-
cusses the scenographic projection of shadows and the variation in inten-

sity of shadows, a question related to the problem of their outlines, and to *sfumato*. After giving geometrical definitions of what he calls the *umbra plena* and *umbra diminuta* of shadow, Aguilon tries to account for the differences between them, which he says are caused by the diffuse luminosity of the air: "For since there is always some light that is derived from the air flowing around that illuminates the darkened area itself, and the area of shadow is not uniform, it happens that the parts of the shadow that are farther away from the light are left darker from the constriction of light."[96] Aguilon explains that the part of a shadow nearer to the body casting it is darker than the part farther away. He states that the illumination in darkness is caused by the air having *portiuncula* of light which mix with the farther shadows.[97]

Although Aguilon uses Dürer's definitions and methods, and the same figures as Guidobaldo and Marolois,[98] he suddenly veers from his predecessors' course. Aguilon deems Dürer's methods valid for torchlight, and allowed for window illumination, but he thinks they are mistakenly extended to solar illumination and shadow projection. Aguilon's remarks are the first published comments on the inadequacy of earlier methods of shadow projection:

> Therefore in order fitly to consider lights on projected forms, I think that something should be recalled in which I see most people dream. Rays of light are emitted in one way by lamps, in another by the sun. Those things which are in the open air and those things which are lit through windows are not apt to be illuminated in one and the same manner; in short the former takes light from many luminous sources, the latter from one source. For those things which are illuminated by lamps, or by light in an enclosed room, ought thus to be expressed in terms of scenography: as the light is small, the shadows are spread forth extensively in all directions. Moreover those things which are exposed to the direct rays of the sun are to be represented *orthographice*: from parallel rays the forms that are portrayed share light and shadow. Finally those things which are in the open air ought to be shown with an equal light flowing all around on all sides, inasmuch as they prevent shadow in nearly every part.[99]

Aguilon here clarifies the distinction between the propagation of light from lamps and the sun. Correcting Leonardo and Dürer when he states that solar rays are parallel and therefore cannot be treated the same way as those from a lamp, he gives another reason why no shadow in the open air can be completely dark.

Pietro Accolti, in his work *Lo inganno degl'occhi* of 1625, continued the critique of shadow projection commenced by Aguilon. Like Aguilon, he was dissatisfied with previous discussions of shadow projection and

sfumato. Accolti is particularly disturbed that in the tradition of discussion established by Dürer most theorists have neglected what is really essential for painting. He, too, thinks that they have not recognized the difference between pyramidal and parallel emanation of light and projection of shadows. He singles out for attack Barbaro, Guidobaldo, and Lorenzo Sirigatti, the Florentine author of a book published in Venice in 1596 entitled *La pratica di prospettiva*, in which the illustrations point out a confusion of what must be daylight illumination with single-point illumination. Accolti's correction of this misunderstanding merits full quotation:

> Truly I have always been not a little astonished that those authors who have written more extensively about perspective than most others (as among the moderns Monsignor Barbaro, Guidobaldo del Marchesi del Monte, and Cavaliere Sirigatti) have not particularly undertaken its noblest part, which is of so much consequence, and moment, to *disegno* and painting, and to which alone it seems that their mastery, study, effort, and all of their practice of perspective ought to belong and be directed.
>
> Even if these men have left anything written about it [i.e., shadowing] it has been such that it is neither masterfully nor with truth applicable to the profession of painting, inasmuch as (like the imitator of things naturally represented to our vision) painting requires the learning of a rule of shadowing and lighting that fits a greater or natural light, and not just the light of a torch or lamp, as these authors have all supposed in their traditions and doctrines. They say that the effect of shadows and cast shadows arising from this illumination of a body will be the same as it will be when this body is lit by the southern part of the sky and by the sun (given the same placing of the light); whereas this is false according to our own opinion, since the sun (as sensory experience proves) causes shading or cast shadows with rays parallel to each other, while every other light of a torch or lantern effects this by pyramidal rays, this fact deriving from the nearness of the one, and the immense distance of the other.[100]

Accolti thus has more than one system of shadow projection in his perspectival treatise. For "pyramidal illumination" Dürer's method is fine; Accolti, in fact, employs Dürer's own diagram of the shadowing of a cube to illustrate this method. He also follows Dürer's suggestion in showing how shadows are found to vary proportionately with the height and distance of the light.[101] Solar projection was another matter altogether: it presented problems of a different magnitude that may have been beyond Accolti's ability to solve by giving a rule, or at least not of interest to him to demonstrate geometrically. All Accolti offered to illustrate how the sun cast shadows was a new invention of an *organo ombrifero*, which consists of a cube framework in which six open octagonal frames are

placed. Accolti claims that by examining the shadows cast by this device in sunlight, one can observe all the effects of solar illumination, including the derivation of *più sfumato termine*,[102] but he does not explain how. Yet this device would still not produce a systematic rule for dealing with shadows. Accolti could also not find a successful way of dealing with window illumination. His "improved method" is nothing more than a variant of De Caus's refinement of Dürer's system, of "pyramidal" shadow projection; he places points at each of the four corners of the window or similar opening, instead of just one point somewhere in its center, as De Caus had done, and draws his shadows from them.[103]

Accolti was more successful in tackling the other major question that bedeviled shadow projection, that of *sfumato*. He stresses that shadow is not only propagated and bounded by but also gradually merges with the light. This mixing is what he says painters call *unione e sfumamento*; it appears in every shadow and is noticeable particularly in shadows cast by sunlight. Accolti rejects the explanation of this phenomenon propounded by Leonardo and published by Aguilon. The appearance of *sfumamento* comes not from the air around the luminous body but completely from the *ampiezza diametrale* of the luminous body, whatever sort of light it may be. Accolti reiterates his point, which is an essentially correct amendment to the Leonardesque explanation of *sfumato*. No matter what the luminous body, a light source is never a mere point; it will create multiple shadows and hence have *confusi* outlines. Accolti proves his argument geometrically, but says the painter does not have to obey these rules all the time. He adds that the imprecise termination of shadows can be seen from the parts of the shadow farther from the light source, and from shadows that fall obliquely upon a plane. As an example of shadows that fall obliquely upon a plane, he discusses how light falls upon two spheres and how it should be united with their shadows.[104] Accolti says that the painter should always keep *sfumato* in mind in order to give his works *proportionata dolcezza*. At the same time he allows the painter to ignore the exact procedure that he defines for *sfumato*. Hence he avoids a dogmatic rejection of any method of shadow projection because of shadows' problematic outlines. He permits proper conceptions of *sfumato* and methods of shadow projection to coexist and discusses them both. Perhaps because of such a practical approach, Accolti was an important conduit for this tradition of discussion for theorists such as Matteo Zaccolini and hence painters such as Poussin.[105]

Accolti and Aguilon had shown that Dürer's method had its limits. Now it was the task of theorists to try to devise new rules for solar shadow projection and *sfumato*. Some attempted to give general rules to painters for conventions in depicting shadows cast by the sun, as in Pietro Antonio Barca's handbook on perspective and architecture. Barca illus-

trates a convention that has since become widely accepted: "At forty-five degrees in altitude and thirty degrees in latitude brightness [*il chiaro*] and shadows are more pleasing to sight."[106]

Other theorists attempted to demonstrate solar shadow projection geometrically. Yet even after Accolti and Aguilon, geometric demonstrations were not free from error: the main mistake made by most treatises was still to represent the sun as a light source of finite distance. A characteristic error was to treat the sun like a lamp whose "height" (or, properly speaking, top) and "foot" on a plane were used to determine the projection of shadows. It was perpetuated by J. A. Dubrueil and Samuel van Hoogstraten among others and again amounted to making solar illumination the same as candlelight.[107] Hoogstraten also misrepresented the shadows projected when the sun was assumed to be shining in a picture.[108] When the way of showing the diminution of shadows is not understood, the shadows do not converge on a proper "vanishing point." Even some like Dubrueil who may have understood the parallel nature of the sun's rays treated the sun as if it were an object of finite size and distance—an error recognized by Dubrueil's contemporary Abraham Bosse.[109]

It seems theorists needed to make an intellectual breakthrough before they could demonstrate a correct rule for solar shadow projection. Just as a new process of understanding was necessary before shadows could first be treated according to the rules of perspective, so a new geometrical development was now needed. What was needed for solar shadow projection was a way of determining the vanishing point of parallel lines. Shadows parallel to the picture plane were not so difficult: they could be handled by convention, as Barca had done. But what if the sun's shadows ran oblique to the picture plane, either into or out of the picture? Then some understanding of a vanishing point was needed.[110]

The inventor of a correct method for solar shadow projection was the great French geometer Girard Desargues. Desargues originated a clear exposition of the theory of the vanishing point according to projective geometry; he also developed a theorem for the vanishing point that is still known as Desargues's theorem.[111] He was also interested in the practical use of shadows and wrote a treatise on sundials.[112] Like Leonardo, he combined his interests in perspective and shadows and came up with the first correct demonstration of the projection of shadows by the sun. His rules were pirated by Dubrueil in 1642[113] and also published by Abraham Bosse. Bosse also gives what he purports to be Desargues's own demonstrations. These consist of a series of illustrations and discussions of how to cast shadows from various bodies.[114]

By the eighteenth century Desargues's theorems had become known throughout Europe. Since the illustrations of Desargues by Bosse do not employ the vanishing point, as B.A.R. Carter noticed,[115] it is thus better to look elsewhere in eighteenth-century treatises for the final form of the

solution to the problem of solar shadow projection. We can appropriately choose to discuss here the work of Brook Taylor as transmitted by Joshua Kirby. Taylor was the first to use the term "vanishing point" in English.[116] Kirby says that shadows are either projected by the sun or else by a "Candle Torch or some such luminous point. . . . But since those produced by a Candle, etc. are but seldom wanted, I shall therefore have regard to such Shadows only as are projected by the Sun."[117] These may be divided into three classes: when the light comes parallel to the picture, when the light shines from behind the picture toward the spectator, and when the light comes from before the picture. Two things are necessary for the perspective of shadows: the angle of inclination with which the rays strike the picture, for which any ray will do, since all the rays are parallel, and the situation of the plane in which the rays are supposed to be, which can be determined at the artist's discretion.[118] When the rays are in planes parallel to the picture, they have no vanishing point but cast shadows parallel to the picture. The length of the shadow of any perpendicular object cast by such rays can be found in calculation when their angle of inclination is known.[119] The shadows of the other two classes of light will have a vanishing point. Since the rays are parallel, "because a Line drawn from the Eye parallel to those Rays will cut the Picture in some one Point, therefore they will have a vanishing Point upon the Picture, which will be the common vanishing Point for all the Rays in that Direction, whether they be all in one Plane or in any Number of Planes, provided those Planes are parallel to one another."[120]

When the rays of light come from behind the picture, their vanishing point is above the horizon line, and the shadows they cast will be toward the bottom of the picture. The height of the vanishing point can again be found from the angle of inclination of a light ray. When the rays of light come from before the picture, from behind the spectator's eye toward the picture, the shadows of objects are thrown toward the horizon line, and the vanishing point is found on it. This is the kind of shadows said to be most generally used in painting.[121]

And what is *sfumato*? Early in the seventeenth century theorists realized that the question of shadows' edges did not allow an objective solution. Perhaps it was again Desargues who showed the way to an understanding of this point. Dubrueil had a sensible statement to make about the problem. After defining the types of shadows caused by torchlight and sunlight, he mentions a third sort of light "caused only by a fine day, which having not enough force to form a figure, only renders a confused darkness around the object. . . . Now this type has no rule, which is why everyone practices it according to his imagination."[122]

The time of Leonardo had passed, and in the seventeenth century the question of shadows' edges was to be reserved more to the formal science of optics than to the informal one of art theory: it was the scientist Fran-

cesco Grimaldi who discovered the law of diffraction that explains the lack of clarity in shadows' edges. Grimaldi demolished the geometrical basis of the study of shadows by showing that the boundaries of shadows observed in his experiments did not correspond with the geometrical model for them, according to which light travels in straight lines.[123] From the time of Grimaldi, physics, not painting, would take up the scientific study of the elusive phenomena of shadows' edges.

When Grimaldi undermined the assumption that light traveled in straight lines, he redirected the course of the study of light. Modern physics does not accept the hypothesis that light travels in rays upon which methods of shadow projection were based. It has instead advanced the hypothesis of quantum propagation that does not require light to travel in straight lines.

But for the artist the visual impression remains the same no matter what the physical theory of light. Developments in modern optics have not affected the artistic theory of shadow projection because the artist can safely ignore them. After all, painters do not deal with the photons that physicists say cause the phenomena we call light. Thus the development of a theory of shadow projection came, in effect, to an end in the seventeenth century when the question of *sfumato* was finally dropped from art theory and that of solar projection finally solved. The principles developed by Desargues were passed on through Bosse to the French Academy,[124] where they were taught and remained in use in academic drawing down through the nineteenth century. The rules Joshua Kirby explicated so clearly are, in fact, taught in art and architecture schools today. It is perhaps fitting that we should let Kirby have the last word here on the vicissitudes of shadow projection:

> I shall procede to shew, that the Perspective of shadows upon the Picture, is to be determined after the same manner as the perspective of objects, being found upon the same Principles and deductible from the same rules; It is therefore very surprizing, that almost every author who has handled this part of Perspective, should have committed such egregious Mistakes in giving such rules as are false in theory, and in Practice the most absurd.[125]

The Nature of Imitation

HOEFNAGEL ON DÜRER

ALONG with his writing as a theo-
rist, as an artist Albrecht Dürer has long gained renown for his studies of
nature. In works such as *"The Great Piece of Turf"* (Vienna, Graphische
Sammlung Albertina) Dürer meticulously reproduced in watercolor and
body color minute details of the visible world. Hence he has been re-
garded as having continued the tradition of the "conquest of reality" in
northern European painting which Netherlandish masters of the fifteenth
century had begun.[1]

Dürer's nature studies also started their own tradition and provoked a
large number of imitators. Among them was Georg Hoefnagel, who
copied at least two of Dürer's studies, those of his famed hare and stag
beetle (figs. 33 and 34).[2]

Two poems by Hoefnagel on Dürer that are to be discussed in this
chapter thus represent both an addition to the early literature celebrating
the artist and also allow insights into the work of a major Dürer imitator.
An interpretation of Hoefnagel's Latin poems furthermore sheds light on
a central issue of imitation, both of art and of nature in the sixteenth
century.[3] In studies of Italian art and art theory it has been recognized that
in the course of the sixteenth century a change occurred in artistic out-
look, whereby the rule of imitating nature was supplemented by that of
imitating art, especially that of the ancients.[4] But even in the opinion of
writers who believe that ideas similar to those expressed in Italy bore
upon the making of art in the north, the descriptive naturalism of north-
ern painters is said to lack a corresponding contemporary literature.[5]

A debate has consequently resulted from a response to a pioneering
essay by Hans Kauffmann on the imitation of Dürer. In this essay Kauff-
mann boldly and broadly related the reception of Dürer to the doctrine of
imitation, as it was discussed in sixteenth- and seventeenth-century art

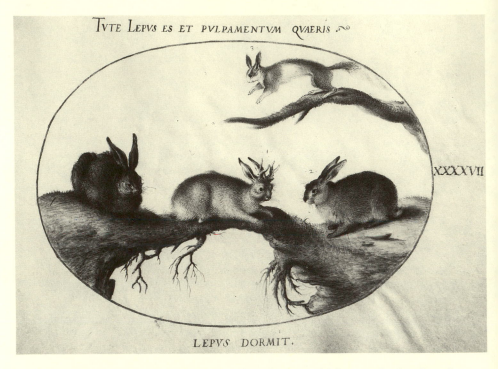

TVTE LEPVS ES ET PVLPAMENTVM QVAERIS .∿

XXXXVII

LEPVS DORMIT.

33. Georg Hoefnagel, Hare, Squirrel, and "Raurackl," *Animalia Quadrupedia et Reptilia (Terra)*

theory, suggesting that the later emulation of Dürer's art was governed by an academic *Leitgedanke* (governing principle or thought).[6] While Kauffmann's ideas have proved fruitful for many scholars during the past four decades,[7] he did not elaborate his argument, and his theory has been subjected to a severe challenge. Bernhard Decker has countered Kauffmann by granting that although the notion of *imitatio* might apply to academies and art theory in Italy, "it says nothing about Dürer imitations that could not be supported by any academic teachings."[8] Decker instead proposes a thorough reexamination of imitations of Dürer. Interpreting them from what may be described as a social historical point of view, he argues that they were made in the interest of concluding a pact with an absolutist sovereign.[9]

Hoefnagel's poems point, however, to another approach to the problem. They allow a different understanding of the cultural situation in which Dürer was imitated. They suggest that "academic" ideals can be interpreted more freely than in Decker's account. Although established academies of art that could have affected the imitation of Dürer obviously did not yet exist in the north, Hoefnagel's poems nevertheless demon-

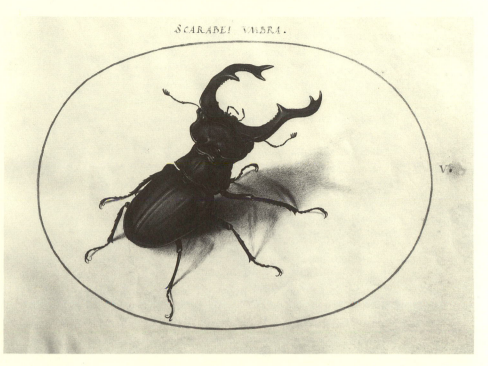

34. Georg Hoefnagel, Stag Beetle, *Animalia Rationalia et Insecta (Ignis)*

strate that there were indeed current in northern Europe ideas about art that can be related to the traditions of humanist and academic discourse.[10] The political and social ideals that Hoefnagel's poetry suggests are also different from those envisaged by Decker: they are related to a complex and subtle eirenist philosophy.

Hoefnagel's poems can be found in the *album amicorum* (*Stammbuch*) of the Netherlandish merchant and poet Johannes Radermacher (also Rademacher or Rademaker; Latinized as *Rotarius*), now in the library of the Rijksuniversiteit, Ghent (fig. 35). A transcription of the texts, with abbreviations expanded in standard manner, follows (with a translation in the notes):

In ALBERTVM DVRERVM. in gra*t*iam
Georgij Hoefnagel.

DVRERI ingenio, qui nil molitur inepte
(Quem graphide aequavit nullus, pauciq*ue* colore)
Consummasse artes pacis non sat fuit: idem
Aggressus belliq*ue* actus, sic Pallada utramq*ue*

Percolit, ut duplicem referat capite inde coronam.
Germanos bellare docet Germanus, et artem
Anormem prius, et diffusam ad certa reducit
Principia, ut pulcro praecepta hinc ordine pandat.
Credas Socraticum Euclidem spectare docentem
Consessu in magno, Megarà admirante Mathesin
A puncto in tantum tractando assurgere limen.
 Saepe idem patriae Dürer*us* certa dedisse
Consilia in rebus dubijs memoratur. In uno
Norica Gens Ciue ut possideret omnia q*uae* sunt
Singula sat pr*ae*clara alijs insignia* laudum. *vel: encomia
 In Melanthonis effigiem.
Qui volet in claro pietatem effingere vultu,
Omne feret punctum hic, unum pingendo Philippu*m*.[11]

Read as an encomium, to employ Hoefnagel's own diction, the first poem praises a number of Dürer's accomplishments. It briefly notes his skill in drawing and color, comments on his teaching about warfare, compares him to Euclid for his mathematics, and claims he was an exemplary citizen of Nuremberg. Hoefnagel's references to Dürer's teaching can be more specifically identified as allusions to his publications, most likely his *Underweysung der Messung* and his *Etliche Underricht zu Befestigung*, and perhaps his work on human proportion as well. The depiction of Dürer as an ideal citizen, particularly the suggestion that he gave advice to his city, probably alludes to his services as a member of the Greater Council (*Grösseren Rat*) of Nuremberg.[12] Given the context in which it appears and the choice of script used to indicate its title, the second couplet on the image of Melanchthon must also be by Hoefnagel, and taken to refer to Dürer's engraved portrait of the reformer (fig. 36). On one level it presents Melanchthon as a model of piety.

Although at first glance Hoefnagel's poems might not appear to be more than perfunctory in what they explicitly say about Dürer as an artist, a careful explication reveals that they are, in fact, rich in implications for an understanding both of Hoefnagel's approach to imitation and more generally for the historical situation in which he responded to Dürer's work. To begin, the *album amicorum* compiled by Radermacher, which contains Hoefnagel's poems, provides a good idea of their cultural context. Radermacher's album is a compendium of poems and letters written by many of the leading figures of humanist culture in northern Europe.[13] Contributors include Janus Dousa, Hugo Grotius, and Philip Marnix de Sainte Aldegonde, as well as artists with humanist inclinations such as Lucas de Heere and Frans Floris. The copy of Hoefnagel's poems found in the album (fig. 35), perhaps written in Samuel Radermacher's own hand when he may have sent them to his brother, belongs to a group

In ALBERTVM DVRERVM. in gram
Georgij Hoefnagel.

DVRERI ingenio, qui nil molitur ineptè
(Quem graphide æquauit nullus, paucisq̃ colore)
Consummasse artes pacis non sat fuit: idem
Aggressus bellig̃, actus, sic Pallada utramq̃
Percolit, ut duplicem referat capite inde coronam.
Germanos bellare docet Germanus, et artem
Anormem prius, et diffusam ad certa reducit
Principia, ut pulchro præcepta hinc ordine pandat.
Credas Socraticum Euclidem spectare docentem
Confessu in magno, Megara admirante Mathesin
A puncto in tantum tractando assurgere limen.
Sæpe idem patriæ Durer! certa dedisse
Consilia in rebus dubijs memoratur. In uno
Norica Gens Ciue ut possederet omnia, q̃ sisut
Singula sat pclara alijs insignia laudum. vel: encomia.

In Melanthonis effigiem.

Qui volet in claro pietatem effingere vultu,
Omne feret punctum hic, unum pingendo Philippu̅.

HYMNVS. Ad Rhenum.

Rex amnium, qui vitreo
Tot lambis undarum agmine,
Tot radis alto flumine
Castra, oppida, arces ardius
In rupibus, ripæ tuæ
Tutamen. Amnium decus
Fecunde Rhene, cui hæc et hac

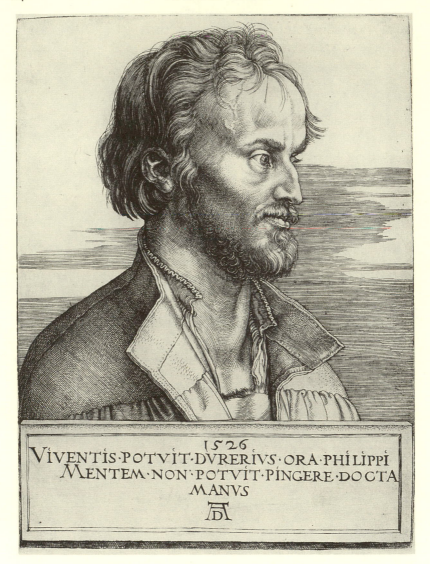

1526
VIVENTIS·POTVIT·DVRERIVS·ORA·PHILIPPI
MENTEM·NON·POTVIT·PINGERE·DOCTA
MANVS

36. Albrecht Dürer, *Portrait of Philip Melanchthon*, 1526

in the same writing. Among other items this group includes a number
of poems written for the famed humanist and student of natural his-
tory Carolus Clusius, one of the *Theatrum* of Abraham Ortelius, the
renowned geographer and friend of Hoefnagel, and an elegy sent by
Johannes Vivianus, a work that was apparently famous enough in its own
time to have merited being copied elsewhere in Radermacher's album and

to have evoked comment from Justus Lipsius in his published letters.[14] Many of the figures represented in the album were also active in the political struggles of the time; Hoefnagel himself associated with the circle of Netherlandish exiles around Radermacher when Hoefnagel visited England in 1568–1569.[15] For reasons to be discussed below, it is possible to surmise that the poems may have been written at that time, when Hoefnagel composed another work for Radermacher, although it should be noted that the poems are undated, that Hoefnagel remained friendly with Radermacher for many years and also dedicated a painting (fig. 42) to him in 1590, and that the poems were not placed in the album until at least 1603.[16] Regardless of its exact date, it is sufficient to stress the significance of the choice of Dürer as a subject worthy of treatment in a poem created in a learned cosmopolitan milieu. Hoefnagel's use of Latin is meaningful in this respect.

Indeed Hoefnagel's poems provide important evidence to support Karel van Mander's description, as well as the testimony of his own emblems, that he was a learned man, a good poet, and a good Latinist.[17] His poems skillfully employ several poetic devices. The first poem uses antithesis in its second line ("graphide . . . nullus, paucique colore"), which is also a chiastic arrangement, personification and metaphor in lines four and five ("Pallada . . . capite inde coronam"), and alliteration in line ten ("magno Megara admirante Mathesis"). In addition to frequent use of such ornaments, Hoefnagel's poetry echoes Ciceronian diction in the last line of the first poem and paraphrases Horace in several places.[18] He also makes a number of learned allusions, most obviously to Euclid, and displays his learning by using Hellenisms in diction and grammar such as *Mathesin* and *Pallada*. His Latin is set out in dactylic hexameter, a meter usually reserved for lofty subjects.

The echo of Horace in the very first line of the poem furthermore demonstrates that Hoefnagel's description of Dürer can be related to a standard humanist discussion of the figural arts. The expression *qui nil molitur inepte* is taken directly from Horace's so-called *Ars Poetica* (line 140). Horace's words describe Homer, whose efforts at mastery he contrasts with those who toil like mountains to bear forth a ridiculous mouse (*Ars Poetica*, 139–40: "parturient montes, nascetur ridiculus mus./quanto rectius hic, qui nil molitur inepte"). In applying Horace's words to Dürer, Hoefnagel draws upon the stock comparison of painting to poetry, as best expressed in another phrase, *ut pictura poesis*, also found in the *Ars Poetica* (line 361).[19] Dürer accordingly becomes the Homer of painting, the consummate master who always strikes the proper note in his work.

The words that Hoefnagel employs to develop his description of Dürer's mastery also reflect both standard humanist criticism of the figu-

ral arts and sixteenth- and early seventeenth-century writings on art in
the vernacular. The second word in Hoefnagel's first poem, *ingenio*, re-
calls a familiar distinction between *ingenium*—inborn talent, genius, or
nature—and *ars*, learned or applied skill.[20] This was a conception that is
also familiar in Dürer's own writing.[21] In the vernacular the word *ingegno*
was also specifically applied to Dürer himself in a letter of 1565 written by
Hoefnagel's Netherlandish contemporary Lambert Lombard to Giorgio
Vasari.[22] The description of the results of Dürer's toil, his art, in the sec-
ond line also utilizes a distinction frequently found in sixteenth-century
art theory. Hoefnagel distinguishes between Dürer's unequaled skill in
graphide, drawing, and his *colore*, or coloring.[23] Not surprisingly, Dürer is
held up as a nonpareil in drawing.

Hoefnagel sets Dürer's artistic accomplishments into a larger context
that further echoes Renaissance debates about the visual arts. Demon-
strating his own learning, Hoefnagel also emphasizes Dürer's importance
as a learned artist.[24] Thus he stresses Dürer's teaching, first on military
matters, then on what can be taken to mean his work on perspective, and
perhaps also on proportion. The knowledge of geometry on which the
fortification and perspective treatises depend (and also the knowledge of
music on which his proportional exercises are dependent) can, of course,
be regarded as pertaining to mathematics, the basis of the traditional
quadrivium. While Hoefnagel's praise of Dürer's military treatise might
otherwise seem unusual, his works on perspective and proportion were
widely known and admired throughout Europe, as we have seen in
Chapter 2. They also inspired later German treatises, drew disparaging
comments from Michelangelo, and conversely praise from Lambert
Lombard. Lombard is again noteworthy here, for he recognized that
Dürer was owed thanks for having demonstrated what may be para-
phrased as the good way to enter into artistic perfection, having sweated
for this end as much in writing as in his works as an artist.[25]

Hoefnagel's claims for Dürer's intellectual status are reinforced by his
evocation of Pallas, goddess of wisdom and patroness of learning and the
arts, in line 5. Pallas (Minerva) is frequently present in allegories on the
arts invented by many sixteenth-century artists, who, by evoking her,
asserted that theirs was an intellectual and not merely a manual pursuit.
Hoefnagel himself created several such allegories, although perhaps
somewhat more easily legible works were made by artists with whom he
was associated. One well-known composition by Hans von Aachen, a
version of which was engraved by Aegidius Sadeler in Munich at a time
when they were collaborating with Hoefnagel, shows Minerva/Pallas
presenting Painting to the Liberal Arts (fig. 37). Another well-known
allegory, the so-called *Triumph of Wisdom* (Vienna, Kunsthistorisches
Museum), executed in Prague by the imperial painter Bartholomäus

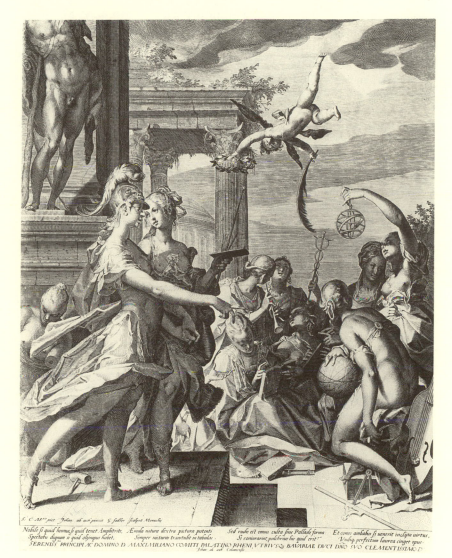

37. Aegidius Sadeler after Hans von Aachen, *Minerva Presents Painting to the Liberal Arts*, engraving, c. 1590

Spranger about the time Hoefnagel began to be patronized by Rudolf II, shows the arts grouped under a triumphant figure of Pallas/Minerva. Spranger's familiar image also helps explain the reference in Hoefnagel's poem to the arts of war as well as those of peace. The circle of arts under Pallas's protection in Spranger's picture includes identifiable representa-

tions of the liberal arts, such as astronomy with an armillary sphere, the fine arts, such as painting with a palette and brushes, and also places Bellona, goddess of war, prominently in the foreground.[26]

The poem on Dürer then proceeds to portray him, in effect, as the embodiment of the humanist ideal. Quintilian had encapsulated this ideal in the phrase *vir bonus dicendi peritus* ("a good man skilled in speaking," *Institutio Oratoria* 12:1:1), which in Allen Ellenius's witty paraphrase, describing what happened to this ideal in sixteenth- and seventeenth-century writings on art, was applied to a painter as a *vir bonus pingendi peritus* ("a good man skilled in painting").[27] In a way Dürer can be regarded as even closer to the original ideal, as Hoefnagel describes him as an active, virtuous citizen who gives advice to his fatherland (*patriae*). Yet in exercising the skills of logic and rhetoric, the art of persuasion, Dürer may also be considered to have drawn upon the trivium, hence the complete encyclopedia of the arts.[28] In this regard he might also be seen as a northern *uomo universale*, a universal man.[29]

During the Renaissance the ancient ideal of education leading to the inculcation of virtue had been given a particular meaning, that of the production of civic virtue.[30] Hoefnagel's stress on Dürer's teaching about war, as well as the arts of peace, may also be placed in context here. Justus Lipsius, a humanist whose opinions and contacts are close to Hoefnagel's, also wrote effectively on armies and warfare.[31] Hoefnagel's description of Dürer's service to his city may similarly be understood to complement the claims made for his intellectual accomplishments. Dürer had, in fact, obtained the highest civic honor possible for a Nuremberger who was not a patrician: membership in the *Grösseren Rat* (greater city council). He could thus be invoked in an argument for the social status of painting, an issue much debated at the time, and no doubt Hoefnagel's references carry some of this overtone.[32]

The characterization of Dürer as an active model citizen can also be related to the contemporary transformation of the conceptualization of wisdom as a goal for education and for life. Eugene Rice has suggested that the transformation of this ideal entailed a shift in the consideration of wisdom as pertaining to contemplation, to a notion of wisdom as involved in action: in other words, from wisdom as knowledge to wisdom as virtue.[33] Several scholars have indicated that the transformation of the ideal of wisdom can be associated with contemporary Neostoicism in the Low Countries.[34] The model of virtue that Hoefnagel presents when he proposes Melanchthon as a model of piety can be interpreted in this context. A standard notion in late sixteenth- and early seventeenth-century Netherlandish political theory, particularly in circles to which Radermacher belonged, held that the emulation of good men was one path to moral or political virtue.[35]

Imitation must here be regarded as a moral or ethical as much as an artistic method and ideal. In the Neostoic circles of personal contacts, and within the framework of cultural references in which Hoefnagel operated, the moral, artistic, and political are all related to each other. These connections may be seen quite clearly in the work Hoefnagel composed for Johannes Radermacher in 1568–1569: namely, an emblem book consisting of drawings and poems with political overtones. Hoefnagel's *Patientia* (figs. 38 and 39) comments on the travails of the Netherlands in its time of troubles with Spain. Yet it expresses itself in Neostoic (and what have also been called Calvinist) terms, stressing the virtue of patience.[36]

The Neostoic conceptualization of the ideal of virtue appears in several allegories by Hoefnagel in which the image of Hermathena is invoked, as has been suggested by Teréz Gerszi, who first indicated the importance of Neostoicism in the circle of Netherlanders at the imperial court.[37] The personification of Hermathena as the combination of Hermes (Mercury) and Pallas Athena (Minerva) presents an active image of virtue, as in the well-known painting by Bartholomäus Spranger (Vienna, Kunsthistorisches Museum), where Pallas stands on a block symbolizing Hermes, at the same time that she triumphs over ignorance. Hermathena can also be conceived as the personification of the virtuous union of wisdom and eloquence, and was so represented by many Rudolfine artists, including Hoefnagel.[38] Hoefnagel's variation on this theme is, for instance, found in an allegory for Abraham Ortelius that can be interpreted as a comment on his own art (fig. 40). This miniature is clearly inscribed Hermathena and expresses the theme with a nicely naturalistic conceit, showing the owl of Minerva (Athena) holding the caduceus of Mercury (Hermes). Another allegory on the same subject, which was invented by Hoefnagel but drawn by Von Aachen for an engraving by Aegidius Sadeler, makes the two-sided nature (artistic/cultural versus ethical/political) of Hermathena quite clear (fig. 41). On one side of the composition are disposed the Muses, who personify the arts, while on the other side Perseus engages in a heroic, thus virtuous action. The parallel is underscored by the presence of Pegasus on both sides of the composition as an element that links the themes: on the left he springs aloft, born from the blood of Medusa, whom Perseus slays; on the right his hoof causes the inspirational waters of Hippocrene to spring forth on Helicon.[39]

Let us first examine the political or ethical side of this ideal. In this regard it is significant that piety is the specific virtue that Hoefnagel emphasizes, and that he chooses Melanchthon as its exemplar. Piety is a virtue often emphasized in Hoefnagel's work, including a painting he later did for Radermacher (fig. 42), and it may therefore also have a personal significance for the artist.[40] Yet in having chosen to exemplify piety with the image of a particular individual, Hoefnagel may also be consid-

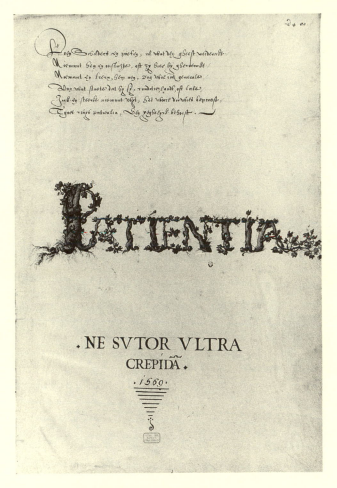

38. Georg Hoefnagel, *Patientia*, 1569

ered to have anticipated the publication of the *Icones* of the Genevan re-
former Théodore de Bèze (Beza), which contained portraits of human-
ists, and of prodromes and proponents of Protestantism, as well as texts
about them. Hoefnagel does so by writing a poem that evokes Dürer's
portrait of Melanchthon, suggesting that it be imitated.[41] Hoefnagel's re-
ligious affiliation is probably not what determined this choice because,
while he selected an associate of Luther to exemplify piety, there is no
reason to believe that he was a Lutheran, any more than was de Bèze,
who was a committed Calvinist. Hoefnagel's father was, in fact, an active
Calvinist who converted to Catholicism, and this family history may
provide the background for his own beliefs.[42]

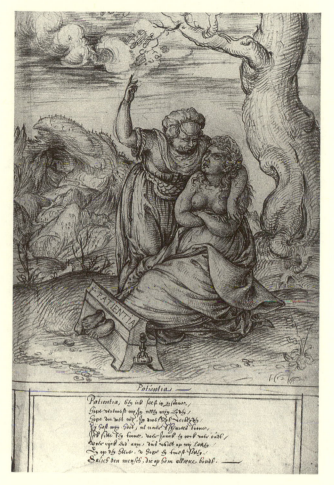

39. Georg Hoefnagel, "Patientia," 1569

The choice of Melanchthon may have been intended to supply a fur-
ther connotation, especially when he stands as a single example (unlike
De Beze's whole series of images of reformers), because at the time
Melanchthon could have been regarded as a paragon of religious mod-
eration and confessional conciliation. The issue of toleration became
particularly pressing both in the Netherlands and in Germany in the
1560s. In the Netherlands outbreaks of iconoclasm occurred, and the
ravages of the troops of the Duke of Alva followed his efforts to re-
impose the order of Spanish rule. In Germany during the 1560s a series
of controversies with their orthodox co-confessionalists, the so-called
Gnosio-Lutherans, including the followers of Flacius Illyricus, placed

40. Georg Hoefnagel. *Allegory for Abraham Ortelius*, 1593

on the defensive the moderate supporters of Melanchthon, the Philip-
pists. Eventually the Philippists were driven from Wittenberg in the
1570s.[43]

Support for conciliatory views in religion flowed together with moder-
ate politics and Neostoical philosophy in the group of Netherlandish
merchants and artists around Radermacher, to which Hoefnagel also be-
longed. De Heere's design of the Valois tapestries and his support for the
duke of Anjou exemplify the *politique* course that was endorsed by this
group, which hoped to steer a middle way in a world buffeted by confes-
sional strife.[44] An allegory that de Heere did for Hoefnagel proves that
they were friends.[45] The attitude of this group toward religion stressed
adiaphora in matters of ritual or confession, an indifferentist or latitudi-
narian position suggested by Lipsius and others, and close to that of the
German Philippists. Like Lipsius, who taught in Lutheran Jena, Calvinist
Leiden, and Catholic Louvain, Hoefnagel found no difficulty in serving
Catholic patrons such as the Wittelsbach dukes of Bavaria, Archduke
Ferdinand II Habsburg ("of the Tyrol"), and Emperor Rudolf II, what-
ever their or his beliefs may have been (and Hoefnagel's confessional
loyalties may be suggested by the fact that he did leave the Spanish-
controlled southern Netherlands).[46] Like other members of the circle
including Johannes Radermacher, Hoefnagel may also have sympathized
with the Family of Love. The doctrine of the Family of Love also deem-

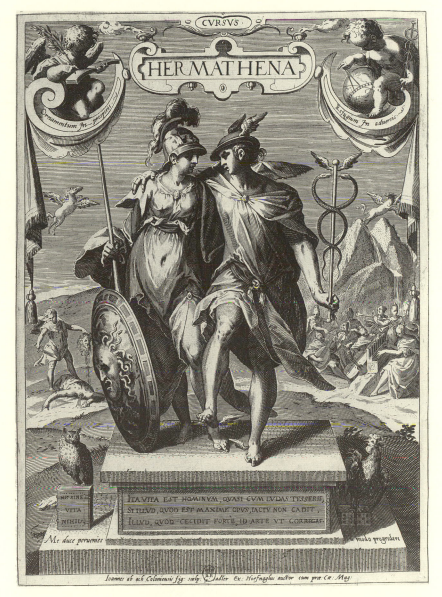

41. Aegidius Sadeler after Hans von Aachen after Hoefnagel,
Hermathena, c. 1590

phasized the importance of ritual and confessional differences in favor of
an outwardly more tolerant view of religion.[47]

The choice of Melanchthon as a model for piety not only echoes these
associations but has a further resonance. As the *praeceptor Germaniae*,

42. Georg Hoefnagel, *Allegory of Friendship between Hoefnagel and Johannes Radermacher*, 1590

Melanchthon had added a religious message to the humanist ideal of education, combining piety with learned eloquence.[48] Dürer's print (fig. 36) can be connected with this aspect of Melanchthon's activities because it dates from the time that he came to Nuremberg to set up a secondary school.[49] Melanchthon was also noted for his personal eloquence. He may even be thought to personify the ideal of *sapiens et eloquens pietas* promoted by Protestant educators, to use the expression of Johannes Sturm, in which the Hermathenic ideal of eloquent wisdom is redefined to suit a newer creed. It is also significant that Melanchthon was the author of an influential treatise on rhetoric that was used in many northern European schools. Dürer can again be connected with Melanchthon in this regard, because Melanchthon's treatise specifically mentions the artist: to help explain differences among rhetorical *genera dicendi*, Melanchthon compares the art of Dürer, Cranach, and Grünewald.[50]

Rhetoric, it may be recalled, is the science of eloquence, rhetoric the expression of the hermetic side of Hermathena (Hermes being the god of eloquence), rhetoric the basis for the application of notions of imitation to politics or ethics. In this sense it is also important to remember that Hermathena was also understood by Renaissance thinkers to symbolize the academy.[51] And in academies of art, as in general in other sorts of contemporary instruction, a widely used method of education was imitation.[52]

Hoefnagel's poem on Melanchthon suggests that the ethical and aesthetic aspects of the Hermathenic ideal, notions of ethical and artistic imitation, were indeed closely linked in his mind. On the one hand his poem explicitly proposes the imitation of an image of piety. At the same time the very language that Hoefnagel employs in this distich is charged with currents from poetic theory. The second line of the poem ("Omne feret punctum hic, unum pingendo Philippum") transforms a famous line (343) of Horace's *Ars Poetica* ("omne tulit punctum qui miscuit utile dulci"). By substituting painting (*pingendo*) for poetry, Horace's actual subject, Hoefnagel seems to be making a further play on the parallel *ut pictura poesis* that the implied comparison of Dürer to Homer in the first line of the first poem had initially suggested. It may therefore not be going too far to read the first line of the second poem by Hoefnagel ("qui volet in claro pietatem effingere vultu") as a reflection of several other lines of Horace (Epistles 2, 1:248–50: "nec magis expressi voltus per aenea signa/quam per vatis opus mores animique virorum clarorum apparent"). Although not as obvious as the borrowings from the *Ars Poetica*, the choice of words such as *claro* and *vultu* and the general conception of imitating faces of famous men (*effingere*, or *expressi*) are striking, and it would not be inappropriate to speak of Melanchthon as a *vatis*, or prophet. Hoefnagel may be playing on Horace's meaning, reversing his point, by stressing the likeness of Melanchthon to be found in an image. He may thus be responding to a topos originating in antiquity, as in the writing of Martial, that a picture was inferior to a poem in being able to represent a man; this topos was revived in a Renaissance debate and may even be evoked by the inscription on Dürer's own portrait of Melanchthon.[53] The play on Horace's words may also make a punning reference to engraving because copperplate engravings can be described as images *expressi per aenea signa*; this kind of wit is common enough in Hoefnagel's work.

We do not need to press the contrasts of painting and poetry too far to grasp the evident significance of the echoes of Horace's *Ars Poetica* in an album belonging to Johannes Radermacher. Whether or not the poems were originally written for Radermacher, they were of enough interest to be collected by him. The picture (fig. 42) that Hoefnagel presented to Radermacher in 1590 was an allegory that shows Painting and Poetry relating to each other in collaboration. This allegory is a visual manifestation of the idea *ut pictura poesis*. Hoefnagel also prefaced the emblem book *Patientia* that he had earlier done for Radermacher with another paraphrase from Horace's *Ars Poetica* (lines 9 and 10), the famed comparison that painters and poets had equal rights for hazarding anything (see fig. 38).[54]

Hoefnagel's poem on Dürer's *Melanchthon* can be explicated further along these lines. The reader readily substitutes the original words of Horace's poem, "qui miscuit utile dulci," for the second half of Hoef-

nagel's second line. Horace's description of poetry thus again becomes a goal for the visual arts.

This additional comparison of painting and poetry is particularly pertinent for emblem books because the mixture of the useful with the sweet, of moral instruction with attractive imagery, is not only a general goal for art but takes on form in an emblem. In emblems, images and poems work in mutually complementary fashion.[55] It is even possible to read the Horatian dicta Hoefnagel places on the title page of *Patientia* as the poem belonging to an emblem that is constituted by the elaborately designed inscription of the title and a Latin motto. The title page then might seem to stand as an emblem for the whole emblem book, as it were (see fig. 38).

These associations with emblems are important because they lead to the specific context in which Hoefnagel's own imitations of Dürer appear. Hoefnagel's copies of Dürer's hare and stag beetle are found in the setting of an emblem book, namely, in the volumes of *Terra* and *Ignis*, respectively. As we have seen in Chapter 1, these are two of the four books of natural creatures organized according to the traditional "Four Elements" that the artist presented to Rudolf II (figs. 33 and 34). The manuscripts depicting the "Four Elements" combine Latin poetry, humanist ideals, moral messages, and the artist's imitation of nature in a way that is consistent with Hoefnagel's poems on Dürer. Hoefnagel's "Four Elements" continuously remind us by their quotations from the Bible—the folio matching the page on which Hoefnagel has copied Dürer's hare offers a quotation from Proverbs 30:26—that the depiction of the world of nature can also evoke pious reflection.[56]

Copying the portrait of Melanchthon by Dürer, and copying his hare, may in the end be seen to stem from not such dissimilar impulses. The association of ethics and the observation of the natural world may also be grounded in the philosophy of Melanchthon, as we shall see further in later chapters. Melanchthon himself praised as aspects of the holy life activities that led to the investigation of nature.[57]

These forms of imitation may be mutually related, moreover, in the matrix of beliefs provided by what can be surmised of Hoefnagel's philosophical outlook. Although the implications of Neostoicism for Hoefnagel's manuscripts of the "Four Elements" have not yet been investigated, and it is rather Epicureanism that has been associated with his still lifes, Stoic thinking suggests a further way of conjoining Hoefnagel's ethical attitudes with his art as an imitation of the natural world.[58] In their own way Hoefnagel's investigation and consequent depiction of the natural world coincide with certain major doctrines of Stoicism. This idea can only be briefly suggested here, since the topic touches on a large issue that needs to be developed more fully by future scholarship.

Seneca could have provided an example of the way ethical, natural philosophical, and aesthetic beliefs could be held in common. Known as

an ethical philosopher, as the author of the *Epistulae Morales*, Seneca was also the author of the *Naturales Quaestiones*, which for ages remained a basic text on natural philosophy. Seneca was also an author who in a famed passage defined art as the imitation of nature (*Epistulae Morales* 65:3: "Omnis ars naturae imitatio est"). He also coined a commonplace for art when he described imitation as a matter of drawing from a variety of sources (*Epistulae Morales* 84).[59]

The Stoics in general believed that the wise man was he who studied the laws of nature and thus learned how rules of conduct were related to natural laws. The happy man was he who saw in the world of nature, God's creation, the guide to righteous living. Hence the Stoic credo: Follow nature.[60]

The sixteenth-century revival of Seneca and more generally of Stoicism made these ideas current.[61] Erasmus, for example, edited the ancient author and in other writings also communicated to a broader public some of the Stoic ideas of nature.[62] It has been suggested that in its Christian guise Stoicism provided an "ideal compromise by founding morality on nature" through its assumption that "the *codex naturae* could be read more or less directly." Stoicism thus also played its part in stimulating the search for natural laws during the sixteenth and seventeenth centuries.[63]

The meaning of nature (*natura*) and the dictum "follow nature" (*suivre . . . nature*), as Hoefnagel employs these expressions, assume a different coloration in this light. His choice of the motto *natura magistra*, or *artis natura magistra*, therefore seems to be more than an aesthetic precept.[64] As the maxim *natura magistra* in the form of *nature . . . maîtresse* appears in Hoefnagel's entry in the *album amicorum* of Abraham Ortelius, for whom he also made a Hermathenic allegory, the association of ethical with aesthetic considerations is reinforced. Hoefnagel's own words demonstrate how closely connected these areas of concern are in his mind, as he writes in French in Ortelius's book (as here translated):

> If God is the father of Nature
> And if Nature the mother of Love
> If of Knowledge the Mistress,
> And of the Arts as well: my Ortelius, what is it?
> That I owe you? Perhaps a good heart?
> A heart that is true to friends, and not a flatterer?
> To follow God and Nature
> And to show pure affection
> (Having nothing else), I also employ
> The art with which Nature has enriched me
> Nature alone, the only nurse of good Spirits
> Abhorring vice.[65]

The relation of these ideas to Hoefnagel's poems on Dürer cannot yet be made precise, among other reasons because the date of the poems cannot yet be determined with certainty. As suggested above, a dating to 1568–1569 might nevertheless be possible, because at this time Hoefnagel prepared for Radermacher the *Patientia*, a work with a Neostoic message that also directly paraphrases Horace, as do his poems on Dürer. Hoefnagel also used his *natura magistra* motto, although perhaps in a more strictly aesthetic sense, in an entry of 1575 in the *album* of Emanuel van Meteren, Ortelius's nephew, to which Radermacher, Vivianus, Ortelius, and many others of the Radermacher circle contributed: this entry has also been considered to be a reminiscence of Hoefnagel's journey to England.[66]

A dating to a period early in Hoefnagel's artistic career might also explain why it is that he praises only books and an engraving out of all the artist's works he might have mentioned. In all likelihood Hoefnagel could not have seen other kinds of work by Dürer, including drawings of the hare or stag beetle, or even other artists' copies made after them, until he visited Germany in the 1570s.[67] If Hoefnagel's poems thus antedate his personal experience of Dürer's nature studies, either original works or copies after them, then it could be established that he would have responded to Dürer's art with the sort of presuppositions—political, Neostoic, and Horatian—that we have teased out of a close reading of his poems on the artist. In any case, this argument does not depend on a precise dating of the poems, for whenever they were written, they express a message that is echoed consistently by Hoefnagel throughout his career.

When we finally turn to consider the visual character of Hoefnagel's versions of Dürer's hare and stag beetle, it is thus warranted to keep these notions in mind. Throughout the "Four Elements," when Hoefnagel depicts creatures of the natural world, he most frequently employs earlier models such as those Dürer supplied for the hare and stag beetle (figs. 33 and 34). While this might seem a traditional enough procedure in the preparation of manuscripts, and those with studies of nature, given the background that, it is hoped, this chapter has provided, Hoefnagel's versions of Dürer can be related to theories of artistic imitation as a kind of emulation. It therefore seems justified to apply to Hoefnagel's copies the words used by Hans Kauffmann and to describe his procedure of Dürer imitation as "ein Aufnehmen der Tradition bei gleichzeitigem Weiterführen auf ein höheres Zielbild" (an assumption of tradition and simultaneously its further direction toward the creation of an image that is a higher goal [in this instance, an ever more accurate depiction of nature]).[68]

Hoefnagel's own hares (and spurious *Raurackl*) are pudgy, sprightly beasts, with a coloristically depicted but less differentiated skin texture

than Dürer's hare, to repeat M. Lee Hendrix's observation (fig. 33). Fritz Koreny has also noted that Hoefnagel sets the hare rather unobtrusively into an ensemble that anticipates later Netherlandish animal painting. Koreny has demonstrated that Hoefnagel also develops Dürer's stag beetle, which (fig. 34) he is able to emulate scrupulously and yet in other images transform into a creature with outstretched wings. This sort of image can justly be called a form of *Weiterführen*, in the spirit of the late Renaissance, as Koreny remarks.[69]

What seems at stake in Hoefnagel's emulation of Dürer is therefore not only the imitation of nature but the idea that the artist can make improvements toward this goal. The idea of artistic progress that Hoefnagel thereby implies can consequently be related to a larger issue that was framed by a contemporary debate over the possibility of cultural progress. This issue will be treated at greater length in Chapter 6: here it is sufficient to emphasize that Dürer himself was also invoked by other writers in this debate, as will be discussed below.

Hoefnagel's imitation of Dürer can therefore, in conclusion, be related to a larger art-historical question. Although his imitation of Dürer can, of course, always be regarded as continuing a northern tradition of manuscript studies of nature, his words on Dürer remind us that his work took place in a rich cultural context that drew from a number of different traditions. The connection that can be established between Hoefnagel's imitation of Dürer and issues of art theory indeed again suggests that although there may not have been an established artistic academy in Prague or elsewhere where Hoefnagel worked, ideas were present in his circles that resemble those expressed in later academic foundations. It may also be recalled that during Hoefnagel's lifetime artists associated with the Haarlem and Bologna academies not only studied from the live model but drew from the landscape around them.[70] Although Hoefnagel's response to nature, like that of many other Prague court artists, is different from that of the Haarlem and Bologna artists, his response to Dürer may nevertheless suggest a further path for consideration. It may prove fruitful to examine how it is that, as in Hoefnagel's own work, academic ideals were linked with a group of other considerations—ethical, religious, and even political—to contribute to the development of independent still life and animal painting toward 1600, a development that both constituted and participated in a general transformation of attitudes that informed the investigation and representation of the world of nature.

Metamorphoses of Nature

ARCIMBOLDO'S IMPERIAL

ALLEGORIES

Iᴎ ʜɪs ᴅɪᴀʟᴏɢᴜᴇ on art, *Il Figino*,
the Lateran canon Gregorio Comanini indicates that Giuseppe Arcimboldo, the Milanese artist best known for his paintings of composite heads representing subjects such as the seasons and elements with objects pertaining to them, can also be considered an assiduous painter of nature. Through the character of the Milanese painter Ambrogio Figino, after whom his treatise is named, Comanini, who knew Arcimboldo well, states that in Arcimboldo's paintings of *Flora* and of *Vertumnus* (fig. 43), heads composed of flowers in one instance and of fruits and vegetables in the other, "there is no fruit or flower that is not taken from life, and imitated with the greatest possible degree of diligence." Speaking of another head composed of animals (a work that is here identified with a composition of *Earth* (*Terra*), formerly in the collection of the Landesmuseum Johanneum, Graz, now in a private collection, Vienna), Figino also remarks, "Let us take it for granted that there is not a head [of an individual animal constituting the figure] that is not taken from life, since the emperor gave him the opportunity for this by arranging for him to see live specimens of the . . . animals."[1] The critic Roberto Longhi may with good reason have counted Arcimboldo among the few precursors of still-life painting he mentions; in his fundamental book on the subject Charles Sterling also mentions his work.[2] More recent studies of still life have also discussed Arcimboldo.[3]

It is not, however, this image of Arcimboldo that has dominated discussion of the artist, but the notion that his pictures are bizarre, eccentric transformations of nature. There exists a long established tradition that his paintings are simply jokes, which the interpretation to be presented in

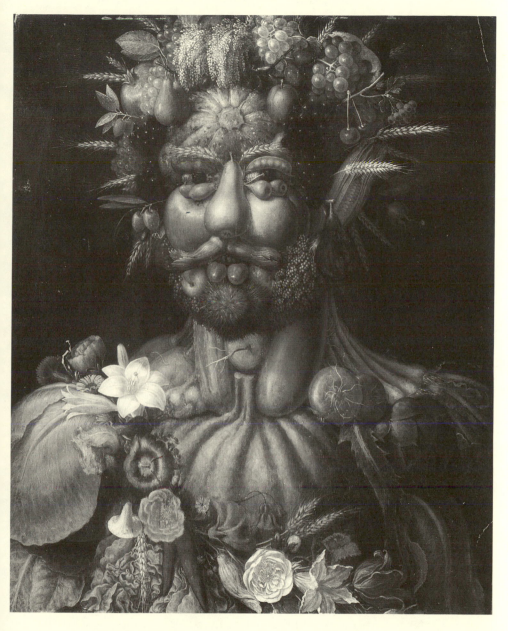

43. Giuseppe Arcimboldo, *Rudolf II as Vertumnus*, 1590

this chapter will contradict. This tradition started in the sixteenth century when Comanini called one of his pictures a *scherzo*, while another of Arcimboldo's Milanese contemporaries, Gian Paolo Lomazzo, discussed his paintings of the *Elements* as examples to inspire bar-room pictures, and yet another, Paolo Morigia, spoke of his *bizzarrie*.[4] In the eighteenth century P. A. Orlandi called Arcimboldo an *extravagante pictore* who had *bizzarri pensieri pittorici*, while Luigi Lanzi called Arcimboldo's paintings *capricci* and said he made jokes with his brush.[5] Many more recent writers have picked up this language. F. C. Legrand and F. Sluys talked about Arcimboldo's *bizzareries picturales*; Benno Geiger called Arcimboldo's works *dipinti ghiribizzosi*, and Paul Wescher interpreted his pictures as "parodistic expressions of the microcosm-macrocosm idea."[6] Sterling also described a painting by Arcimboldo as a *scherzo* worthy of adorning a curiosity cabinet, where it could well assume a place beside a grotesque fetus.[7]

This interpretation has persisted to the present. Several essays that accompanied a major exhibition devoted to Arcimboldo still talked of his paintings as amusing works of fantasy and invention, as jokes; a reviewer of the show asked why this reading seems inadequate.[8] The most recent book on Arcimboldo treats him as the creator of "the portrait of eccentricity," of mannerist *capricci* whose *bizzarrie* transcend the rules of art.[9]

While Arcimboldo's paintings were described during his own time with words that connote invention and fantasy, this language does not, in fact, mean that his works were to be regarded as merely fanciful, in the present-day sense, nor as simply humorous. Comanini's treatise, which contains the most extended discussion of the painter in these terms, treats Arcimboldo rather in the context of a consideration of artistic invention and imitation. Arcimboldo is invoked as an exemplar of fantastic imitation, of caprices or *bizzarrie*, since in his composite heads, natural elements have been combined to create something that cannot be found in nature itself. As such they are also like dream pictures. But for Comanini, as for many other writers on similar subjects, this did not mean that they were merely free flights of fancy.

Dream pictures, grotesques, emblems, and other comparable creations of the Renaissance often posited a deeper meaning within a playful framework. It is in this context, the world of Renaissance *imprese*, specifically of dream images and hieroglyphs that Comanini places Arcimboldo, whom he calls a "learned Egyptian"; Lomazzo's description of another work by the artist also indicates that he incorporated what the Renaissance regarded as hieroglyphs in his paintings. For Comanini, who, as we shall see also explicates the artist's *Vertumnus*, Arcimboldo is a maker not only of gracious inventions (*gratiosa inventione* are his words) but of learned allegories (*dotte allegorie*).[10]

It has been said with some reference to Arcimboldo that "the play of fantasy is never without significance,"[11] and some earlier interpreters had indeed already grasped that fantasy and allegory are connected in Arcimboldo's art. Wescher's remarks, for instance, demonstrated a recognition that there is more to the interpretation of Arcimboldo's work. His paintings can be seen not as bizarre fancies but as the expression of the complicated intellectual world of the late sixteenth century. Sven Alfons, Pavel Preiss, and R.J.W. Evans had earlier followed clues in Comanini's dialogue[12] to the identification and interpretation of *Vertumnus*.[13] They argued that Arcimboldo's painting relies on the conception of a system of correspondences between microcosm and macrocosm, the Aristotelian theory of the elements, and the Renaissance notions of physiognomy.

We can, in fact, thoroughly reinterpret Arcimboldo's work in relation to the culture for which it was created, namely, the imperial court in Vienna and Prague, where from 1562 to 1587, chiefly during the reigns of Maximilian II (1564–1576) and Rudolf II (1576–1612), Arcimboldo was court painter and designer of festivals.[14] More can be said about his pictures of heads composed of fruits and vegetables than that they are just *bizzarrie* and *scherzi*.[15] This chapter discusses a number of rediscovered texts that correct the impression that Arcimboldo's paintings were merely funny or fanciful flights of the imagination. The popular present-day image of him as the grandfather of fantastic art and surrealism is not the historical Arcimboldo. The world of Arcimboldo is not Kafka's Prague, despite legends about the oddity of his patron Rudolf II.[16] Arcimboldo's portrait of Rudolf II as Vertumnus (fig. 43) was not simply a bizarre joke meant to make the emperor laugh at himself.[17]

G. B. Fonteo and the Interpretation of Arcimboldo's Painting

A number of rediscovered texts written by Giovanni Baptista Fonteo (Johannes Baptista Fonteius Primio) that remained unknown to previous writers on Arcimboldo amplify their interpretations, as well as that suggested by Comanini, and allow readings of his paintings as imperial images. One of Fonteo's manuscripts, Codex 10152 of the Österreichische Nationalbibliothek, Vienna, is a Latin poem 310 lines long in nine folios dedicated to Emperor Maximilian II on "The Paintings of the Four Seasons and Four Elements by the Imperial Painter Giuseppe Arcimboldo."[18] Codex 10206 of the Österreichische Nationalbibliothek, a compendium of documents connected with festivals held in Prague in 1570 and in Vienna in 1571, includes a revised version of this poem 308 lines long with additional marginal comments. It also contains on the last folio a poem sixteen lines long invoking Maximilian's aid for Arcimboldo,

which again has marginal notes giving further information on his
paintings.[19]

Fonteo's manuscripts are important for an insight into Arcimboldo be-
cause he was a close collaborator of the artist, indeed probably his hu-
manist adviser—a personage for whose existence in Vienna in the 1570s
Chapter 5 presents incontrovertible evidence. Like Arcimboldo, Fonteo,
who is also called Fonteio and whose name was actually Giovanni Bap-
tista Fontana, came from a Milanese milieu. Like many other humanists,
he romanized his name to claim association with a distinguished ancient
gens; in his own right he was nephew of the Milanese scholar Primo de'
Conti, hence probably the reason why the name Primionis appears in the
title of one of his works.[20] From the date of his initial poem on Arcim-
boldo's paintings, Fonteo was present at the imperial court in 1568 at the
latest, arriving there a young man, since he died at age thirty-three to-
ward 1580. He remained at the imperial court until at least June 1572, and
other evidence suggests that he was there even later.[21] While at court he
completed other projects, including a learned treatise in Latin on laughter
(De Risu), a subject to whose pertinence we shall return, which he dedi-
cated to the Venetian ambassador in 1570. The introduction to this
treatise indicates that he was a member of the court retinue, following
the emperor regularly as his court moved from one residence or diet to
another.[22]

A biography of the Milanese Sister Paola Antonia de Negri that he
published in Rome in 1576 contains Fonteo's confession about his earth-
bound (terreno) past life dedicated to profane studies: this suggests some
sort of conversion, as well as his return to Italy between 1572 and 1576.
After his departure from the imperial court, Fonteo probably settled for
a while in Rome, where he could have written a learned Latin history of
the ancestors of the Cesi family that was published in Bologna in 1582.[23]
Fonteo was commissioned by Cardinal Borromeo to write a history of
the archbishops of Milan, for which notes in Milan still survive[24]; it may
be noted that Carlo Borromeo had probably earlier commissioned a work
that was executed by Arcimboldo, and that Arcimboldo was present on
a visit in Milan in 1576 or 1577.[25]

At the imperial court Fonteo assisted Arcimboldo in the organization
of festivals. Lomazzo says that Arcimboldo gave Fonteo the task of de-
signing the cartel, the statement of challenge that was an allegorical pro-
gram, for one of the imperial fêtes. A program that was probably one
consisting of several manuscripts passed out to spectators still exists for a
festival held in Vienna in 1571 to celebrate the marriage of Charles of
Styria to Maria of Bavaria. This document further designates Fonteo as
the coordinator of the festival and Arcimboldo as its fabricator.[26] Fonteo

was also a draftsman, as is demonstrated by a long drawing that bears his monogram (Berlin, Kunstbibliothek; formerly on the art market in New York), recording another imperial festival.[27] He could thus have helped Arcimboldo with scholarship on programs, costumes, and themes, as well as with the actual drafting of designs. On occasion Fonteo acted as Arcimboldo's spokesman; he wrote a summary for Arcimboldo of the 1571 festival beforehand and sent it to Archduke Charles for approval.[28] It is therefore probable that Arcimboldo also enlisted Fonteo to write his poems on the pictures of the *Seasons* and *Elements*.

The style and content of Fonteo's poetry suit Arcimboldo's painting well. Fonteo's longer poems are forms of panegyric familiar in Renaissance neo-Latin literature. They begin with a brief laudatory prologue in elegiac distich and follow with a hexameter "divination" of Arcimboldo's paintings and a series of hexameter couplets that are dialogues between matching *Seasons* and *Elements*. Like much other late sixteenth-century poetry, they are expressed in a terribly complicated syntax using learned allusions and metaphors. Fonteo's poems are marked by the mannered style of literary *concettismo*: they employ what one writer has referred to as the "poetic of correspondence." Similarly, as earlier interpreters have also said, Arcimboldo's paintings are visual conceits. They represent the individual *Seasons* and *Elements* with objects corresponding to each.[29] Fonteo's poems of praise furthermore enable us to see how Arcimboldo's pictures are imperial allegories. They establish the occasion on which the pictures were given to the emperor, where they were displayed, and how they were regarded. They indicate the identity of each of the *Seasons* and *Elements*, their content, and their relation to other aspects of imagery and ceremony at the imperial court. Finally they suggest what the portrait of Rudolf II as Vertumnus may mean as an imperial image.

It is, however, still not possible to determine the exact relation of Fonteo's poems to Arcimboldo's pictures. The earliest versions of Arcimboldo's *Seasons* and *Elements* are dated respectively 1563 and 1566, but Fonteo's earliest manuscript, Codex 10152, is dated *tertio Calendas Januariae* 1568 (29 December 1568).[30] Is Fonteo's poem a program for the pictures? Is it simply an *ekphrasis*? Or is it an explanation made in collaboration with the painter?

While the point is moot until more definite information is available, the last possibility, that the poems elaborate a literary response made with the painter's knowledge, is most likely. As will be discussed further below, Arcimboldo also collaborated with poets after his return to Milan, when several other poems were written on his paintings: a copy of the poem by Comanini on the painting of *Vertumnus* that appears in *Il Figino* was sent along with the artist's approval when the painting was shipped to the

imperial court. Since Fonteo also announces that he is speaking on behalf of the artist, it is most probable that Arcimboldo approved of the message of his poem, which is certainly consistent with the visual features of the images it explicates.

It is also most likely that Fonteo's first poem accompanied pictures of the *Seasons* and the *Elements* that were presented to Maximilian II in Vienna at the beginning of 1569. The title of Fonteo's poem and a note in the second version state that he had composed it as a New Year's gift for the emperor. Fonteo says that it was the practice for the emperor's protégés to bring him gifts on New Year's day; a New Year's poem dedicated to Rudolf II and Tycho Brahe's planned presentation of his star catalogue as a New Year's gift to him are but some evidence that confirms this custom.[31] The following lines would seem to indicate that Fonteo's poem went along with the paintings as a form of explanation:

> I shall not at all desist, but indeed best Caesar,
> Since it is not permitted to go to one's lord with empty hands
> And since it is fitting that his clients bear the king tokens
> The gifts that are due for the New Year
> I venerate you with seasons of the year that have changed form
> And also visible images of the elements
> These I bear desiring to animate these wondrous [imperial] paintings.[32]

What could be a more appropriate gift for the New Year than pictures of the seasons and elements out of which the year is made?

It is likely that the small poem at the end of Codex 10206 was presented at the same time. The poem is probably a copy of a work written before 1571, the date of Codex 10206, as marginal notes refer to the painter's past intentions. The title also suggests that it was written on behalf of Arcimboldo when he offered his painting to the emperor: "For Giuseppe Arcimboldo, the imperial painter, offering his picture of a *grillo*, seeking aid" (Pro Josepho Arcimboldo caesareo Pictore, Picturae grillum offerente, auxiliumque petente).

Regardless of the difficulty of determining with absolute certainty the painter's own original intentions, the reception of Arcimboldo's paintings at the imperial court also demonstrates that the significance as imperial images, with which Fonteo endows them, was well established there. As we shall see, the message that the poems suggest was present in the paintings was soon repeated in an imperial festival gloryfying the Habsburgs in which the emperor himself participated. In an annotation to the later version of the poem on the seasons and elements, Fonteo notes that the order of the elements in the tournament was changed according to Maximilian II's suggestion; this remark verifies a comment made by Lomazzo, who also says that Maximilian II often discussed with Arcim-

boldo the program for this tournament, whose message he must therefore have known and approved.[33]

Marginal notes to the poems indeed indicate that the pictures were well received. Fonteo's use of the terms *caesareas tabellas* and *caesareos vultus* show that the *Seasons* and *Elements* were meant to be read as "imperial paintings." The emperor evidently liked them, for Fonteo suggests that the pictures be hung in his bedchamber.

Yet even though Fonteo's poems went along with the paintings, and they seem to have been appreciated, their full meaning was not immediately understood. Fonteo himself apparently found it necessary to add the explanatory notes in the margins of the revised version of his poem in Codex 10206, since both his original poems and Arcimboldo's paintings were not absolutely clear. What, to raise but one question, did Fonteo and Arcimboldo mean when they called them *grilli*? How can pictures be imperial that are called by a "joking name," as *grilli* is usually understood? Are the interpreters since Lomazzo who think these pictures are simply jokes then right?

Consequently Fonteo says that the whole booklet (Codex 10206) is an "adumbration" of the painter's meaning because "all impediments" to understanding the pictures had not been removed since he first wrote his poems. He explains that they are meant to clear up the disposition of the works; they are to be like a daughter speaking for painting and begging support for the painter.[34]

These comments, in fact, come as part of Fonteo's explanation of *grilli*, a term that Pliny had used to describe a genre of paintings by the painter Antiphilus. By referring to Arcimboldo in Plinian language, Fonteo is trying to assure him a place in the painter's pantheon. As he states elsewhere, Polygnotus is distinguished in the invention of colors, Pyrrhus in the invention of lines, Gyges in the invention of shadows, but Giuseppe Arcimboldo is outstanding in the invention of *grilli*, or *chymerae*.

Yet, as E. H. Gombrich first pointed out, Pliny's references lend themselves to many interpretations—and Fonteo does not thereby mean that Arcimboldo's *grilli* are humorous paintings.[35] Rather, they are like the chimera, the mythical beast composed of the fore parts of a lion, the middle of a goat, and the hind parts of a dragon. Fonteo says that Arcimboldo meant by *grillus* a kind of painting made up of the instruments or other things pertaining to the image depicted: "the painter meant by *grillo* an image of painting such as the theme is supposed to express, that is, an image made up of intruments and objects pertaining to the object itself."[36] He alludes to a number of pictures by Arcimboldo in this genre that are named grilli ("appellantur Grilli huiusmodi picturae Arcimboldianae"): a rustic made up of farmers' tools, and a cook of kitchen utensils ("armis/ Rusticus agricolum . . . Coqua texta suis").[37]

The term *grilli* as used by Fonteo and Arcimboldo moreover suggests a possible source of inspiration for the latter's paintings of composite heads. Relationships to Arcimboldo's compositions have been found in numerous visual sources, including prints of fantastic heads by Tobias Stimmer or René Boyvin.[38] The idea of making compositions out of fruit and vegetables may also have been inspired by actual banquets at which food was formed into figures.[39] But *grilli* as a kind of chimera bring to mind other objects: ancient jewels made out of various compositions of human and animal forms or monsters. Such jewels, which are commonly known as *grilli*, must have been present in the imperial collections; Arcimboldo quite possibly drew from them for his own inventions.[40]

On the other hand, Arcimboldo's inventions are a new genre of *grilli*, a new kind of painting: this is one reason, according to Fonteo, why his pictures are imperial images. Fonteo says that the ancients did not write about Arcimboldo's kind of picture, nor did ancient painters know similar effects.[41] He implies that a new empire with claims even greater than those of ancient realms—encompassing the New World as well as the Old—is worthy of a new type of imperial painting. Maximilian's imperial painter, Arcimboldo, makes paintings that even the great Apelles, the legendary painter who served Alexander the Great, did not know how to do. These are worthy of the new Caesar.[42]

THE IDENTIFICATION OF ARCIMBOLDO'S INVENTIONS

Much as Arcimboldo's contemporaries could not immediately comprehend the meaning of *grilli*, so art historians have not unanimously identified all his paintings of the *Seasons* and *Elements*. Four of Arcimboldo's images—the *Fire* and *Water* (figs. 45 and 47) from the original series of the *Elements* presented to Emperor Maximilian II, and the *Summer* and *Winter* (figs. 44 and 46) from the *Seasons*—can be identified with certainty. They have signatures and other old identifying marks, as well as a provenance from the former imperial collections.[43] In addition, the images of the two other *Seasons* (though not the actual pictures given to the emperor)—paintings of *Spring* and of *Autumn* (figs. 49 and 51)—can be identified from their inclusion in another series by Arcimboldo that has remained together. These images of the *Seasons* correspond to a well-known description by Lomazzo: "Furthermore he has represented the four seasons in the form of a man with the things pertaining to each season, such as Spring with flowers, Summer with grains and vegetables, Autumn with fruits, and Winter in the form of a tree; all are painted in just so many pictures."[44]

Fonteo's descriptions in his marginal notes confirm the identification:

> Winter through the old trunk of a willow represents the appearance of a rustic.
> The head of Spring is blown together from flowers and the herbage of the same flowers.
> Summer imitates the personage of a man with a woven basket, and with grains and fruits.
> Autumn represents a human face out of various fruits.[45]

His descriptions of *Water* also agree:

> Water represents itself as a man through the collocation of different fish.
> The head of Water is woven together out of fish of all kinds.[46]

And his reference to *Fire* also agrees: "Fire joins together a human face out of sulfureous tinders, candles, and flints."[47]

There has been considerable disagreement, however, about the identification of the other two *Elements*. Lomazzo describes *Air* as being composed of birds, and so does Fonteo: "Air expresses a human face in the manner of birds that have been gathered together." Elsewhere he says: "The head of Air is woven together out of birds of all kinds."[48]

But what painting can this be? Geiger proposes a work in the Bossi Collection in Genoa, but Alfons suggests a painting formerly in the Wenner-Gren Collection in Stockholm, now in a private collection in Basel (fig. 48). An allusion in Fonteo's poem clarifies what sort of picture is intended: "Aër Caesare munitus pectora rostro/ Cassidis et tendens fausta Junone decorum."

Fonteo explains in a marginal note that this passage alludes to the eagle and peacock of the House of Austria; hence *Air* is a painting in the torso of which a peacock and an eagle's beak figure prominently—a painting that must have resembled the one formerly in the Wenner-Gren Collection (fig. 48).[49]

The identification of *Earth* is still more problematic. J. Baltrušaitis proposed that the painting formerly in the Johanneum in Graz (now in a private collection, Vienna) represents this element. Alfons and Preiss have rejected this suggestion, however, and, following the lengthy account of this picture in Comanini, proposed instead that this painting represents *Homo* (*Man*), or perhaps even an allegorical portrait of Maximilian II; in their rejection of the identification of this work with *Earth*, they have been followed most recently by Eliška Fučíková. Based on Lomazzo's descriptions of the *Elements* cited below, they think that *Earth*, now lost, is depicted in a number of seventeenth-century prints of a fan-

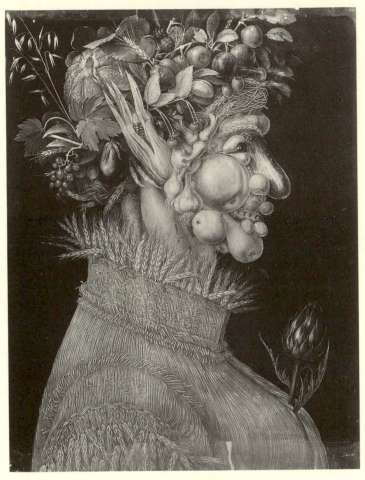

44. Giuseppe Arcimboldo, *Summer*, 1563

tastic landscape. The paintings of the *Elements* that Arcimboldo did for
the Emperor Maximilian are described by Lomazzo as follows:

> He composed, and furnished the figure of Fire as with members of
> lights, flashes of torches, of candlesticks, and of other parts that are
> fitting for fire; Air out of birds that fly through the air, so perfectly that
> the members appear all consistent with air; Water all of fish, and
> shellfish, well composed so that truly Water appears as if it were a form;
> and the fourth element of Earth, of crags of rocks, of caverns, tree
> trunks, and terrestrial animals.[50]

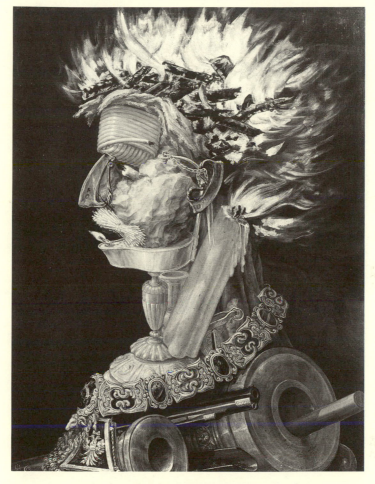

45. Giuseppe Arcimboldo, *Fire*, 1566

In this instance Fonteo seems a better source than Lomazzo; his descrip-
tion is earlier and closer to Arcimboldo; his account also antedates that of
Comanini by more than twenty years. Fonteo consistently makes refer-
ence to *Earth* as a head composed of animals: "Why Earth rightly consists
of animals" (Terra cur recte ex animantibus constet). He says elsewhere:
"The head of Earth is woven together out of terrestrial animals" (Ex
animantibus terrestibus contexitur caput Terrae).

Some additional remarks, where the original text bears repetition,
clinch the identification: "Si minus expressum flava de pelle Leonis/Terrae
humerum Reges uideat praetendere boios."[51]

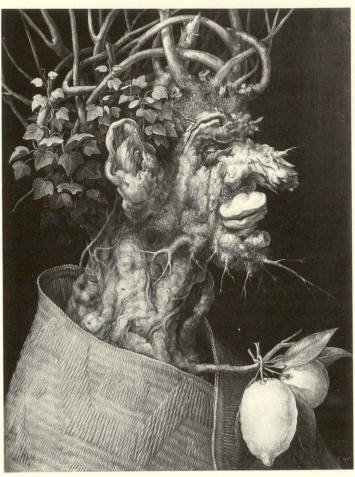

46. Giuseppe Arcimboldo, *Winter*, 1563

These lines suggest that the shoulders of the personification of *Earth* bear a lion's skin and support a bull, and thus characterize the painting formerly in Graz: Lomazzo's remarks may refer to another later version by Arcimboldo or else to a painting by an imitator.

The identification of the painting formerly in Graz with Arcimboldo's *Earth* has much further support. Like the other paintings in the series of the *Seasons* and the *Elements*, it is a composite head in profile. Like them it has a provenance from the former imperial collections in Vienna. Its dimensions (70.2 by 48.7 cm.), if not exactly the same, are very close to those of the paintings of *Fire* (66.5 by 51 cm.) and *Water* (66.5 by 50.5 cm.).[52] Furthermore, its iconography corresponds closely to that of other

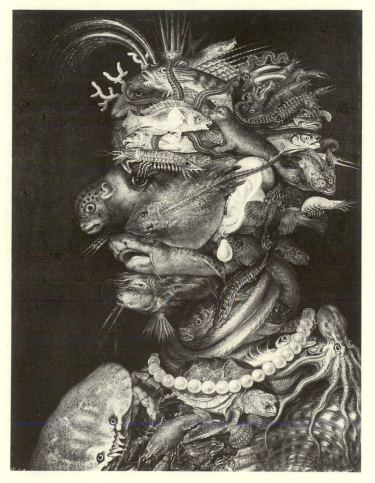

47. Giuseppe Arcimboldo, *Water* [1566]

personifications of the elements from the court of Maximilian II, where Arcimboldo was *Conterfecter* and *Maller*. In a work by the court historian Johannes Sambucus (Janós Zsámboky), published in 1572, a stag symbolizes Earth (fig. 52); similarly in the painting of *Earth* identified by Fonteo stags and antlered beasts of all kinds figure prominently.[53]

The similarity of iconography again directs us to the imperial milieu, to seeing how Arcimboldo's images are imperial images, fitting gifts for an emperor. Fonteo states that the *Elements* have joined the *Seasons* in clothing themselves in human form as heads in order to adore "the demigod Austriad glory."[54] Hence Arcimboldo's paintings, like Fonteo's poems, are forms of imperial panegyric.

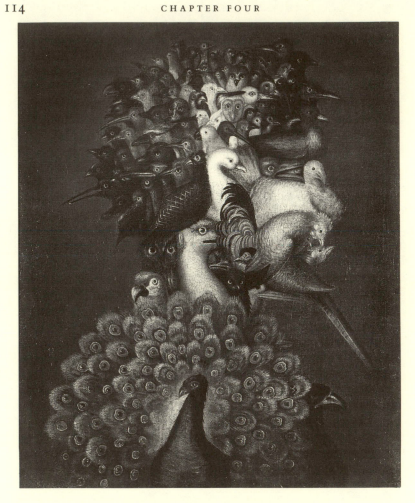

48. Giuseppe Arcimboldo, *Air*

IMPERIAL HEADS: THE COMPOSITION OF ARCIMBOLDO'S
METAMORPHOSES

Arcimboldo's paintings glorify the emperor because they are new kinds
of metamorphoses. Fonteo compares the transformation of *Elements* and
Seasons at the hand of Arcimboldo to the metamorphoses of Jove de-
scribed in Ovid. But Arcimboldo's paintings have not been transmuted
for the same reasons as characters in Ovid's *Metamorphoses*. Danger and
wild desire have not driven them to take on a new form. Instead they
have a pious cause; the clemency of Caesar has impelled them to adorn
themselves anew. Thus just as Arcimboldo's pictures are new forms of

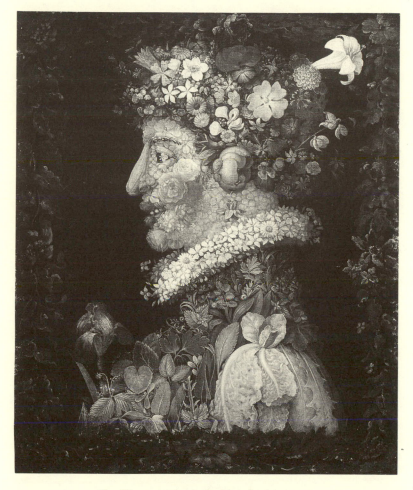

49. Giuseppe Arcimboldo, *Spring*, 1573

grilli, so are they new imperial metamorphoses. According to Fonteo, the paintings of the *Seasons* and the *Elements* have been compelled to take new form by their lord (the *Dominus Mundi*, overlord of all the kings of the world), because he holds the empire of the world, which consists of the elements and is ruled during the seasons of the year ("Domino, quia Imperium habet orbis, qui constat ex elementis, et regitur anni temporibus").[55]

In order to understand this encomium we must grasp the system of correspondences common to Renaissance thought on which it is based. In this way of thinking, parallels are found between the various parts of nature, the greater world or macrocosm. In turn the macrocosm corre-

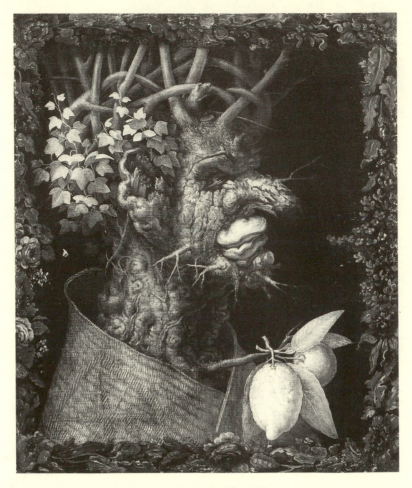

50. Giuseppe Arcimboldo, *Winter*, 1573

sponds with the smaller world, the microcosm that is man. Like is linked with like. Accordingly, what may otherwise seem extravagant hyperbole became acceptable allegory. The emperor rules over the world of state, of human affairs (the "body politic"), and so may be said to govern the microcosm that is man. But since the microcosm corresponds to the macrocosm, he may be said to rule over the greater world and its seasons and elements as well.[56]

Fonteo's poem verifies the application of this system of thought on many different levels in Arcimboldo's paintings of the *Seasons* and *Elements*. As Alfons, Preiss, and Evans note, using a description in Co-

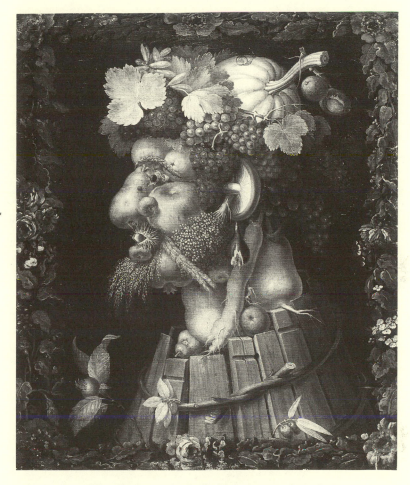

51. Giuseppe Arcimboldo, *Autumn* [1573]

manini without properly identifying the painting, the features of *Earth* are based on traditional conceptions of physiognomy. Its face is conceived on the basis of the correspondence between the animals having certain emotive characteristics and the parts of the face that display them. Thus, for instance, the elephant, which according to Pliny is a modest animal, is placed in the cheek, which shows shame.[57]

The composition of the heads in turn relates to Fonteo's claim that the emperor rules over the *Seasons* and *Elements*. Thus the harmony that exists between the various fruits and vegetables or types of creatures that join together to form the different heads parallels the harmony that exists

under the beneficent rule of the House of Austria and the Emperor Max-
imilian. As Fonteo puts it: "Just as the greatest harmony is shown in these
heads of elements and also of seasons, so do the realms of the world har-
moniously bow their head to the House of Austria" (Sicuti summa con-
cordia ostenditur in his rerum atque Temporum capitibus, sic concorditer
regna orbis caput submittent Austrigenis).

Similarly the harmony that exists between the individual elements
or seasons in each series reflects the peace that exists under the clement
Maximilian's rule, which will temper the times and increase the produc-
tion of the land. While Fonteo elaborates this idea, the ideal of world
harmony that he expresses is a common one, no doubt known to the
artist as well.[58]

Fonteo goes to great lengths to show further how harmony exists be-
tween paintings of the *Elements* and *Seasons*, how they correspond to each

52. Triumphal
Arch from Johannes
Sambucus, *Arcus
Aliquot Triumphal*

other. Again the governing principle is that like is linked with like. Thus the seasons may be linked with elements whose qualities they share. *Summer* is hot and dry, and so is *Fire*; *Winter* is cold and wet, as is *Water*; *Air* and *Spring* are both hot and wet, *Autumn* and the *Earth* both cold and dry. But Fonteo does not stop there, and continues piling up points of correspondence. For instance, the goddess of *Winter*, Proserpine, is the friend of the god of *Water*, Neptune, and hence *Winter* will be the friend of *Water*. In *Spring* we see many colors of flowers in bloom, which are made visible through the air. Their common planet, the sun, reconciles *Summer* and *Fire*, and the moon *Earth* and *Autumn*.[59]

The pairs that Fonteo thus forms are the couples in his poem that conduct dialogues with each other. In antiphonal distichs *Winter* and *Water*, *Spring* and *Air*, *Summer* and *Fire*, and *Autumn* and *Earth* exchange questions and answers about why they are composed as they are, and how they can be gifts for the emperor. These dialogues are also a form of panegyric, as the lines of *Fire* suggest: "Quam quo succendar, superat mihi, quodque, peruram, Tam domus Austriaco Domini durabit amore."[60]

The harmonies and parallels between the *Elements* and *Seasons* that Fonteo plays upon have their visual counterparts as well. Arcimboldo's paintings can also be seen as having a kind of visual dialogue between them. *Winter* faces to the right and *Water* to the left; *Spring* to the left and *Air* to the right; *Summer* to the right and *Fire* to the left; and *Autumn* to the left and *Earth* to the right. Within each series there is also obviously a kind of harmonious disposition, as two in each set face right and two left.

The harmonious conjunction of the *Seasons* and *Elements* in the hands of the emperor has for Fonteo a further prophetic significance related to contemporary Habsburg politics. The world is composed of the elements, and he who rules the elements controls the world; so will the emperor control world affairs and break the power of the Turks. The seasons come and go, but return year after year, signifying the order of nature that exists for eternity. Thus he who rules over the seasons will have eternal rule. Fonteo develops these tropes, saying that it is no different in nature than in art; the four ages of man correspond to the four seasons. "Just as the elements and the seasons in art are in the power of Caesar, so in nature are they in their own places, and bounds not otherwise: just as the elements and seasons themselves refer to the ages of man, so in the House of Austria there shall always be boys, youths, men, and old men, who either shall rule, or be about to rule."[61] Hence each of the seasons seems to be of a different age, progressing from the youthful visage of *Spring* to the gnarled old man *Winter*.

The continuation of Habsburg dominion is, of course, dependent on marriage and offspring. Consequently hymeneal notes are present in Fonteo's poem and in the reception of Arcimboldo's paintings. Fonteo says that the *Elements* are happily married to the *Seasons*, *Earth* with its spouse *Autumn*, for example; so will the offspring of Maximilian be married to foreign rulers. This may in some instances be suggested by gender differences in the matching *Seasons* and *Elements*: for example, the feminine figure of *Spring* is accompanied, as an inscription on the verso of one version says, by the bearded *Air*.[62]

Marital politics formed a traditional element of Habsburg foreign policy—"Let other nations wage war, but you, Austria, marry" (Alia bella gerant/Tu, felix Austria nube) runs a famous tag. This policy had contemporary significance in the late 1560s, as Emperor Maximilian II and other members of the House of Austria were engaged in a series of efforts at dynastic marriages. Besides the wedding of Archduke Charles to the daughter of the Duke of Bavaria, the celebrations for which Fonteo and Arcimboldo designed, Maximilian arranged marriages for two of his daughters to the kings of France and of Spain. These marriages all took place around 1570: Charles was married to Maria of Bavaria in 1571, Elizabeth of Austria to Charles IX of France in 1571, and Anna of Austria to Philip II of Spain in 1570. Fonteo refers to the marriages of Maximilian's daughters specifically in the margins of the 1571 version of his poem, which itself is found in a set of documents dealing with the festivals connected with Charles's wedding. In both poems he includes several lines of appropriately epithalamial verse.[63] Although Fonteo's remarks are obviously, at least in the case of the 1571 comments, an *ekphrasis* of Arcimboldo's paintings, since, for example, Philip II of Spain was still married to another spouse when the pictures were actually done, when they were presented in 1569 they could be seen as a reflection of Maximilian's policies and a prophecy of their eventual outcome.

The prophetic nature of Arcimboldo's pictures explains something of their peculiar forms as heads. The depiction of the four seasons as heads has a long tradition; the seasons are shown as adorned heads on Roman coins, for example. Arcimboldo could well have known such images, as similar coins were no doubt in the imperial collections. A book published by Sambucus in 1564 depicts one such coin (fig. 53).[64] In Arcimboldo's and Fonteo's reading the heads of the *Seasons* and *Elements* have a more specific classical source, however: their form relates to the prophetic story of the Capitoline told by Dionysius of Halicarnassus and, in a slightly varying account, by Livy.

According to Dionysius of Halicarnassus and Livy, the builders of the Temple of Jupiter on the Capitoline when digging its foundations found a severed head that bled continuously, in Dionysius' account, and that

QVATVOR ANNI TEMPORA,
IN NVMMO REGIO MAXIMI
PRECII IN FONTENOBILI.

EXCVDEBAT CHRISTOPHORVS PLAN-
TINVS ANTVERPIAE, VIII. CAL.
SEPT. ANNO M. D. LXIV.

53. Coin with a Depiction of the Seasons in the Form of
Heads, from Johannes Sambucus, *Emblemata cum
aliquot Nummis . . .*

had its features intact in Livy's. In Dionysius' version a soothsayer pro-
claims that the place where the head was found should be the head of all
Italy; hence the origin of the name Capitoline, since the Romans call
heads *capita*. In Livy's account the omen is even more prodigious: the
finding of the head portends that the site will be the citadel of empire and
the head of the world ("arcem eam imperii caputque rerum fore porten-
debat").[65] Hence the origin of the idea that Rome would be the "caput
mundi." For Fonteo, just as the finding of the head on the Capitoline
portended that the Romans would take possession of an empire, so the
heads of the elements and the seasons offered to Maximilian portend that
in all centuries the world would be ruled by the House of Austria. To
implement this design, Maximilian will make his beautiful offspring heir
to vacant thrones ("vacuis . . . regnis")—surely another allusion to his
politics of marriage.[66]

ARCIMBOLDO AND IMPERIAL IMAGERY

Once we are aware of the political significance of Arcimboldo's paint-
ings, many other details assume extra meaning. Thus features of the
pictures that may be interpreted on one level as referring to the elements
on another level become allusions to the Habsburgs. One such allusion
has already been cited: the peacock and the eagle that form part of the
torso of *Air* belong there as birds, as creatures of that element. But they
are, according to Fonteo, also specifically Habsburg symbols, marking
the element as under their dominion.[67] Indeed, the element may make a
specifically warlike allusion, as the imperial beak (*rostro*) is also a sign
of war (*Cassidis*). Similarly aspects of *Fire* have this kind of double mean-
ing. On the one hand, the Golden Fleece worn around *Fire*'s neck con-
notes the element, according to Fonteo, as the chain consists of flints and
striking irons that make a flame when brought together.[68] On the other
hand, the Golden Fleece is a specifically Habsburg order and indeed may
be considered the House order par excellence. *Fire* has another clear allu-
sion to the Habsburgs in the medallion with the arms of the House of
Austria that it wears. With its cannon, powder, and wicks, *Fire* also has
obviously military features. Undoubtedly Alfons was correct when he
saw these as having contemporary significance in reference to the Turkish
wars, as we can now assume from reading the lengthy anti-Turkish
prophecies that also are found in Fonteo's poem.[69] Similarly the painting
of *Earth* has specifically Habsburg features. On its shoulders it wears
what Comanini could identify as a lion skin and the order of the fleece ("la
pella poi del leone d'Hercole, & quella dell'ordine del Tosone").[70] Both
are specifically Habsburg symbols: the association with Hercules is a
long-standing claim of the Habsburgs, and the fleece seen by Comanini as
the "ordine del Tosone" is again, of course, the order of the Golden
Fleece. It is remarkable, in fact, how close this conception is to depictions
of emperors in profile, such as Leone Leoni's of Charles V or that by
Adriaen de Vries of Rudolf II (fig. 54).[71] According to Fonteo, the image
of *Earth* has a further allegorical connection with politics, as the lion is the
symbol of the kingdom of Bohemia, one of the Habsburg dominions
("Leo insigne Regum Bohemorum").[72] With this background it may not
be too farfetched to find another such allusion in *Water*: perhaps the pearls
may be seen as a mark of great estate, and the crab, shells, carapace, and
octopus as a suggestion of some elaborate armor, a mark of military
standing. Moreover, all of the pictures in both series bear the suggestion
of a crown or wreath; the antlers in *Earth* can surely be read this way,
another reason for linking this composition with the two series. All the
Habsburg *imprese* thus mark the *Elements* as Habsburg possessions in
some sense.

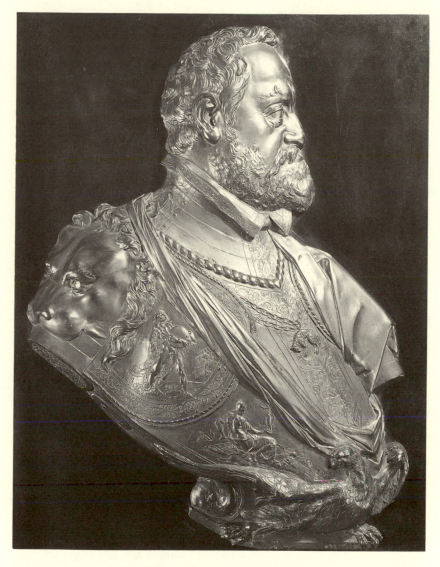

54. Adriaen de Vries, *Rudolf II*, 1609

Fonteo helps unravel another similar allusion in the series of the *Seasons*. While all the *Seasons* may bear some sort of political symbol in wearing a kind of wreath or crown, *Winter* has a specific emblem. In the Vienna version (fig. 46) *Winter* wears a cloak emblazoned with a striking iron and what can be read as a capital letter *M*, four strokes of which can be seen in the lower left corner of the cloak. The iron, which when struck

against flint starts a fire, forms part of the chain of the Golden Fleece (see, for example, the chain *Fire* wears) and is therefore a Habsburg *impresa*, or device[73]; the *M* stands for Maximilian. The version of *Winter* painted for the elector of Saxony (fig. 50), which wears a cloak with a shield with crossed swords—the arms of Meissen connoting the Saxon elector's ceremonial office as sword-bearer of the empire—allows a similar reading of Arcimboldo's painting and emphasizes his choice of *Winter* to bear a specific allusion.[74] Fonteo explains why when he discusses at length what season the year begins with, which peoples hold this opinion, and for what reasons. The Romans, authors of empire, made winter the beginning of the year, *caput anni*. As Maximilian is the new Roman emperor, the author of another empire, it is fitting that his particular *caput anni* should be winter; obviously there is a pun here on the depiction of *Winter* as a season of the year (*anni*) as a head (*caput*). In the 1571 version of his poem on the paintings Fonteo alludes further to the fact that Maximilian II actually portrayed the element Winter in the tournament held in Vienna that year and was himself concerned about the position of winter in the order of the seasons.[75]

Fonteo's last allusion makes clear that the paintings and festivals designed by Arcimboldo are closely related to each other. The same allegories of the seasons and elements appear in both, as earlier historians have noticed.[76] But the similarity reaches to the content, message, and even to the costumes. Arcimboldo's paintings are imperial metamorphoses; a commentator on the 1570 festival he designed in Prague refers to it as being taken from Ovid.[77] Arcimboldo's paintings reflect the marriage of the seasons and elements and refer to the marriages of the Habsburgs; the festivals of 1571 celebrate Habsburg marriages. Arcimboldo's paintings are allegories of the emperor's power and of the harmony of the world under his reign; the festivals, particularly that of 1571, give the same message. The paintings and Fonteo's poem prophesy the universal reign of the Habsburgs, as does the 1571 festival. The paintings and poems imply the defeat of the Turks; the 1571 festival held forty days before Lepanto prophesies this victory.[78] Most interesting, some of the costume designs of the 1571 festival may be activations of Arcimboldo's paintings. In that festival the costumes of the figures representing *Earth* and *Water* seem to have been something like Arcimboldo's paintings. Fonteo describes the costume of *Earth* as being painted in part "a ghiribizzo d'animali," and *Water* as also being adorned with fish and fishlike trappings.[79]

It is thus fitting that Fonteo included poems on Arcimboldo's paintings in a collection of festival descriptions and documents. The tournaments elababorate the compressed message of the paintings. They in turn are in a way a culmination of the imperial pageants, or better their epitome.

In her writing Frances Yates suggests that the imperial theme in the sixteenth century had a tremendous generative force. She shows how this

theme was presented in numerous sixteenth-century festivals. In various countries the impulses expressed in the festivals were also set forth in other art forms. In France the ballet may be seen as the culmination of the ideology of these festivals, and in England the poetry of Spenser.[80] But in the Holy Roman Empire itself, where the imperial court was not endowed with musicians or writers of the same quality as those in France or England, but where the leading designer of ceremonies was also the court painter, it would seem that these themes were given another form of cultural expression, in the visual arts. At the imperial court it is in the painting of Arcimboldo that these imperial themes have their fullest flowering.

The imperial imagery created by Arcimboldo had great cultural resonance. If the individual nation-states of Europe used the ideal of empire that was revived with Charles V for their purposes of self-advertisement, so much more so did Charles V's actual successors in the Holy Roman Empire cling to notions of imperial grandeur.[81] Their claims grew ever more grandiose until the elements and seasons themselves were invoked to do the emperor's bidding. This theme is echoed in other imagery from the court of Maximilian II. It appears in a book by Sambucus, the imperial historian, for an imaginary series of triumphal arches to celebrate the victory at Lepanto of Don Juan of Austria, who had himself participated in Arcimboldo's fêtes. On one of these arches, which has already been illustrated (fig. 52), the four elements join together to combat the Turks on behalf of the Habsburgs.[82]

The imperial imagery and political messages of Arcimboldo's paintings explain why they could also be used as a form of imperial representation or alternatively, *mutatis mutandis*, to convey another sort of politcal content, including serving as a form of flattery. Thus the Holy Roman Emperor sent to His Catholic Majesty of Spain, Philip II, a version of *Earth*, whose overt Habsburg imperial references perhaps flattered the Spanish line's claims to world dominion.[83] As a form of flattery for a lesser figure, which might also convey a subtle eirenic message of harmony in a time fraught with tension and open conflict, Maximilian II had Arcimboldo paint a series of the *Seasons* with the Saxon arms for the elector August of Saxony. If furnished with some sort of further explanation, August could probably have appreciated the paintings' message. He had been a participant in a festival held in Prague in 1570 that Arcimboldo had designed, in which the artist himself had played a role; August undoubtedly met Arcimboldo at this occasion and probably saw his paintings. Through such gifts Arcimboldo's images were disseminated throughout Europe. When princes came to collect them, artists in Arcimboldo's time and later would imitate his works.[84]

Arcimboldo's paintings of the *Seasons* and *Elements* can thus be seen as part of a tradition of imperial iconography. His use of the seasons and elements as a form of visual panegyric is picked up in later regal images.

A good example comes from the court of the "Sun King," Louis XIV, where a series of tapestries of the *Four Seasons* and *Four Elements*, after paintings by Lebrun, were presented to the king. Although the medium, scale, and exact iconography of the images have been changed for a different culture and taste, the message as related by André Félibien is strikingly similar. Again the transformation of the seasons and elements occurs under the beneficent and peaceful rule of the monarch, whose recent marriage has brought peace; again *imprese* mark the *Seasons* and *Elements* as their ruler's own. Félibien gives the gist of these transformations of the *Elements* and *Seasons*:

> If philosophers have written that Love dissolved chaos, and put all the elements in their place, one can say with even more truth that His Majesty has, by his happy marriage, established peace in his realm, and has, as it were, changed all the elements which were in a horrible confusion, during the cruel wars with which it had been so long afflicted.
>
> . . . having painted in a rare work the transformation that His Majesty has brought to the elements (if it is necessary to say so) in changing the bad use that one had made of them, and in what way he led them back to that disposition which through Peace produced such extraordinary effects, it was necessary to represent still by some other paintings those marvelous effects, whose cause one had only imagined. To make visible that His Majesty, having thus set the elements as if in a new order, has also rendered the seasons more beautiful and more fecund, or rather has filled our days with happiness, and overwhelmed our years with all sort of good.[85]

Arcimboldo's Portrait of Rudolf II as Vertumnus

It is now clear that Arcimboldo's painting of the Emperor Rudolf II in the guise of the god Vertumnus also belongs to this tradition of imperial iconography. The painting can be identified as a portrait by its general resemblance to Rudolf's features and, more important, by a poem published in 1591 in Comanini's *Il Figino*, which meticulously describes it. Comanini's poem, like Fonteo's, must have been composed to accompany the painting when it was sent to the emperor. As the poem was written before the painting was shipped from Milan, where Arcimboldo had retired at the end of his life, and as Comanini was his close friend, like Fonteo's work it may indeed represent Arcimboldo's thinking.[86] Giacomo Berra has discovered another compendium of poems that includes several more on this painting. The introduction to the compendium that Berra found indeed specifically states that a manuscript version of Comanini's poem had been sent along to the emperor with the painting of *Vertumnus*, and that this was done with the painter's consent.[87]

Like several of the other poets who wrote about *Vertumnus*, Comanini states that the painting has a serious content: some of his first words alert the viewer not to have a smile on his face when he sees the picture, and his last words give instructions to sing the praises of the artist and to bow down to Rudolf. Comanini describes how Rudolf has undergone an apotheosis into the god of the seasons. His poem also has a long discussion of how just as Jove ended chaos and put order into the conjunction of the elements, so has the artist created his own image out of disparate parts.[88] As we shall see in the Excursus to this chapter, however, there is a further inference to be drawn from the tradition of literary sources for Comanini's poem and for Arcimboldo's image, according to which Vertumnus as god of the seasons may also be considered god of the elements, and hence also like Jove. The apotheosis of Rudolf as god of the seasons may thus also be read as an implied apotheosis as god of the elements.

Once Arcimboldo's paintings of the *Seasons* and the *Elements* are seen as imperial images, then the seemingly unusual choice of Vertumnus rather than another god fits as an apotheosis of Rudolf II. The earlier paintings are new kinds of *grilli*, new metamorphoses that reveal the power of their lord, the emperor, and the harmony of his rule, and prophesy the eternity of his House's dominion. The elements and the seasons are designated as servants of the Habsburgs. The depiction of the emperor as Vertumnus, god of the seasons, who may at the same time be regarded as ruler of the elements, compresses these themes into one image. Instead of a suggestion that the Habsburgs rule the world as they do the elements and seasons, which somehow are theirs, the claim is made more direct. The emperor in the guise of Vertumnus rules the seasons, and perhaps implicitly the elements, and can assume any form in the world over which he has dominion, just as in Ovid's well-known story Vertumnus became an old woman among other forms to woo Pomona. Arcimboldo eschews this traditional image of Vertumnus, the most popular with painters, in favor of something more suitable for an emperor whose motives are lofty. Rudolf's visage as Vertumnus visibly manifests both the harmony of his reign and its timelessness. The combination of fruits and vegetables from all seasons in his face expresses his undying majesty.[89]

Arcimboldo's painting of Rudolf II is thus full of the expression of imperial iconography. It is easy to understand why Rudolf anxiously waited for it and was pleased to receive it.[90] The iconography developed in Arcimboldo's paintings for Rudolf's father, Maximilian II, seen in later reflections in Lebrun's designs for Louis XIV, implies the return of a golden age, a myth often associated with the imperial theme. After a period of unrest and war, the emperor with his beneficent rule ushers in an era of peace and prosperity in which cities and men are blessed.[91] The emperor's clemency has transformed the world itself and brought about an age in which the elements and seasons, and hence all things, are in

harmony. Arcimboldo's portrait of Rudolf is even more pregnant with meaning. In the classical Ovidian sense it is an even more significant image of a golden age than his earlier pictures. For the differentiation of the world into seasons is in Ovid's account a product of the silver age. In the golden age there is only eternal spring, in which everything flourishes. In Rudolf's face as Vertumnus, fruits and flowers of all seasons are shown, or rather are born as in one everlasting undifferentiated season. Rudolf's image portends the true golden age.[92]

The image of Rudolf II as Vertumnus is therefore the culmination of a type of imperial iconography invented by Arcimboldo to glorify the Habsburgs. Seen in this light, Arcimboldo's paintings no longer seem so strange or funny. They are allegories made with a specific political content and an intentional message.

To be sure, Arcimboldo's metamorphoses display considerable wit in the way that they are made up as *grilli*, with faces like visual metaphors composed of parts that fit human features. Comanini described them well as products of the imagination, of fantasy. As visual *concetti* produced by *fantasia* they are a kind of pun, a play of wit, or *scherzo*. But in the late Renaissance "wit" meant something more profound: related to *fantasia*, it was regarded as the "faculty that seeks out and realizes the hidden resemblances between things." A display of wit would have been part of the paintings' aesthetic as well as intellectual appeal.[93]

A frequently encountered aspect of Renaissance culture, found in the work of Erasmus, Rabelais, and many other writers and artists, is the expression of serious matters in a seemingly lighthearted form. Like several of these writers, Comanini also made the Socratic comparison to Silenus, a figure whose ugly, ridiculous, and grotesque exterior contained admirable virtues within, applying this image to Arcimboldo's *Vertumnus*. The use of paradoxes was in fact not only current in the Renaissance but had long been employed in rhetoric as a basis for the treatment of serious matters in a joking or playful way. These notions of serious playfulness, of *serio-ludere*, were well known in Arcimboldo's immediate circles, in Milan as well as at the imperial court, where Fonteo discusses them at length in his tract *De Risu*. Furthermore, even the seemingly joking exterior of Arcimboldo's pictures may also have assumed an imperial quality, since the ideal ruler was supposed to be urbane, able to take and tell a joke.[94]

If Arcimboldo's paintings are jokes—and they are so only in this Renaissance sense—they have a serious intent. In the words of his time that Arcimboldo would have known and understood well, they are serious jokes.[95]

Excursus

❦

ARCIMBOLDO AND PROPERTIUS

A CLASSICAL SOURCE FOR *RUDOLF II AS VERTUMNUS*

Although a wide variety of origins have been suggested for Arcimboldo's inventions, ranging from Indian painting to ancient gems,[1] the significance of a telling source for the artist in classical literature has been largely overlooked. In a version of the poem on a painting by Arcimboldo that accompanied the picture when it was sent c. 1590 to his patron, Emperor Rudolf II Habsburg, Comanini alludes, however, to classical poetry. As seen above, Comanini's poem can be used to identify the picture (fig. 43) as a portrait of the emperor as Vertumnus, the Roman god of the seasons, as well as otherwise to correct earlier misinterpretations, and this clue may also be more closely pursued. Comanini, in fact, refers to the ostensible subject of Arcimboldo's painting in the following words: "Vertunno chiamaro/Ne'lor carmi gli antichi/Dotti figli d'Apollo."[2]

Among the "dotti figli" (the ancient learned sons of Apollo) are Ovid, whose *Metamorphoses* (XIV:623–771) narrate the familiar story of Vertumnus and Pomona and whose *Fasti* (VI:410) also refer to Vertumnus; Horace, in whose *Satires* (II, 7:14) and *Epistles* (I, 20:1) Vertumnus is briefly mentioned; and Tibullus, in whose corpus of poetry (as traditionally attributed) there is a similar brief mention (IV, 2:13, according to divisions of his work established by Renaissance scholars). But more important for Arcimboldo is Propertius, who devoted to Vertumnus an entire elegy, the second poem of what is generally considered to be his fourth book. Except, however, for one brief reference to Propertius by Sven Alfons, his elegy on Vertumnus has remained unnoticed in the art-historical literature on Arcimboldo, which instead has tended to evoke Ovid's better-known story of Vertumnus and Pomona.[3] Although Ovid is no doubt also important for Arcimboldo, recognition of the artist's (and also Comanini's) reliance on the Roman elegist clarifies and deepens

an understanding of his painting of Vertumnus. At the same time the
association of Arcimboldo with the Vertumnus elegy contributes to a
fuller account of the history of the reception of Propertius during the
Renaissance.

If it cannot be claimed that Propertius was as popular with poets and
particularly with painters as was Ovid, his works were nonetheless
widely known and read during the late fifteenth and sixteenth centuries.
The elegies of Propertius were first published in Venice in 1472, and
many later editions followed.[4] Already during the fifteenth century Poli-
tian, Filippo Beroaldo, Antonio Volsco, and Domizio Calderini, among
others, produced learned commentaries on Propertius.[5] In the sixteenth
century Propertius's distinguished commentators include Marc Antoine
Muret and Joseph Scaliger.[6] Justus Lipsius made numerous emendations
to the work of Propertius and also intended to publish a commentary on
the elegist.[7] Propertius also had an impact on Renaissance authors both in
Latin and in the vernacular. Echoes or imitations of the elegies can be
discerned in the poetry of such major figures as Giovanni Pontano, Poli-
tian, Christoforo Landino, Ariosto, Tasso, Ronsard, and DuBellay.[8]
There is also evidence that soon after the publication of his text painters
were already using Propertius.[9]

Significantly, the elegies that constitute what is now generally consid-
ered to be the fourth book of Propertius, and in particular the poem on
Vertumnus (IV, 2), received special attention during the Renaissance. It
is likely that what modern scholars have often described as the "etiologi-
cal" or "archaeological" aspect of the Vertumnus elegy contributed to its
popularity, particularly with readers or writers with humanist interests.
The poem offers a number of possible etymologies for the god's name,
describes his attributes, gives some of the history of his cult and its rela-
tion to Roman history, as well as information on the history of his statue,
which was located by the Roman Forum. The elegy also has manifest
importance for Renaissance mythography because it is the most extensive
Latin literary source for Vertumnus besides Ovid's *Metamorphoses*.[10] For
one or several of these reasons, Giovanni Nanni (Johannes Annius of Vi-
terbo) often cited this elegy and chose this poem alone out of Propertius's
oeuvre for a special commentary. Nanni's [*Comentaria*] *Super Vertunni-
anam Propertii* [sic] relates the poem to other ancient texts both real and
spurious, including several of Nanni's own fabrications, and appears in
his largely concocted farrago that was first published in 1498.[11] Nanni's
derivation in this commentary of the name Vertumnus has been regarded
as characteristic of his etymological procedures in its use of the device of
aequivocatio, and thus as providing a sample of his historical method.[12]

Nanni's own work was also widely read. By the time Arcimboldo
painted his picture about a century later, the text had gone through nu-

merous editions. Some of Nanni's constructions of the text of Propertius became standard and were often adopted by later commentators, such as Scaliger, even when they did not know they were employing his readings.[13] Nanni also had a powerful appeal to historians in the mid-sixteenth century, for whom it has been said he provided a pervasive stimulus.[14] Nanni's text, including his extensive comments on Vertumnus, was used by figures associated with the imperial court, such as Guillaume Postel and the imperial historian Wolfgang Lazius; Italian contemporaries of Arcimboldo who treated topics related to his interests, most prominently Guido Pancirolli, also used Nanni.[15] Along with Propertius, Nanni was similarly important for Renaissance mythographers, who, even when they criticized some of his readings, regarded his fabrications as authentic.[16]

Conceived in a more general way, the kind of reading that Nanni's interpretation established may also be related to the poem's possible attraction for Arcimboldo, and for Comanini. Just as Nanni had employed Propertius's poem as a source for information on Vertumnus, so Comanini's reference to the "dotti figli d'Apollo" may allude to the learning that he thought Propertius revealed in his poem.[17] It may have been this sort of display that also appealed to Arcimboldo, whose other works reveal him to be what contemporaries would have considered a learned artist.[18] Arcimboldo was probably regarded as something of an expert on ancient art, since Rudolf II sent him to buy antiquities in Germany during the 1580s.[19] As shall be shown in Chapter 6, the painter's own words reveal his familiarity with Renaissance archaeological discoveries. Other evidence, including, as we have seen, the poems by Fonteo on Arcimboldo's paintings of the seasons and elements, and the painter's own remarks, also to be discussed in Chapter 6, suggest that, besides Ovid, Arcimboldo would have been familiar with other ancient writers such as Pliny, Livy, and Horace. These sorts of interests may well have led him to Propertius.

If the archaeological aspects of the elegy, as well as its importance as a source for mythography, were not enough to have gained Arcimboldo's interest, its poetic genre also had great appeal in Rudolf II's Prague. There the favorite form of contemporary poetry in Latin was not epic narrative but the elegy, or epigram. The elegy's presentation of a situation, its balanced construction in distich form, and its compressed, witty expression can now be regarded as a parallel to the painted *poesie* that were created by artists at the imperial court.[20] For a depiction of Vertumnus, rather than a pictorial narrative about the god's exploits, an artist active in Prague could thus perhaps have had additional reasons for turning to Propertius.

Whatever the reasons Arcimboldo turned to it, there are good grounds to believe that Propertius's elegy on Vertumnus, in whatever form he

found it, was used extensively by the artist. Propertius provides a number of specific details for his picture that can neither be traced to Ovid nor explained by reference to the method of composition that Arcimboldo had created in his earlier heads of the seasons and elements, nor by the allegorical messages they contain. Neither Ovid nor the artist's method of composing heads out of objects pertaining to the subject represented explains the choice of particular fruits and flowers for prominent display in the face of Vertumnus. On the other hand, many of these are the first fruits of each season that Propertius evokes specifically. The grape clusters and spiked ears of corn that Propertius mentions (ll. 13–14) appear in the hair of Vertumnus, cherries (l. 15) in one eye and hair, a mulberry (l. 16) in his other eye; a pear (l. 18) forms his nose, and an apple conjoined with pears mentioned in the poem (l. 19) his cheek, while the squash, cucumber, and cabbage mentioned further on in Propertius's poem as marking him out (ll. 43–44) are all prominent in the torso of Vertumnus. It seems more than coincidental that the fruits and vegetables mentioned by Propertius also appear in much the same order in the painting—if one scans it from top to bottom—as they do in the poem.

Furthermore, in addition to the kinds of visual metaphors and puns that occur throughout his painting and characterize what has been described as its "linguistic foundation,"[21] by which, for instance, a cherry can become an eye, Arcimboldo seems to be making a series of puns that pertain directly to the language of Propertius's poems. For example, since the *coma* mentioned in Propertius (l. 14: "et coma lactenti spicea fruge tumet") might be read to refer to the hair of Vertumnus, in the painting of Vertumnus corn (grain) appears in the hair, "lactenti spicea fruge," as it were. The mention of cherries (*cerasos*) and mulberry (*mora*) may also be read ambiguously (ll. 14–15: "hic dulces cerasos, hic autumnalia pruna/ cernis et aestivo mora rubere die").

These lines allow a reading by which *cerasos* might be construed to refer (as an accusative of specification) to the organs of sight (*cernis*, l. 16), and this might lead to a similar interpretation of *mora*. In like fashion the gourd (*cucurbita*), described (l. 43) as "tumidoque cucurbita ventre," forms much of the torso (*ventre* – stomach) of the painted Vertumnus.

More recently Giacomo Berra has proposed that Vicenzo Cartari's presentation of Vertumnus, particularly in the 1571 edition of his popular mythographic handbook, provided the immediate source for Arcimboldo's image, including some of its visual elements. While Cartari's Italian translation provides clearer readings for some of the ambiguities of the original Latin text of Propertius, this interpretation, particularly of the visual material, is not entirely convincing: in any case, Cartari's treatment must, after all, be seen as only one trace of the larger phenomenon of the reception of Propertius during the Renaissance.[22] A reader of Car-

tari could not have ignored that he specifically acknowledges that he is translating Propertius, in effect, offering a free Italian version of approximately the first forty-eight of the sixty-four lines of the elegy.

An association of Arcimboldo with the larger tradition of the reception of Propertius in the Renaissance, in fact, helps to explain other aspects of the painter's interpretation of Vertumnus. The history of the interpretation of Propertius's poem during the Renaissance provides a firmer foundation for the hypothesis that Vertumnus could have been regarded as god both of the seasons and of the elements. In the syncretistic mythography of the time such descriptions as Propertius's discussion of Vertumnus's ability to transform himself into, among other forms, a hunter, fowler, and fisherman (ll. 33–34, 37–38) may well have given rise to the idea that he was the god of the elements—earth, air, and water— with whose creatures these activities are associated. In any event, Giovanni Nanni did syncretize Vertumnus, Janus, and Noah, and, as noted, this reading was well known to figures at the imperial court. By suggesting that the epithets applied to Janus fit Vertumnus, Nanni allowed a way of regarding Vertumnus as the god of the constituents of the universe. Nanni says that Ovid's remarks (*Fasti* I:117) that Janus has been given rule over the sky, clouds, water, and earth can be applied to Vertumnus. The rule of Janus over the universe can be compared to the power of Vertumnus to mix things.[23] Here then is a god of the seasons who was also a god of three (if not of all four) elements, and who also exercises universal domination.

It is possible to associate Arcimboldo's work with this kind of equation of Janus and Vertumnus. Probably before executing his Vertumnus, the artist also painted a depiction of Janus. Much as Vertumnus bears fruits and flowers of all the seasons over which he rules, and consequently stands for the cycle of the seasons, the year, as a whole, so Janus was composed of personifications of spring and summer. Like the painting of Vertumnus, the picture of Janus, according to Lomazzo, who describes it, stood for the year itself; since it seems likely that Arcimboldo's associate Fonteo was also familiar with Nanni, it is even possible that this interpretation may be traced back to his writings.[24]

The last message of universal dominion to be read out of Nanni's interpretation lies, moreover, at the heart of Arcimboldo's allegories of seasons and elements, and accordingly of Vertumnus, as images symbolizing the Habsburgs as rulers of the world. Although Nanni concentrates more on the Etruscan, and thus pre-Roman, origins of Vertumnus, this message of universal dominion, so important for Arcimboldo's imperial allegories, can also be linked to a reading of the "Roman" elements of the elegies, which is grounded in the Renaissance interpretation of Propertius and certainly also constitutes part of Nanni's discussion. The "Roman"

elements of the elegy are manifest in statements made by the personifica-
tion of Vertumnus, such as one to the effect that although he was once an
Etruscan god, he has become Roman (ll. 3-6). Propertius suggests that
this transformation occurred when the Lycomedian Etruscans came to
aid Rome against the Sabines under Tatius (ll. 49ff).[25] The statue of
Vertumnus personified in the poem has been placed near the Forum (l. 6).
His prayer is that the Romans will march forever beneath his feet (ll. 55-
56)—again a suggestion that might be read as referring to Rome's eternal
dominion.

These Roman elements of the Vertumnus elegy correspond to what has
been called the "etiological" character of the fourth book of Propertius.
The etymological and etiological aspects of the Roman second elegy coin-
cide with the description of the history and topography of Rome in the
first elegy of Book Four, the fourth elegy of Book Four's discussion of the
origins of the Tarpeian grove, the sixth's account of the battle of Actium,
the story of the establishment of an altar by Hercules on the Palatine in the
ninth elegy, and the account of the origins of Feretrian Jupiter in the tenth
elegy. Modern scholarship has pointed out how the second elegy of Book
Four is in particular linked to the first poem in the book.[26] These associa-
tions are important, for during the Renaissance Propertius's elegies could
be turned to contemporary subjects. Thus the poet Christoforo Landino
applied the themes of Propertius IV, 1 to his evocation of the origins of
Florence.[27] Arcimboldo's painting of Vertumnus, the subject of the re-
lated second elegy, seems to rely on similar evocations for his portrayal of
Rudolf II.

This play of associations fits the general character of Arcimboldo's im-
perial allegories, which, as argued above, also invoke what might now be
called etiological references. We remember that Arcimboldo's collabora-
tor Fonteo justifies the painter's depiction of the seasons and elements in
the form of heads that portend the eternal universal dominion of the
Habsburgs by reference to the story of the founding of the Capitoline. In
similar manner Arcimboldo might have turned Vertumnus's prayer that
the Romans march forever beneath his feet into an evocation of the eter-
nal dominion of a Holy Roman Emperor from the House of Habsburg.
Rudolf II's rule might be seen as that of a new Augustus, of whom Prop-
ertius sings in other poems in Book Four.

Other aspects of Propertius's poem and Arcimboldo's picture reinforce
the idea that the artist is playing the "New Rome" off against the old, and
his pictorial means against the poet's. For instance, both Comanini and
Arcimboldo seem to play off the use of *prosopopoeia* by Propertius (whose
use by the Roman poet Nanni also specifically emphasized). On the one
hand, where the sculpted Vertumnus addresses the reader or passerby in
Rome in Propertius's poem, Comanini employs the same device to arrest

the reader in his poem, where he has Arcimboldo's painting speak. On the other hand, Arcimboldo may have been thought to have personified Vertumnus as Rudolf II in the painting for which Comanini has supplied words. Indeed the artist goes a step beyond Propertius, since he has transformed the sculpture mentioned in the poem into a painting.

This transformation of the sculpture of the poem into a painted bust sets up a further series of visual and verbal contrasts. A comparison is immediately established between Arcimboldo's modern imperial Vertumnus in paint and the ancient sculpture mentioned in the poem. This comparison thereby suggests that a *paragone* beloved in the Renaissance is involved, in which the virtues of painting may be compared with those of sculpture and poetry.[28] This tradition is pertinent for the imperial artist Arcimboldo, since the *paragone* not only became a Renaissance *topos*, but it seems that it may have inspired actual works of art by Rudolf's court artists in the 1580s and 1590s.[29]

This particular contrast of painting and sculpture also suggests a *paragone* of ancient and modern, where Arcimboldo's new painted invention for a depiction of a Holy Roman Emperor is contrasted with that of the ancient Roman poem: this sort of contrast is a topic to be discussed at length in Chapter 6. Recognition of the importance of Propertius as a source for Arcimboldo therefore allows a whole series of thematic and formal plays to come to light. With the recovery of several different facets of the painting, we can imagine that much more than even the message expressed by its imperial allegory might have caused Rudolf II to wait impatiently to receive the picture.[30]

5

Astronomy, Technology, Humanism, and Art at the Entry of Rudolf II into Vienna, 1577

THE ROLE OF PAULUS FABRITIUS

On 17 JULY 1577 Rudolf II made his first entry as emperor into Vienna. Two triumphal arches were erected for the occasion, at the Danube gate to the city and on the old *Bauern-markt*, in the vicinity of the present-day *Graben*. To judge from the number of accounts written at the time, the entry was a much celebrated event.[1] The entry has also become well known in the subsequent scholarly literature on Rudolf's reign, probably largely because one of the arches is described in the *Schilder-Boeck* of the Netherlandish historian and artist Karel van Mander, who was working at the time in Krems and was requested by the painter Bartholomäus Spranger to come to Vienna to help on its construction.[2] Van Mander specifically calls the event a *blijde Inkomst*, no doubt echoing the tradition of ceremonial entries into Netherlandish towns, and scholars who have been concerned with imperial imagery or propaganda have treated the entry in this regard. Art historians have also often referred to the *Ehrenpforte* that was erected on the *Bauernmarkt*, since it gives evidence not only of Spranger's early activity in Central Europe but also provides a firm record of the last works that can be definitely attributed to the elusive Hans Mont and to Mathias Monmacher (Manmacher).[3]

Several largely unstudied documents shed further light on this entry. Besides supplying many details about this important event, these documents also allow us many insights into cultural life in Vienna in the mid-sixteenth century.[4] Even more significant than the compilation of additional details about the entry, the most important compendium provides fascinating information about the connection of astronomy, technology, humanism, poetry, and the visual arts at the beginning of Rudolf II's reign.

This is a compendium of Latin texts delivered to the Vienna *Burgermeister* and *Rat* (*Consuli senatuique Reipublicae Viennensis*) on 17 August 1577 by Paulus (Paul) Fabritius (Fabricius), doctor of medicine, imperial astronomer (*mathematicus*), personal physician (*Leibarzt*) to three emperors, and professor of medicine at the University of Vienna (fig. 55).[5] Fabritius's gathering of eleven folios includes descriptions of the two triumphal arches built for the occasion, the texts placed on them, and the congratulatory poem that he was ordered by the university to present to the emperor. This document provides a more complete account of the arches, their designers, sources, and appearance, than has been available heretofore; supplementary materials for this event may also be found in the Vienna archives.[6] This information is complemented by another document, a request for release from university duties delivered to that emperor in 1587, which effectively provides an autobiographical account of Fabritius's life.[7]

The major compilation of Fabritius is entitled, in abbreviated form, *Arcus sive portae triumphalis . . . descriptio brevissima*. It describes the circumstances in which the arches were made. Care for the construction of

55. Paulus Fabritius, Title Page, Compendium of Documents on the Entry of Rudolf II into Vienna, 1577

the triumphal arches to welcome the emperor had been committed to Fabritius. His writings were meant to preserve from oblivion the arches that the city council had ordered destroyed before they could be worn away by the elements (as they had been made out of perishable materials such as hay, plaster and terra-cotta). Fabritius further suggests one reason why the arches had been made in the first place. The city fathers had been excited (*excitamini*) by the example of the emperor's entry earlier in 1577 into Breslau (the present Wrocław), one of several such events, and, significantly, the arch erected there. Perhaps they had become familiar with accounts or even engravings of this arch, which in any event provide an idea of the general appearance of the Vienna monument (fig. 56); in any case, they seem to have wanted to emulate the Breslau example.

Fabritius says that the sculptors, painters, and architects who were chosen by the council for his enterprise aided him mightily in the undertaking. For the first arch he names specifically as "artifices, statuarij et pictores longe praestantissimi" Mathias Monmacher (Manmacher),[8] Hans Mont (Johannes de Monte), and Bartholomäus Spranger. He states that they all had executed outstanding works of art for a long time, in many places, above all in Italy, for the pope ("omnes diu multis in locis praesertim in Italia apud Pontificem Maximum artis suae opera"). Fabritius notes that a second arch was made by the "industrius artifex," the Viennese citizen and painter Jacob Maier. In this project Maier was aided by other "insignes artifices," namely, the imperial *Tischler* (carpenters, "arcuarii") Anton and Georg Haas, who are best known for their work in the Niederösterreichisches Landhaus on the Herrengasse in Vienna.[9] Fabritius indicates that everything was done with his advice and persuasion, using specifically the expression "consilio et suasu meo." To emphasize the point, he therefore offers an undeniable example of a creature whose importance, if not existence, has been sometimes debated recently: he acted as a humanist adviser to artists.

Fabritius's account is confirmed by other documents for payment at the same time that it clarifies them. The names of the artists Fabritius mentions, along with others, are cited in payments connected with the entry.[10] Although hitherto overlooked, the name of one "Herr Doctor Paul Fabritius" also appears in these documents: on 26 September 1577 Laurenz Heubermer received a payment for making the coat of arms of the city of Vienna on the lid of a gilt silver *Hofbecher* executed by Franz Höfleiner, which was presented to Fabritius together with a sum for an *Ehrencleid* (clothing as an honorarium) for his wife and an additional hundred Thaler. These rewards were granted "wegen seiner gehabten mue und verrichter arbait bei dem werk der zwaien ehrnporten alhie" (because of the effort he extended and the work he undertook in the construction of the two triumphal arches here). At the end of 1578 the painter Jacob Grienperkh received another payment for work done on a *pecher* [sic]

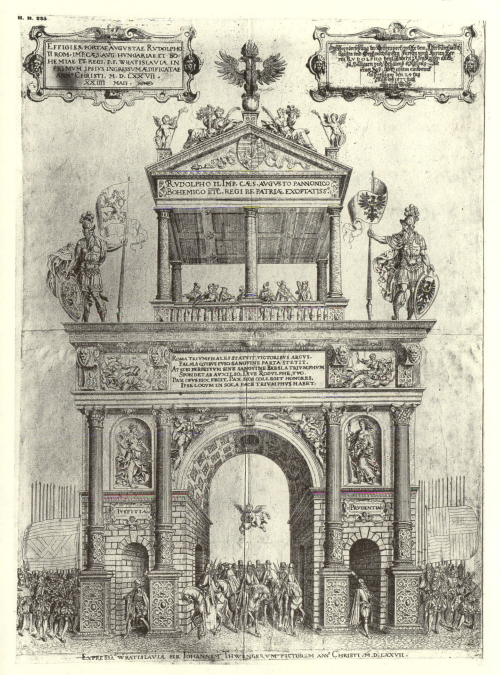

56. Johannes Twenger, Triumphal Arch for the Entry of Rudolf II into
Wrocław (Breslau), 1577

(cup) for Fabritius, most likely the same object.[11] In 1839 J. E. Schlager published another document recording a payment made in 1578 to Fabritius that suggests that the manuscript discussed in this essay may have been used for a publication; although such a work cannot yet be identified with certainty, Fabritius does seem to have published a description of the suburban arch in a work dedicated in 1580 to the Breslau (Wrocław) humanist Jacob Monau.[12]

In the main, Fabritius's description complements the accounts of Van Mander, the papal nuncio Giovanni Delfino, bishop of Torcello, and a certain (anonymous?) "L'Abbé," correspondent of the archbishop of Prague, all of whom also wrote reports on the entry.[13] Where the artist Van Mander lays emphasis on the physical appearance, design, and technique used on the arch, the humanist Fabritius details its iconography. Where the nuncio Delfino describes the ceremonies involved in the entry, the poet Fabritius records at length the texts that he had written for the occasion, which are cited in part by "L'Abbé." All accounts confirm that statues of Maximilian II and Rudolf II flanked the opening of the arch on the *Bauernmarkt*. According to Fabritius, Delfino, and "L'Abbé," beside each emperor stood effigies of the cardinal virtues, Prudence, Justice, Fortitude, and Temperance. Above each of these personifications were painted scenes from ancient history exemplifying each of the virtues, which Fabritius describes at length. Atop the whole arch was not only a large figure of Pegasus but also statues of the gods Neptune and Pallas Athena. On the reverse of the arch were statues of Jupiter and Hercules. Painted on the ceiling of the archway (*sub testitudine*) itself, according to Fabritius, were the coats of arms of the realms (*regnorum*) ruled by the Habsburgs, on the adjacent walls flying angels (*angeli*). The whole arch was decked out further with inscriptions and poems that made reference to the virtues of the Habsburgs.

Fabritius has more to say about the second "suburban" (*suburbana*) triumphal arch, which he also calls a *porta gratulatoria*. He notes that the arch was surmounted by a statue of a large double-headed Roman eagle, the imperial symbol, accompanied by a poem and an inscription. On the side of the arch that faced the Danube were painted representations of the Mediterranean and of Europe, the latter so designed that it resembled a person who could bend her head and knees in reverence to Rudolf as he passed. What must be imagined here is an image of Europe in the form of a woman, a representation much like that seen in the so-called *Weltallschale* (fig. 57) presented to Rudolf some years later; Fabritius indeed describes such an image in a poem on Rudolf's accession as emperor that he had published in 1576.[14] On the other side of the arch was depicted a personification of Austria in the form of a maiden dressed in red and white, who held a lance in one hand and a shield with the arms of the archducal house in the other. On her body were depicted the lands of

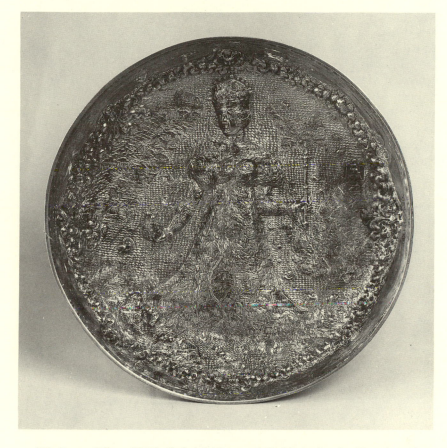

57. Jonas Silber, "*Weltallschale*" (Covered Goblet), detail of Interior of Goblet with Depiction of Europe in the Form of a Woman, 1589

Austria, along with a portion of Hungary. She, too, was made in such a way that she could bow in reverence to the emperor. Both sides of the arch were also bedecked with poems. Since more details about the texts and the physical features of the arch can be read in the documents printed in appendix 3, and gleaned from other published sources including Van Mander, it is the extraordinary elements, especially of the first arch, re-counted by Fabritius but not noted by other commentators on the entry, that will be discussed here.

According to Fabritius's description of the arch on the *Bauernmarkt*, two large stone globes, three and a half feet in diameter, that were placed beneath the statues of Maximilian II and Rudolf II seem to have been especially remarkable. Beneath the figure of Maximilian, Fabritius had made most appropriately, he says, a celestial globe. This was adorned

with the Latin hemistich "sub pedibus videt Astra" (beneath his feet he sees the stars). An idea of what this object may have resembled is suggested by the celestial sphere made by Georg Emmoser in 1579 (fig. 58). On the other side, at the feet of Rudolf II, a terrestrial sphere was set beneath the inscription "sed hic terrena gubernat" (but he governs earthly realms). Although Delfino also noted these features, he did not record an important detail that Fabritius mentions: as the emperor passed by, each globe rotated on its axis, revealing thereby another set of inscriptions. On the celestial globe there appeared "Ex Ptolomei Alexandrini et receptiore philosophorum sententia" (from the opinion of Ptolemy of Alexandria and the more received opinion of philosophers). On the terrestrial globe, because, as Fabritius says, it was represented as moving ("quia mobilis proponebatur"), there appeared the words "Ex Heraclidis Pontici Eophanti Pythagorici et Nicolai Copernici sententia" (from the opinions of Heracles of Pontus, Ekphantes the Pythagorean and Nicolas Copernicus).

Just twenty-four years after the publication of the treatise *De Revolutionibus* by Copernicus, the appearance of this rotating terrestrial globe offered an extraordinary public demonstration of one of the doctrines of the Polish astronomer.[15] Against the received opinion that the heavens moved around a stationary earth, Copernicus had assigned to the earth a triple movement, including rotation around its axis. While Fabritius allowed for a demonstration of how the heavens moved according to traditional Ptolemaic teaching, he also showed how the earth moved according to Copernican doctrine.[16] Furthermore, Fabritius's reference to the ancient Greek astronomers Heraclides and Ekphantes, who had also taught that the earth moved, demonstrates that he had direct knowledge of the text of Copernicus's tract *De Revolutionibus*, since Copernicus specifically links his own teaching to his predecessors in the preface to his book.

In addition to the genuflecting figure of Europe, which was apparently operated mechanically, the arch contained other technological demonstrations, including astronomical mechanisms. Fabritius says that on the columns of the gateway another mathematical device indicated the time in all those places that lay in the same parallel as did Vienna. A clockwork mechanism, which must have been built into the arch, pointed out the hour. Because this mechanism had been built at little expense and had many uses, Fabritius says that he gave a private demonstration of it, or most likely a smaller model of it, to Maximilian II. He claims that he would also use this device, which was most likely some kind of armillary sphere with clock, to show in what manner an eclipse of the moon soon to occur would happen. According to Th. von Oppolzer's canon of eclipses, this is most likely the lunar eclipse that did occur on 17 September 1577.[17] It is intriguing to speculate that Emmoser, who presented a

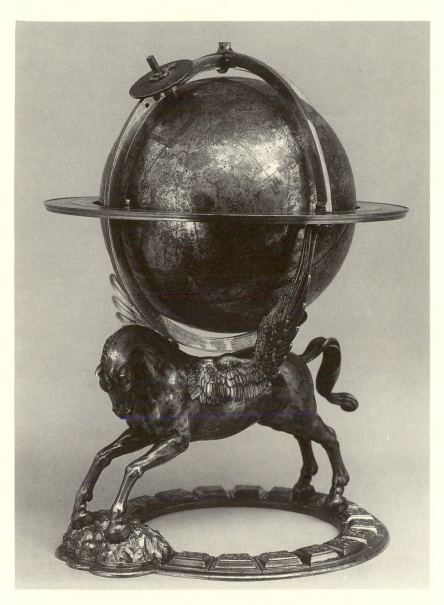

58. Georg Emmoser, Celestial Globe with Clockwork Mechanism, 1579

sphere to Rudolf soon afterward, was the sort of person available in Vienna who would have possessed the requisite amount of technical knowledge to assist Fabritius in making such a sphere, although Fabritius himself had already designed sophisticated clocks.[18]

These demonstrations of Copernicanism and of a new astronomical device provide further evidence of the capabilities of Fabritius, who now appears as a personality of great interest in what have been called the circles of learned celebrities around the imperial court of Maximilian II.[19] This "court academy" included Crato von Craftsheim, the historian Johannes Sambucus, Julius Alexandrinus, the botanists P. A. Matthioli, Carolus Clusius, Rembert Dodonaeus, Hugo Blotius, and Oliver Busbeck.[20] Fabritius is known to have been a friend of several of these men, including Matthioli, Clusius, and Blotius.[21] It is even possible to consider Fabritius's work on the arch as representing the culmination or combination of many of his talents and interests.

Fabritius was a Lusatian who was born in Lauban (now Lubań in Poland) in 1519 or 1529. According to the request he submitted in 1587 for release from his position at the University of Vienna, he had been brought to Vienna by the imperial counselor Johann Ulrich Zasius after having served Prince (later King) Philip II of Spain.[22] He had accompanied Philip to a *Reichstag* in Augsburg in 1551 and then returned to Spain with him to serve as *mathematicus*, or astronomer. In 1553 he was invited to Vienna. After being examined by the orientalist Widmann Stadius, the cabalist Guillaume Postel, and (Saint) Peter Canisius, Fabritius was installed as imperial *mathematicus*.[23] Until at least his request for release from his university position in 1587, he also functioned both as imperial *mathematicus* and as physician to the emperors Ferdinand, Maximilian II, and Rudolf II. In the latter capacity Fabritius was also called to the University of Vienna in 1553, where he became a doctor in 1557, a professor in 1558, and served as dean five times in the period until 1578. He died on 2 April 1589.

The question of Fabritius's religious beliefs is also significant. From documents regarding his having granted permission for burial without church ceremonies, and from his failure to be advanced to the highest ranks of the university, it has been hitherto assumed that he was a Protestant, although the evidence put forth to date has not been completely convincing.[24] The rediscovery of a rare polemic by Fabritius directed against Flacius Illyricus and his followers demonstrates that Fabritius involved himself in the Lutheran controversies of the 1560s: this tract strongly suggests that he was a follower of the Philippist line.[25] If he was indeed an adherent to the cause of Melanchthon, as seems likely, his presence at court would have been another piece of evidence not only for the relative tolerance of Ferdinand, Maximilan II, and Rudolf II, but for the importance in court circles of the mediating position that we have already

encountered in Hoefnagel, who, as previously noted, also wrote a poem on Melanchthon at roughly the same time.

Moreover, Fabritius's scientific and particularly astronomical activities may well be consonant with his Melanchthonian stance. Melanchthon was a firm believer in astrology. Although his own attitudes toward Copernican theory were ambiguous, Melanchthon may be considered to have adopted a "typically moderate stance" toward the question. While he rejected the idea that the earth moved, he nevertheless supported the activities of those who carried out reform in astronomy, wrote prefaces to their works, and an oration in praise of astronomy.[26] Historians of science have long associated many thinkers in the circle of men around Melanchthon with Copernicanism; under Melanchthon's aegis, the University of Wittenberg did develop into one of the leading centers of mathematics, the home of many "new astronomers."[27] Seen in this light, Hoefnagel's poem on Melanchthon may also deserve reconsideration as directly pertinent to his approach to nature.[28] In any case, it is also striking that many of the figures who held the position of imperial *mathematicus* were moderate Lutherans of a Philippist disposition, including Fabritius's successors Tycho Brahe and Johannes Kepler, and this attitude has been associated with their intellectual formation.[29]

In his official position of imperial *mathematicus*, Fabritius produced what we might call astrological writings, much as Brahe and Kepler were later to do. These again were not out of keeping with Melanchthon's own beliefs in astrology. Fabritius's writings include prognostications, astrological calendars (also known as ephemerides or almanacs) for the years 1556, 1567, 1576, 1580, 1582, 1585, 1586, 1588, and 1590. But, like Brahe and Kepler, Fabritius also wrote astronomical works of an observational character, including tracts on the nova of 1572 and comets of 1556, 1558, and 1577, among other phenomena.[30] Brahe also published on the nova and the 1577 comet, and indeed wrote favorably of Fabritius's account of the nova.[31]

Because of its public presentation of a Copernican theory, Fabritius's work on the arch may also be considered an example of advanced technical astronomical thinking at the imperial court at the beginning of Rudolf's reign. In 1578 Fabritius was called upon to provide a new calendar for the University of Vienna, according to the Gregorian reform, and in 1582 he was again consulted for his advice on the adoption of the Gregorian calendar; he also wrote a number of treatises on the problem. Significantly, in 1582 he advised that calendrical determinations be established on the basis of observations and urged the construction of an astronomical observatory for this purpose.[32] More evidence both for the connection with observational astronomy and the prevalence of Copernicanism in Fabritius's circles is provided from further associations with Tycho Brahe. Monau, the humanist to whom Fabritius dedicated the

published version of his description of the suburban arch, was an acquain-
tance and correspondent of Brahe and knew the astronomer Paul Wittich,
who played an important role in the formulation of new theories at this
time.[33] Brahe, who at the end of his life also assumed the post of imperial
mathematicus, received from the imperial astronomer Thaddeus Hayek a
manuscript copy of the technical treatise of Copernicus known as the
Commentariolus at the Regensburg *Reichstag* of 1576, where Rudolf be-
came emperor.[34] This treatise also contains the quintessence of Coperni-
canism. Hayek thereafter remained one of Brahe's closest correspon-
dents. In one of Hayek's surviving letters, he sent Brahe Fabritius's greet-
ings, suggesting some kind of bond between them, and both Brahe and
Hayek elsewhere expressed regrets at Fabritius's demise.[35] Moreover,
like Fabritius, Hayek was an imperial *Leibartzt* (personal physician to the
emperor), and he probably was Fabritius's collaborator in astronomical
matters as well, since in 1574 he published with him in a compendium of
poems and commentaries on the nova of 1572.[36]

Fabritius was, in fact, much more than an astronomer. Georg Eder,
the sixteenth-century historian of the University of Vienna, refers to him
as "vir magnae eruditionis & in omni artium genere probe exercitatus" (a
man of great erudition and well accomplished in every kind of art).[37]
Fabritius's own autobiography speaks of his "diversa studiorum et exer-
citiorum genera" (diverse kinds of studies and endeavors). He was an
esteemed professor of medicine, although he seems not to have published
much in this field.[38] He did possess skills in chorography and cartogra-
phy, in which area he made one of the first modern maps of Moravia.[39]
He was also learned in botany, and like his friend Clusius, whom he ac-
companied on an ascent of the Oetscher, he wrote on plants, publishing
one of the first studies of growths in the Vienna region.[40] Long before the
mechanisms he made for the triumphal arches, Fabritius had also de-
signed a sophisticated clock.[41]

Furthermore, much like his successors Brahe and Kepler, who, as has
recently been demonstrated, was also an accomplished poet and humanist
as well as an astronomer,[42] Fabritius was a skilled poet. Fabritius himself
singles out *poeterey* in his autobiographical account, and some of his re-
marks of 1573 on a celestial phenomenon even take the form of a poem.[43]
Among his poetic works, Fabritius wrote an idyll *Tityrus*, as well as one
on the birth of Christ, an epic on the story of Abraham and Isaac, and
various "oracles" in defense of the Christian faith.[44]

Among his previously published works, Fabritius had already written
poems for four Habsburg emperors. In 1558 he oversaw a memorial ser-
vice for Charles V and wrote an oration and poem for the occasion.[45] He
contributed to a compendium compiled by the University of Vienna that
celebrated the entry (*triumphus*) of Ferdinand I into Vienna in 1560.[46] He
composed two elegies on Maximilian II's garden on the Prater island near

Vienna, which were included in Georg Tanner's description of this creation.[47] For Rudolf II he wrote an idyll, *Tagus*, on his return from Spain in 1571 (the very event that was one of the causes for celebration in the tournament designed by Arcimboldo and Fonteo, mentioned in Chapter 4), and a series of congratulatory works on his various coronations.[48]

It was probably his talent as a poet who had already provided encomia of the Habsburgs, and as an organizer of festivities, that recommended Fabritius to the Vienna city council. He had presided over ceremonies of poetic laureation at the University of Vienna in 1558 and 1560, when he had also demonstrated his own poetic prowess. These events glorified the Habsburg dynasty, as well as the university, attacked the Turks, and drew upon ancient mythology (as well as the Bible) for their subject matter: in one of these festivals masquers posing as the gods and muses appeared.[49] In these regards the ceremonies must have resembled the imperial entries of the 1560s and 1570s, as well as the tournaments that Arcimboldo and others were to design during the 1570s.[50]

Fabritius's involvement as humanist adviser in the 1577 entry gives further evidence of the way in which poetry and humanism were involved with the making of art in Vienna during these decades. As we have seen, painters like Arcimboldo collaborated directly with humanists: Arcimboldo, in fact, worked not only with Fonteo in Vienna c. 1570 but also much later; even after he departed from court in the late 1580s he also collaborated with Comanini and others.[51] It can now be confirmed that Spranger and Mont did, too.

Fabritius's text reveals the kind of learned application of poetry that determined the character of this sort of collaboration. The arches' imagery and *tituli* are drawn from a wide variety of sources, "modern" and "ancient," with verses applied accordingly. Although a public event, like other tournaments and entries of the Renaissance, the program was not to be comprehended by all spectators. Fabritius specifically mocks the "indocti et insulsi," unlearned and silly, who twisted themselves about curiously in order that they might appear learned and festive.[52] In this way his account again demonstrates the cleft that existed in Renaissance audiences between those who were meant to understand an event or work of art and the great mass for whom they remained incomprehensible mysteries.[53]

This collaboration of a humanist astronomer with Spranger provides more clues to the interpretation of the painter's own later independent work. Fabritius presents learned poems and supervises paintings that are not to be understood by all, that invoke mythological sources. He employs visual images that he specifically calls histories. This term is also encountered in inventories of the imperial collections as a description of paintings.[54]

While the kind of historical or mythological imagery placed on arches for a triumphal entry is, to be sure, not the same as that found in

Spranger's erotic mythologies of the late 1570s or early 1580s, there is a way in which the assumptions involved in the public presentation Fabritius designed can also be applied to Spranger's pictures. The program that Fabritius supplied specifically involved the transference of poetic thinking to visual imagery. He says that the painter he calls Bartholomäus painted fitting histories most elegantly above the statues on the arch. So that the variety might appear greater, Spranger mixed these pictures with what Fabritius specifically calls poetic personifications ("poeticas prosopopeias"). Spranger therefore intended to place representations of the virtues on the arch to provide visual equivalents of poetic figures.

Fabritius's application of poetic thinking and terminology to visual imagery provides a stunning confirmation of an interpretation that has been offered for Spranger's mythologies of the 1580s. I have called them *poesie*, on the basis of the application of the principle of *ut pictura poesis* and according to a later inventory reference to some of Spranger's "middle-sized" paintings (fig. 59) as *poetisch*.[55] By *poesie* I have meant that Spranger's pictures were like Titian's—if epigrammatic rather than epic in thrust—in being conceived as visual poems. They clearly contain many antitheses, and I believe that it is not inappropriate also to find in them some of the other rhetorical or ornamental features, such as *chiasmus* and *anaphora*, that the learned poetry of Fabritius employs. Fabritius's statement that his collaborator Spranger painted "poetic personifications" does, after all, clearly indicate that Spranger was directly familiar with this way of thinking about painting.[56]

In fact, Fabritius reveals that Spranger expressed himself similarly about the invention of imagery. Another striking passage in his report indicates that the process of collaboration was one of give-and-take, in which ideas came from the artists as well. Fabritius says that the artists persuaded him to replace his own idea of a pyramid for the top of a globe with a statue of Pegasus. The artists urged that this be done for the sake of variety, ornament, and novelty. Fabritius accepted their idea.

Fabritius's anecdote about the creation of the Pegasus image can be related to certain other details of Rudolfine iconography. The connection of Pegasus with an arch, which now can be seen to have contained an active celestial globe, supplies a striking parallel that may suggest why Emmoser's celestial globe presented to the emperor soon afterward, in 1579, is borne on the back of a Pegasus. Pegasus can also be related to his appearance in many Hermathenic images, such as that concocted by Hoefnagel, Von Aachen, and Sadeler some years later in Munich, which we have already encountered (fig. 40). Here the double aspect of the image, as one of virtue and of inspiration or patronage of the arts, is emphasized.[57] It is probably this dual significance of Pegasus, as an heroic image of patronage (of the arts), that inspired the artists to suggest it be placed on the arch.

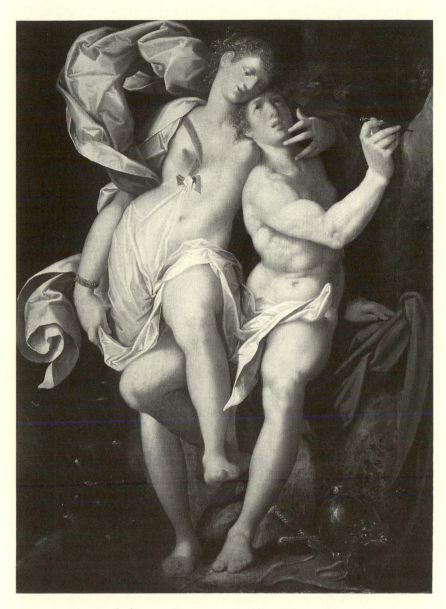

59. Bartholomäus Spranger, *Angelica and Medoro*, c. 1580

Evidence for this kind of Pegasus imagery is frequently found elsewhere in Central Europe during the mid-sixteenth century. For example, the imagery of a Latin poem by the German poet Georg Sabinus explains that the poet has chosen Pegasus as his heraldic device because it alludes both to vatic inspiration and to the heroism of Perseus.[58] At approximately the same time as the Vienna entry, the academy (*schola civilis*, *Academia Politica*) for noble youth established by the Polish Hetman Jan Zamoyski in his new town of Zamość was known as the *Hippeum*, choosing Pegasus as its emblem for similar reasons.[59]

The artists' suggestion to place Pegasus on the arch furnishes another piece of evidence that artists connected with the imperial court were themselves learned.[60] Painters like Spranger were capable of coming up with compelling inventions on their own, of making suggestions that even a polymath like Fabritius found persuasive enough to substitute for his own ideas. This process of collaboration is not only a striking demonstration of their learning and seriousness but also an important document for the way painters actually worked with poets and humanists during the Renaissance. It also adds another dimension to the sort of collaboration among patron, humanist, and artist that we have already encountered in Chapter 4 in the festivals and paintings Arcimboldo designed for Maximilian II and Rudolf II.

The collaboration of Spranger and the other artists with Fabritius provides yet a further insight into this era. The entry they arranged for Rudolf II into Vienna can be regarded as a symbolic introduction to many of the cultural accomplishments of his reign. While most often "mannerism," magic, and the occult are emphasized in characterizations of art and science at the court of Rudolf II, under the imperial aegis Rudolfine culture made great strides in astronomy, technology, humanism, and the arts. Painting at Rudolf II's court not only had connections with poetry and rhetoric but also contained the roots of several new genres, including independent still life, animal, and "naturalistic" landscape painting. Some of the most important optical and astronomical theses associated with the "new science" of the seventeenth century were also promulgated by Brahe and Kepler at the imperial court. Advances were also made in clockwork mechanisms by figures such as Jobst Bürgi. The arch's Copernican message and mechanisms usher in a new era.

The collaboration of Fabritius with artists on the Vienna arch also reinforces what can already be deduced from the work of artists such as Hoefnagel and Arcimboldo. Art, science, technology, and humanism were interrelated in the circles of the imperial court of Rudolf II. The entry of 1577 indicates that several cultural fields were already well prepared for the interdisciplinary cross-pollination that was eventually to bring forth such extraordinary fruits.[61]

"Ancients and Moderns" in Prague

ARCIMBOLDO'S DRAWINGS FOR

SILK MANUFACTURE

Probably shortly before his departure from the court of the Emperor Rudolf II in Prague during the course of the year 1587 the imperial painter Giuseppe Arcimboldo executed a series of thirteen drawings (now in the Museum of Fine Arts, Boston) (figs. 60–64).[1] Together with the explanatory texts written on each sheet, these drawings demonstrate the processes of sericulture and silk manufacture. In an accompanying letter from Arcimboldo to Baron Ferdinand Hoffmann (or Hofmann) von Grünpichl und Strechau (1540–1607), a nobleman of Styrian origins who arrived in Prague c. 1586 to begin twenty years of service as president of the imperial *Hofkammer*, the artist explains that the drawings were proposed for the decoration of Hoffmann's residence in Prague.[2] More important, Arcimboldo's letter opens up perspectives not only on his own art and what may be called his aesthetic attitude but also more generally on the culture of Rudolfine Prague. Considered more broadly, the self-conscious modernity revealed by his text may be related to a similar "modern" attitude toward technological innovation and to the "new science" of the seventeenth century.

Arcimboldo's letter is important for its documentation of the opinions of an artist active at the court of Rudolf II. It reads:

Al molto Ills: Sig. Barone il Sig Ferdinando / Hofman. Presidente della Camera di Sua / Sac.ᵃ Caes.ᵃ M:ᵗᵃ / Conosendo di quanto gusto e la Pittura ad ogni nobili^{mo}ssi / et come V.S. Molto Ills. se ne diletta et veramente vi*sta* / degna ad ogni gran' Principe et sapendo io come / sig.ᵃ e per far' depingere alcune stantie nelli soi cas*telli* / mi e parso de dar' alcuna inventione fatta cosi in / grossa maggia per non haver tempo di poter' con

/ quella deligentia far detti schizzi come si conve*ne* / e tanto piu che al presente mi trovo ocupat*o* / nelle opere di sua Sac.ª Caese.ª Mᵗᵃ mio Sig.ʳᵉ / Diro come gli antiqui furno prima inventor *di* / crotteschi ma non da quelli antiqui nominati cro*tte* /schi, se non da moderni per questa causa in R*o*ma / come ogni giorno vano scoprendo diversi edeficii so*tto* / terra dentro alle crotte si trovano depinte nelli uom(. . .) / dette inventione et mentre che li pittori le ano po*rtati* / fuora in disegni da dette crotte gli an' / posto no*me di?* / grotteschi . . . si vede che gli antiqui no*n*:ano fatto a cas(o) / ne posto figure ne animalli in detti croteschi mu(. . .) / qualche sua intentione si che da questo ho pensat*o* / che li moderni medensamente potran' mettere nel*la* / tesidura dentro a gli spacii in vezzo come gli anti*qui* / mettevano altari sacrificii animali ho altra. . . . *se* se *ebbe* / intentione che si potra mettere alcun' lavorerio / io dimostro nelli presenti schizzi che e il lavorer*io* / da sede e per esser' questo piu incognito dentro / Germania ho pensato di haver' posto questo prim*o* / come si potra fare

60. Giuseppe Arcimboldo, *Preparing the Eggs of Silkworms,* c. 1587

in una altra Camera il lavorerio dalle Lana e in altra Camera si potra / far il lavorevi della tela o vogliamo dire il / principio del Lino come prima si coglie et / lino e poi de man in mane siva facendo la / tela. / D.V.S. Molto Ills. / Affeccions.ᵐᵒ Sersʳᵉ / Giuseppe Arcimboldo.[3]

Although scholars have previously dealt with several aspects of this text in their interpretations of the Boston drawings, Arcimboldo's letter is rich in connotations that deserve further consideration. Heretofore Arcimboldo's drawings have been related to his activity as a *uomo universale*, as seen in his design of festivals; to his "surprisingly modern" attention to everyday and working subjects; to other representations of the silk industry; to grotesques and other interior decorations in Rudolfine Prague; and to their economic or social significance as designs that could have interested Hoffmann, a "new man," who was a court official concerned with the economic affairs of the empire.[4] But a thorough examination of

61. Giuseppe Arcimboldo, *Picking over Mulberry Leaves*, c. 1587

the language and themes of Arcimboldo's letter reveals much else about
his attitudes toward invention, grotesques, the "ancient-modern" con-
troversy, his composite heads, and the patronage of art and science in
Prague. This chapter offers a close analysis of several of the key concepts
of Arcimboldo's letter in relation to these themes.

Since Arcimboldo's letter opens with a seemingly customary proem
whose significance can be better appreciated after an examination of the
rest of the text, let us turn first directly to his proposal.

ARCIMBOLDO'S INVENTION AS A "MAGGIA"

After stating that since he knows painting is fitting for every nobleman,
and that Hoffmann delights in it and is planning to have some rooms in
his residence in Prague painted, Arcimboldo offers what he describes as

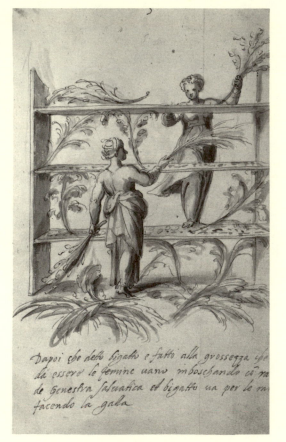

62. Giuseppe
Arcimboldo, *Spreading
Branches of Wild Broom for
Cocoon Spinning*, c. 1587

"alcuna invenzione fatta cosi in grossa maggia." Arcimboldo's use of these words recalls other language found in Renaissance writings on the visual arts. It thus supports other evidence for his interest in aesthetic and poetic issues that were topics of contemporary discussion, and again may also be a reflection of his collaboration, both at the imperial court and after his return to Milan, with humanists and art theorists.[5]

Arcimboldo's use of the word *invenzione* here and throughout his letter indicates that concepts derived from poetics and rhetoric that were standard throughout Europe were also familiar to artists at the imperial court. Invention is a standard subject of ancient instruction in rhetoric, where, for example, it constituted the topic of a separate treatise by Cicero, *De Inventione*. In Cicero's view, as often stated in writings on rhetoric, for instance, by the author of the anonymous treatise *Ad Herennium*, invention was one of the principal parts of rhetorical instruction.[6]

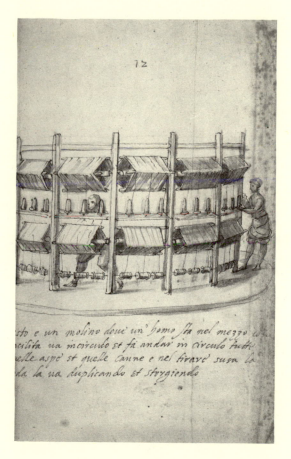

63. Giuseppe Arcimboldo, *Making Silk Thread (Doubling)*, c. 1587

During the Renaissance, as the terms and structure of thinking that ultimately derive from this ancient tradition of rhetoric came to be applied to the theory and practice of the visual arts, invention became a standard critical term for painting. In the fifteenth century Guarino da Verona mentioned a painter's invention, and Bartolommeo Fazio spoke of *inventio* as one of the principal parts of painting.[7] A better-known treatise, Alberti's *De Pictura*, also said that painting shares much in common with poetry and rhetoric, and that accordingly its greatest virtue or praise consists in invention.[8] By the sixteenth century the term had become a commonplace in the description of a wide variety of artistic projects. To give but one example of the continuing rhetorical and poetic flavor with which this term was endowed, Ludovico Dolce, who had also written several treatises on literary theory as well as a work on rhetoric, called *invenzione* one of the divisions of painting.[9]

64. Giuseppe Arcimboldo, *Dyeing the Silk*, c. 1587

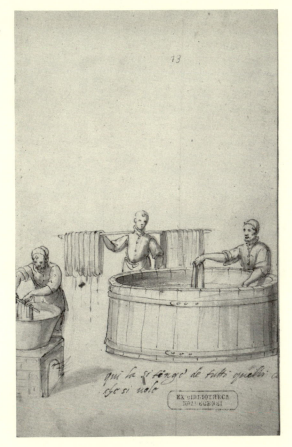

Arcimboldo's repeated reference to the concept of invention in his let-
ter may merit further comment because it was precisely for his powers of
invention that the artist was famed. Lomazzo says that it was for "tutte le
invenzioni" (all his inventions) that Arcimboldo gained favor at the impe-
rial court; according to Lomazzo, Arcimboldo was truly "singolare nelle
invenzioni" (unique in his inventions). Arcimboldo was said to show his
"acutissimo ingegno" not only in his paintings and masquerades but also
in his artificial means of diverting rivers and his ciphers.[10] Attention to the
notions of invention and its relation to the artist's *ingegno*, his *ingenium* or
wit, indeed suggests that Arcimboldo's letter turns around these very
concepts.

In sixteenth-century art treatises, *ingegno* and invention, which flows
from it, were often closely related to discussions of design, *disegno*, or
drawing.[11] The connection in Arcimboldo's own mind between inven-
tion and its expression or realization in drawings is, in fact, suggested by
the very next words that he uses to describe the drawings he has done: "in
grossa maggia." *Maggia* is moreover a loaded term, the word in Milanese
for *macchia*[12]—a notion fraught with significance for Renaissance discus-
sions of artistic invention.

The term *macchia* frequently appears in Renaissance discussions of the
power of imagination, *fantasia*, to create or invent forms. Several scholars
have traced this concept back to Aristotelian ideas of the power of the
imagination to project images into such things as clouds.[13] This tradition
formed part of what became a common description of the nature of artis-
tic inspiration in Renaissance writings; it may be related to the discussion
of the "image made by chance," a tradition that had its roots in antiq-
uity.[14] Leonardo da Vinci introduces the notion of the *macchia* or spot as
a form that quickens the imagination when he says that Botticelli saw a
beautiful landscape in the spots made by a sponge thrown against a wall.
Vasari reports similarly on how Piero di Cosimo derived compositions
from spumen on walls or images in clouds. These descriptions of the spot
(*macchia*) are reflected in the treatment of imagined images in Cinque-
cento art treatises. Antonio Doni, for instance, mentions the way in
which animals, men, heads, and "altre fantasticherie" can be seen in a
spot of landscape, and similar images can be seen in clouds. Writing at
approximately the same time that Arcimboldo composed his letter, Ar-
menini also said that "diverse fantasie & nuove forme di cose stravaganti"
could be seen in *macchie*.[15]

While Arcimboldo may have been familiar with some of these state-
ments, the most famous passage about the *macchia*, and an even more
pertinent source for his thinking, is Leonardo's piece of advice to painters
for quickening invention. Leonardo's well-known counsel for "stimulat-
ing the *ingegno* to various inventions" was to look at walls with spots

(*macchie*) on them, or composite stones, in order to see images of various landscapes, battles, or figures *et infinite cose*. Provided that the artist already knows how to render well "all the members of those things" that he wishes to make, Leonardo says that *confuse cose* can stimulate the *ingegno*.[16]

This piece of advice is found in the so-called *Treatise on Painting* that was composed from Leonardo's manuscripts in mid-sixteenth-century Milan. The compilation of this text and also of the Leonardesque Codex Huygens in the same milieu demonstrate a continuing interest in Cinquecento Lombardy for Leonardo's oeuvre. As we have already seen in Chapter 2, Leonardo's manuscripts were read, copied, and discussed in mid-sixteenth-century artistic circles in Lombardy. Since, as mentioned in Chapter 4, Arcimboldo was born the son of a painter who had been closely associated with Leonardo's follower Bernardino Luini in Milan in 1527, worked there from 1549 to 1558, and retained contact with his birthplace, to which he returned from Prague to rejoin these very circles, it is more than likely that he was familiar with at least some of the Leonardesque heritage.

Leonardo's suggestions are important for an understanding of Arcimboldo's arguments because they can be applied directly to the making of drawings. As Gombrich has suggested, the ideas of invention and the making of sketches as indeterminate forms that keep the flow of the imagination in flux are connected in Leonardo's mind.[17] Gombrich elsewhere notes that Leonardo "goes so far as to advise the artist to avoid the traditional method of meticulous drawing because a rapid and untidy sketch may in its turn suggest new possibilities to the artist."[18]

Arcimboldo clearly did not entirely subscribe to the idea that the artist should avoid working up his drawings. The next words in his letter are an apology for not having had the time to do his *schizzi* as would have been fitting, thereby implying that he might have eventually wanted to submit drawings done, as he says, with the proper amount of diligence. Nevertheless his notion of sketches, *schizzi*, as a kind of *maggia* approximates an idea that seems to stem from Leonardo. In this regard, although he may not have shared Vasari's assumed preference for the sketch, Arcimboldo's use of the word also seems close to that of the Tuscan artist-historian. For Vasari, sketches were also the visible forms of the artist's furor of imagination. According to Vasari, sketches were done in the form of a *macchia*, stimulating the mind and leading it on to other sorts of drawings.[19]

An understanding of this sort of definition of the sketch can help in a characterization of some of the formal aspects of Arcimboldo's Boston drawings. Since Arcimboldo's drawings are sketches that might be considered to have originated from the furor of his imagination, they express

what Vasari would have called their *concetto* or concept in only a few strokes. Moreover, since they are pen drawings, they may be linked with that "kind of free and copious invention"—observe that there are thirteen separate sheets—that had been associated with this medium since Dona-tello.[20] But while the Boston drawings are done in a technique of pen and blue ink outlines, with graded blue wash used to model forms, give di-mension, and indicate cast shadows (figs. 60–64) similar to that found in many of the artist's other sheets, they are executed in a summary manner that contrasts with most of his other works in the medium (figs. 65–66). The facial features of the workers in the Boston drawings are not clearly delineated; their fingers are suggested with only a few lines and are not always connected to each other or to the hand; details of clothing are not articulated, but again drawn only with a few fleeting, often broken, lines. In sum, the Boston drawings, if attractively composed and decorative in the effect made by their arrangement on the page, suggest the speed with which Arcimboldo drew them. According to the artist himself, he would

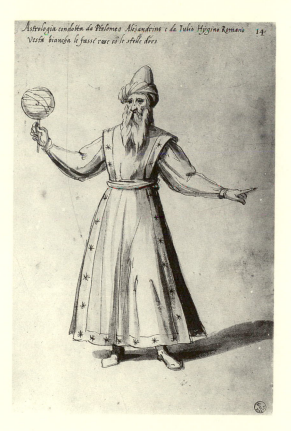

Astrologia condotta da Ptolomeo Alesandrino e da Iulio Hygino Romano 14

Vesta biancha le fasse rase co le stelle dore

65. Giuseppe Arcimboldo, *Companion of Astrology (Costume Design for a Tournament in Vienna, 1571)*

have next proceeded in some manner to other, more finished sheets, in a manner such as can be imagined from his projects for tournaments (figs. 65 and 66), and as is suggested by Vasari's definition of drawings.[21] The negative qualities ("pochezza espressiva" and "corrività formale") that one critic has found in the Boston drawings[22] can therefore better be considered part of their character as *schizzi*.

Arcimboldo's *schizzi*, understood as a kind of *macchia*, have a further significance in the context in which they were to function, as part of a decorative scheme of grotesques. Moreover, as an expression of the artist's inventive furor they are specifically comparable to grotesques, which were also regarded as characteristic products of the inventive imagination of *fantasia*.[23] Doni's description of the *macchia* found in paintings, which he also calls *fantasie, castelli in aria, sogni* and *chimere*, in fact, occurs in the course of his discussions of grotesques. Armenini also relates the origins of grotesques to the *macchia*. And Lomazzo also seems to echo Leonardo's description of what was seen in the *macchia* when he speaks of grotesques as something *confuse* of *diverse cose*.[24]

66. Giuseppe Arcimboldo, *Costume Design (Perhaps for Ball Held in Vienna, 1571)*

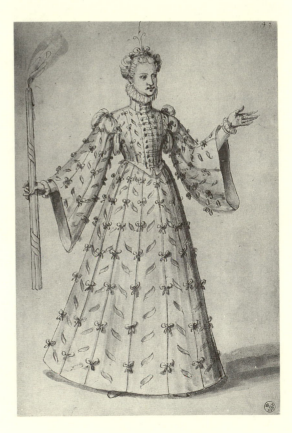

ARCIMBOLDO'S GROTESQUES

Arcimboldo's own thoughts lead his letter next to the topic of grotesque ornament. The artist proceeds to describe and explain the project he is proposing to Hoffmann as a kind of grotesque decoration, occasioning a discussion of the subject in which the artist again reflects a lively Cinquecento debate.

Arcimboldo first says that although the ancients (*antiqui*) were the first inventors of grotesques, they did not give the decoration that name, as did the moderns (*moderni*) who found such paintings in buildings (*edificii*) underground in grottoes (*alle crotte*); from the drawings made of these paintings in grottoes the moderns gave them the name grotesques. Arcimboldo's description here closely resembles the explanation of the name that Benvenuto Cellini provides.[25] His text is also comparable to the description of the origins of grotesques given by Pirro Ligorio.[26]

These comparisons seem significant because Arcimboldo's additional arguments about grotesques can also be related to a contemporary theoretical debate. Arcimboldo's letter goes on to justify his proposal for a specific kind of grotesque decoration by reference to a meaningful ancient practice. He says that the ancients did not place figures or animals in their grotesques by chance (*a caso*); although the trimming of the letter makes the text somewhat unclear at this point, he seems to argue that they instead had some intention (*intenzione*) in so doing. Arcimboldo here again recalls Pirro Ligorio's description of grotesques. Ligorio says that "all were symbols . . . as if to show how moral matters were figured, certain things, false things, true ones."[27] Arcimboldo's letter may also recall Lomazzo's description of grotesques as a form of ornament for an *istoria* in which the "painter expresses things and concepts, not in their own forms, but with other figures." For Lomazzo the chimerical form of grotesques conceals a more profound meaning, like that expressed in hieroglyphs, and we may remember that Arcimboldo not only made a painting incorporating a hieroglyphic image, but was also called a "learned Egyptian."[28]

Arcimboldo's description of grotesques does not evoke their symbolic character, and the explanation he gives may appear to be contrary to what has been called Ligorio's and Lomazzo's "rigid and reactionary" interpretation, which regards grotesques as concealing meaning from the masses by hiding it in hieroglyphic form.[29] Nevertheless, Arcimboldo's ideas seem to approximate those of Ligorio and Lomazzo in that his interest is also limited to the content of grotesques, the only aspect of their design he discusses. Arcimboldo's interest in this aspect of grotesque decoration may even explain in part why the Boston drawings depict merely the subject matter or content of the decoration, what can be explained as their central fields, and not their more purely ornamental surroundings.

In any event, Arcimboldo's self-conscious justification of grotesque decoration by reference to their content seems to indicate his awareness of the contemporary critical debate on grotesques and may also be regarded as a characteristic post-Tridentine response to the issue. As Nicole Dacos and David Summers have demonstrated, during the sixteenth century grotesques became the focus of a debate because they were seen to be representative of a kind of free, imaginative invention that was related to those forms that the classical authority of Horace and Vitruvius seem to have condemned. In Summers' words, "the grotesque appeared as a symbol of pure art," a "critical commonplace" that "pointed beyond decorative practice to the greater question of the nature and possibility of artistic freedom."[30] After the attacks on grotesques by Daniele Barbaro and Cardinal Paleotti, and the defense of figures such as Vicenzo Danti, the debate over grotesques intensified, and the question of content increased in importance.[31]

Although Arcimboldo's laconic remarks cannot be regarded as a complete statement of his response to this debate, his words still seem to reflect some of its issues. Arcimboldo clearly uses the term *invenzione* to refer to grotesques and speaks of the ancient Romans as their first inventor. The artist's use of the word "intention" may, as in other medieval and Renaissance contexts, also perhaps convey the meaning of an image of the imagination.[32] Such an implication is certainly consonant with the idea that he is proposing preparatory designs. In this context, he may also be regarded as approximating the opinion of many other authors of the time who considered grotesques as having meaning.[33]

ARCIMBOLDO'S GROTESQUES AND *GRILLI*

Arcimboldo's discussion of grotesques helps to deepen an understanding of his most famous invention: his paintings of composite heads of the seasons, elements, and other personages and personifications. The composite heads, which are constituted from objects pertaining to the subject represented, may be linked with grotesques in that they were also regarded as free plays of fantasy.

As we have seen in Chapter 4, Arcimboldo's contemporaries used similar language to describe them. Arcimboldo's paintings were seen as "dream-images"; Lomazzo's poems, many of which are on painters, including Arcimboldo, are also called grotesques and are also closely associated with dreams, in fact with the compilation of his thoughts on art that he specifically called dreams (*sogni*).[34] Lomazzo, who also conjoins the term *grillo*, *grilli*, or *grillerie* with inventions, specifically linking grotesques with *grillo*, which may have a related meaning.[35] Grotesques as a kind of whimsical or capricious invention are moreover connected with Arcimboldo's paintings as described by his associate Fonteo.[36]

As we recall, Fonteo specifically says that Arcimboldo used the term *grillus* to describe his pictures as chimeras.[37] The notion of grotesques as a kind of chimera is also applied to grotesques by Doni, Barbaro, Armenini, and Lomazzo, who either speak of grotesques as *chimere*, or as *cose confuse*, *sogni* composed out of various parts.[38] Indeed, this is what makes them appropriate examples of fantastic imagination for Comanini, and they may also be considered *fantasie* in the sense of antinatural inventions of the imagination, because their combination of elements emphasizes their licentious violation of Horatian, classicist proscriptions. Horace's own statements about the ridiculous character of composite creatures were known and quoted elsewhere by Fonteo, and it is quite possible that he, or even perhaps Arcimboldo, had them in mind when he described Arcimboldo's paintings as *grilli*.[39]

As free or capricious inventions, both grotesques and *grilli* could be considered products of wit. Emanuele Tesauro indeed conjoined *grilli* and grotesques in his later discussion of *acutezza*, or witty expression, when he specifically related the *grillo* to the *capriccio*. According to Tesauro, "All painters call their capricious and grotesque inventions GRILLI."[40] It was this witty or *acuto* aspect of Arcimboldo's art that Lomazzo seems to praise when he speaks of Arcimboldo's *acutissimo ingegno*, and to which Comanini refers, as argued in Chapter 4, when he calls one of Arcimboldo's paintings a *scherzo*.[41]

In that they present a series of designs for silk manufacture, Arcimboldo's grotesques are no more to be regarded as simple jokes than, as Chapter 4 has demonstrated, are his composite heads of the seasons, elements, and Vertumnus.[42] Like them, they would have presented a serious message within what would have been a playful exterior, had the grotesque decoration the artist proposed been completed.

Fonteo claimed that Arcimboldo's wit led to what he called new inventions in the genre of *grilli*, new types of imperial painting, which he regarded as worthy of a ruler whose claims to dominion included the New World; these themes were also involved in the way that Arcimboldo's use of a Propertian elegy for his image of Rudolf II as Vertumnus plays the modern emperor off against the ancient Augustus. Further imperial associations may have been attached to Arcimboldo's drawings since, as Guido Pancirolli, Arcimboldo's North Italian contemporary, relates, earlier sources connected the importation of silk manufacture to Europe with the interest and involvement of Emperor Justinian.[43] An image of silk-making by Johannes Stradanus (Jan van der Straet, Giovanni Stradano) also depicts this legend (fig. 68). It is possible that the implied reference to a Christian emperor, Justinian, and one moreover who still ruled over Constantinople, which in Rudolf II's time was the seat of the Habsburgs' Ottoman enemies, may have provided part of the appeal to an important servant of the Holy Roman Emperor.

Just as there is a comparison implied here between ancient and modern rulers, so for Fonteo Arcimboldo's inventions were comparable to those of the ancients. As we have seen, Fonteo thus presented his own parallel, saying that just as Polygnotus was outstanding in the invention of colors, Pyrrhus in the invention of lines, Gyges in the invention of shadows, so was Arcimboldo in the invention of *grilli* or *chimerae*. Fonteo thus also seems to be suggesting a parallel between ancient and modern painters, especially since Arcimboldo's paintings were unknown to the ancients.

The debate over grotesques as products of imaginative invention on which Arcimboldo touches may thus also be related to the "quarrel of the ancients and the moderns," as both Summers and Dacos have briefly noted.[44] Arcimboldo's description of grotesques as an ancient invention to which a modern term has been applied already seems to make the ancients distinct from the moderns. His crediting the invention of grotesques to the ancients at the same time that he suggests the moderns use the form might even seem to evoke several questions about free invention versus imitation. After mentioning the origins of grotesques, Arcimboldo's letter, in fact, next addresses several related issues of the ancient-modern controversy.

ARCIMBOLDO IN THE "QUARREL OF THE ANCIENTS AND THE MODERNS"

Arcimboldo's own intention in presenting his sketches to Hoffmann may be considered to represent what in the sixteenth century would have been called a form of "emulation" rather than a strict or slavish "imitation" of an ancient form of decoration.[45] Arcimboldo uses the argument that the ancients had some "intention" in their decorations as a license for the suggestion of his own new sort of grotesque. Instead of "altars, sacrifices, animals" that he says the ancients (*antiqui*) placed inside their decoration, he says that "if one had [the] intention," one could show some form of manufacture (*lavorerio*). His suggestion seems to indicate that themes of weaving (*tessidura*) could be placed in the interstices in the midst of a grotesque ornament (*dentro a gli spacii*); this sort of decoration can be found in many ancient and also Renaissance examples.[46] While Arcimboldo invokes an ancient custom (*invezzo come gli antichi*) to justify his proposal, his own designs seem to contrast with the ancient examples he gives. His idea may in this sense be regarded as a new or "modern" form of grotesque.

Arcimboldo's choice of silk manufacture also emphasizes the modernity of his innovation. While he says that other forms of manufacture, of wool or linen cloth, could be shown in other rooms in Hoffmann's residence, his own drawings depict steps in the making of silk because "it is

more unknown in Germany." The choice of a new form of manufacture for a new kind of grotesque decoration is appropriate and therefore seems deliberate.

Arcimboldo's emulation of ancient forms to create a new type of design thus takes the question of freedom of invention close to a central issue of the "quarrel of the ancients and the moderns." As Eugenio Garin has suggested, the quarrel was born with the problem of the valuation of the "moderns" versus the "ancients," when the question of imitation was opened.[47] As Arcimboldo seems to realize in his letter, the problem is that if an ancient practice validates the use of a form of art, and if the ancients therefore provide a model for imitation or emulation, by what claim or standard can an artist depict something hitherto unknown in art? From at least Horace on, the question is thus how poetic invention, including the choice of subject, can allow for the creation of something new.[48] Arcimboldo's proposal therefore seems to touch upon an issue that H. R. Jauss has found embedded in the ancient-modern controversy, that of aesthetic invention versus imitation, conceived either as an imitation of nature or of earlier aesthetic standards. Jauss argues that the modern stance tends toward the establishment of creative invention instead of imitation as the basis for artistic creation.[49]

These issues were most clearly articulated in the late seventeenth-century *querelle des anciens et des modernes*, which was carried on in France around Fontenelle and Charles Perrault; the full establishment of creative invention as an aesthetic criterion also had to await the cultural movements of the late eighteenth and early nineteenth centuries associated with "Romanticism," when the notion of the "modern" was redefined.[50] Nevertheless, the group of concerns is an old if not perennial one, which August Buck has described as a "constant phenomenon" in Western culture.[51] The distinction between old and new, between "*antiqui*" and "*moderni*," and the question of the license to invent something unknown to an ancient or established canon that Arcimboldo's letter raises relate to problems of canon formation and the interpretation of history that begin at least in classical antiquity. A main topic of Tacitus's *Dialogue on Oratory* is, for instance, the question of the superiority of the older orators to contemporaries.[52] As E. R. Curtius has indicated, a consciousness of the distinction between old and new writers, and their relative merits, was also an issue for Terence, Cicero, and Quintilian.[53] Ancient discussions of history and of nature formulated a variety of arguments that formed the basis for later debates about decline or progress.[54]

These debates were continued in the post-classical world, when the dimensions of what later became the quarrel of ancients and moderns took on further shape. The sixth-century grammarian Priscian, for example, coined the cliché "quanto iuniores, tanto perspicaciores," providing

a foundation for what might be considered a modern position.[55] The related image of "dwarfs standing on the shoulders of giants," than whom they see farther, can also be traced back to Bernard of Chartres.[56] August Buck has found many other examples of what he calls the "pre-history" of the ancient-modern controversy in other medieval writings.[57]

The growing historical consciousness of the Italian Trecento and Quattrocento made the comparison of ancient and modern accomplishments an even more pressing issue. When Renaissance writers enshrined the ideal of antiquity while at the same time arguing that their own era was one in which the golden age could be thought to have returned, a real problem evolved. Several scholars have pointed out that the issues that were to come into sharp focus in the late seventeenth century were debated from at least the fifteenth.[58] In Arcimboldo's own time, the Cinquecento, literary polemics demonstrate, in the words of Bernard Weinberg, that "the quarrel of the ancients and moderns had not only its origins but also its full development."[59] The themes of the debate had long been applied to the visual arts. Already in the Quattrocento, Alberti had stated that the accomplishments of contemporaries like Brunelleschi made him believe, after preliminary doubts, that his own age equaled the accomplishments and indeed in some ways surpassed those of antiquity. Ugolino Verino established his own "parallel" of ancients and moderns when he compared the painters of his own age to those of antiquity.[60] In Arcimboldo's era, Vasari's description of the history of art in the proems to his *Vite*, his life of Michelangelo, and in several other passages indicates that the theme of the equality or superiority of the moderns to the ancients was a current issue.[61] Thus, long before Perrault's and Fontenelle's formal statements, many ideas present in their arguments had already been adumbrated.

One such issue that is developed in the seventeenth-century quarrel is the creation of a new standard of judgment to replace that of antiquity. Perrault argued most clearly for the principle of *scavoir inventer*, for the power of invention instead of imitation. Perrault based some of his claims that the modern age had surpassed the ancients on the new inventions that were to be found particularly in the fields of science and technology.[62] But this late seventeenth-century argument also had its origins in earlier discussions.[63] In the visual arts, for instance, Cinquecento art theorists had already implied that a premium should be placed on invention.[64] Speaking of other realms of endeavor, Pancirolli, as related by Heinrich Salmuth, had described the new discoveries, the *nova reperta* of the modern age, as things the ancients had not known, but the moderns had discovered. They included gunpowder, printing, engraving, and the compass, largely therefore what might be called technological or scientific innovations.[65] These arguments were continued into the seventeenth century

and eventually were adopted in the French *querelle*. Moreover, they were specifically applied to Rudolf II's Prague. Caspar Dornavius, for instance, mentions one of the emperor's own inventions to prove that his own time was more advanced than previous ages.[66]

Arcimboldo's choice of a process of manufacture, and indeed his specific choice of silk, takes on added significance in this context. For silk manufacture can be regarded not only as an innovation in Bohemia or Germany but also as a "modern" invention. Pancirolli specifically included silk-making among the *nova reperta* or new discoveries.[67] Stradanus similarly depicted silk manufacture and sericulture among the series of *Nova Reperta* he drew datable to the 1550s, which were later engraved by Johannes Galle and Hans Collaert (figs. 67 and 68). Stradanus's drawings are some of the first depictions of the silk industry in Western art, preceding Arcimboldo's. They accompany depictions of the discovery of the New World, the lodestone, gunpowder, printing, clocks, distilled alcohol, stirrups, mills, oil, sugar, oil color, spectacles, copper engravings, and the like.[68] Stradanus was apparently so taken with the subject of silk-making that he completed an entire second series of drawings, likewise later engraved as the series *Sericus Vermis*, that depict processes of silk manufacture.[69]

Arcimboldo would not have had to rely on Stradanus to learn how to depict stages in the process of silk manufacture, since he could have been familiar with sericulture in Lombardy, which was a major center for the production of silk. But in light of Stradanus's designs, and Pancirolli's discussion, Arcimboldo's proposal to Hoffmann may now be regarded as revealing the artist's modern stance. Arcimboldo's proposal for a "modern" type of grotesque decoration has important consequences for the consideration of his own art, and more generally for Rudolfine Prague.

Ancients and Moderns in Prague: Arcimboldo's Audience, Art and Science

In any case, the matter of implementing a plan to introduce silk manufacture raises the question of Arcimboldo's patronage, and thus returns us to the themes evoked by the proem of his letter to Hoffmann. The introduction to this letter presents what may be regarded almost as a topos of Renaissance literature on the nobility of the arts. The argument that painting was to every nobleman's taste, and that it was worthy of every great prince, can be read not only as a kind of compliment but also as a standard defense of the worth of the art itself. This latter theme is found frequently both in the literature of the age, as exemplified by Karel van Mander's remarks on patronage, and in a large number of allegories, including many by Rudolf II's court artists.[70]

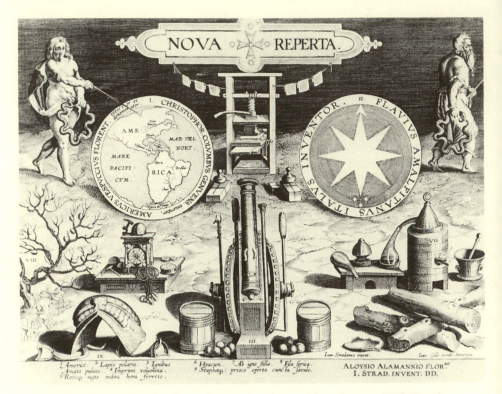

67. Johannes Galle after Johannes Stradanus, *Nova Reperta* (Title Page)

Consideration of Arcimboldo's situation at the Prague court should cause us to hesitate before dismissing his remarks as a mere rhetorical exercise.[71] Although the artist may be flattering Hoffmann, and Van Mander embellished a similar point in reference to Arcimboldo's imperial patron, Rudolf II, the emperor who Arcimboldo says was keeping him thoroughly occupied was, in fact, one of the greatest patrons and collectors in the history of European art.

While Arcimboldo's remarks about Hoffmann's delight in painting may need to be regarded with some skepticism, and the subject merits further investigation, it may be that his statement contains an element of truth. Evans has noted that Hoffmann became well known in literary and artistic circles. A great bibliophile, he amassed a library of over four thousand books on a wide variety of subjects. There is also some other evidence for his involvement with the visual arts and artists at the imperial court. Evans first pointed out that Hoffmann owned two manuscripts that were produced by the imperial *antiquarius* Ottavio Strada.[72] These works may

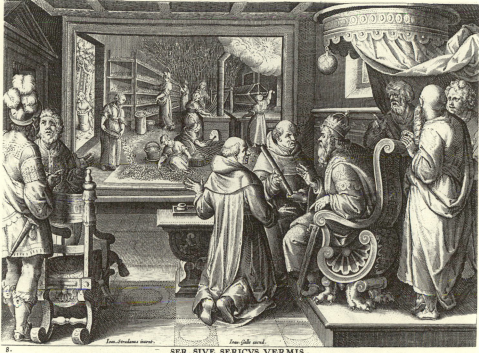

SER, SIVE SERICVS VERMIS.
Iustinianus oua vermis accipit Serinda ab vrbe, fila qui net aurea.

68. Johannes Galle after Johannes Stradanus, *Ser, Sive Sericus Vermis*
(The European Discovery of Sericulture)

now be identified as a collection of *imprese* in a manuscript compendium, versions of which were also owned by many important nobles and rulers in Europe, and a series of designs for vessels and other decorative objects that had been copied from drawings by Giulio Romano and his workshop, which Jacopo Strada had owned and which are still in Prague.[73] Matthias Gundelach designed Hoffmann's bookplate, which was engraved by Lukas Kilian.[74] The imperial engraver Aegidius Sadeler dedicated to Hoffmann a series of prints of the twelve months, which he struck after drawings by the imperial painter Pieter Stevens.[75]

Although there is no evidence that Hoffmann commissioned the Arcimboldo drawings now in Boston, it is not unreasonable to believe that the artist may have learned that the court counselor was planning to have his palace painted, and that he was interested in the visual arts. It was thus most likely Arcimboldo's departure from Prague soon thereafter, rather than Hoffmann's insufficient enthusiasm, that put an end to the project.[76] Hoffmann, in fact, seems to have later demonstrated some interest in the

designs because sometime between 1603 and 1607 he had them bound in a book from his library that contains architectural and perspective treatises along with engravings for grotesques. The book includes among other pamphlets works by Hans Vredeman de Vries: these are not unusual in themselves, as De Vries's grotesque designs were standard visual source material, but further testimony for Hoffmann's interest in grotesques, and for a taste he shared with Rudolf II, who employed both Hans Vredeman de Vries and his son Paul in the imperial palace.[77] The green binding of the book now containing Arcimboldo's drawings may even suggest an aspect of Hoffmann's personality that might have led him to appreciate Arcimboldo's art. The green binding makes a pun upon Hoffmann's name, Grünpichl = *Grünbüchl* or *Grünbüchlein* = green booklet in South German or Austrian dialect. Hoffmann's preference for this kind of display of wit may provide another reason for believing that he might have been expected to respond to the artist's proposal for a decoration in a witty form, that of grotesques.

Hence the issue of Hoffmann's potential patronage and interest also leads to a consideration of the wider implications of Arcimboldo's drawings for the art and culture of Rudolfine Prague. At first it might seem that several aspects of the drawings as here described might be related to what has been called "Prague mannerism." Their play of wit, and even Hoffmann's punning, may be related to a supposedly conceptist stance.[78] The belief in the equality or superiority of the moderns, and the notion of progress calling for ever new inventions that it may imply, has been linked to attitudes of the "mannerist" age of Vasari and his followers, when new "demonstrations" (*dimostrazioni*) of traditional subjects were demanded.[79] Arcimboldo's own particular "modern" emphasis on inventions of new forms of grotesques, which are not imitations of classical prototypes, might also be compared to the attitude of other artists who worked, as Van Mander put it, from their imagination (*uyt den geest*). His free inventions might even be compared to the work of Bartholomäus Spranger, a fellow artist at the court of Rudolf II, who, it may be remembered, similarly is said to have eschewed close imitation of earlier art when he returned north from Rome with his bags empty of studies.[80]

But while these may be pertinent connections, "mannerism" does not cover all the important aspects of Arcimboldo's drawings nor their importance for Prague. The conceptist associations of Arcimboldo's art can perhaps better be related to seventeenth-century texts such as those of Emanuele Tesauro or Baltasar Gracián. The modern position in the controversy of ancients and moderns in the seventeenth century is associated at that time not, of course, with "mannerism" but with artistic forms of French classicism.[81] A formal comparison with Spranger's figure drawings reveals that Arcimboldo's Boston sheets cannot be seen as "man-

nered" in appearance. Allowing for their character as sketches, they do not seem to possess any of those qualities of refined or elegant execution that are found in some of the artist's other preparatory designs.

It would rather seem that the forms of Arcimboldo's Boston drawings can be related to their didactic function and their subject. Their unembellished style of representation suits their function of representing workers involved in the manufacture of silk. They thus seem to follow those principles in decorum that seem to have existed in Rudolfine Prague—here even in the realm of grotesque decoration.[82] The self-conscious modernity of Arcimboldo's drawings consists neither in the demonstration (*dimostrazione*) of a new solution to a traditional subject nor in an ornamented style of execution—what might be thought to correspond to the element of rhetorical elocution—but rather in their choice or invention of new subject matter.[83]

The conceptualization of modernity in Prague court art can more broadly be related to the notion of emulation of the ancients that affected many arts. As we have seen in the Excursus to Chapter 4, Arcimboldo uses Propertius as a source, but plays him off rather than following him faithfully. Not only does Arcimboldo's portrait of Rudolf II as Vertumnus take the form of a painting, it is a head composed of the elements mentioned in Propertius's poem and therefore a modern invention that could not have been known to the ancients. Moreover, by recomposing elements from nature that are also mentioned in Propertius, Arcimboldo creates a new form of grotesque or *grillus*, of the sort discussed in the present chapter. The artist also portrays a "modern," that is, the Holy Roman Emperor. Propertius's poetic images have in effect been recreated to form a new sort of portrait.

This "modern" accomplishment was also noted by Arcimboldo's commentators. Comanini himself stressed the superiority of Arcimboldo's painting of Vertumnus to the works of ancient painters. Comanini contrasted Arcimboldo to Zeuxis and Parrhasius: "Col suo pennel, ch'avanza/ Pur quel di Zeusi, o quello/ Di chi gli fe' l'inganno/ Del sottil vel dipinto/ Nel certame di gloria?" (With his brush, that surpasses that of Zeuxis, or that of the master who made the trick of the subtle painted veil in the contest for glory [Parrhasius]).[84]

The notion of artistic progress that this idea implied was also extended to more recent artists and genres, including nature studies. Joseph Heintz, for example, was called an architect to be compared with the ancients ("architectus cum antiquis comparandus"). In a passage that appeared in his work *Felicitas Seculi* shortly before that in which Dornavius refers to Rudolf II's invention, Dürer is taken as an example of the equality or superiority of the moderns in comparison with the ancients.[85] It has been noted that Hoefnagel's nature studies, studied in previous chapters, may

also suggest a rivalry with descriptions of ancient works of art, and the association of Dürer with the ancient-modern controversy reinforces this suggestion.[86] It moreover seems to indicate that Hoefnagel carries on a rivalry with modern figures as well: his versions of Dürer seem to represent an effort at continuing progress in the depiction of nature, even in the "modern" age.

The importance of the "modern" manufacturing subject in Arcimboldo's drawings takes us ultimately not merely to "mannerism" but to another side of Rudolfine culture—its interest in the world of nature and thus to what can be called scientific, and mechanical, matters. As discussed in Chapter 5, Rudolf II's Prague provided patronage for artists as well as for several major figures involved in the development of "modern" science and technology. The court's involvement in these matters extended from interest in natural history to imperial support of the court *astrologi* Tycho Brahe and Johannes Kepler. Kepler devised his laws of planetary motion while in Rudolf II's service and, of course, named the compilations that he had in part derived from Brahe's work the "Rudolfine Tables." The court also patronized technological inventions, calling into its service many clock and instrument makers. Erasmus Habermel, Christof Margraf, Bürgi, Emmoser, and many others all worked for the emperor.[87]

Both Arcimboldo and Hoffmann can be connected with these developments; they indeed shared common interests in certain mechanical pursuits. Arcimboldo's drawings of sericulture, particularly his depiction of a silkworm and cocoon (fig. 60), much like his paintings composed of various animals, birds, and fishes, are, as suggested in Chapter 4, comparable to the contemporary interest in nature studies at the Prague court, as evinced by the work of Hoefnagel, in whose oeuvre a similar display of wit is also found. Arcimboldo's desire to exploit his knowledge of nature for a practical end might even be compared to the work of makers of automata and other instruments. He also invented a variety of devices, including chromatic musical instruments, ciphers, and a means for crossing rivers.[88]

Hoffmann was also deeply involved in the experimental, scientific side of Rudolfine culture. He collected works on the occult and natural sciences, which may have been useful to Tycho Brahe when he resided in Prague.[89] He had made a brass quadrant after a design in Tycho's *Mechanica*, which the two men used to observe a solar eclipse in 1600.[90] Hoffmann also provided pumps both for Brahe and Kepler.[91] This was a sign of his interest in the work on pumps and water machines that Kepler conducted in Prague, with the aid of Bürgi.[92]

Hoffmann, in fact, played a key role in the patronage of Kepler in Prague. He tried to attract him there, in part by mentioning that there

were instrument makers who could provide him with suitable equipment: later Kepler indeed says that he employed a sextant and a small quadrant that were put at his disposal through Hoffmann's generosity (*liberalitate*).[93] Hoffmann paid for Kepler's transport to Prague, offering him accommodations when he arrived in the city in 1600 and helping to obtain a position for him. He also acted as an intercessor between Kepler and Brahe, trying to smooth over differences between the two when the Dane held a well-paid position as imperial *mathematicus*.[94]

In the treatise *De Stella Nova*, which Kepler in turn dedicated to Hoffmann, the astronomer may even suggest a way in which an interest in the arts may have run parallel to one in the sciences in Rudolfine Prague. In the very passage in which he praises the *automatopoeus* (instrument-maker) Bürgi, the creator of horological mechanisims, Kepler makes a reference to the visual arts. Perhaps trying to establish a telling comparison for Hoffmann, Kepler compares Bürgi's growing fame in his pursuits as no less than that of Dürer in painting, an artist who was not only an exemplar of modernity but one of Rudolf's favorite masters and also, as seen in part in Chapter 3, a paragon for the court artists.[95] In this way, Kepler may have related what he regarded as parallel developments, and perhaps also interests.

It may be noted in conclusion that just as Rudolfine Prague provided a home for Kepler, who discovered his laws of planetary motion there, so it did for artists who contributed to the early development of several modern genres. We recall that some of the first independent still-life paintings, animal paintings, and informal cityscape drawings were all done in Prague, where a new "naturalistic" attitude was also expressed in other landscape and "genre" compositions.[96] Although, as discussed in Chapter 4, Arcimboldo has been connected with various aspects of what the twentieth century has called "modern" art, including surrealism, Arcimboldo's Boston drawings reveal a different and more historically appropriate idea of his self-conscious modernity. They resemble the attitude of Brahe and Kepler; Kepler called the publication of his discoveries utilizing Brahe's observations the new astronomy (*Astronomia Nova*). The modern stance that they presuppose in the culture and patronage of the imperial court suggests a way in which an openness to new inventions in Rudolfine Prague may have created an environment favorable not only to innovations in the visual arts and to mechanical inventions but perhaps also to some of the more important scientific discoveries that can be associated with the advent of our own "modern" age.

7

From Mastery of the World to Mastery of Nature

THE *KUNSTKAMMER*, POLITICS, AND SCIENCE

I<small>N HIS ESSAY</small> on Galileo as a critic of the arts, Erwin Panofsky brought to light a passage in which the Italian scientist delivered a critique of what Panofsky identified with the "*Kunst-und Wunderkammern* so typical of the Mannerist age."[1] Commenting on Tasso's poetry, Galileo compared Ariosto's *Orlando Furioso* with Tasso's *Gerusalemme Liberata*. Galileo contrasted "a regal gallery adorned with a hundred classical statues with countless complete historical pictures by the most excellent masters and full of everything that is admirable and perfect" with the sort of collection contained in "the study of some little man with a taste for curios who has been pleased to fit it out with things that have something strange about them because of age or rarity or for some other reason, but are, as a matter of fact, nothing but bric-a-brac."[2] Galileo's richly suggestive remarks are open to numerous interpretations, in addition to Panofsky's own; they thus provide an excellent introduction to a reconsideration of the *Kunstkammer*.

Galileo's comments, as Panofsky interpreted them, may indeed be related to Julius von Schlosser's classic account of the *Kunst-und Wunderkammer der Spätrenaissance*. In Panofsky's opinion, Galileo's words revealed his "aesthetic attitude," which he described as a "classicistic prejudice in favor of simplicity, order, and *séparation des genres*, and against complexity, imbalance, and all kinds of conflation." Panofsky contrasted this attitude with that of Kepler and Kepler's world, suggesting that it helped account for differences between the two astronomers' ideas about planetary motion. This interpretation does not seem far from Schlosser's contrast of northern and southern mentalities revealed in the *Kunstkammer* in comparison with Italian collections.[3] In the spirit, but not the words,

of Galileo's comparison, Schlosser differentiated between princely col-
lecting and the *Kunstkammer* north of the alps, with its adventurous and
unsystematic qualities, and the artistic and monumental collections of
Italy.[4]

Since Schlosser's initial publication at the beginning of the twentieth
century, and especially through scholarly research during the decades
since Panofsky's publication of the mid-1950s, much has been learned
that has led to an adjustment of this picture of the history of collecting.
While dramatic distinctions between northern and southern ways of see-
ing may remain current in some esteemed art-historical literature,[5] many
scholars have emphasized that the *Kunstkammer* was in general similar
both in content and organization, if not in all details of display, to other
universal collections of the late sixteenth and early seventeenth centuries,
like those found in Italy.[6] Other contemporary documents make clear
that the German collections were not only looking to Italy for models as
well as particular objects, but suggest that the distinction made by Galileo
between a sculpture or picture gallery and a collection of apparently more
curious or scurrilous objects did not hold for those who actually at-
tempted to establish collections in the sixteenth and early seventeenth
centuries.[7]

Yet with all the information that continues to be learned about Euro-
pean collections of the sixteenth and seventeenth centuries, significant
disagreements persist about the nature of the *Kunstkammer*.[8] Many pur-
poses, functions, and satisfactions have been associated with the *Kunst-
kammer*: As has been argued since Schlosser, it may have served as a place
of refuge or delight, of entertainment, pastime, or even a kind of *omnium
gatherum* for everything found "curious."[9] A debate has, however, con-
tinued about the interpretation of the "social" or "political" aspects of
collections, as suggested by Galileo's contrast between a "regal" gallery
and a "curiosity cabinet" owned by a little man (*ometto* is his word). An-
other continuing controversy, also intimated by Panofsky's reading of
Galileo, involves the relation of collections, and especially the *Kunstkam-
mer*, to the developments associated with the "new science" promoted by
Galileo and Kepler. As Galileo's remarks imply, and the present chapter
will argue, these issues are interrelated.

We may take the thesis of Gerard l'E. Turner as representative of one
side in this debate. Turner says that "the private collection, or cabinet,
whatever its content, served a three-fold purpose: self-advertisement,
economic advancement and utility, and intellectual satisfaction."[10] In par-
ticular, the importance of collections as a form of political expression has
been emphasized; similarly there has been further discussion of the rela-
tionship of the *Kunstkammer* to the development of the "new science" and
technology of the sixteenth and seventeenth centuries.[11]

On the other side, Antoine Schnapper has argued most strongly against the view that "cultural politics" applies to collections. Schnapper criticizes what he calls the "systematic and uncritical application" of the notion that "every act of a prince, in the arts as in other fields is given what is essentially a rather simple political interpretation: its purpose is to demonstrate the power of the prince in the eyes of his subjects, of foreigners, and of posterity."[12]

For another aspect of his counterthesis, Schnapper has relied on the work of Krzysztof Pomian, who in a series of well-received essays has most completely articulated an alternative argument about the relation of the *Kunstkammer* to questions of utility and the "new science." Pomian argues that the culture represented by collections like the *Kunstkammer* is that of "curiosity"; he designates this as a stage prior to and independent of that of modern science. Pomian believes that objects in collections were "temporarily or permanently removed from economic circulation": thus part of what marks an object as curious would seem to be precisely that it is not useful. Accordingly the collection of the *curieux* may with some logic be called a "curiosity cabinet," comparable to those of more recent origin evoked by other critics.[13]

In entering this debate, this chapter will return the focus to the Central European *Kunstkammer* of the late sixteenth and early seventeenth centuries, and away from the idiosyncratic, or later French, Venetian, and British collections studied or invoked by Schnapper, Pomian, and others.[14] The Central European *Kunstkammer* has, after all, served as a paradigm since at least Schlosser. And of these collections, the imperial *Kunstkammer* of Rudolf II was the most important in quality as well as quantity of objects. Perhaps in part because of the revival of interest in Rudolfine Prague, the imperial *Kunstkammer* has continued to provide a focus for debate, and it is a recurring point of reference here.[15]

MASTERY OF THE WORLD? THE *KUNSTKAMMER* AND CULTURAL POLITICS

Recent discussions of the Central European *Kunstkammer* have raised both general and specific questions about their symbolic role in politics as a form of "representation." During the past two decades historians have stressed the importance of considering the function of various court activities in support of the ideology and system of rule.[16] They have applied some of the insights gained from anthropology and sociology to the German and Habsburg courts of the sixteenth, seventeenth, and eighteenth centuries.[17] They have suggested how the court was a *Theatrum der Selbstdarstellung* (theater of self-presentation), most concretely embodied architectonically in the ruler's residence, but also in patronage and collec-

tions. Several scholars have also argued independently for a similar view of the *Kunstkammer*.[18]

This view has been contested: Schnapper has gone farthest in offering a general critique of what he calls the cultural political interpretation of collecting, as well as an analysis of the organization, function, and symbolism of the imperial collection. While Schnapper accepts the idea that patronage might at times have a political content, he questions this notion in regard to collecting, and thus has sought to establish an "essential" distinction between the roles of patron and collector. He argues that it is a "largely erroneous idea" that a picture collection may be an important means of propaganda, as distinguished from its possible use as furnishing or decoration.[19]

While much hinges on what might be meant as propaganda, this generalization seems to rely on a number of false distinctions. It occludes the way in which the very act of collecting may itself be viewed as a form of conspicuous consumption no less so than patronage; both depend upon leisure and sufficient means. It ignores those instances, known from several European courts, where the formation of a collection might involve a programmatic or systematic accumulation of objects.[20] And it overlooks a fundamental role for which artists were employed at court, namely, to provide works for a prince's collection.[21]

Clearly, many of the activities implicated in court collecting and those involved in patronage are not so easily differentiated. Copies were often commissioned by collectors when originals could not be obtained. Rudolf II is known to have ordered the imperial ambassador in Spain, Count Khevenhüller, to procure a copy of Correggio's *Ganymede* if the original were not attainable.[22] Both the emperor and the Munich dukes also had copies made of works by Dürer and other old German masters when they could not obtain the originals.[23] Kaltemarckt mentions how Marcus Laurinus sent Hubert Goltzius to collect old coins or to make copies. He even proposed having molds made of ancient and modern sculpture to enrich the collections in Dresden.[24] The procedure for acquiring copies may account for the frequent record of their presence in collections, as acknowledged by inventories.[25] In some instances the patronage of objects for collections applies no less to *naturalia* than to *artificialia*, as for instance in Kassel, where the Hessian landgrave would order rare plants for his gardens.[26]

Moreover, no specific new evidence from the region and era has been presented to challenge the general thesis that collecting as well as patronage at the Central European courts expressed princely prestige.[27] On the contrary, information continues to accumulate to suggest that German collections were conceived, at least in part, to an end that is in keeping with the ethic of magnificence, as it was formulated in Renaissance Italy.

Kaltemarckt's proposal emphasizes the undying fame gained by earlier and contemporary monarchs through the collecting of works of art.[28] The founding document of the Munich *Schatzkammer* also states that it was meant to express the grandeur of the Wittelsbachs, and other aspects of their collecting also demonstrate this interest.[29] Rudolf II's effort to retain the collection of his uncle, Archduke Ferdinand II (of the Tyrol), manifests his intention to uphold the honor of the house of Habsburg.[30] A letter of his successor, Matthias, justifying the establishment of a central *Kunstkammer* and *Schatzkammer* speaks similarly of fulfilling the intentions of his deceased brother, and of furthering the fame and glory of the House of Austria.[31] Even the establishment and maintenance of botanical collections in Hesse have been regarded at least in part as an expression of the prestige of a princely demesne.[32] The issue of representational prestige may also be related to the way in which collections were demonstrably enmeshed in a web of gift giving and receiving, which had many diplomatic aspects.[33]

What remains more open for discussion is how the princely collection could have represented a ruler's majesty, in addition to whatever other ways it might have functioned. It is irrefutable that the ostentatious display of precious objects was a practice initiated at the Burgundian and Berry courts and continued by the Habsburgs through the eighteenth century, and emulated by other courts.[34] Thus an analogous use of precious objects from a collection may be observed in the court banquet.[35] Ostentatious displays of works of art also provided a backdrop for other formal court events in Prague as elsewhere.[36]

But a banquet was a public event, at which ostentation in the form of displaying expensive items and demonstrative consumption in its real sense were made manifest. In contrast with this sort of outward show, many of the *Kunstkammers* were private, often contained in secluded spaces. While some of the court collections may have been occasionally open to visitors, and a few commoners even managed to see extremely private collections like that of Rudolf II, the princely *Kunstkammers*, and especially that of the emperor, were certainly not glimpsed by a large number of eyes. Doubts have therefore been expressed about the way princely collections, and particularly that of the emperor, may have functioned as external forms of representation, in contrast with more accessible and comprehensible means of propaganda.[37]

This question of accessibility needs to be reformulated. The public for these sorts of collections was not the same as that of modern bourgeois society, which has been created through a structural transformation.[38] Those who could not have seen a princely collection might nevertheless have been impressed by rumors of its splendor, if not the actual sight itself. The fame of Rudolf's collections became legendary even for those who could not visit them; as comments such as those of the Netherlan-

dish historian and artist Karel van Mander demonstrate, their reputation quickly spread throughout Europe.[39] For example, in dedicating their corpus of inscriptions to Rudolf II, Jean Gruter and Joseph Scaliger indicate that they had a good idea of the emperor's patronage and collecting, speaking of it as a private activity with a public dimension.[40] Rumors about the treasures in the Prague Hradčany were indeed so compelling that Swedish armies were led to sack the collections in 1648.[41]

Because official visitors had to be of sufficiently high rank, the evidence is understandably limited for those awarded the privilege of being shown that apparently most exclusive of all collections, that of the emperor. It is nevertheless undeniable that high-ranking princes were taken to see the imperial *Kunstkammer* on what can be called state visits, even if no formal protocol was involved in this particular demonstration of favor.[42] The custom of showing the imperial collections as part of a ruler's visit was already established during the reign of Rudolf II's father, Maximilian II, as evinced the treatment afforded the king of France in 1574.[43] Although the circumstances of seclusion may have been more restrictive during Rudolf's reign, at least four such instances have thus far been discovered for his period, and further research may uncover more.[44] On occasion ambassadors were also shown the collections as a sign of favor.[45]

The remarks of one visitor who describes the conditions on which ambassadorial visits occurred shed light on the controversy over the regularity of such events. Noting that he was to be taken to the gallery and the space where the emperor's pictures were found, the Savoyard ambassador Carlo Francesco Manfredi di Luserna says this was "cosa che sogliono li ambasciatori ricercare quando pensano partirsi da questa corte" (something that ambassadors are supposed to seek out when they are thinking of parting from this court). If the word *sogliono* is descriptive, it means that this practice was an established custom; if normative, it certainly indicates the possibility of such visits on set occasions.[46]

Luserna also called the *quadri di pitture* (pictures) he saw "veramente cosa rarissima, avendo Sua Maesta cumulato in quel luogo quanto era di bello in molte provincie, credo perche sentii far strepito come di chi aprisse piano una porta" (something truly most rare, His Majesty having accumulated in this place as much as there was of what was beautiful in many provinces, I believe because he thought to make a loud noise like someone who opens a door slowly); he spoke similarly of the objects in the *Kunstkammer* proper that he saw on another occasion.[47] The comparison Luserna makes between seeing the collection and hearing the noise produced by a loudly opened door indicates that we should be wary of underinterpreting the kind of impression the collections were intended to make, of accepting any argument to the effect that the Rudolfine collections revealed an "absence of an attempt to astound with hoards of treasure," or dismissing as "banal" the telling remarks of another dignitary

that the imperial collection was a "tesoro degno di chi il possede" (a treasure worthy of its owner).[48] It seems, on the contrary, that an extraordinary collection did make the kind of grand impression an important ruler might have expected.

Another problem is to determine if, and how much, the display of princely collections enhanced or communicated a general impression of splendor, or any more specific message beyond that of some sort of accumulation of "treasure." At least some aspects of princely collections received a suitably stately display. The Antiquarium in Munich, the largest room north of the Alps designed for a secular purpose, was but one of several specially designed and splendidly decorated spaces made for collections of sculpture or antiquities, which in this regard resembled similar rooms in Italy. Other examples could be found in the Dresden Lusthaus or the Neu Saal of the Prague castle.[49] Despite doubts about the relation of inventories or descriptions to the order in which collections were found, recent studies have also offered careful reconstructions of the way in which the objects in the *Kunstkammers* in Munich, Prague, and Ambras (along with its other collections) were set out.[50]

It is more difficult to ascertain what, if any, specific kind of impression these collections might have made, and if this impression is to be related solely to their presentation. While some collections, or parts thereof, might have been exhibited in an august setting, it has been noted that many items in Rudolf's *Kunstkammer* might actually have been kept in a kind of storage facility.[51] It has also been suggested that the organizational categories of his or other collections may be strange or alien to us, as are their principles of display.[52] Scholars have therefore been led to emphasize other, more easily legible functions of the collection, and to argue that in order for a collection to have had a representational character, more overt demonstrations of political power should have been present.[53]

Here the symbolic dimension of collecting must be more broadly understood. Regardless of their accessibility, display, and organization, symbolic content must be taken into account, since princely collections, no matter how large they were, possessed but a sampling of all the objects to be found in the world. Even the largest or best collection, that of the emperor, could not manage to acquire all the works of art he desired.[54] The typical *Kunstkammer* contained not the common creatures found in nature—dogs, cows, or the like—but extraordinary specimens, "curiosities." The principle of choice involved has been explained as a way of representing what was most characteristic of nature.[55] If some order was present in the *Kunstkammer* (and all the evidence accumulated since Schlosser regarding the theory of collecting, their inventories, display, and systematic acquisition of objects suggests there was an order), then the necessary element of selection involved in the constitution of the

Kunstkammer must have presupposed some more general principle of organization, which may be considered to have been of a symbolic nature.

Even those scholars who have been skeptical about other aspects of the interpretation of the *Kunstkammer* have not seriously doubted the notion that in containing specimens of a variety of objects in the world, the princely *Kunstkammer* was encyclopedic in scope. Whatever other specific principles were involved, it has long been recognized that the *Kunstkammer*, like other collections of its era, may be regarded as a kind of microcosm of the world.[56] Already at the time of the origins of courtly *Kunstkammers*, Samuel Quiccheberg, a contemporary writer who was involved with the Munich collections, called the Munich *Kunstkammer* a *theatrum sapientiae*. He later applied Giulio Camillo's notion of the memory theater to the *Kunstkammer* in his treatise on collecting. The notion that a *Kunstkammer* is a memory theater has not only been more widely accepted in interpretations of German collections, but Camillo's specific treatment of the theme has also been demonstrated to apply to the organization of the *studioli* of Italian princes.[57] The *Kunstkammer* and the *studiolo* have thus been viewed by many scholars as a kind of memory theater in which all that could be thought or seen in the world was contained.[58]

It is, of course, open to speculation as to how far a ruler, or anyone else who owned or visited a *Kunstkammer*, may have taken this notion. As I once suggested, it may be that a ruler like Rudolf II believed that in his *Kunstkammer* he could grasp and control the world as if in a version of Camillo's magical memory theater[59]: more evidence, to be discussed below, supports this reading. While it is more probable that this idea would have been held by rulers of Rudolf's disposition who had interests in occultist beliefs, in any event it is also likely that there would have been general assent to a number of more widely held assumptions about the collection as a microcosm of the greater world, the notion that is basic to a view of the collection as a theater of the world. One conception is the analogy by which the collection may resemble the world as a whole. Another related conception, to be discussed further below, is that knowledge grants power by offering a key to understanding the world. A third organizing conception is that of hierarchy, by which the world of nature no less than that of the world of states is organized into a coherent system.[60]

It is therefore also likely that the conceptualization of the *Kunstkammer* as a theater or microcosm of the greater world implied something more about a collection when it belonged to a prince as opposed to a private citizen. The decoration of several princely collections reveals not only that they possessed cosmic themes but also suggests that they further advanced political claims associated with these themes.[61] Recent investigations of the *studiolo* of Francesco I in Florence and its painted decoration

have confirmed that some principle of universal control was suggested in the cosmic themes of that collection[62]; similar associations are also evident in what is known of the decoration of the spaces in which several German collections were housed.

Views of Bavarian towns added to the decoration of the Munich Antiquarium after the construction of the room itself may have served to associate the greatness of the past, as represented by the ancient works of art in the collection, with the holdings of the present Wittelsbach dynasty. In turn the virtues depicted on the ceiling of this room may be linked with the supposed qualities of the Bavarian rulers.[63]

The decoration of the Dresden Lusthaus further elaborated this combination of motifs. The lower hall of this structure contained busts of Saxon dukes, while its walls had oil paintings depicting their outstanding deeds (*praeclaras res gestas*). The ceiling of the room upstairs portrayed the four elements, day and night, and the twelve signs of the zodiac, while a frieze immediately below represented Trojan *historiae*. Together with the ten personifications of virtue, five statues each of emperors and of the Saxon electors of the Dresden line who were contemporaries of these emperors stood in this room, all of them adorned with the arms of a Saxon province and an emblem.[64]

A similar cosmic symbolism introduced a visitor to the *Kunstkammer* in Prague: it is now clear that the room connecting the emperor's dwelling to the *Kunstkammer* was adorned with paintings of the parts of the year, the twelve months, and the elements, in whose midst stood Jupiter. The encyclopedic nature of the *Kunstkammer* also seems to have been emphasized by a fresco in the midst of the suite of rooms housing the collection: this work by Bartholomäus Spranger depicted Hermes and Athena, who may be associated with the Hermathenic ideal of the encyclopedia of the arts.[65]

In their use of an analogous hierarchical symbolism that draws upon parallels between the world of nature and that of the state, Arcimboldo's imperial allegories, discussed above, seem to provide a clue to understanding the encyclopedic, or cosmic symbolism of the *Kunstkammer* and its decoration.[66] Although often subsequently called scurrilous, they were, in fact, read as representing a ruler's symbolic mastery of the world.[67] I still believe that this idea of *representatio* was one of the messages of the *Kunstkammer*, and especially that of the emperor.

Critics who would deny a political meaning to works made for the emperor and to the collections insist instead on "an emphasis on impressive (and hence explicit) emblems of power,"[68] but this seems to misunderstand much of the art produced for Rudolf II and for many other German rulers. Scholarship in the twentieth century has become aware that much of what Panofsky and others used to call the "Mannerist age" was

deliberately elusive, subtle, and mysterious. Often art did not aim to communicate with a larger public, but intentionally veiled meaning. In a culture that cultivated the epigram, the conceit, and the learned allegory, a message was often not meant for the masses. As suggested in previous chapters, a work might have an inner or esoteric meaning that its outer appearance did not at first display.

The deliberate exclusiveness, esotericism, and secrecy that are associated with the apparent inaccessibility of collections, of which Rudolf II's is only one of several examples,[69] can therefore be related to the qualities of this culture. These are indeed the same characteristics of the political allegories, small in scale and esoteric in content, that were produced for the Habsburgs and many other contemporary German courts.[70] In this world the secrets of nature, the *arcana naturae*, held in the *Kunstkammer* were no less forbidden to the masses than were the *arcana imperii*, the political mysteries that the *Kunstkammer* probably expressed; as we have seen in Chapter 4, related works such as Arcimboldo's paintings definitely presented a similar veiled message (and, in fact, Galileo criticized Arcimboldo's works along with the *Kunstkammer*).[71] The world of the *Kunstkammer* is not the world of the public museum, familiar to modern critics, but one in which the collection might almost be considered the reserve of the initiated.[72] The elite who gained access to the imperial collection might grasp its message; and this message might even have been ultimately intended for that most perfect initiate, the ruler himself.[73]

In addition to the size, quality, and range of objects collected, as well as its deliberate esotericism, the character of the princely *Kunstkammer* thus distinguishes it from the collections of private citizens. In the empire the princely *Kunstkammer* had priority as far as foundation dates are concerned. In the *Standesstaat* that existed in Central Europe, a society was created in which thinking about order was related to one's own estate, one's place in the social and political order.[74] To answer the objection that in having seemingly encyclopedic collections "all these lawyers, doctors, and apothecaries also sought to dominate the world," it can be stated that it is highly unlikely that the symbolic meanings that might be seen in princely collections could be extended to those of members of the lower estates.[75] Yet a further consideration of this question leads to a recognition that the symbolic significance attached to the *Kunstkammer* also changed with time and place.

The diffusion of knowledge as power in the form of the symbolic construction of the *Kunstkammer* as the theater of the world, which proliferated with the spread of collections, may in effect be related to an eventual epistemological transformation. The spread of encyclopedic collections not only accompanied other changes in thinking about the world but may even have contributed along with them to the undermining of the *Kunst-*

kammer as a useful vehicle for symbolic expression. Just at the same time, and in the same milieus where *Kunstkammers* were formed and grew, other ideas were generated that involved a different conception of the "mastery of the world," with political as well as epistemological implications. A refashioning of the notion of knowledge and of power ultimately did lead to a transformation in the understanding of the *Kunstkammer* from microcosmic memory theater to mere curiosity cabinet.

A Transformation of Utility: From Mastery of the World to Mastery of Nature

Comments by another thinker identified with the "new science" help further to relate the *Kunstkammer* to other intellectual developments of the late sixteenth and early seventeenth centuries. In a passage in the *Gesta Grayorum* of 1594, Francis Bacon recommends establishing a library, a garden, a stable for rare beasts, and a cage for rare birds, and lakes for salt- and fresh-water fish. In addition, he proposes a "goodly huge cabinet, wherein whatsoever the hand of man by exquisite art or engine has made rare in stuff, form or motion, whatsoever singularity chance, and the shuffle of things hath produced; whatsoever nature has wrought in things that want life and may be kept; shall be sorted and included." As a fourth component he suggests a still-house with instruments and vessels "as may be a palace fit for a philosopher's stone."[76]

Bacon's proposal has been employed previously to situate the "museum (or "cabinet")" within "contemporary endeavors" of the late sixteenth century.[77] While Bacon's plan has been associated with the "essential apparatus of the learned gentleman," its proper context had already been established as that of a program for a prince.[78] Bacon's proposal has also been brought into an account of the Prague *Kunstkammer* as a study collection.[79] Nevertheless, the full import of Bacon's words in relation to the *Kunstkammer* has yet to be recognized.

The circumstances in which Bacon's proposal for collections was presented should be emphasized: here Bacon is presenting one of several such counsels at a court masque. The English court masque, like similar entertainments at other courts, including imperial tournaments, was a way of celebrating the ruler's majesty. In this regard it functioned in part similarly to political allegories in the visual arts, among other uses of the arts.[80] The very next counsel offered at the masque, "advising Eternizement and Fame, by buildings and Foundations," suggests another use of the arts to assure the prince's glory.[81] It would seem that the supposedly scientific and the more directly representational or political aspects of Bacon's program are closely connected, as they indeed were in practice.[82]

Much of Bacon's plan for the "new instauration" of learning, and what we would call science, is associated with a ruler. In England, as else-

where, it was the prince who had the authority and the means to effectu-
ate such a plan. Bacon's ideal for the role of science in society accordingly
envisages not a private occupation but an all-encompassing program for
a new sort of polity to be put into effect by a ruler. The attraction of this
program for the prince is that the knowledge he would thereby gain
would increase his power over the world.

Bacon's idea in his proposal of how, as he says, the "Conquest of the
Works of Nature" was to be achieved is noteworthy. The garden, stables,
and other collections he proposes are to enable the collector to "have in
small compass a model of the universal nature made private." This pas-
sage gives further credence to a reading of the *Kunstkammer* as microcosm
of the world, a "universal museum," whether or not details of execution
in the display of actual *Kunstkammers* were always consistent with this
view. Moreover, this idea of a universal collection may be related to a
conception of the world theater that is far from one of "passive display or
contemplation."[83]

It has not hitherto been noticed that Bacon's proposal may be related to
a specifically Hermetic, magical view of collecting. In this regard, his
proposal for collecting would lend support to arguments that have related
Bacon to the Hermetic tradition.[84] It would also strengthen the thesis that
the princely collection might have connotations of a magical memory
theater. The concluding lines of Bacon's proposal—"when all other Mir-
acles and Wonders shall cease, by reason that you shall have discovered
their natural Causes, your self shall be left the only Miracle and Wonder
of the World"—have not been cited in full, leaving out a key passage that
the printing of the text itself emphasizes. This passage begins: "Thus
when your Excellency shall have added depth to Knowledge to the
fineness of Spirits, and greatness of your Power, then indeed shall you
lay a **Trismegistus** [*sic*—Bacon's emphasis]." In other words, by carry-
ing through the project of studying natural philosophy, as facilitated by
the establishment of collections, the ruler will become a new Hermes
Trismegistos.

As in Bacon's other reformulations of Hermetic projects, his proposal
for collections may therefore be construed as having a direct, practical
function that carries on the procedures of "natural magic" in a new way.[85]
The inclusion of mills, instruments, furnaces, and vessels in the fourth
part of his proposal, which are to be included in a "Palace fit for a Philos-
opher's Stone," may be related to the activities of the true Hermetic sci-
ence, alchemy. They also indicate that the collections and institutions as-
sociated with them are directed more generally to a utilitarian purpose.

As a proposal with a specific utilitarian end, this plan explicitly does
not belong to the "culture of curiosity." After all, even exoterically the
aim of the search for the Philosopher's Stone was ultimately to enable the
production of gold. It therefore seems inappropriate to deem the type of

collection envisaged by Bacon a "curiosity cabinet." It would seem best to reconsider, and perhaps restrict, the use of this term. It should be emphasized that even for those sixteenth- century writers who responded to the "wonders of nature," this response is not necessarily to be deemed one of curiosity.

In antiquity the Greek conception of πολυπράγμον, the equivalent of *curiosus*, connoted a busybody, as, for example in Plutarch; in Latin the idea of *curiositas* often connoted love of useless or dangerous knowledge. This connotation is evident in *The Golden Ass* of Apuleius, where it is also associated with the occult.[86] This association persisted among contemporary English antiquarians (to whose thought Bacon's may be related), who sought to avoid the charge of being merely "curious."[87] Similarly *curiositas* had been regarded as a vice during the Middle Ages, and this association also persisted in later times.[88]

From a moderate Erasmian point of view, as exemplified also by such writers as Ronsard, there were marvels of nature that stopped the course of reasoning, being inexplicable, to be known only to their creator.[89] This point of view is paralleled by certain passages in Melanchthon's writings that relate the study of nature to the admiration of the works of God.[90] An epigram on one (number 9) of the engravings, which were made for Hoefnagel's nature illustrations known as *Archetypa* (fig. 69), published in 1592, reads similarly: "Ne humanis rationibus diuina opera curiosius excutiamus/sed ex operibus manuducti/admiremur artificem" (Let us not too curiously examine divine works with human reasoning, but having been led along let us admire their artificer).

Although the notion of *curieux* and *curiosité* may have had various shades of meaning on the continent, and thinkers like Bacon or Galileo may effectively have promoted what we now call "curiosity," while not calling it by that name, the specific conception of *curiositas* (or *curiosità*) also clearly continued to bear negative overtones for someone like Galileo. In his critique of collections cited above, Galileo spoke of an *ometto curioso*.[91] Not this image of the collection of an idly curious little man, but an assemblage useful to a prince was of interest to Bacon in this matter as in others.[92]

Further consideration of Bacon is pertinent because even though he undoubtedly belonged to a distinctive insular culture, his utilitarian considerations have been found to bear a broader cultural significance with regard to developments on the continent as in Britain. While, for example, Bernard Palissy has been linked with the world of the "*curieux*," a more convincing argument has been made that the "purpose of Palissy's museum of natural objects was not to amuse readers or to arouse their curiosity." Like Bacon's collections—and Palissy was probably known to Bacon—his "was potentially a powerful instrument of scientific explica-

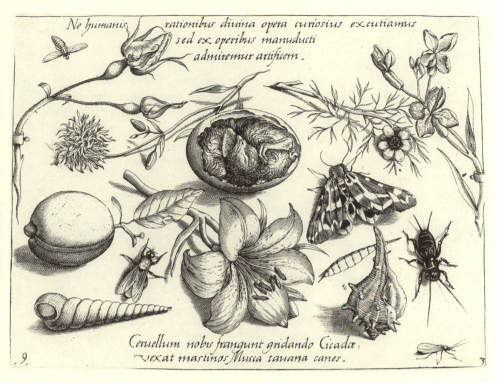

Ne humanis rationibus diuina opera curiosius excutiamus sed ex operibus manuducti admiremur artificem.

Ceruellum nobis frangunt gridando Cicadæ: vexat mastinos Musca tauana canes.

69. Jacob Hoefnagel after Georg Hoefnagel, *Shells, Flowers, Fruits, Insects, and a Chick.* From *Archetypa,* 1592

tion and research."[93] Bacon's ideas may therefore be compared to those of a broad current of sixteenth-century thinking.[94]

Bacon may thus also be used as a source to illuminate the utilitarian, practical, or "scientific" side of German princely collections. It is not necessary to claim Bacon as a continental thinker, even though he had many connections with intellectual developments in contemporary Europe, to notice that he articulated many of the tendencies in collecting that were evolving on the continent, and which he may indeed have observed before they came into play in England. It has already been noted that the collection of a great prince like Rudolf II, with its stables, aviaries, gardens, ponds, workshops, and libraries, represents a close approximation of the Baconian ideal. Bacon's research program has already been related to scientific investigations in Prague.[95] But the terms of the comparison can be made clearer, once one is aware that Bacon's suggestion to a prince to turn himself into a new "Trismegistus" also applies quite well not only

to the interests of the "Hermes Trismegistos Germaniae," Rudolf II, but also to those of many of his fellow rulers. Bacon and his remarks thus again help to explain the possible relation of collecting to what may be construed as science at the German courts.

It may be recalled that, in addition to patronizing the visual arts, many German courts of the mid- and late sixteenth century, not just that in Prague, also promoted various kinds of scientific and mechanical investigation. These mixed occult concerns with exoteric, or more strictly "scientific" interests.[96] Patterns of patronage of science at the court of Hesse-Kassel, the German court that has been most thoroughly studied in this regard, have suggested that the landgrave acted as both adept and prince, as his social role demanded. Political, social, and scientific interests, both esoteric and exoteric, and contacts with scholars and other individuals who pursued these interests, were thus all demonstrably interwoven in the activities of Wilhelm IV of Hesse-Kassel. These included the establishment of a garden with botanical specimens and exotic animals, the accumulation of a library, patronage of astronomy, and consequently patronage of the construction of clocks and other celestial automata by such celebrated mechanics as Jobst Bürgi. The landgrave was also personally involved in alchemy and other occult sciences.[97]

Many other courts supported similar combinations of interests. Perhaps because of his interest in astrology, the elector Ott-Heinrich, count palatine of the Rhine, sponsored the manufacture of clocks.[98] The later castle gardens established next to the palatine residence in Heidelberg probably housed alchemical workshops, and also presented a particular iconography, which among presented themes related to claims to universal hegemony in which religious, political, and scientific (including occult) symbolism were mixed.[99] In a 1562 treatise on the making of sundials, Andreas Schöner extolled the involvement of the emperor (Ferdinand, whom, as we have seen, was followed in this interest by his son Maximilian II and grandson Rudolf II), Elector August of Saxony, Duke Johann Frederick of Saxony, and Elector Johann of Brandenburg, in addition to mentioning the Hessian landgrave's interest in astrology.[100] Petrus Ramus expressed himself similarly about the interest of German rulers in mathematics and astronomical instruments.[101] Much else is known about Elector August of Saxony's interest in technology. Like many other rulers who dabbled in the alchemical laboratory or worked in the craftsman's atelier, August himself worked on the lathe.[102]

The activities and interests of Rudolf II, who was widely known for spending time in his workshops and laboratories, can be set in this context. As an emperor who was acknowledged as the greatest patron and who in reality was probably the greatest art collector of his day, Rudolf

could fittingly become foremost in supporting both the occult sciences and the mathematical or natural sciences. The imperial court in Prague was notorious for attracting all sorts of occult practitioners.[103] But the court also allowed astronomers such as Kepler to flourish and attracted writers on botany such as Clusius, and on gems such as Anselm Boethius de Boodt.[104] Figures such as De Boodt were also accomplished artists, suggesting the close connection between these activities at court.[105] It is possible that the imperial alchemical laboratories may very well have been situated in close proximity to the other collections, just as it has been hypothesized that the imperial workshops were located directly below the rooms housing the imperial collections.[106]

Not only the collections of Rudolf II but various other princely *Kunstkammers* reflect all these sorts of interests. Many collections also probably played an active role in the "scientific" endeavors of their courts. First, the collections housed instruments and other aids that may have been used in research. In this regard a collection such as that of the landgrave of Hesse can be looked upon as bearing traces of the ruler's interests, containing his books or scientific automata, for example.[107] Similarly, the Dresden *Kunstkammer* contained an abundance of technical tools and books that reflect the interests of the Saxon elector and that could have been employed in various investigations.[108] An important part of the objects listed in the 1607–1611 inventory of Rudolf II's *Kunstkammer* consists of so-called *scientifica*, instruments that could be utilized for scientific investigations.[109]

Still other connections can be drawn between the *Kunstkammer* and the various esoteric and exoteric investigations of the courts. The Prague *Kunstkammer* provided a source for raw materials to be used by craftsmen and examples to be studied by artists.[110] Much like the collections of private scholars, the princely *Kunstkammer* must also have served as a study collection in another sense, in that it contained examples of *naturalia* for consultation and investigation by the court humanist/scientists.[111]

A previously overlooked passage in the writing of Johannes Kepler demonstrates how the possessions in a courtly collection could stimulate scientific thought. In his treatise on the six-cornered snowflake, Kepler mentions having seen in the "royal" (*regia*, properly electoral) palace at Dresden a "panel inlaid with silver ore, from which a dodecahedron, like a small hazelnut in size, projected to half its depth, as if in flower."[112] This extraordinary specimen, which might otherwise seem to be just the kind of "curiosity" that was merely fit for a *Wunderkammer*, provoked in Kepler's mind the idea that geological specimens formed six-cornered crystals, as did snowflakes.

The *Kunstkammer* in Prague, which toward 1600 also undoubtedly served as an inspiration for Dresden,[113] was accordingly probably impli-

cated in both esoteric and exoteric investigations. On the one hand, it has been observed that many of the objects recorded in the 1607–1611 Prague inventory as having been removed by the emperor from the *Kunstkammer* possessed some sort of magical association: it is possible that they were removed to supply materials for the emperor's or his servants' personal esoteric dabbling in magic.[114] In his alchemical writings Oswald Croll also thanked the emperor for allowing him to use material from the *Kunstkammer*.[115] On the other hand, the utilization of technical terminology derived from contemporary scholarship to describe speciments listed in the 1607–1611 inventory of Rudolf's collection also indicates that procedures involving the establishment of proper nomenclature for *naturalia* that were involved in natural history were applied in the listing of objects there, and this suggests a process much more like standard zoological and botanical practice.[116] There are also many examples known of the court nature painters providing works to supplement the actual wonders of nature found in the *Kunstkammer*.[117]

These last instances suggest that although there may have been a Hermetic impulse to some aspects of the *Kunstkammer*, the actual interconnections with and implications for scientific developments are even more far-ranging, and here a comparison with Bacon is again illuminating. Just as it has been argued that magic was only one side of Bacon's thought, from which he evolved toward pronouncements that may be associated with the ideology of modern science, so it may be demonstrated that there was much more to science at the German courts, most notably in Prague, than an interest in magic or the occult.

Bacon may be regarded as having bridged the gap between alchemy or magic and science because of the way that he eventually came to reformulate a conceptualization of the nature of scientific research. For Bacon science had a public, democratic, and collaborative character; for its lack of these qualites he condemned magic.[118] In his project of formulating a "new science," Bacon stands for a larger development in which scientific learning evolved "from the secrets of nature to public knowledge."[119]

Although Panofsky contrasted Kepler, and indeed more generally the supposedly "mannerist" culture of Prague, with Galileo, in this regard Kepler shares a similar outlook with his Italian contemporary, and even more closely with Bacon. Like Bacon, Kepler continued to be caught up in a belief in the powers of the stars, as revealed by astrology, and in other occult forces. Throughout his life he continued to mix astronomony with astrology, casting and interpreting horoscopes; a kind of astral mysticism also informs much of his other work, most notably on the harmony of the spheres and the *Mysterium Cosmographicum*. Yet Kepler's emphases on the importance of mathematics and observation squarely place him in the camp of the "new science"; along with Galileo and others, he indeed established the new cosmology.[120]

It is illuminating to consider further the possible relation of the parallel development of Bacon's and especially Kepler's scientific thought and activities to the *Kunstkammer*. It has already been noted that the Prague *Kunstkammer* contained lenses that had been bought in Venice and were probably to be mounted in telescopes.[121] More can be made of this observation. The lenses may be related to the next item listed in the inventory of the *Kunstkammer*, a group of telescopes. These are described as being one better than the other, suggesting that these telescopes had actually been used.[122]

But just how useful were these telescopes? The reference that the emperor had had the unmounted lenses procured in Venice by (Count) Taxis is instructive because it demonstrates the relation between patronage and collecting, here of a scientific variety, and also because it shows the emperor's active role in both capacities. According to Kepler's testimony, Rudolf II had been keenly interested in the possibility of an instrument that would work like a telescope since first learning about such a purported device from reading Giovanni della Porta. He had pressed Kepler, who was at first skeptical about this invention, for an opinion.[123] Upon learning of Galileo's discovery of irregularities on the surface of the moon, the emperor himself questioned Kepler about them and offered him the opportunity to use what Kepler describes as the ruler's own telescope (or looking glass: *specillum . . . suum*), no doubt one of those from the *Kunstkammer*. In this Kepler says the ruler was endowed with the same restless spirit of seeking out nature that the Italian scientist possessed, and so emulated Galileo.[124]

The telescopes in the *Kunstkammer* as well as the lenses were acquired in Venice. The city is in closest proximity to Padua, Galileo's home at the time, also a traditional center of glass manufacture and, of course, the center of the republic to which Padua belonged. Most important, these instruments, like Galileo's, are probably to be connected directly with Kepler's astronomical investigations of the time.

The inventory was written about 1610, just the period when Kepler was trying to look through telescopes to verify Galileo's astronomical discoveries; the chief problem for him at the time was ascertaining the existence of the moons of Jupiter. Just as the emperor had been the first to let him see a copy of Galileo's treatise, so Kepler also notes that Rudolf provided a stimulus to follow up on Galileo.[125] Kepler's frustration in this matter is well known.[126] The *Kunstkammer* inventory suggests that the lens had to be imported; in part because of the inadequate lenses at his disposal, Kepler was led to write his *Dioptrice*, his path-breaking work on refraction, which among other things discusses the operation (and making of) lens.[127]

Kepler complained directly that at first he could not see what Galileo had discovered because the equipment at his disposal in Prague was not

adequate to the task.[128] He repeatedly beseeched his Italian colleague to send him a telescope that would help him accomplish this aim.[129] However, not until Galileo sent along a telescope via the archbishop of Cologne, in the last days of August and the beginning of September 1610, could Kepler obtain an instrument powerful enough to enable him to observe the phenomena he sought in the heavens, evidently by looking out of his windows near the Charles Bridge in Prague.[130] He repeated his observations with the aid of another telescope later in the same year.[131] He could then joyfully confirm Galileo's observations of the moons of Jupiter.[132]

Kepler's outburst at the revelation afforded by a useful telescope, which is included in the preface to his *Dioptrice*, is worth quoting here: "O multiscium, et quovis sceptio preciosius perspicillium: an, qui te dextra tenet, ille non Rex, non Dominus constitutur operum Dei? Vere tu" (O telescope, instrument of much knowledge, more precious than any scepter! Is not he who holds thee in his hand made king and lord of the works of God!)[133] According to Kepler, now the master of the world is he who possesses the telescope, not the scepter; the observing scientist, with powerful enough equipment, can gain a mastery of nature through the knowledge that his observation brings.

This transformation of the notion of the mastery of nature is thus obviously tied up with a fundamental transformation of the notion of knowledge. The knowledge that now grants power is exoteric, public, and observable, to be confirmed and established by anyone looking through a telescope. Kepler's earlier anxiety, which he overcame when he could look through the telescope, was indeed related to the possibility that the validity of Galileo's discoveries could not be publicly, independently confirmed.[134] It was his confirmation by observation through a telescope borrowed from Italy that allowed him to be certain.

In this sense the location of the telescopes listed in the inventory of the *Kunstkammer* does suggest that the *Kunstkammer* and its contents were being surpassed by a newer attitude toward science. Since we know that it was only a borrowed telescope that could do the task, the presence of the instruments listed in the *Kunstkammer* suggests that they might really have been more objects for the curious than for the truly active astronomer. Kepler's remark that the emperor claimed he saw Italy with its adjacent islands when he trained his own telescope on the moon gives some idea of their far from perfect serviceability. In this context the story of Kepler and the telescope suggests that the contents of the *Kunstkammer* were in effect gradually being proven useless for the chief tasks posed to the leading investigative observers of the day.

Moreover, the story of the telescopes suggests that the esoteric, secretive, personal approach that was embodied in and encouraged by the

more magical side of the *Kunstkammer* was being replaced by another attitude. In its stead came the more open, collaborative approach that, far from being a mentality or attitude that divides Galileo and Kepler, seems to join their interests and investigations. While most rulers' *Kunstkammers* were not open to the public, anyone could look at the stars, provided he had the right equipment (and telescopes became reasonably accessible by mid-century).[135]

As is well known, the nature of artistic collecting and patronage changed soon thereafter, and along with them the nature of scientific knowledge and the role of technology were also transformed. During the seventeenth century, as rulers' claims and authority became increasingly uncertain and the nature of political power was restructured, both court art and science changed direction. In Central Europe these transformations can already be seen in Prague in the generation after Rudolf II, in the person of Kepler's later patron in Bohemia, Albrecht Eusebius von Wallenstein, both in Kepler's scientific endeavors and in the art made for this opportunistic *parvenu* who capitalized on his ability to keep armies in the field during the Thirty Years War. In science Kepler was still much involved with feeding the astrological fancies of his superstitious patron; yet it was during the time of his activity for Wallenstein that Kepler also published the tables of astronomical observations meant for a wider public, which, in honor of his previous patron, he named the *Rudolfine Tables*.[136]

Similarly, many of Rudolf's court artists were taken over by Wallenstein, along with many of their formal inventions and the iconography of heroism and world domination created for the emperor. Yet these themes were expanded on a completely different scale. Writ large, themes of grandeur in art made for Wallenstein appear in direct, easily comprehensible imagery, unlike the subtleties of the Rudolfine era: Wallenstein appears as the patron saint of Bohemia or flies through the clouds in the guise of Mars in apotheosis. The whole tendency of the designs created for him is toward *grandezza*, toward the large public gesture. Wallenstein was not interested in symbolic control of the world in microcosm in a *Kunstkammer*, but in building a huge residence by destroying whole tracts of houses in Prague, or establishing a capital for a new state by restructuring the whole town of Jičin.[137] It is already this transformation that leads to the world of Louis XIV: with Louis, as with Wallenstein, the need to control the real city or state as a whole, to form directly a whole new center of power, creates completely different conditions for patronage, collecting, and political symbolism.

The example provided by Wallenstein is but one of many attesting to the wider phenomenon of the growing use of the arts and science for public, political purposes throughout Europe in the course of the seventeenth century. The conditions in which scientific investigations were un-

dertaken also underwent a transformation from the traditional private, or semi-private, model, as exemplified by science at court.[138] The growth of public Baconian science also attended the development of public collections, in universities such as Leiden, and the proliferation of scientific societies, the most famous of which is the Royal Society; at the same time court collections became increasingly accessible, and this development also provides a counterpart to the growth of large-scale programs for princely patronage.[139]

By the middle of the seventeenth century the new view of the world promoted by Galileo and others, which was founded on observation and mathematics, transformed the presuppositions of symbolic expression as well. The book of nature, for which the memory theater and the *Kunstkammer* alike promised to provide a key to decipherment, could now be read openly, according to Galileo. And the text of this book was now written in mathematics, not a secret code of hidden correspondences.[140]

Strikingly, a telescope is again the key symbolic device in this transformation. For Emanuele Tesauro at mid-century, it was the telescope that had driven mystery out of the world. In Tesauro's poetics, wit may still make metaphors, but metaphor now imposes on the world an arbitrary conceptual reality of its own and no longer reveals the hidden correspondences of nature. The book of nature is in this way no longer legible as the book of God.[141] With the new conception of the mastery of nature that may be related to the use of the telescope for celestial observation, the old view of the ruler as master of the world may therefore have evolved merely into an extravagant simile; seventeenth-century collections that rely on Tesauro's postulates may reveal a play of wit like those products of acuity Tesauro proposed, but can no longer rely on the assumptions that informed the creation of the German princely *Kunstkammer* in the late sixteenth and seventeenth centuries. The modern interpreter who is unaware of the fundamental shift that occurred in the course of the seventeenth century may therefore well miss the representational, allegorical, even possibly cosmic significance of the *Kunstkammer* and see in it no more than the scurrilous curiosity cabinet that it had already begun to appear to Galileo.[142]

Appendix I

❦

TEXTS ON THE THEORY OF

SHADOW PROJECTION

A.
Albrecht Dürer's Statement on the Relation of Shadow
to the Action of Light, from [*Die*] *Underweysung der Messung*,
Nuremberg, 1525, fol. 81v:

Ein yetlichs liecht reicht durch gerad linien so weyt sein streym lauffen.
so aber ein undurchsichtiges ding für das liecht wirt so stossen sich die
strahlen daran ab unnd es felt ein schatten so weyt die streym linien des
liechts verhalten werden.

B.
François Aguilon's Distinction between Artificial
and Solar Illumination, from *Opticorum Libri Sex*,
Antwerp, 1613, p. 683:

Igitur vt lumina in proiectas iam formas apte ducantur, primo id ad-
monendum censeo, in quo plurimos video halucinari, aliter a lucernis,
aliter a sole effusos radios luminis admitti; non vno item modo illustrari
ea quae in aperto sunt aëre, & quae fenestris obiicuntur in concluso; alia
denique ratione a pluribus luminaribus, alia ab vno lumen suscipi. Nam
quae a lucernis, aut suscepto per fenestras lumine in concluso illustrantur,
secundum Scenographicen sic exprimi debent, vt lumine quidem parcius,
vmbris vero vberius perfundantur: quae autem directos solis radios ad-
mittunt, orthographice sunt designanda: ita ut parallelis radiis ex aequo
lumen vmbramque descriptae formae participent. Denique quae in aperto
sunt aëre pari vndique lumine circumfusa exhiberi debent, vtpote quae
omni propemodum parte vmbram excludunt.

C.
Pietro Accolti's Criticism of Theories of Illumination and Shadow Projection, from *Lo inganno degl'occhi: prospettiva pratica*, Florence, 1625, pp. 95f.:

Io veramente mi sono sempre non poco marauigliato, che quelli Autori, che più degl'altri hanno diffusamente scritto di prospettiva (come fra moderni Monsignor Barbaro, Guidobaldo de Marchesi del Monte, & il Cavaliere Sirigatti) non habbino particolarmente intrapreso questa nobilissima parte di essa, che è di tanta conseguenza & momento al Disegno, & alla Pittura, Alla quale unicamente pare che deuino appartenere, & indirizzarsi tutto loro ammaestramento, studio, & fatica, & ogni loro pratica di Prospettiva:

Questi se pure hanno dicio lasciato scritto alcuna cosa, e stata tale, che non viene magistralmente, nè con verita applicabile a quello, che la Pittura ha dimestriere, impercioche (come immatatrice delle cose naturalmente rappresentate al veder nostro) richiede apprender regola di quell'ombreggiare, & sbattimentare, che viene dal lume naturale maggiore, non da lume di fiaccola, et lucerna, come essi Autori tutto hanno supposto nelle loro tradizioni, & dottrine: Nè dichino che quell'effetto di ombre, & sbattimenti, che farà un corpo si fattamente illuminato, sarà anche il medesimo, che se verrà illuminato esso corpo della meridiana parte del Cielo, & dal Sole, data la medesima situazione de lumi, impercio questo è falso al creder mostro, ombreggiando, & sbattimentando il Sole (in quanto all'esperienza del Senso) con raggi fra di loro parallelli, & ogn'altro lume di fiaccola, & Lucerna, con raggi piramidali, cio derivando dalla vicinanza dell'uno, & dall'immensa distanza dall'altro.

Appendix 2

❦

G. B. FONTEO'S POEM ON ARCIMBOLDO'S PAINTINGS

(VIENNA, ÖSTERREICHISCHE NATIONALBIBLIOTHEK, COD. 10152)

(fol. 1r)
Ad Sacrum Caesarem Invictissimum et clementissimum/ Imperatoris Max-
imilliani secundi sem/per Augustissimum Maiestatem,/ Baptistae Fonteij
Primionis/ In quatuor temporum, et quatuor elementorum/ ad humanam
effigiem à Josepho Arcimboldo/ caesareo pictore expressorum Caesari/
ipsi dicatam Picturam./ Carmen cum Distichis: et Diuinatio,/ cui titulus
Clementia est./ Viennae Austriae tertio calendas Ianuarias/ Anno Domini
M D lxviij.[1]

(fol. 2r)
Ad. Sacrum Caesarem Maiestatem Carmen/ de quatuor Temporibus et ele-
mentis ad humanam speciem delineatis.

> O sese melior, quo sospite sustinet orbis,[2]
>> Ipsáque promptaque suo Tempora, Resque iugo;
> Cuius quae satagunt agnoscere sceptra, beatas
>> Cernimus esse vrbes, cernimus esse viros;
> Vel mea sors grandi sub Maiestate tremiscens,
>> Vel uetat iniustus limina magna timor;
> Non tamen absisto, sed quandoquidem optime Caesar
>> Ad Dominum uacua non licet ire manu:[3]
> Haec fero caesareas cupiens animare tabellas.[4]
>> Omina fortunans gratius extet opus:[5]
> Scilicet expresso duxi super orbe sorores;
>> Dona iuuent placitis subdita muneribus;
> Nam quod miramur si se Diuos, hominesque,
>> Juppiter in uarias uerterit effigies;
> Vt moti calides animi restingueret aestus,
>> Et foret à turpi tutus adulterio.
> Non minus acta tuo Caesar pietatis honore
>> Nunc elementa ratis addita temporibus[6]

(fol. 2v)

Humanum uestire caput miremur, adorent
 Ut pia semideum te decus Austriadum:
Quo tua non tantum sint Rerum dona, sed ipsae
 Et Res, et Rebus iuncta elementa datis;
Quae si pace iugent, si quid sunt dißona, iudex
 Iosephi[7] mira Caesar es arte tui:
Qui quoque ne similes subeant Lenaeus, et armis
 Rusticus Agricolum, ne Coqua texta suis.[8]
Sed magna potius fieri ratione putetur,
 Vel si hominem totum dent Elementa sibi;
Paulo post homini, dum fit, dabit haec haec Elementa;
 Post quae qui factus, post ea dandus homo.[9]
Interea unde recens laruas persuasa viriles
 Aetatum, et Mundi semina prisca uelint,
Et quibus ex habitu promissis addere sensis
 Vel vatum dicto, uel ratione fidem,[10]
Dum quoque diuinans libetbridas urgeo, Caesar,
 Quis ordo positis, quis modus oppositis,

(fol. 3r)

Laturi maiora olim pius assere carmen.
 Qui scopus est, idem quàm bene fautor erit?
Sed prius alternis quae Res, et Tempora uerbis
 Iactent, optandus Caesar utrisque leges.[11]
Debebunt tibi Castalides praeconia, dona
 Te penes ut fides credita donec erunt.

Disticha quae temporibus, et elementis inter se collo-/
quentibus posse ascribi uidentur.[12]

 Hyems interrogat Aquam.
Dic Aqua, et hanc Diui speciem dignentur honores,[13]
An homninem mihi, uel me homini det truncus inesse.
 Aqua soluit dubium Hyemis.
Dic, piscesne tegam, uel piscius obtegar? ambae?[14]
Hic decus Austriadum, Naturae ibi dona notamus.
 Ver contra Aërem.

(fol. 3v)

Fare bonis auibus quid aues, Aetherúe colore[15]
Ostentas Domino, quae herbis, qui flore uirescunt.
 Aër pro se contra Ver.
Fare, sciatne idem, reddam quod luce colores,[16]
Rore herbas, auris volucres vegetemque, feramque?
 Aestas alloquitur Ignem.

Quàm decore Ignis ouas, metuens tam Caesaris ora[17]
Nuda prius, uestita meis ego frugibus asto.
 Ignis respondet Aestati.
Quam quo succendar, superat mihi, quodq#e peruram[18]
Tam domus Austriaco Domini durabit amore.
 Autumnus sic affatur Terram.
Caesaris ad placitum mihi vir, quod poma viro sunt,[19]
Tu conferta refer, quia habes animantia Tellus.
 Terra ita satisfacit Autumno.
Caesaris in nutus, his morte, graduq#e uteroq#e.[20]
Ossa, pedes, foetus, contego, firmo, paro.

(fol. 4r)
Ad Inuiclissimum, et clementissimum Caesarem/ Maximillianum *secun-*
dum in Arcimboldianam Tem-/ porum, atq#e Elementorum picturam
Diuinatio/ cui titulus Clementia. B*aptistae* F*onteii* P*rim*i*onis.*[21]

Prima quod insuetos Elementa nouentur ad ortus,[22]
Temporaq#e assidui linquentia quattuor Anni
Claustra, nouos capiant humanae frontis honores,
An Jouis hoc numen? Cuius mitissime Caesar
Insignemq#e geris volucrem, ualidaq#e retentas
Sceptra manu? Non,[23] ille fidem si prisca merentur,[24]
Fictis si fas est factum componere dictis,
Ignem miscuerit pelago, terrasq#e profundo,
Iussent esse lupum ueteri de Regi, Iuuencam
Iusserit Inachiae speciem celare puellae,
Siue dolos auro, seu turpior alite culpam,
Mentitoq#e malos sexu promouerit astus;
Nam quia primaeuos finxerunt crimina Diuos.
Non vis Imperij similis non Ira, nec ardor
Efferus id ualeat tua quod Clementia Caesar[25]
Austriadum tali Diuum de sanguine ducta,

(fol. 4v)
Antiquis exorta prius, maioribus inde
Aucta tuis, atauisq#e pijs,[26] elementibus at nunc
De patruo forti, sanctoq#e recepta parente:
Non leporem Leo, non Aquil*ae* genuere columbam.
Impulit haec uarijs elementa superba figuris,
Impulit ipsa pares signantia tempora formas
Ora uelint hominum Domino sua sistere leni;
Cunctaq#e tam faustis portendere prospera monstris,[27]
Quam faustis perhibent Romanae gentis alumnos,
Humano scitum[28] capite inter saxa reperto

Eruta fundandae Capitoli nobilis arci,[29]
Imperio debere virum, sceptrisque potiri;[30]
Sic expectatos Caesar dum prole beata
Haeredes uacuis das Clementissime Regnis,
(Quos laetas iam sorte sibi, numeroque Camoenas
Hactenus esse pari, fallens pharetratus Apollo,
Nunc decimum, modo sit placandis foemina Musis,
Felicem uoluit, cui cum ridere parentes

(fol. 5r)

Inuicti, tum festa parant natalia gentes,)[31]
En oblata tibi caput hoc primordia Rerum,
Oblata humanos imitantur Tempora gestus,
Quod iam perpetuo pacatis tempore Rebus,
Quà uel ad occidues Euris uia plurima, uel quà
Frigentem calidis ad Thylen curritur Austris,
Certa paraturi Austriadae[32] sint regna nepotes,
Ante ferox quae Turca ruens, immitior hostis
Christiadum generi, tantum non robore, quantum
Perfidia uictis uexauit pinguia Moesis,
Illa tuas Aquilas sed enim, victricia signa,[33]
Accitasque manent in martia pectora uires;
Expectant Dominum saeui pertaesa Tyranni;
Quaeque Musulmani pandunt oracula vates,
Qualibus inuito resonant sua carmine templa,
Quae mixtim recitant hominum genus omne quotannis.
Dicit Alha Maohmet, sed Alha bis dicite Maohmet,
Dirpiet, sostrique fidem mox vatis in oras

(fol. 5v)

Extendens profugos dabit ima in tartara Canes.
Qui Graecos domat, atque orientibus imperat arcuis.
Dicite Alha Maohmet, sed Alha bis dicite Maohmet,
Malo Dux noster potietur comminus Auri,
Auri, nota loquor, nisi reddat septima malum,
Antiquis Dominis aestas bissena fauebit;
Interea noster miranda palatia victor,
Arua triumphator Bromio felicia ponet:
Ista quidem laeti fieri fors cernitis at iam
Heu Turcae laniate genas cum prole parentes.
Ut Leo, qui catulis sublatis praepete cursu
Praedonem sequitur, rabidoque reuerberat ungue;
Austria sic Turca, sic nos Domus Austria terret.
Ab miserae mordete manus cum coniuge Nuptae;

Ferrea planta pedum, sunt ferrea bracchia prisco
Imperio, cuius moderatrix incluta Turcas
Austria pulsabit, Turcas domus Austria pellet.
Ipsa quidem placidam complectitur Austria pacem,

(fol. 6r)

Crimine sed nostro volucrum Regina, Pedumq*ue*
Eximium Imperio praesentia corriget vno.
 Ergo, quo melius, Caesar tam dissita in unum[34]
Ire caput, seq*ue* Austriacis submittere colla
Possint ut tabulis tibi se concordia praebent[35]
Tota, nec Autumno ver cinctum suauibus herbis,
Nec glacialis hyems aestati ducere bella
(Cum Pan riuali Boreae iam gratior, atq*ue*
Persephone matri, placeat Venus alma Lyaeo),
Sustinet, ac quando niueae Junonis amorem[36]
Ops, ac Aethnaei curam pro Caesare Fabri
Consus amat, Terram neq*ue* purus prouocat Aether,
Nec liquidas Ignis flammis crepitantibus undas.
Non qua quadrupedum simul huc uenere, minori
Certaret maior, non hostem caederet hostis:
Flexiuagos inter floret concordia pisces
Haud saeui pauidas Milui petiere Columbas
Haud[37] diuersa suo coeunt quae vertice Rerum.[38]

(fol. 6v)

Scilicet is Caesar, meritas cui stemmate laudes
Tempora, Resq*ue* canunt, supero cui lumine Titan,
Orbe Diana nouo, demisso Juppiter imbri
Temperat, ac auget, parentiaq*ue* irrigat arua,
Post belli causas est pacis amator honestae;[39]
Pacis, quae Cereri mater, quae prouida nutrix
Musis, et Cypriae comes est, Artiq*ue*[40] magistra;
Qua virtus superare queant, qua Regna coire,
Cui studeant etiam coelestia numina, veris
Quae tibi Tyndaridae, Phrixi, Cadmiq*ue* sororis[41]
Portitor Imperium, aestatis quae commoda praestant
Herculeusq*ue* Leo, herculeus cum virgine cancer;
Hinc qui Patris opes Autumni Scorpius acer
Obtulit, aequatum lancem comitante sagitta;
Tum capra, tum Pisces, et onustus Aquarius vrna
Tali qui cupiunt Hyemem ditione teneri;[42]
Quam reliquis Hyemem labentis partibus Anni[43]
Hic geminis cinctam pomis hederq*ue* sequaci,

(fol. 7r)

Iure caput tuus, o Caesar, praeponit Apelles;
Nam licet Assyrijq*ue* omnes Asiaeq*ue* Coloni[44]
Praecipue quibus Autumni sub tempore dextra
Diuina quondam fabrefactus creditur orbis,
Cum syluae leuibus uolitantes frondibus et cum
Sol late[45] radijs calcatas conspicit vuas, [*sic*]
Ritè nouos anno statuant solemniter ortus;
Quamuis principium nascenti iusserit esse[46]
Qu*ae* circum dotas Regio consistit Athenas
Cum sata flauescunt, cum fluctuat area messe,
Cum siculis Lybicisq*ue* tument grauida borrea lueris;
Nec minus auspicium repetenti a finibus orsa[47]
Caudam qui referunt uersum mordere Draconem.
Felicesq*ue* notent Arabes mollesq*ue* Sabaei,
Cum glaciem Zephyri, cum soluunt flumina cursus;
Arbuta cum gemmis, cum rident floribus arua;
Vt sua quosq*ue* trabit Ratio, et discriminat usus;
Attamen Imperij vero te Caesare digni,

(fol. 7v)

Quod iustas regis, et dignè[48] moderaris habenas,
Idem Caesar honos, idem dignißimus autor,[49]
Quâ sese latis Romanis potentia Terris
Inijceret, cana renouanda exordia Bruma
Esse sui posuit rectis rationibus Anni:
Nam prius aetheream quàm fruges lumins oram;
Aspiciant, floresq*ue* uagis nascantur in agris,[50]
Et uiridi uictura solo noua gramina serpant;
Accipiunt primas hyberno germine vires;
Illas non alius, si uera dedere periti,
Quàm mandata suae, quae seruat semina curae
Radicum, Brumaeq*ue* potens Prosperpina donet;[51]
Quod si perpetuoq*ue* vices in nocte diurnis
Ordine pra*e*ferimus passim, tenebrasq*ue* diei
Cum qu*ae* sint hodie, qu*ae* cras distincta notamus;[52]
Cur et Hyems tenero dubitat praecurrere veri:
Quandoquidem parilis repetito tramite cursus
Ducere solis equi noctes, Hyememq*ue* uidentur.

(fol. 8r)

Nec uerò tua magna Thales te gloria laetum,[53]
Si rigidae sese iugens Aqua frigida Brumae.
Quae rebus tibi compositis Aqua fertur origo,

Praeferri reliquis Elementis forte uidetur;
Nec te postposito raptum Decus Aëre tristem.
Reddat Anaximenes; Tibi non obscure sophorum[54]
Heraclite, vdis lachrymae labantur ocellis[55]
Quòd socijs ardens tuus haud praemittitur Ignis;
Non pius Ascraeum delusent arte poetem[56]
Terra Arcimboldous postrema sede locata,[57]
Noluit vtra vtris praestent decernere sed quae
Temporibus primisque forent communia rebus.
His etenim causa una una est in origine namque[58]
Humidus ille rigor rigidus quoque creditur is, qui
Possit Aquis hyemeis aqueas hyemalibus Humor[59]
Possit aquas aqueis hyemales cogere Brumis;
Quin est caeruleo Proserpina grata parenti[60]
Quod fratri nubat, Cereris quod filia Diuae;

(fol. 8v)

Cuius amore Deus numero se iunxit equorum.
Haud aliter tepidus tepidum ver reddidit Aether,[61]
Aethera si non ver tepidum dedit esse tepentem:
Praeterea uarios quos Tempora uerna colores[62]
Dant, oculis hominum pellucidus imprimit Aër.
Aër Caesareo munitus pectora rostro,
Cassidis et tendens fausta Iunone decorum:[63]
Iam nisi se flauis Aestas uestiret aristis,
Cogeret et nudos ad messes ire colonos.[64]
Vix hac temperie calida, siccaque negoti
Esse sibi quicquam claudo cum patre putares,
Quem uideas totis gestantem partibus Ignem.
Quaeque fouent, quaeque eliciunt cum fomite flammam:[65]
Cingentem[66] aurata sic colla nitentia torque,
Quae scilici igniuocum confert aptissima ferrum
Maximus ut Caesar gestamine uelleris aurei:[67]
Attamen[68] Autumni, magnaeque parentis honores,
Affectus qui sint bona, quae communia, fructus

(fol. 9r)

Si fingat nescire sagax in limine Momus,
Si minus expressum flaua de pelle Leonis
Terrae humerum Reges uideat praetendere boios,[69]
Ipsa monet pictura nouis exculta tabellis,
Quales nec finxit, magnus nec sciuit Apelles;[70]
Tales hoc miti uos Caesare dicite dignas.
Quotquot sub Domino Clementi uivere, quotquot

Autore hoc Domino dignas in Carmina Musas
Accire et uiridi laudes memorare sub umbra,
Vel uictos oculos aspectu pascere Nymphae;
Vel sine sorte thori modicis gaudere licebit;
Nulla grauis nulla est sub miti Regula Rege:
Scilicet humano scire hoc sub corpore quaerunt.[71]
Quae nunc Caesarea nec mirum creditur aede
Exiguo spacio distringunt tempora tempus.
Mira locum res ut coeant Elementa sub arctum,
Quaque solent nunquam nusquam ferere otia possint;
Sed referant, si quando cient, quae Caesaris ante[72]

(fol. 9v)

Ora salutati sua poscere iura uidentur.
Reddant, siue rogent Dominantem singula noscunt:
Quin ex his aliquot connubia iungere tentant
Artificis rari studio è Regione locata;[73]
Diuinos instare uident quia laeta hymenaeos:
Propterea tacitis quam torques spicea signis
Cinxerit, aestatem cupido Sol aureus Igni,[74]
Pomifero Autumno faecundam Luna bicornis
Tellurem iungat; non illam postulet Aether,
Non dilecta viro, quia sit barbata, negetur,
Et tali Cytheraea fuit Lacedaemone barba;
Quae iucunda suo spernit Dea florida Marti[75]
Veris coniugium puerili aetate tenelli:
Eccontra effoetam non curat Libera Brumam[76]
Nubere prudentisque uetat sapientia Jani:
Nec cunctis faciles superi dant esse maritis.
Et Neptunus aquas et candens aethera Juno[77]
Caesaris artifici referunt connubia praeter

(fol. 10r)

Fundere cunctarum genitalia semina Rerum:
Digna sit Igne aestas, Autumno coniuge Tellus
Farra aestas, taedas geniales afferat Ignis,
Terra feras mensis, Autumnus vina ministret;
Supremis eadem promptè latura hymenaeis:
Quos ego magnanimi si vates Caesaris olim[78]
Concinnisque modis non auditaque Syringe
Inter pastores inter pia numina Nymphas
Vel memorare queam, uel cantu accersere Diuos.
O hymenaee hymen repetens o hymen hymenaee;
Non ibi Maeonidae faciles inuidero Graios

Nec nouus Augustos magno superasse Maroni;
Nunc ausis libeat tenero primoribus aeuo
Depositis, gracili decidere tempus auena.
 Quare uti ver, aestasque calens, Autumnus hyemsque[79]
Te penes et solito Caesar, numerantur in anno,
Haud secus aetates referunt quia Tempora nostras,
Qui latis, haec picta monent dominentur in oris

(fol. 10v)

Austriadum[80] herôum claro de sanguine cretos
Staturos pueros, iuuenesque, virosque, senesque,
Dum uaga Luna dies dum menses Phoebus, iterque
Maximus astrorum cunctorum terminet Annus.
 Quae si pro patriae, pro libertate turorum
Quaesita toties, toties nascente Rebellum
Mulctata, et digne armis seditione repressa[81]
Actutum fixisse vides vestigia Caesar;
Si Dij tanguntur meriti et fortibus ausis,
Si pietate tua, si Religionis amore
Et virtute animi, gestis et Rebus auorum,
Denique synceris Augustae moribus Aulae,
Ut castis licitum pia diuinare poëtis.
Te propter, formas quia Res, et Tempora mutant,
Quantum clementi gaudebunt Caesare, tantum
Saecla sub extremo fulgebunt optima saeclo.[82]

Appendix 3

❧

DOCUMENTS RELATING TO THE ENTRY OF

RUDOLF II INTO VIENNA, 17 JULY 1577, AND TO THE

ACTIVITY OF PAULUS FABRITIUS

A.

D[ominus ?] l'Abbé (?), Description of the Ceremonial Entry of Rudolf
II into Vienna, 17 July 1577, from a Letter to the archbishop of Prague,
7 August 1577 (Prague, Státní Ustřední Archiv, APA I C 71 Recepta,
Kart. 710, 1577, VII ff., fol. 123 a–c.)

(fol. 123b recto)

In honorem maiestatis Caesareae binae fuerunt portae triumphales, in
quibus uaria erant depicta problemata, diuersa significantia, in quarum
prima, ad Danubium scilicet, erat ad manum dextra depicta Austria, et ad
Sinistram Europa ad imaginem foeminarum, et in cacuminae porta [sic]
Aquila Romana depicta cum sequenti dicto.

 Aquila Romana Imperatori.
 Suo Rudolpho II. Invictißimo.
 Ante polus stellis, uer floribus, imbribus aether,
 Danubius rapidis ante carebit aquis.
 Ante tibi, ante Ioui, communis desinet usus,
 Esse aquilae quam te non ego fida colam
 ARCHIDUCI SVO SERENNISIMO RVDOLPHO II IMPERATOR
 CAESAR Augustus gratulatur Austria.
 Austria.
 Austria qui redeas. tua maxime gaudeo Caesar,
 Succeßu foelix opte fruare bono.
 Res est suceßus qua non praeciosior ulla,
 Res uenit à solo tam precioso Deo
 Europa.
 Romanorum Imperatorem Rudolphum II. Caesarem
 Salutat Europa humillime.

In te magne mihi spes est sita magna Rudolphe,
 Caesar ades rebus tuq*ue*, DEVSq*ue*, meis.
Afflictae mea fata uides, afflicta sed oro,
 Sis memor Europae per mea fata tuae.

In altera autem porta, constructa mirae altitudinis in platea vulgo graben dicta, erant depictae statuae Maximiliani ad dexteram, super cuius caput hoc symbolum positum erat: sub pedibus uidet Astra, et Rudolphi Imperatorum ad sinistram, super cuius caput similiter sequens symbolum scriptum erat, sed hic terrena gubernat. Et ad cuius manum dexteram erant sequentia uerba depicta. Quanto Cae*sa*r es Clementior, eo DEO Propinquior. Ad sinistram ueró Maximiliani alia sequentia. Imperia nemo violenta continuit diu. Et in tela depictae quatuor figurae antiquae Romanorum erant,

(fol. 123b verso)
in quarum priori erat descriptum subsequens dictum: Prospice finem. In altera, Debellatura superbos, in tertia: Cuiq*ue* suum, in quarta, Vrbs caput orbis. Ad manum sinistra*m* Rudolphi erant todidem figurae antiquae, cum alijs quatuor subsequentibus dictis, quoru*m* primum fuit Imp*erator*es septem uiri. Secundum, Animo aequo. Tertium, Haec fedora gentibus aptat. Quartum, Ne Quid Nimis. In sumitate portae erat equus ex creta ad instar Equi Capitolij Romani, et sub illo arma Imperialia, cum sequentibus uerbis Rudolpho II. Imp*erator*i Caes*ari* Augu*sto* A*r*chiduci Aus*triae*. Et in inferiori quadam tabulae haec alia habebantur.

 DOMINO SVO CLEMENTISSIMO
 S. P. Q. Viennen*sis* honoris et obseruantiae ergo
 P*osuit*.
Rudolpho rerum Domino Regniq*ue* Monarcha,
 Gratatur studijs laeta Vienna suis,
Respice Caesar opus parata fronte tuorum,
 Sic Ciues poteris, sic recreare tuos.

Fuerunt etiam Astra sub pedibus Maximiliani et sub Rudolphi terra in sphaeris, ad Maximiliani manum destram sunt depictae statuae Iustitiae, et prudentiae, à sinistris Rudolphi fortitudinis et Temperantiae, ac super quatuor columnas magnae altitudinis, eiusdem portae, positi fuerunt quatuor statuae etiam ex creta compositi, quorum nomi*na* sunt, Neptunus et Hercules, à dextris, et à sinistris Pallas et Iupiter, quae statuae correspondent quatuor antepositis virtutibus, Iupiter nempe, Iustitiae: Neptunus, Temperantiae, Hercules fortitudini, Pallas uero Prudentiae. Adfueruntq*ue* cantores, et Tibicines qui suam M*aiesta*tem Caesar*am* ad portam hanc adventantem cantu*m* exceperunt, ex Turri maiori S*ancti* Stephani fuit demißa Aquila per funes usq*ue* ad alteram minorem turrem inperfec-

tam, fuitq*ue* quidam in pinaculo turris eiusdem templi dico, super pomo aureo, teneris manu uexillum Austriacum, et emittens in aerem ignem artificiosum, eratq*ue* in eodem pinaculo Turris Draco niger depictus in tela, et agitatus uentis: Ciues cum nouem uexillis, ac Itali. Mercatores cum Decimo obuiam Suae M*ae*iesta*t*i progreßi sunt, usq*ue* ad Tabor. Emißa sunt uaria tormenta bellica, et alia facta in sua M*aiesta*tis Caes*are*ae honorem, quae thipis breui dabuntur.

B.

Description of the Ceremonial Entry of Emperor Rudolf II into Vienna, 17 July 1577, and of the *Ehrenpforte* erected by the City of Vienna, submitted to the City Council by Dr. Paulus Fabritius, Imperial Physician and Court *Mathematicus*.
(Niederösterreichisches Landesarchiv, Stände Archiv, A 9/26, fol. 10r–21r)

(fol. 10r)
Arcus/ Sive Portae Triumphalis, Imperatori Rudolpho/II Caes*ari* August-*issimo* Archiduci Austriae *etc.*/ à senatu populoq*ue* Viennense extructae Descriptio/ Brevissima

(fol. 11r)
Consuli Senatüiq*ue* Reipublicae/Viennensis S*uis* D*edit*/ Paulus Fabricius Med*icinae* Doctor/Caesaris Mathematicus

Tamesti ab eo tempore quo mihi patres conscripti, curam structurae Arcus Triumphalis omnem commisistis, curam, siue consilio Autoritateq*ue* V*est*rà feci: cuius enim honori haec gratitudinis monumenta et offitia destinata essent, et quo modo in suscepto opere honore iusto, ille cui summus debetur honor Romanorum uidelicet Imperator, afficiendus esset. Non ignauiter consideraui, ideoq*ue* in me nihil recipere facile sum ausus. Tamen in hac festinatione quam temporis angustia, in tantae molis aedificatione postulabat, totius operis modum nobis exponere ac causam afferre eorum, quae in singulis partibus fierent, uix potui.

Quod igitur promittebam tunc, uelle me absoluto opere breui scripto, quod sermone efficere inter susceptos labores non possem, p*r*aestare, id nunc quasi deposita p*r*ovincia quam simplicissime acturus, rationem multorum breuiter reddam. Vos pro sapientia et humani*t*ate V*est*rà, ut non grauate ea cognostatis oro. Si v*est*ram volunt*at*em hic p*r*aedicare studiumq*ue* in declaranda animi obseruantia erga Imperatorem nostrum Augustissimum, co*m*memorare (fol. 11v) vellem; dies non modo sed et lingua tam prompta V*est*rà affectione oratio deficerat. Hoc unicum dico, quod quam primum uobis constaret, quid ad publicum luctum in gratulationis laeticia uobis licerat, nihil neglexisse, quod ad declarationem obser-

uantiae atque obedientiae erga Imperatoriam Maiestatem facere uidere-
tur. Atque si mi potestate et facultatibus Vestris positum fuisset, pro
animi uoluntate honores Imperatori Augustissimo decernere, nullae es-
sent diuitiae, quae uoluntatem animorum Vestrorum exequarent. Fecistis
itaque nunc, quod potuistis, non quod uoluissetis, si facultas fuisset praes-
tandi maiora. De me hoc dico me in toto huius portae gratulatoriae,
opere, eo respexisse, ut propter gratulationis studium festiuia multa fier-
ent, propter personam tamen Imperatoriae Maiestatis, grauitas festiuitati
coniugeretur, in utroque autem, culte et erudite aniquitatis studium atque
imitatio, utcunque expressa eluceret.

Qua in re me statuarii, pictores et architecti, quo communiter mecum
elegistis, mihique socios laborum adiungistis, uiri me hercle, in sua arte
praeclari et laudati, (id enim eorum eorum [sic] elaboratissima opera tes-
tantur) strenue iuuerunt.

Cum autem arcum triumphale, antequam prorsus iniuria tempestatum
uioletur, demoliri constitueristis, eius memoriam hoc scripto quasi con-
seruare, et ab interitu uindicare, mihi conuenire visum est. Si igitur partes
nunc breuiter enarrando recenseam, etiam simul totius operis rationem
proferam et exponam. À primaria autem parte exordiar.

(fol. 12r)
Utrumque ad portae latera, loco nec edito nec depresso nimis, statuae
Imperatorum collocatae sunt, quarum quae dextra est Diuum Maximilia-
num II Imperatorem Caesarem etc. sanctae memoriae refert. Altera Rudol-
phum II Imperatorem Caesarem Augustum, cuius honori, haec gratulato-
ria porta constituta est, et consecrata Utrique statuae unicum carmen
(diuisim tamen) adieci:
 Sub pedibus uidet Astra, sed hic terrena gubernat.
Prius hemistichium (quo ad illud Virgilij in Daphnide de Caesare: sub
pedibus uidet nubes et sidera caeli, allusi) super diui Maximiliani II effigie
cernitur. Posterius super nostri Imperatoris Rudolphi II Augusti [tissimi?]
Caesaris effigie.

Et quia ornatus causa, architecti solent globos lapideos grandes, tali in
loco portarum structuris adijcere. Ego globos mathematicos, quorum
singulorum diametri trium sunt pedum, cum dimidio ad tonauij [?].
Utque uerbis inscriptionum, res consentirent, in eo quam ad diui Max-
imiliani pedes collocaui extremae caeli spherae faciem cum omnibus sig-
nis ac stellis, iusto modo, intra suos circulos designaui, picturaque decenti
ornari curaui.

Ut autem in altero latere paria facerent, ad pedes statuae Augusti nostri
Rudolphi II etc. globum geographicum eadem magnitudine, designatione
regionum et marium recte ornatum posui. Conueniunt et hic res inscrip-
tiam verborum

(fol. 12v)

Sed hic Terrena Gubernat.

Uterque globus, praetereunte Imperatore, circa axem suum conversus est ita ut metio, euidenter deprehenderetur, sub caelestem haec pertinet inscriptio

Ex Ptolomei Alexandrini et receptiore philosophorum sententia. Sub terrestrem uero, (quia mobilis proponebatur) haec: Ex Heraclidis Pontici, Eophanti Pythagorici Et Nicolai Copernici sententia

Quia uero columnas portae, proximae alijs conspicuas magis esse placuit, ornauimus eas, delineato mathematico organo, quod omnes omnium gentium horas ostendit, et coaequat in paralello eo, cui subiacet nostra Vienna addito horologio automate, quod indices ex alto ad perpediculum suo ordine demitteret, in indice ad Divum Imperatorem Maximilianum erat pictura occasionis hoc hemistichio

Hac duce res coepta.

Ad nostrum uero Augustissimum Rudolphum II Imperatorem posterius hemistichium

Tulit et fert caetera tempus.

Cum pictura Atlantis Herculi molem mundi imponentis, quo tamquam aenigmate significare uolui, cum iustum tempus a Deo Optimo Maximo datum fuisset.

(fol. 13r)

Imperatorem patrem Diuum Maximilianum et electores Rudolphi II *etc.* humeris accepta, iusta occasione regnum imposuisse, quod ipsum, ipse sic quoque acceptaret.

Quam uero multiplices usus, opera ac sumptu exiguo, hoc horologium alijs praestat priuatim iam Imperatori nostro clementissimo declaraui, et alijs publice ostendam quando brevi venturam eclipsin lunae, in eodem demonstrabo, eodem quo in coelo eveniet modo.

Super arcum portae, nymphae duae, ramos oleae manibus praetendentes pictae sunt, et Imperij Romani Imperatorisque nostri Insignia clÿpeo amplissimo affixo superius uero sub equo alato, duae tabulae sunt, cum hac inscriptione, quae est ipsa quasi dedicatio totius operis

Rudolpho II Romonorum Imperatorem Caesarem
Augusto Archiduci Austriae
Domino suo clementissimo
Senatus Populusque Viennensis Honoris et obseruantiae
ergo Posuit

Rudolpho rerum domino, Regnique **monarchae**
Gratatur studijs, laeta Vienna suis

Respice Caesar opus, pacata fronte tuorum
Sic ciues poteris, sic recreare tuos

(fol. 13v)

ANNO DOMINI M. D. L. XXVII
Augusti mens*is* d*ie* xvii

Tot uersus mihi hoc loco sufficere uidebantur, consulto enim breui*t*ati studere animo meo constitui, quod prolixi in tali loco inscriptionum commentarij uere taediosi sint.

Nunc ea, quae consilio et suasu meo, artifices, statuarij et pictores longe praestantissimi, Matthias Manmacherus, Johannes de Monte, Bartolomeus Sprangerius qui omnes diu, multis in locis, praesertim in Italia, apud Pontificem Maximum, aliosque magnatos artis suae opera, praeclara cum laude exercuerunt, ad latera portae gratulatoriae et in aeditione parte stauerint, enarrandum est.

Ad latera duorum imperatorum statuas quatuor virtutum cardinalium, (ut uocant) efformarunt et locarunt, sub crepidinibus ad hoc confirmatis, uulgaris quidem et freque*n*s *est* pictura virtutum. Verum cu*m* sint necessariae in omni uita et o*m*nibus tam magistratibus quam subditis communes, non uidi quare, etsi frequenter et ubiq*ue* pingantur, et hic quoq*ue* no*n* apponerentur.

Supra has statuas conuenientes historias elegantissime pinxit Bartholomeus, et quia ordo structurae, plures scripturas requirebat, ita temperaui, ut et antiquae historiae et recentiores, exemplo Valerij Maximi pingerentur. Utque maior esset varietas, etiam poeticas pr*o*sopopeias cum quibusdam actibus suis miscuimus, victoriae scilicet pacis et antiquae Romae hoc ordine:

(fol 14r)

Super statua*m* prudentiae, Imperatoris Sigismundi quoddam factum ex cronicis historicorum depinximus. Is imperator cum esset, et sapientissimus, et liberalissimus simul, à quodam ministro aulae, familiari ueterano obliq*ue* notatus est, quod minus esset ni se munificus. Cum enim equus imperatoris fluuium ingressus immeyerat, hic ijsdem moribus esse equum, quibus dominus. Ubi enim multae essent aquae, ipse plus effunderet, sensit imperator se perfringi. Iussit duas pixides aequali magnitudine, forma et pondere fieri, alteram auro, alteram plumbo oppleuit, aduocato veterano, ibet tollere altera*m* pixidem, hic pensitatis utrisq*ue* eligit plumbum. En, inquit imperator, uides no*n* meam uolunt*a*tem, sed tuam tibi fortunam defuisse, alias auram abstulisses. Sic in alijs multis fatum et fortuna, haud parum res humanas moderantur, atq*ue* hoc est sapienti et festiuo facto, à se repehensionem istam repudiauit, nec tamen ministrum sine munere dimisisse ferunt. Sunt qui hoc ad fortunam referre debere putant, sed illi male iudicant, dum no*n* uident, primas partes imperatoris esse in tota historia.

Debebant adscribi duo uersus, sicuti et alijs singulis statuis ac tabulis pictis, et hi iam dudum erant à me compositi, verum quia spatium erat exilius quam ut grandiorem scripturam admitteret, difficileque id fuisset ex loco sublimiori inferius legere, satis uisum est apophtegmata conuenientia statuis ac picturis sȳmbola adnotare.

(fol. 14v)
Dedi igitur Prudentiae hoc Solonis: PROSPICE FINEM. Quod in omni negotio prudenter pertractando, à finis consile ratione, Principium deliberationis recte praedat. Iustitiae uero hoc: SVVM CVIQVE. Id enim illa sua proprietate decernit, ut suum cuique tribuatur pictura super iustitiae statuam, historiam Cambyses refert, qua inustum iudicem excoriari iussit, pellem in tribunali extendi, et filium in eadem patris loco collocari, uno meminerit iustitiae in iudicio.

Fortitudinis statuae, Mucij Scaeuolae factum, apud Persennam [sic] Regem (uide Liuium libro decimo) assignauimus, cum hoc symbolo AEQUO ANIMO. Quid enim in viro forti aliud magis, quam aequabilis in utraque fortuna requiritur animus.

Temperantiae adscripsi hoc: NE QUID NIMIS. Cum enim adeo delectetur Cicero parens eloquentiae Romanae et vindex honestatis in offficorum libris, in philosophicis commentationibus et epistolis, sententijs ex Terentio frequenter citatis, hoc enim brevissimo et elegantissimo prouerbio, amplissimae virtutis ac anctissimiae, dignitatem pulchre ornare uidebatur. Pictura super hanc, praesentat Scipionem, qui captam bello sponsam, conseruata ipsius pudicitia, Alluio Allobrogum, principi iuueni, cum magna modestiae laude restituit. Historia est apud Liuium.

(fol. 15r)
Supra duos porticus, quae inter virtutes ex oppositis locis transitum praebent, victoria triumphans effigiata est, cum inscriptione DEBELLATURA SUPERBOS ex opposito pacis simulachrum cum hemistichio **Pax foederae** gentibus aptat. Super Diui Maximiliani imperatoris imagine depicta est Roma, ut ab artificibus pingi, etiam antiquitus consueuit, cum hoc dicto **Urbs Caput Orbis.**

Super imperatore nostro Rudolpho II *etc.* institutio septem electorum cum inscriptione: imperij septem viri.

Facta inscriptione et pictura duabus de causis, à me adornata est. Primo ut ostenderem, quasi picturae symbola, ordinariam et legitimam nostri imperatoris electionem, qua legitima uocatione et electione imperatoribus regibus et omni magistratuum ordini, nihil potest euenire honorificentius, nihil contingere ad conscientiae quoque securitatem gloriosius, deinde ut antiquae Romae opponerem recentioris imperij formam. Hac enim electorum institutione Otto III imperator imperium Romanum

uariae concussum quasi instaurauit, et Germanicae Nationi confirmauit, cui haud paruum deinceps quoque contulis Carolus IIII Aureae Bullae author. Et de his satis.

Quae in supremo sunt loco, ut omni varietate delectationem spectatoribus afferremus, ex fabulis desumpsimus, cum enim statuarijis et pictoribus placeret, pro pyramide, quam statuere ibi primo constitueramus, equum ornatus et nouitatis gratia isthic collocare, gratificatus in hoc sum illis libenter, atque iis ut Pegasum efficerent hortatus sum. illique adiungi propter contextum et ordinem fabulae totius inter Neptunum et Palladem,

(fol. 15v.)
cum suis manubrijis et insignijs. Itaque tridentem et delphinum Neptunus habet Pallas hastam minaciter ostendit, et caput Medusae, à qua Medusa propter pulchritudinem Neptuno adamata, fabulae initium habet, et hinc ad Perseum detexitur qui propter violatum Palladis templum obtruncat Medusam, ex cuius sanguinis guttis denique nascitur Pegasus, author fontis Musarum in Helliconis monte, cui libitum est plura scire, legat apud Ouidium, integrum harum fabularum contextum.

Haec ex priori parte in fronte arcus triumphalis spectantur.

Ut autem omnia sibi essent similia, ex altera parte Iouis et Herculis grandes statuae cum suis manubrijs sunt collocatae. Et possem quidem mytholgias et allegorias haud inconcinnas ad imperia sapienter et faeliciter in toga domi in armis foris, administranda, in medium adducere, tum quae ad sapientiam et bonarum artium studia commendanda facerent. Verum relinquam alijs hanc argutandi occasionem, in qua mirum, quam indocti et insulsi se torquebunt curiose ut docti et festiui scilicet viderentur.

Insignia regnorum in clypeis proposita per se spectantur sub testudine, parietibus huic inde bini uolontes, seseque complectentes, angeli depicti, gratulabundo gestum, flores omnis generis spargunt.

(fol. 16r)
Et quia ex utraque parte graues sententiae quarum altera, ad personam caesaris referetur, altera deforma cuiuscumque boni imperii aliquid pronuntiaret, uiderentur adscribendae super portico dextra hoc scriptum est.
Quo Caesar es clementior, eo Aero [?] propinquior
Adscripturus eram illud Claudiani ad Honorium Imperatorem in Consilio IIII

Sis pius ni primis, nam cum uincamur in omni
Munere: sola Deos aequat clementia nobis.
Sed uidebatur prolixius.

Quid autem clementia in tali Heroe quali nos hic gratulamur est Augustus? haec enim sola alias virtutes illustrat et effundit, ut radij lumen solis diffundunt, et de caelo inferioribus naturis dispensant, omniaque fouent et laetificant.

Ex opposito uero super altera portico, praescripseram aliquot sententias pictori, qua ibi annotaret. Quatuor ex Seneca, unum ex Platone, unam itidem ex institutionibus iuris. Principium uidelicet ipsum, dedique libertatem eligendi quam uellet, ipse uero hanc adscripsit ex Troiade, Senecae grauissimi authoris:

Violenta Nemo Diu Continuit Imperia Moderata Durant

Sunt haec uerba Agamemnonis Imperatoris primarij exercitus Graecorum apud Troiam, alloquentis Pyrrhum iuuenem Achyllis filium.

(fol. 16v)
Placuit autem mihi quod hanc elegisset, potuit enim lector attentuis tacite moneri, de uirtutibus serenissimorum Archiducum Austriae, inter quas clementia et moderatio ut gemma praetiosissima ex auro, ita è uirtitibus reliquis, eorum splendore delectabiti fulgent et emicant, ideoque haud mirum si successio in Romanorum Imperij summo gradu, in ea familia tanto consensu electorum, et statuum imperij continetur. Interim tamen haec sententiae grauissima non tantum de Regio Imperio uerum etiam de politica et oeconomia intelligi debet. In his enim omnibus quam primum uiolentia admissa est, aequitas honestasque tollitur, vitae quoque humanae societas dissoluitque.

Sic itaque uideor mihi reddidisse rationem mei, in Vestro hoc opere instituti et actorum, speroque nihil esse quod adeo magnopere reprehendi aequis possit, si quid tamen admissum, ueniam peto. Homo sum, errare alicubi, negligere aliquid possum, atque in Germanice prouerbio dicitur

Saepe etiam quadrupes caespitat acer equus

Si uero apud aliquos aliquid alio trahentur, atque à me cogitata sunt, eam fortunam mihi communem euenisse putare debeo, cum ijs, qui in publico loco et omnium conspectu, aliquid extruunt. Omnium enim illi iudicijs diuersissimis sunt exposti, et quamuis quaedam uarie, primo hic quoque accepta sunt, tamen absoluto opere sermone rumusculi euanuerunt, et omnium

(fol. 17r)
quoque optimorum sententijs opera mea approbata; vestraque in Imperatoriam Maiestatem, voluntas laudata, studium obseruantia magnopere commendatum.

Quod restat Patres Conscripti me et meum studium quod uobis bene mereri, Imperatorem autem nostrum longe clementissime etiam hoc

loco, et occasione, honore quam potui maximo, afficere conatus sum, Beneuolentia V*estra* ut complectamini, oro, atq*ue* alia simul om*n*ia mea defero officia. Si quid in opere deicere uidetur, uel temporis ipsius angustia, ad me excusandum, aliquid haud parum afferret apud aequitatem V*estram* momenti, trium enim septimanarum et quinq*ue* dierum spacio et huius et suburbane, de qua breui et suo loco dicetur. Portae gratulatoria structura c*o*epta et uniuersa absoluta est.

Cum enim uobis in luctu publico, ob mort*em* immaturam diui Maximiliani II *etc.* quid de negotio tali statueretis, nondu*m* constaret, unoq*ue* inclyta Reipublicae Vratislavienisium exemplo tantum excitaremini, cum q*ue* grauium et sapientum uirorum authorit*atem* respiceretis, ut eorundem consilia ac sententias ab aula Caesarea expectaretis, hucusq*ue* tempus effluxit. Ut viginti tantum hi et sex dies ad optatissimum Imperatoris Inuictissimi aduentum superessent. Quem aduenientem, ut etiam apud Academiam Viennensem, obseruantiam mei animi declarare, sic meae musae exceperunt.

Finis.

(fol. 19r)
Portae Gratulatoriae suburbanae/descriptio.

Suburbana structura arcus triumphalis, P*atres Conscripti*, tota philosophica est, nata in domo mea, inter musas meas, ea quamuis depingetur ad aeditionem, aeque ut altera tame*n* et ea*m* brcuiter describere, cuiusq*ue* memoria*m* ab obliuione litteris uindicare, in animu*m* indico, non dubitans, quin et hoc in officio nobis rem gratam sum facturus, dum bona fide uerbis pronuntio, quod pictura uix satis significare potest. In suprema igit*ur* parte statui amplisimam bicispitem Romanam Aquilam, insignia Imperatoria praese ferentem cum hac inscriptione

Aquila Romana, Imperatori suo
Rudolpho II. Inuicl*issimo*

Ante polus stellis, ver floribus, imbribus aether,
Danubius rapidis, ante carebit aquis
Ante tibi, ante Ioui Communis desinit usus
Esse Aquilae, quam te no*n* ego fida colam
Duxq*ue* Comesque, tibi sistat, belloq*ue* togaq*ue*
Custosq*ue*, et clypei fida ministra fui.

In latere illo, quod, ad Danubium spectat, iussi in tabula alta lata pedes, pingi Mare Mediterraneum cum suis insulis, littoribus, partet etiam Aphricae et Asi*ae* minoris. (fol. 19v) Huic tabulae applicata est et superposita, alia singularis et libera tabula, in qua Europa rep*rae*sentatur, ea ita conformata est, ut et caput et genua cum decenti et ciuili motu totius

corporis flectere possit, atque hac reuerentia, honorifico gestu, ter exhibito, saluauit ut excepti accedentem Inuictissimum Imperatorem Rudolphum II. Cum à vestro senatorio ordine more solenni ac solito exceptus humillime fuisset, spetaculum hoc mirum in modum omnibus placuisse fertur. Huic haec carmina adscribi iussi:

> In te magne mihi spes est sita magna Rudolphe
> Caesar, ades rebus tuque deusque meis.
> Afflicta mea fata uides, afflicta sed oro.
> Sis memor Europae per mea fata suae.

Ex altero latere picta est Austria, forma puellae venustae ac lepidae, ornata veste rubra et alba, ea genibus flexis statuta est ut reuerenter Imperatoriae Maiestati honorem verecundo gestum exhibere uideatur. Altera manu pileum gentili cum serenissimorum Archiducum Austriae, Altera clypeum, in quo insignia Austriae vetustiora ac noua continebantur, porrigit. Est autem per totum huius corpus et ornatum ipsum, Austriae territorium, cum primarijs ciuitatibus, oppidis, Arcibus, montibus, fluminibus, geographicarum justa dispositione et mensura milliarium Germanicarum graduum, item longitudinis et latitudinis ornate designatum.

(fol. 20r)
Danubius ita est figuratus, acsi a capite peplum vsque ad pedes dependeat. Austriam superiorem, non potui totam adiungere, aliquot de causis, pauca ex Hungaria addidi, circum circa autem, confinium, prouinciarum, et regnorum, nomina adsignaui. Huic hanc descriptionem, accomodaui breuem, ubique brevitate concinnae studui.

Archiduci suo serenissimo, Rudolpho II. Imperatorem Caesarem August[issim?]um Gratulatur Austria

> Austria quod redeas tua maxime gaudeo Caesar
> Successu foelix opto fruare bono
> Res est successus, qua non preciosior ulla,
> Res uenit a solo tam preciosa Deo.

Alia ex typo hoc, quem industrius artifiex Jacobus Maierus, ciuis et pictor Viennensis, qui ipse et hoc modo maioris arcus formam, ad aeditionem adornauit, spectrare commodissime possunt.

Prestittere autem in omni procuratione mechanica, mihi fidelem operam, Caesaris arcularij, insignes artifices et architectonices bene periti, Antonius et Georgius Hassius.

(fol. 20v)
Quod igitur reliquum est, oro ut mea opera vestro amplissimo ordini grata sit, simulque precor Deum optimum maximum ut imperatori nostro

Rudolpho II *etc.* et uitat diu, et imperium late, pro sua diuina bonit*ate* proroget, gubernationemq*ue* ipsius tranquillaq*ue* faelicem efficiat.

Exceptio et nomina
senatorum. Nunc ne officij mei in ordine meo uidear oblitus, ea quae nomine Academiae Viennensis iussus scripsi, his coniungem.

Rudolpho II
Romanorum Imperatori Caes*ari* Aug*ustissimo* Archiduci Austriae, Viennam redeunti, gratulatur Academia Viennensis

Nos quoque qui colimus musas, et Palladis artes
Rudolpho rerum domino, regniq*ue*; monarchae
Gratemur; meritosq*ue* illi tribuamus honores
Iura. Magistratumq*ue* Deus, sanctumq*ue* senatum
Qui statuit, populusq*ue* dedit sua vincula leges
Ille tuas Aquilas. Tua sceptra est facta gubernet,
Caesar, cui magna sunt tradita regna parentis
Hactenus ingenti luctu transegimus annum.
Caesare defuncto, quo no*n* clementior alter

(fol. 21r)

 Quid labor et benefacta iuuant*e* hunc deniq*ue* nobis
 Ante suum seuera diem crudelia Fata
 Eripuere modum lachrimas tamen addere fas est
 In te magne et enim spes est sita magna Rudolphe
 Tu mitis luctum lenis, tu pectore in aegro
 Gaudia succendis, tuq*ue* omnia laeta reportas
 Nulla salus armis, fas sit modo poscere pacem.
 Ex armis cadit rerum pax optima falces
 Mutat vomeribusq*ue* enses, atq*ue* addit aratris
 Pax opibus galeas, pax foedera gentibus aptat,
 Si tibi quis bellum, sumptis tamen inserat armis
 Parcens subiectis, debellatura superbos
 Laeta tibi e caelo portat victoria lauras.

 Paulus Fabricius Med*icinae* Doctor
 Caesaris Mathematicus

C.

Description of the Ceremonial Entry of Rudolf II into Vienna, 17 July 1577, by Giovanni Delfino, bishop of Torcello, Papal Nuncio (Archivio Secreto Vaticano, Nunziatura di Germania 74, Letter of 27 July 1577)

(fol. 153r)

Finalmente dopo tredeci mesi di peregrinationi mi sono condotto sano con li miei à li xv del presente à Vienna, nella quale città l'Imper*atore* entrò

al xvii. havendo in campagna hauuto l'incontro del Serenissimo Arciduca
Ernesto della nobilità del paese con forse mille caualli, di tre mille fanti
benissimo armati et d'una compagnia d'Italiani la più bella che già molti
anni si sia ueduta in Germania. A la porta del Danubio, per doue Sua
Maiesta doueua entrar, era stato fabricato un'arco trionfale con due pi-
ramidi ornati di varie pitture, et d'una grand'aquila imperiale con queste
parole: Aquila Romana Imperatori suo Rudolpho Secundo Inuittissimo.
Et poi seguiuano questi versi:

> Ante polus stellis, Ver floribus, imbribus Aether
> Danubius rapidis ante carebit aquis
> Ante tibi, ante Ioui communis desinet usus.
> Etsi Aquilae, quam te non ego fide colam.

A mano destra dell'arco era una figura cosmografica, che rappresentaua
l'Austria con le seguenti parole, et versi:
Archiduci suo Serenissimo Rudolpho Secundo Caesari Augusto gratulatur
Austria

> Austria quod redeas tua maximè gaudeo Caesar
> Successu foelix opto fruare bono
> Res est successus, aut non preciosior ulla
> Res uenit à solo tam pretiosa Deo.

Et a mano sinistra un'altra figura dell'Europa, che diceua: Romanum
Imperatorem Rudolphum Secundum Caesarem salutat Europa humillime.

> In te magne mihi spes est sita magna Rudolphe
> Caesar ades rebus tuque Deusque meis
> Afflicta mea fata vides afflicta sed oro.
> Sis memor Europae per mea fata tuae.

Passato ch'hebbe l'arco, il consule et senato Viennese presentorno a Sua
Maiesta le chiaui della città, che subito furono loro restituti con le solite
ceremonie, et poi la raccolsero sotto al baldachino di broccato, et andando
inanzi tutta la cauallaria, et seguitanda poi la fanteria la Maiestà Sua
scavalcò, et adorò et baciò la croce, et recivutta sotto un altro baldachino
preparato da i preti entrò in chiesa, doue si cantò il Te Deum con molte
orationi, le quale finite Sua Maiesta rimontò a cauallo, et giunta à la piazza
detta de Villani passò un altro arco di gran fattura, et spesa, nella somità
del quale in una fronte era un gran cauallo Pegaseo, et a man destra un
Nettuno grandissimo et à la sinistra una Palade, et dall'altra parte un Er-
cole, et un Gioue fulminante, fra quali era l'arma antica di casa d'Austria.
Il titolo dell'arco era questo: Rudolpho secundo Romano Imperatori Caesari
Augusto Archiduci Austriae Domino Suo clelmentissimo Senatus Populus
Que Viennensis honoris et obseruantiae ergo Posuit [?]. Seguiuano questi
versi:

Rudolpho rerum Domino, Regnique Monarchae,
 Gratatur studiis laeta Vienna suis.
Respice Caesar opus pacata fronte tuorum
 Sic ciues potens, sic vereari tuos.

Si vedevano poi molti quadri di chiaroscuro con i loro motti, et sig-
nificati, quali non entraro à scriuere, cosi per non fare la lettura lunga, et
tediosa, come per esser occupato in questo principio in diuersi negotij. Vi
erano a mano destro dell'Arco la statua dell'Imperatore Massimiliano
finta di marmore, ch'haueva sotto a piedi un gran globo celeste, et sopra
queste parole: Sub pedibus videt astra, et poi la giustitia e prudenza, et
dalla mano sinistra la statua dell Imperatore presente con un globo ter-
restre sotto a piedi, et di sopra questo motto: Sed hic terrena gubernat, et
dopo seguivano le statue della fortezza, et tempranza. Sotto al cielo
dell'arco d'una banda erano tali parole: Violenta nemo imperia continuit
diu, et dall'altre, Quo Caesar es clementior, eo Deo proprinquior, dalle
quale et da altre, che non scriuo, facilmente si puo comprendere l'opin-
ione, che hanno ametta della serenità di Suà Maiesta, la quale spero, che
con la bontà, et pietà sua, sgannarà ogn'uno, et manterra illu[trissima (?)]
l'autorità, et dignità sua. Giuntà Sua Maiestà al palazzo si fece una bellis-
sima salua d'arcobussi, et artiglierie, et poi la notte si uidero sopra tutte le
torri fuochi accesi, et s'udirono molte musiche per la città. La mattina
poi seguente queste della Prouintia presentorno un gran tazzone dorato a
Sua Maiesta beino [?] et il medesimo fecero col Serenissimo Principe
Ernesto.

D.

Letter of Dr. Paulus Fabritius to Archduke Ernst Requesting Permission
to Retire from the Function of Professor of Mathematics, which He had
Exercised at the University of Vienna since 1553. (Österreichische
Nationalbibliothek, Handschriftensammlung, Nr. 8805)

(fol. 1r) No. III
Copeij
Pauln Fabritij
Durchleuchtigister Furst, gnädigster Herr. Ich bin Anno 1553 durch
Herrn Doctorem Zasium als einen khönighlichen Abgesanten, auss dem
Reich von Nürenberg in namen unnd auf gehaiß hochloblichister
gedächtenus Ferdinandi Römischer khöninglichen Maiestäts etc. alhieher
gehn Wien für einen Mathematicum, wie ich dan das Jar zuuor zu
Augspurg in ausgang des grossen Reichstags, auch von den durchleu-
chtigsten Fursten und Herrn Herrn Philippum (damals princen in Hi-
spanien) mit In in Hispanien zu ziehen erfordert worden. Wie ich mich
ghen Wien gestellet, haben mich Ir Römische Khayserliche Maiestät etc.

allergnedigst personlich in Ir Zimmer berueffen, (fol. 1v) in bey sein der Herrn Doctoris Petri Caniserj, Widman Stadij Guihelmj Postellj, examiniert, befragt, probirt, unnd zu Irer Maiestäts Mathematico von Irer Maiestäts selbst auff unnd angenommen worden.

Ferner auch auff die hohe Schuel mich durch Herrn Doctorem Widman Stetter, Lucretium Genandi Niederösterreichischer [?] Canzler und der Universitet Superintendenten Herr Doctor Laurentium Khirchamer Rectorem, Herr M(agister ?). Georgium Muschlerum et einem Erwürdigen Consistorio des Erzherzoglichen Archigymnasij, fur einen professoren unnd leßmaister der Mathematisschen khunst presentiren und ein anworten lassen, wie dan hie beijligendt copey meines paßbrieffs A. außzaigt. Bey diser Erzherzoglichen Universitet, hab ich ausser der hoffdiensts, in die vier unnd dreissig Jar nach meinen besten vor(fol 2r.)mügen unnd verstandt, nicht allain in sachen, der Mathematiken verwant und zugethon mit profitiren unnd lesen gedient, sonder auch bey der selben, onera, Guehabschaften und Ampter, wie sie furgefallen, wie geschweigen **diversa studiorum et exercitiorum genera**, als poëterey unnd dergleichen mir auflegen lassen, unnd willig ertragen. Weil aber ich mich willig und gehorsamblich brauchen lassen, dar zu für mich selbst vleissig so vil mir Gott verlihen in anderen facultetten und disciplinis darneben erzaigt und geübt, und forthin mit zimblichen hohn alter belegt, und vast mude bin, werde ich noth halb gedrungen die profession auff zu sagen, und umb erlassung oder uhrlaub von der selb su nemen. Nach dem ich aber wie oben angezogne Copey A des paß (fol. 2v) oder bestalbrieffs ausweisset, zuhoff angenomen, hab sich meins eractens auch wöllen gebüren daselb doch om ainige Herrn Rectores Khayserlichen Superintendenten und Venerabilis Consistorij Praeterition verstanden urlaub zunemen, wie ichs dan hiemit diser Supplication neme.

Ist derohalp hierauff main unterthenigist bit, Eure Fürstlichen Durchlauts wöllen mit meinem geringen doch fleissigen sö lang würdigen und willigen diensten gnedigst vor guet nemen, wie ich mich dan ganzlich verstehe, die fur gesezten auf der hohen schuell, wolliche ietz aller erst bemelt Herr Rector Superintendens, so wol consistorialen, auch die discipuli, solliches gunstiglich thuen werden: Ferner ist auch mein unterthenigist bit Eure Fürstlichen Durchlaut geruhen neben parer abzallung und klainen Rest, den man mier in der Remanenz (fol. 3r) noch an meinen stipendio hinderstöllig zuthuen, die sach dahin et mit iren Consenz zu richten unnd an zu ordnen das ich nach dem (wie hochlöblichister gedachtnus Khayser Ferdinandi etlichmal gesagt, **Mathematica non est de pane lucrando**) mein Stipendium die khurze zeit meins lebens forthin jarlich neben meinen geringen vermüegen zu bösserer unterhaltung zu geniessen haben möge [mügen crossed out], wie dan **de consuetudine** in Welsch unnd Teutschen landen brauchsam ist das einer als emeritus, nach

24 jaren sein stipendium sein lebenlang genust. Nun hab ich 10 jar drüber gedient, entgegen insonderhait, wöllen Eure *Fürstliche Durchlaut* gnedigist bedencken das neben mir an der khaiserlichen reformation der zeit Mathematicus mit jarlichen besolding 200 fl. angestellet, wellicher (fol 3v) doch dise 34 Jar ein gehalten worden, ich aber alzeit sein staat vertretten müssen, **maxima ex parte pondus et aestum dies tuli**. Dardurch ich dan den onrario in die 6000 fl. erhalten. Das übrige raite ich nicht, weil man mir auff die lezt etlich jar her mit 30 fl mein stipendium gebössert hat aber dise 6000 fl hat man ontmittl müssen außgeben, also dass ich der hohen schuel gleich doppelt so vil in 34 Jaren ersspart als ich selber hab eingenumben. Entgegen aber bin ich erbiettig nicht allain der hohenschuel sonder auch meinnen furressoren da vor mein aigne person soo vil müglich willig und freundtlich zu dienen unnd bestant zu laisten Thue mich also hiemit zum unthertenigisten Eure *fürstliche Durchlaut* **commendieren**.
 Finis.

E.
Payments Relating to the Activities of Dr. Paulus Fabritius and of Some Artists Involved in the Entry of Rudolf II into Vienna, 17 July 1577 (Vienna, Wiener Stadt- und Landesarchiv, Oberkammeramtsrechnungen)

1577 (1/107. Rechnung des Oberkämmerers Michael Startzer, *Ausgaben*)

(fol. 75 v)
Den sechsundzwanzigsten dis [September] Zalt ich dem Larenzen Huebemer, burger und goltschmit alhie, vonwegen gemainer stat wappen, so er in ainen pecher in das deckl gemacht, welichen pecher dem herrn Paulln Fabricium verehrt worden, fünf selben vergulden und macherlohn 1 gulden laut quittung id ist 1 fl. fl.

(fol. 76 r)
Den gedachten sechs und zwanzigisten september zalt ich Franzen Höfleiner, handlman alhie, umb ain silbren vergulden hofpecher, so zway mark vier lot ain quint drei sechzehentail gewegen, thuet in gelt drey und vierzig fund zwelft kreizer, welicher von meinen genedigen herrn dem herrn doctor Paulln Fabricium sambt ain hundert talern, jeden derselben zu 70 khreizern gerechnet, und seiner hausfrauen achtzehen gulden reinisch zun ehrclaid [corrected from *drinkgelt*] wegen seiner gehabten mue unnd verrichter arbait beim dem Werrkh der zwaien ehrnporten alhie verehrt und geschenkt worden, laut seiner bekanntnuss hiebei thuet ain uhundert sibenund siebzig pfund sechs schilling achtund zwansig pfennich Id est 177 fl. 6 sh. 128 dn.

(**Auf die Einblaitunng der Römischen khayserlichen Maiestät** etc.)

(fol. 158v)
No. 848. Den drey unnd zwanzigsten diz [Junii] zalt ich Dionisien von Hallart, Maller alhie, von ainem fann mit dem österreichischen alten und neuen schilt das malerlohn laut seiner quittung hiebei 17 fl.

No. 849. Item den dritten augusti zalt ich Davitten Hüpschman, maler und bürger alhie, wegen ains fann, so er zu Einblaitung der kaiserlichen Mayestät gemalet hat, namblichen (fol. 159r.) ain schwarzen adler mit seiner kaiserlichen cron auf ain gelben daffat, dreyzehen gulden reinisch. Laut seinr quittung hiebey.

No. 851. Den Sibszehnden diz zalt ich Jacoben Mair, burger und maler alhie, vonwegen dass er zu Einbelaittung der Khayserlichen Mayestät ain schwarzen mit ainem vergulden adler auf baiden seiten gemalet hat, laut seiner quittung acht und dreissig gulden reinisch Id est 38 fl.

(fol. 162r)
Auf die Ernporttenn ausgeben:

No. 861. Item den zway und zwainzzigisten junii anno *etc.* siben und sibenzigisten zalt ich Hannsen Spanring, puechfärer alhie, umb ain riss Augspurger regalpapier, die vier puech hab ich in die contorei geben, die übrigen seind zur ehrnporten gepraucht worden, laut quittung geben 3 fl. 6 sh. 22 dn.

No. 862. Den zwanigisten augusti zalt ich Marchs Vogl, Modlschneider alhie, wegen dass er vier tag sambt ainem pueben gyps zu der ehrnporten geprennt hat, laut seiner quittung 1 fl.

No. 863. Den sechsten septembris zalt ich Hannsen Mondt unnd Bartlmeen. Spranger, maler, und Monmacher wegen irer bemüehung der Ehrenportten halber am Graben laut des Ratschlags, dessen datum den funftten tag Septembris anno *etc.* im siben unnd sibenzigistn (fol. 162v) Jer jedem zway hundert gulden reinisch [*sic*] zugeben bevolhen worden, die ich inen an heut dato gegen irer quittung als Par zuegestelt und überantwortt hab, id est 400 fl. [*sic*]

No. 864. Den neunzehnden diez zalt ich Georgen Hass, burger und tischler alhie, wegen seiner müe so er am werk der ehrnporten am Graben gehabt hat, auf sein gethonnes supplicieren und darauf ervolgten ratschlag, dessen datum den sechszehnden septembris anno *etc.* sibenunndsibzigisten, und laut seiner quittung hiebei vierzig pfundt fl.

No. 865. Den 20. diez zalt ich Anthony Moess, Römisch kais. maj. hoftischler, vonwegen seiner gehabten müeh und vleiss an der ehrnporten am Graben laut ratschlag, siben und sibenzigsten vier und zwanzig gulden Reinisch den 16. septembris anno etc. im datiert, und seiner quittung hiebei.

No. 866. Item den vierzehndn tag novembris zalt ich Mathiasen Monmacher wegen der grossen mann, so er zu der ehrnporten am graben (fol. 163r.) gemacht hat, für soliche sein müe ist ime durch herrn burgermaister und rath ain hundert funffzig pfundt zugeben bevolhen worden laut ratschlag dessen datum den fünften tag septembris anno etc. im sibenundsibenzigisten und seiner quittung, id est 150 fl.

No. 867. Item so zalt ich Mathesen Schwarzen, leinbater und burger alhie, umb funf stuck praune leinbat, so man zu der ehrnporten gepraucht hat, haben zusamen gehalten hunderts funffzig Elln, jede Elln per siben kreizer, thuet in gelt sibenzehen pfundt vier shilling pfenning laut quittung. Id est 17 fl. 4 sh. dn.

Summa 636 fl. 2 sh. 22 dn.

[See for these documents also Karl Uhlirz, Urkunden und Regesten aus dem Archive der k.k. Reichshaupt- und Residenzstadt Wien, *Jahrbuch der Kunsthistorischen Sammlungen des Allerhöchsten Kaiserhauses*, 18, 1897, no. 15821, whose transcription differs somewhat, however, from that offered here.]

1578 (1/108. Rechnung des Oberkämmerers Michael Startzer, *Ausgaben*) NO. 1015

(fol. 278r)
No. 1015 Den lezten deto [December] zalt ich ainem Mahller Jacob Grienperkhnn genannt, wegen zwyer Wappen, so er in zwee hofpeher, welche Herr Burgermeister unnd Rath, den ain dem Herrn Doctor Fabrity, unnd den anndern mir obercammerer auf mein jochzeitliche feudt verehret, unnd geschenkeht, gemach unnd geschmehzt hat, für das Malen 12 schilling

Id est 1 schilling 4 dn. [*sic*].

F.
Account of Some of His Early Activities as Physician, Astronomer, and Designer of Clocks by Dr. Paulus Fabritius (from [Paulus Fabritius] *Encomion Sanitatis Recitatum a Paulo Fabricio, Rom. Regis Mathematico, cum Gradu Doctatus in Medicina Ornaretur. Dicatum Magnifico, Virtute et eruditione praestante viro Do. SEBASTIANO magno, Senatori Noribergensi & apud Rom. Regiam Maiestatem tunc Oratorem agenti*, Viennae Austriae X [ante] Calend*as* Aprilis 1557 Raphael Hofhalter)

(Dedication, fol. 1v)
MAGNIFICO VIRO, Domino Sebastiano Magno, Senatori Noribergensi, Patrono suo observando *Salutem Dicit*

Quamvis non dubito, te malle sanitatem in tuo corpore experiri, quam de eius laudibus audire, tamen cum fuerit occasio, ut ego de ea dixerim, orationem, quam habui, ad te mitto. Non equidem ignore, vile hoc esse, et te indignum, sed cum virtutes tuas intueor, spero tibi propter meam in te beneuolentiam gratum fore. Vbi feret occasio, gratum me exhibebo: haec interea sit quaedam grati animi significatio. Haberem quae ad te scriberem, alia, sed nunc relinquo. Hoc addo, (quia tibi meam salutem certo scio curae esse) Regiam Maie*statem* hinc abeuntem ad Comitias, clementissime dignissimo liberalitate Regia. Oro tuam Magnificentiam, vt semina earum stirpium mittat quas domi plantare consueuit. Ego hic etiam addidi Catalogum stirpium quas duobus annis praeteritis circa Viennam inueni: si quid in ijs est, quod petis, ego libenter mittam. Magnificum sapientia et eruditione pra*e*stantem virum, Do. Hieronymum (fol. 2r) Baumgartnerum, cuius nomine me saepe salutasti, salutes precor. Institui editionem Asterimorum, sed iam Regia Maie*stas* sculptorem, quem habui, usurpat: sic sit, vt cogar aliquandiu relinquere opus. De eo opere cum bene sit meritus amicus tuus optimus, Do*minus* Ioannes Newdorfferus, rogo et eundem salutare non graueris. Do*mino* Andreae Wolfio, Quaestori Ratisponi, hospiti tuo, viro integerrimo, paratur iam id, quod ipsius nomine petuisti, Horologium, exigua quantitate est, et sine ambiguitate in eo non modo minuta, sed et secunda scrupula, imo et quindena tertia scrupula notari poterint. Res ipsa indicabit. Priorem orationis meae partem intelliges, si arbitraberis me alicui respondere, de ea, quam noto consuetudine. Iubet tuam Mag. saluere Lauterbachus meus. (fol. 3r) Vale. Viennae 9 [*ante*] Cal*endas* Aprilis 1557.

T. Magnif. Obseruantiss. Paulus Fabricius.

Notes

PREFACE

1. Seneca, *Naturales Quaestiones*, ed. and trans. Thomas H. Corcoran, Cambridge, Mass., and London, 1972, 2, p. 293. Where not otherwise indicated, translations are my own. Kepler cites another similar passage from the same work by Seneca on the title page of his *De cometis libelli tres*, Augsburg, 1619, reprinted in *Gesammelte Werke*, ed. F. Hammer, Munich, 1963, 8, p. 131.

INTRODUCTION

1. For this account of history, see E. H. Gombrich, *The Story of Art*, London and New York, 1950, from which the phrase "conquest of reality" derives. Gombrich's survey may be regarded as representative of the paradigm I am describing, in that it went through eleven editions in English alone by 1966, and then was reprinted every year from 1966 to 1970. Gombrich's thesis is, of course, also fundamental to his influential *Art and Illusion*, which had also gone through three editions by 1969 (see also the Princeton reprinting, 1972).

2. The classic survey of the literature of art also was made current in the 1960s, when it was brought up to date in a new edition: Julius von Schlosser (-Magnino), *La letteratura artistica*, trans. Filippo Rossi (3rd ed.), ed. Otto Kurz, Florence and Vienna, 1964. Moshe Barasch, *Theories of Art from Plato to Winckelmann*, New York and London, 1985, p. 108, gives voice to a prevailing view when he emphasizes that the "student of art theory . . . knows for sure that the theory of the visual arts—in the precise and full sense of the term—is a product of the Renaissance period." Barasch, ibid., pp. 114ff., summarizes the discussion of the "imitation of nature" in the theory of the visual arts.

3. See, especially for these notions in regard to the Italian Renaissance, E. H. Gombrich, "The Leaven of Criticism in Renaissance Art," in *Art Science and History in the Renaissance*, ed. Charles S. Singleton, Baltimore and London, 1967, pp. 3–42, republished as "The Leaven of Criticism in Renaissance Art: Texts and Episodes," in *The Heritage of Apelles. Studies in the Art of the Renaissance*, Oxford and Ithaca, N.Y., 1976, pp. 111–31; idem, "From the Revival of Letters to the Reform of Art; Niccolò Niccoli and Filippo Brunelleschi," in *Essays in the History of Art Presented to Rudolf Wittkower*, eds. Douglas Fraser, Howard Hibbard, and Milton J. Lewine, London, 1967, pp. 71–82, reprinted in *The Heritage of Apelles*, pp. 93–110. These essays are based on the approach enunciated in "Visual Discov-

ery through Art," first given as a lecture in 1965 and published a number of times, most recently in *The Image and the Eye. Further Studies in the Psychology of Pictorial Representation*, Ithaca, N.Y., and Oxford, 1982, pp. 11–39.

4. See Lynn Thorndike, *A History of Magic and Experimental Science* New York, 8 vols., 1923–1958. The account summarized here is found, with variations, in standard texts on the history of science of the 1960s, e.g., Marie Boas, *The Scientific Renaissance 1450–1630*, London and Glasgow, 1962; see also the texts cited in the next note.

5. As presented in standard works of the 1950s and 1960s such as Boas, *The Scientific Renaissance*; Herbert Butterfield, *The Origins of Modern Science*, London, 1950; E. J. Dijksterhuis, *The Mechanization of the World Picture*, trans. C. Dikshoorn, London, 1961; and A. R. Hall, *The Scientific Revolution*, London, 1954; A. C. Crombie, *From Augustine to Galileo*, Harmondsworth, 1969 (first published 1952).

6. It should be understood that the references given here are meant merely to suggest some of the basic works on the topics concerned and do not take into account any subsequent controversies around any of the theses mentioned. To give but one example out of many, E. H. Gombrich has continued to elaborate his theories in response to criticism, e.g. "Representation and Misrepresentation," *Critical Inquiry* 11, 1984, pp. 195–201.

7. This paragraph summarizes Panofsky's important statement first articulated in a lecture given in a series at the Metropolitan Museum of Art, New York, 1951–1952 (initially published in *The Renaissance: A Symposium*, New York, 1953, pp. 77ff.). This thesis had its greatest impact in the revised publication as "Artist, Scientist, Genius: Notes on the 'Renaissance-Dämmerung,'" in *The Renaissance: Six Essays*, New York, 1962, pp. 121–82. As Panofsky himself notes, p. 121, his points are repeated or enlarged upon in his other writings, notably *Renaissance and Renascences in Western Art*, Stockholm, 1960, pp. 1–41.

For an eloquent statement of this theme by another historian whose work exemplifies a larger body of literature, see Joan [Kelly] Gadol, "The Unity of the Renaissance: Humanism, Natural Science, and Art," in *From the Renaissance to the Counter-Reformation. Essays in Honor of Garrett Mattingly*, ed. and intro. by Charles H. Carter, New York, 1965, pp. 29–55.

8. The thesis that art and science part company in the seventeenth century is elaborated by James S. Ackerman, "Science and Visual Art," in Hedley Howell Rhys, ed., *Seventeenth Century Science and the Arts*, Princeton, 1961, pp. 63–90.

9. For the place of Burckhardt's *Civilization of the Renaissance in Italy* (*Die Cultur der Renaissance in Italien: Ein Versuch*, Basel, 1860) and his other writings in the historiography of the Renaissance, until the period discussed here, see Wallace K. Ferguson, *The Renaissance in Historical Thought. Five Centuries of Interpretation*, Cambridge, Mass., 1948.

10. This problem and its roots in history are lucidly discussed by Anthony Grafton, "Introduction: The Humanists Assessed," in *Defenders of the Text: The Traditions of Scholarship in an Age of Science, 1450–1800*, Cambridge, Mass., and London, 1991, pp. 1–22.

11. This position was stated in its most extreme form by George Sarton in "Science in the Renaissance," in J. W. Thompson, G. Rowley et. al., *The Civili-*

zation of the Renaissance, Chicago, 1929. It still informs the works of Boas, *The Scientific Renaissance*, and Hall, *The Scientific Revolution*, and a similar thesis was still being presented in lectures and seminars I attended in the late 1960s and early 1970s.

12. The most recent reassessment of this problem, which has occupied historians for a long time, is provided by Martin Kemp, " 'Disciple of Experience,' " in Martin Kemp and Jane Roberts, with Philip Steadman, *Leonardo da Vinci*, New Haven, Conn., and London, 1989, pp. 12-16.

13. See Erwin Panofsky, *Idea. A Concept in Art Theory*, trans. Joseph J. S. Peake, Columbia, S.C., 1968, especially for the notion of "classicism," pp. 101ff.; the appearance of this translation in the late 1960s made this thesis even more widely accessible. Elizabeth Cropper discusses the impact of Panofsky's interpretation and offers a critique of it in *The Ideal of Painting: Pietro Testa's Düsseldorf Notebook*, Princeton, 1984.

14. Bellori's life of Caravaggio was also made accessible to English-language readers in Walter Friedlaender, *Caravaggio Studies*, Princeton, 1955, a work that, along with Friedlaender's teaching, helped spark a revival of interest in the artist and art related to him in the United States and promoted the idea of his "naturalism." See also on the subject of science and seventeenth-century "naturalism," Ackerman, "Science and Visual Art," pp. 73ff. Bellori is, of course, the writer whom Panofsky also singled out to exemplify classicism in *Idea*, pp. 105ff.

The history of the critical reception of Caravaggio is laid out by Richard E. Spear, "The Critical Fortune of a Realist Painter," in *The Age of Caravaggio*, New York and Milan, 1985, pp. 22-27; see also M. Cutter, "Caravaggio in the Seventeenth Century," *Marsyas* 1, 1941, pp. 89-115.

15. The humanist associations are certainly obvious in the pioneering effort of William S. Heckscher, *Rembrandt's 'Anatomy of Dr. Nicolaas Tulp.' An Iconological Study*, New York, 1958. See also the essays of Edy de Jongh, starting with *Zinne- en minnebeelden in de schilderkunst van de zeventiende eeuw*, Amsterdam, 1967. Opposition to this way of looking at Dutch art seems to lie behind the response of Svetlana Alpers, most comprehensively expressed in *The Art of Describing. Dutch Art in the Seventeenth Century*, Chicago and London, 1983.

16. As represented by the collection of his *Gesammelte Schriften*, ed. Gertrud Bing, 2 vols., Leipzig and Berlin, 1932. Warburg's essays were again made available in the 1960s by a reprint (Nendeln, Liechtenstein, 1969) and an Italian edition (*La rinascita del paganesimo antico*, ed. Gertrud Bing, Florence, 1966). A long-awaited book by E. H. Gombrich, *Aby Warburg. An Intellectual Biography, with a Memoir on the History of the Library by F. Saxl*, London, 1970, also provoked discussion of Warburg's work.

17. This debate centered on the thesis of Hans Baron, as restated in his revised edition of *The Crisis of the Early Italian Renaissance*, Princeton, 1966. See J. E. Seigel, " 'Civic Humanism' or Ciceronian Rhetoric: The Culture of Petrarch and Bruni," *Past and Present* 34, 1966, pp. 3-48, and Baron's response, "Leonardo Bruni: 'Professional Rhetorician' or 'Civic Humanist,' " ibid. 36, 1967, pp. 21-37; see also Seigel, *Rhetoric and Philosophy in Renaissance Humanism. The Union of Eloquence and Wisdom*, Princeton, 1968.

18. In its more explicit form, this was the statement of the Marxist thesis on bourgeois culture of the Renaissance, which also was current in western debates of the 1960s, stimulated by such works as Alfred von Martin, *Sociology of the Renaissance*, trans. W. L. Luetkens, ed. Wallace K. Ferguson, New York, 1963, and especially Frederick Antal, *Florentine Painting and Its Social Background*, London, 1948, to which Millard Meiss responded in a review in the *Art Bulletin* 31, 1949, pp. 143–50; and Arnold Hauser, *The Social History of Art*, trans. Stanley Goodman, London and New York, 1951, and also *The Philosophy of Art History*, Cleveland and New York, 1963, reviewed by Gombrich, *Art Bulletin* 35, 1953, pp. 79–84 (whose currency was extended in "The Social History of Art," *Meditations on a Hobby Horse and Other Essays on the Theory of Art*, London, 1965, pp. 86–94).

19. See, for example, the essays and bibliography assembled by Roy Strong in *Splendor at Court: Renaissance Spectacle and the Theater of Power*, Boston, 1973; Michael Levey, *Painting at Court*, New York, 1971 (based on the Wrightsman Lectures of 1968); and the essays and bibliography in A. G. Dickens, *The Courts of Europe: Politics, Patronage and Royalty 1400–1800*, London, 1977. "The festivals of the Renaissance" evokes the landmark collections of Jean Jacquot, ed., *Les fêtes de la Renaissance*, 3 vols., Paris, 1956–1972.

20. A good idea of the state of debate can be gained from a discussion held in 1973, "The Interplay of Literature, Art, and Science," in Owen Gingerich, ed., *The Nature of Scientific Discovery, A Symposium Commemorating the 500th Anniversary of the Birth of Nicolaus Copernicus*, Washington, D.C. 1975. (This discussion also has personal pertinence in that two of my teachers at the time, Otto von Simson and James S. Ackerman, were participants.)

21. See Michael Baxandall, *Painting and Experience in Fifteenth Century Italy*, Oxford, 1972; also *Giotto and the Orators; Humanist Observers of Painting in Italy and the Discovery of Pictorial Composition 1350–1450*, Oxford, 1971. The impact of especially the latter work can be discerned in an essay not included here: "The Eloquent Artist: Towards an Understanding of the Stylistics of Painting at the Court of Rudolf II," *Leids Kunsthistorisch Jaarboek* 1, 1982 (published 1983), pp. 119–48.

22. Most pertinent in this regard are Frances A. Yates, *Giordano Bruno and the Hermetic Tradition*, Chicago and London, 1964; *The Art of Memory*, Harmondsworth, 1966; *The Rosicrucian Enlightenment*, Boston and London, 1972; the essays collected in *Astraea: The Imperial Theme in the Sixteenth Century*, Boston and London, 1975; and *The Valois Tapestries*, London (2nd ed.), 1975.

23. As represented by "Alberti's Light," in *Studies in Late Medieval and Renaissance Painting in Honor of Millard Meiss*, eds. Irving Lavin and John Plummer, New York, 1978, pp. 1–27; "Leonardo's Eye," *Journal of the Warburg and Courtauld Institutes* 41, 1978, pp. 108–46; "On Early Renaissance Color Theory and Practice," *Studies in Italian Art History* 1, 1980, pp. 11–40. These and other essays related to similar questions have now been collected in *Distance Points*, Cambridge, Mass., 1991.

24. R.J.W. Evans, *Rudolf II and His World. A Study in Intellectual History, 1576–1612*, Oxford, 1973.

25. Frances Yates, "Imperial Mysteries," *New Statesman*, 18 May 1973, p. 735.

26. "The Problem of Northern 'Mannerism': A Critical Review," in *Mannerism: Essays in Music and the Arts*, eds. S. E. Murray and Ruth I. Weidner, West Chester, Pa., 1980, pp. 89–115; "The Eloquent Artist;" *The School of Prague. Painting at the Court of Rudolf II*, Chicago and London, 1988, pp. 90–99. Nevertheless, and in spite of the essays on Arcimboldo collected here and those cited in note 33, this notion still frequently appears, recurring most recently in Giancarlo Maiorino, *The Portrait of Eccentricity: Arcimboldo and the Mannerist Grotesque*, University Park, Pa., 1991.

27. Yates, "Imperial Mysteries."

28. As indicated by the works cited in n. 26.

29. Published as *Variations on the Imperial Theme in the Age of Maximilian II and Rudolf II*, New York and London, 1978.

30. *Drawings from the Holy Roman Empire, 1540–1680: A Selection from North American Collections*, Princeton, 1982; *L'école de Prague. La peinture à la cour de Rodolphe II*, Paris, 1985; *The School of Prague. Painting at the Court of Rudolf II*, Chicago and London, 1988 (revised and expanded version of *L'école de Prague*); *Art and Architecture in Central Europe, 1550–1620. An Annotated Bibliography*, Boston, 1988; *Central European Drawings, 1680–1800. A Selection from American Collections*, Princeton, 1989.

31. See "Introduction" to "Special Issue. The Culture of the Holy Roman Empire, 1540–1680," *Central European History* 18, 1985, pp. 4–13. The catalogues, *Drawings from the Holy Roman Empire* and *Central European Drawings*, have also been accompanied by cultural historical introductions that discuss this isssue.

32. The vast variety of connotations of the word "nature" are indicated in the appendix "Some Meanings of 'Nature,' " in Arthur O. Lovejoy and George Boas, *Primitivism and Related Ideas in Antiquity (A Documentary History of Primitivism and Related Ideas, 1)*, Baltimore, 1935, pp. 447–56. For some of the most common expressions of this idea during the Renaissance, see A. J. Close, "Commonplace Theories of Art and Nature in Classical Antiquity and in the Renaissance," *Journal of the History of Ideas* 30, 1969, pp. 467–86; see also R. G. Collingwood, *The Idea of Nature*, Oxford, 1945, pp. 4–8, 93–113.

33. Other related studies on Arcimboldo include "Arcimboldo au Louvre" *Revue du Louvre et des Musées de France* 27, 1977, pp. 337–42; "The Allegories and Their Meaning [Author's title: "Fantasy and Allegory in Arcimboldo's Art"]," in *The Arcimboldo Effect*, Milan, 1987, pp. 89–108; and "Arcimboldo's Serious Jokes: 'Mysterious but Long Meaning,' " in *The Verbal and the Visual: Essays in Honor of William Heckscher*, New York, 1990, pp. 57–86.

34. In *Variations on the Imperial Theme*, with further references.

CHAPTER 1

1. This paper is based on a lecture composed by the two authors and originally delivered by Thomas DaCosta Kaufmann at the J. P. Getty Museum on 10 January 1990 and then translated into German and delivered by the same lecturer at the University of Zurich on 7 May 1990.

2. Malibu, The J. Paul Getty Museum, Acc. No. 86 MV 527 (shelf no. MS. 20), 150 fols., 6 9/16' x 4 7/8' (16.6 x 12.4 cm). This manuscript has been previ-

ously published by Franz Ritter, "Ein Wiener Schriftmusterbuch aus dem 16. Jahrhundert mit Miniaturmalereien," *Mitteilungen des k.k. österreichischen Museums für Kunst und Industrie. Monatsschrift für Kunstgewerbe*, N.F. II, no. 17, 1887, pp. 336–42; Ernst Kris, "Georg Hoefnagel und der Wissenschaftliche Naturalismus," in A. Weixlgärtner and L. Planiscig, eds., *Festschrift für Julius Schlosser*, Vienna, 1927, p. 244; Ingvar Bergström, *Dutch Still-Life Painting in the Seventeenth Century*, trans. Christina Hedstrom and Gerard Taylor, London, 1956, p. 32; Tibor Szánto, "Ein grosser Schreibkünstler des XVI. Jahrhunderts," *Gutenberg-Jahrbuch*, 1963, p. 38; Theodora Alida Gerarda Wilberg Vignau-Schuurman, *Die Emblematischen Elemente im Werke Joris Hoefnagels*, Leiden, 1969, vol. 1, p. 9, vol. 2, p. 11 n. 3; Kaufmann, *L'école de Prague*, pp. 248–49, cat. no. 9–9; 9.5; Ingvar Bergström, "On Georg Hoefnagel's manner of working with notes on the influence of the Archetypa series of 1592," in *Netherlandish Mannerism*, Stockholm, 1985, pp. 177, 178, fig. 3; Kaufmann, *The School of Prague*, pp. 85, 207–8, cat. no. 9.9; Lee Hendrix, "An Introduction to Hoefnagel and Bocskay's *Model Book of Calligraphy* in the J. Paul Getty Museum," in *Prag um 1600. Beiträge zur Kunst und Kultur am Hofe Rudolfs II.*, Freren, 1988, pp. 110–17; *Prag um 1600. Kunst und Kultur am Hofe Kaiser Rudolfs II.* (exhibition catalogue, Vienna, Kunsthistorisches Museum, 1988–1989), Freren, 1988, pp. 132–33, cat. no. 600 (entry by Thea Vignau-Wilberg).

3. Vienna, Kunsthistorisches Museum, Sammlung für Plastik und Kunstgewerbe, inv. no. 975; for this manuscript see chiefly Wilberg Vignau-Schuurman, *Emblematischen Elemente*, with references to earlier publications. Subsequent publications of this manuscript include *L'école de Prague*, p. 247, cat. no. 9–5; Bergström, "On Georg Hoefnagel's manner of working," pp. 177ff; *The School of Prague*, p. 205, cat. no. 9.5; *Prag um 1600*, pp. 130–32, cat. no. 599.

4. For the background to the view of Rudolf II's patronage presented here, see *The School of Prague*.

5. Oxford, Ashmolean Museum, inv. 56 e: see *Ashmolean Museum Annual Report*, 1951, p. 63; Ingvar Bergström, *Maestros españoles de bodegones y floreros del siglo XVII*, Madrid, 1970, p. 49, fig. 34; idem, "Flower-pieces of Radial Composition in European 16th and 17th Century Art," in *Album Amicorum J. G. van Gelder*, The Hague, 1973, p. 22; *Stilleben in Europa* (exhibition catalogue, Münster, Westfälisches Landesmuseum, 1979–1980, and Baden-Baden, Staatliche Kunsthalle, 1980), 26, 556, no. 3; Laurens J. Bol, " 'Goede onbekenden'. hedendaagse herkenning en waardering van verscholen, voobijgezien en onderschat talent," *Tableau* 3, 1980, p. 445, fig. 10; Fritz Koreny, *Albrecht Dürer und die Tier- und Pflanzenstudien der Renaissance*, Munich (exhibition catalogue, Vienna, Graphische Sammlung Albertina, 1985) (English trans., 1988), pp. 248–49, cat. no. 91; *Prag um 1600* (exhibition catalogue), p. 359, cat. no. 222.

6. See, for example, the inventory references cited in *The School of Prague*, pp. 210, 214. A good discussion of the issue of Hoefnagel's possible independent still lifes is found in Bol, " 'Goede onbekenden,' " pp. 444ff.

7. Bergström, *Dutch Still-Life Painting*, pp. 36ff. Bergström presents the archival and visual evidence for still-life paintings by Hoefnagel. Though one of the existing works that he proposes cannot be credibly attributed to Hoefnagel, in 1989 there came onto the art market in Paris a large still life in miniature that is the size of a painting, signed Hoefnagel and dated 1610—therefore most likely a work

by Joris's son, Jacob. This painting is discussed in my "Addenda Rudolphina," *Annales de la Galerie Nationale Hongroise*, 1991, pp. 141–47.

8. For Savery and other nature painters in Prague, see the summary in *The School of Prague*, pp. 74–89, with further references. Other examples of independent still-life painting in miniature were executed by Netherlandish artists for Rudolf II, including paintings in a manuscript by Jacques de Gheyn II (Paris, Institut Néerlandais), for which see Florence Hopper, "Jacques de Gheyn II and Rudolf II's Collection of Nature Drawings," in *Prag um 1600. Beiträge zur Kunst und Kultur am Hofe Rudolfs II.*, pp. 124–31. See also the studies cited in the next notes.

9. The most extensive comments on these subjects will no doubt appear in the introduction to the facsimile of the Getty manuscript being prepared at the time of writing by Marjorie Lee Hendrix of the Getty Museum and Thea Vignau-Wilberg of Munich and which was to appear in print while this book was in press. We may, however, briefly note some of the general lines of intepretation that have already been made of Hoefnagel's work. In Vignau-Wilberg's dissertation (Theodora Alida Gerarda Wilberg Vignau-Schuurman, *Emblematischen Elemente*), which was devoted chiefly to the Bocskay codex now in Vienna that may be considered a mate to the Getty codex, she discussed at length the humanistic elements in Hoefnagel's emblems, demonstrating both the classical and biblical sources of Hoefnagel's other manuscripts. In Marjorie Lee Hendrix's dissertation ("Joris Hoefnagel and the *Four Elements*. A Study in Sixteenth-Century Nature Painting," Ph.D. dissertation, Princeton University, 1984), which was largely about the Washington manuscripts, she discussed the specific naturalistic qualities of these manuscripts. Hendrix was the first to point out that the sources of most of the images had been taken not directly from observation of nature but from earlier Netherlandish and German illustrations. In this regard Hendrix transformed the older discussion of Hoefnagel's work, which had, in fact, specifically evoked the Getty manuscript, as products of scientific naturalism. While correcting this earlier view, Hendrix emphasized the ornamental quality of Hoefnagel's designs—something we can appreciate from the way the marginal decoration of the Getty manuscript often functions to set off the text. Both of these authors have also discussed the general symbolic content of Hoefnagel's works. To their comments, interpretations of the philosophical, that is, Neostoic, politically moderate, religious, and rhetorical aspects of the manuscripts have been added as a kind of competitive emulation of earlier sources: see chaps. 3 and 6 of the present book.

10. The most comprehensive discussion of this question remains the still unpublished dissertation of Hendrix, "Joris Hoefnagel and the *Four Elements*," which is in part corrected by Peter Dreyer, "Zeichnungen von Hans Verhagen dem Stummen von Antwerpen. Ein Beitrag zu den Vorlagen der Tierminiaturen Hans Bols und Georg Hoefnagels," *Jahrbuch der Kunsthistorischen Sammlungen in Wien*, 82/83, 1986/87 (published 1989), pp. 115–44. See also Dagmar Thoss, "Georg Hoefnagel und seine Beziehungen zur Gent-Brügger Buchmalerei," ibid., pp. 199–211.

11. The relation of Hoefnagel's use of *trompe l'oeil* devices to that of the earlier tradition of book illumination in Hoefnagel's additions to the fifteenth-century Hours of Philip of Cleves is noted by Léon Delaissé, *Le siècle d'or de la miniature*

flamande, (exhibition catalogue, Brussels, 1959), cat. no. 274; Bol, " 'Goede Onbekenden,' " p. 444; *Quinze années d'acquisitions*, Brussels, 1969, no. 93; Thea Vignau-Wilberg, "Die Randilluminationen und Initialen," in *Das Gebetbuch Kurfürst Maximilians I. von Bayern. Bayerische Staatsbibliothenk München Clm 23646*, Frankfurt and Stuttgart, n.d. (1986), p. 85 and n. 15, and Thoss, "Georg Hoefnagel und seine Beziehungen zur Gent-Brügger Buchmalerei," art. cit. Neither Vignau-Wilberg nor Thoss cite the discussion of this issue in Bol or in Hendrix, "Joris Hoefnagel and the *Four Elements*," pp. 37–39, 84 n. 28, 17, 209 n. 7.

12. New York, Pierpont Morgan Library, M 944: Colin Eisler, intro., *The Prayer Book of Michelino da Besozzo*, New York, 1981.

13. Chantilly, Musée Condé, MS. 28, fol. 168v: for a convenient illustration see Millard Meiss, *French Painting in the Time of Jean de Berry: The Limbourgs and Their Contemporaries*, London, 1974, plate vol., ill. 592.

14. New York, Pierpont Morgan Library, M. 917 and M. 945: John Plummer, *The Hours of Catherine of Cleves*, New York, 1966; F. Gorissen, *Das Stundenbuch der Katharina von Kleve: Analyse und Kommentar*, Berlin, 1973; R. G. Calkins, "Parallels between Incunabula and Manuscripts from the Circle of the Master of Catherine of Cleves," *Oud Holland* 92, 1978, pp. 137–60; idem, "Distribution of Labor: The Illuminators of the Hours of Catherine of Cleves and Their Workshop," *Transactions of the American Philosophical Society* 69, 1979, part 5; A. Châtelet, *Les primitifs hollandais: la peinture dans les Pays-Bas du Nord au XVe siècle*, Fribourg, 1980, pp. 51–59; *The Golden Age of Dutch Manuscript Painting* (exhibition catalogue, New York, Pierpont Morgan Library, 1990), no. 45–46, pp. 152–57.

15. Utrecht, Universiteitsbibliotheek, Ms. 400: *The Golden Age of Dutch Manuscript Painting*, (exhibition catalogue, New York, Pierpont Morgan Library, 1990), no. 48, pp. 160–70, ill. 77.

16. Anne H. Van Buren, "The Master of Mary of Burgundy and His Colleagues. The State of Research and Questions of Method," *Zeitschrift für Kunstgeschichte* 38, 1975, p. 309.

17. Erwin Panofsky, *Early Netherlandish Painting. Its Origins and Development*, Cambridge, Mass., 1953, p. 28.

18. Otto Pächt, *The Master of Mary of Burgundy*, London, 1948, especially pp. 19, 25ff.

19. Ibid., p. 19.

20. Ibid., p. 26.

21. Van Buren, "Master of Mary of Burgundy," p. 288.

22. Sixten Ringbom, *From Icon to Narrative* (Acta Academiae Aboensis, ser. A, vol. 31, nr. 2), Åbo, 1965, pp. 198ff.

23. Clark Hulse, *The Rule of Art. Literature and Painting in the Renaissance*, Chicago and London, 1990, p. 53.

24. Van Buren, "Master of Mary of Burgundy," p. 288.

25. Pächt, *Master of Mary of Burgundy*, p. 42.

26. For Pächt's argument, see his *Master of Mary of Burgundy*, p. 32.

27. Ibid., pp. 32, 42.

28. Van Buren, "Master of Mary of Burgundy," p. 306; also Vignau-Wilberg, "Die Randilluminationen und Initialen," pp. 97, 101–4.

29. Frank Büttner, "Ikonographisches Eigengut der Randzier in spätmittelalterlichen Handschriften: Inhalte und Programme," *Scriptorium* 48, 1974, pp. 197–224ff.

30. Hulse, *The Rule of Art*, pp. 49ff.

31. For similar arguments regarding the patronage of liturgical or devotional objects, see Heidi (Virginia) Roehrig Kaufmann et al., *Eucharistic Vessels of the Middle Ages*, (exhibition catalogue, Cambridge, Mass., Busch-Reisinger Museum, 1975), pp. 14–15; Elisabeth Klemm, "Die Regensburger Buchmalerei des 12. Jahrhundert," in *Regensburger Buchmalerei. Von frühkarolingischer Zeit bis zum Ausgang des Mittelalters* (exhibition catalogue, Munich, Regensburg, 1987), pp. 42–43.

32. Virginia Reinburg, "Prayer and the Book of Hours," in Roger Wieck, *Time Sanctified. The Book of Hours in Medieval Art and Life* (exhibition catalogue, Baltimore, Walters Art Gallery, 1988), pp. 39–44, esp. p. 40.

33. It has been argued that they had this freedom because they were relatively free from liturgical bounds or clerical control: Ringbom, *Icon to Narrative*, p. 31.

34. Kurt Köster, "Religiöse Medaillen und Wallfahrts-Devotionalien in der flämischen Buchmalerei des 15. und frühen 16. Jahrhunderts. Zur Kenntnis gemalter und wirklicher Kollektionen in spätmittelalterlichen Gebetbuch-Handschriften," in *Buch und Welt. Festschrift für Gustav Hofmann zum 65. Geburtstag dargebracht*, Wiesbaden, 1965, pp. 459–532, and idem, "Kollektionen metallener Wallfahrts-Devotionalien und kleiner Andachtsbilder, eingenäht in spätmittelalterliche Gebetbuch-Handschriften," in *Das Buch und sein Haus I. (Festschrift Gerhard Liebers)*, Wiesbaden, 1979, pp. 77–130.

35. Joachim M. Plotzek, *Andachtsbücher des Mittelalters aus Privatbesitz* (exhibition catalogue, Cologne, Schnütgen Museum, 1987), pp. 51–54.

36. Köster, "Metallener Wallfahrts-Devotionalien," p. 110, makes this point about provenance.

37. Vienna, Österreichische Nationalbibliothek, MS. ser. nov. 2596, fol. 1v: Köster, "Medaillen," pp. 485–86; Otto Pächt and Dagmar Thoss, *Die illuminierten Handschriften der ÖNB: Französische Schule*, vol. I, Vienna 1974, text, p. 130, pl. nos. 191 and 221; Köster, "Metallener Wallfahrts-Devotionalien," p. 107.

38. Brussels, Bibliothèque Royale, MS. 11035, fol. 6v: Frederic Lyna, "Un livre de prières inconnu de Philipppe le Hardi (Bruxelles, MS. 11035–37)," *Mélanges Hulin de Loo*, Brussels, 1931, pp. 249–59; Camille Gaspar and Frederic Lyna, *Les principaux manuscrits à peintures de la Bibliothèque Royale de Belgique*, 2 vols. Paris, 1937 and 1945, I, pp. 419–23, II, pl. xcviiia; *Trésors de la Bibliothèque Royale de Belgique*, Brussels, 1958, p. 43f., no. 19; Köster, "Metallener Wallfahrts-Devotionalien," pp. 87–95.

Another example from this period is provided by the special devotion of members of the House of Burgundy to the Holy Face (Vera Icon). For instance, Margaret of Bavaria was well known for adding devotional images of the Veronica to her books of hours: see Millard Meiss, *French Painting in the Time of Jean de Berry: The Late Fourteenth Century and the Patronage of the Duke*, London and New York, 1967, p. 201, ill. 666; and Gaspar and Lyna, ibid., pp. 403, 421.

39. Vienna, Österreichische Nationalbibliothek, Cod. ser. nov. 2624: Eduard von Sacken, *Die K. K. Ambraser-Sammlung*, vol. 2, Vienna, 1855, p. 211; Köster,

"Medaillen," pp. 486–87; Köster, "Metallener Wallfahrts-Devotionalien," pp. 108–10.

40. Princeton University Library, Garrett MS. 59: Philip Webber, "Medieval Netherlandic Manuscripts in Princeton University Library," *Archief- en Bibliotheekwezen in Belgie* 53, 1982, pp. 101–5; Adelaide Bennett, Jean Preston, and William Stoneman, *Dei Sub Numine Viget: A Selection of Religious Medieval Manuscripts at Princeton*, forthcoming.

41. For a consideration of the notion of devotionalia, see Lenz Kriss-Rettenbeck, "Zur Bedeutungsgeschichte der Devotionalien," in *Umgang mit Sachen. Zur Kulturgeschichte des Dinggebrauchs (Regensburger Schriften zur Volkskunde* 1), Regensburg, 1983, pp. 213–34.

42. A similar phenomenon has been recorded with respect to objects collected at Buddhist pilgrimage sites (S. Tambiah, *Forest Monks and the Cult of Amulets*, Cambridge, Mass., 1985). For help with anthropological evidence, James Boon of Princeton University and Luis Millones, Lima, Peru are to be thanked.

43. See Lens and Ruth Kriss-Rettenbeck and Ivan Illich, "HOMO VIATOR— Ideen und Wirklichkeiten," in *Wallfahrt kennt keine Grenzen. Themen zu einer Ausstellung des Bayerischen Nationalmuseums und des Adalbert Stifter Vereins, Munchen*, Munich and Zurich, 1984, pp. 10–22; and David Freedberg, *The Power of Images. Studies in the History and Theory of Response*, Chicago and London, 1989, pp. 99–135.

44. Brussels, Bibliothèque Royale, MS. IV 40: Eduard Laloire, "Le livre d'heures de Philippe de Cleves et de la Marck, Seigneur de Ravestein," Les arts anciens de Flandres I, Brussels, 1906, pp. 172–87; Köster, "Medaillen," pp. 464–65; *Quinze ans d'acquisition* (exhibition catalogue, Brussels, 1969), no. 93; Bol, " 'Goede onbekenden,' " p. 444, ill. 9; Hendrix, "Joris Hoefnagel and *The Four Elements*," pp. 37–39, 175; Vignau-Wilberg, "Die Randilluminationen und Initialen," pp. 85–87; Thoss, "Georg Hoefnagel und seine Beziehungen zur Gent-Brügger Buchmalerei," art. cit.

45. Oxford, Bodleian Library, MS. Douce 311: Otto Pächt and J.J.G. Alexander, *Illuminated Manuscripts in the Bodleian Library Oxford*, 1. *German, Dutch, Flemish, French and Spanish Schools*, Oxford, 1966, no. 362, p. 27; Köster, "Medaillen," pp. 465–67; Wescher, "Beiträge zu Sanders und Simon Bening und Gerard Horenbout," *Festschrift Friedrich Winkler*, 1959, pp. 126–35; Pächt, *Master of Mary of Burgundy*, p. 60.

46. Köster, "Medaillen," and idem, "Gemalte Kollektionen von Pilgerzeichen und religiösen Medaillen in flämischen Gebet-und Stundenbüchern des 15. und frühen 16. Jahrhuderts. Neue Funde in Handschriften der Gent-Brügger Schule," in *Liber Amicorum Herman Liebaers*, eds. Frans Van Wijngaerden et al., Brussels, 1984, pp. 485–517.

47. Munich, Bayerische Staatsbibliothek, Cod. Lat. 28345: F. Winkler, *Die flämische Buchmalerei des XV. und XVI Jahrhunderts*, Leipzig, 1925, p. 187; Köster, "Medaillen," pp. 469–71.

48. With gratitude to Adelaide Bennett Hagens for sharing this observation with respect to Garrett ms 59 of the Firestone Library, Princeton University (see n. 40).

49. Köster has identified many of the badges illustrated in books of hours and provided a catalogue of the most frequently identified badges; "Medaillen," pp. 489–99.

50. Brussels, Bibliothèque Royale, MS. II 5941: Köster, "Medaillen," p. 476.

51. Plotzek, *Andachtsbücher*, p. 52. The importance of Plotzek's suggestion is emphasized in a review by Virginia Roehrig Kaufmann, in *Speculum* 65, 1990, p. 487.

52. For overviews of Marian devotion, see L. S. Beissel, *Die Geschichte der Verehrung Marias in Deutschland während des Mittelalters*, Freiburg i. B., 1909, and Hilda Greiff, *Mary. A History of Doctrine and Devotion*, London and New York, 1964.

53. Lisbon, Calouste Gulbenkian Foundation, inv. L.A. 210: Köster, "Medallien," pp. 474–76.

54. Köster, "Metallener Wallfahrts-Devotionalien," p. 108.

55. Virginia Reinburg, "Popular Prayers in Late Medieval and Early Reformation France" unpublished doctoral dissertaion, Princeton University, 1985, passim; Plotzek, *Andachtsbücher*, pp. 51–52, 83ff.

56. James Marrow has generously provided this information regarding his unpublished discoveries of flowers and insects in books of hours.

57. In his comments on the botanical and horticultural aspects of Hoefnagel's Getty codex, to appear in the commentary on the facsimile publication of the manuscript in press at the time of writing, D. Onno Wijnands notes that the "tradition of preserving plant specimens in a *herbarium siccum* originated in Tuscany during the time of Luca Ghini's (1490–1556) teaching at Bologna and Pisa."

58. Heidrun Ludwig has kindly pointed out that *Blütenblätter* are found pressed in the pages of an anonymous flower book of the eighteenth century that also contains paintings of flowers and plants: (library of the) Germanisches Nationalmuseum, Nuremberg, 2* Hs. 137 689, fols. 26 and 104.

59. For other relevant aspects of man's changing relation to nature, see Keith Thomas, *Man and the Natural World. Changing Attitudes in England 1500–1800*, London, 1983, especially pp. 223–41 for attitudes toward plants and flowers.

60. See Lenz Kriss-Rettenbeck, *Ex Voto. Zeichen Bild und Abbild im christlichen Votivbrauchtum*, Zurich and Freiburg i. Br., 1972, pp. 36–39.

61. See, for example, Josef Zihlmann, "Was sie von Einsiedeln heimbrachten. Religiös-Volkskundliches über Wallfahrtsandenken," in *Der Hinterländer. Heimatkundliche Beilage des Willisauer Boten* 14, nr. 5, 1976, pp. 33–37 (Professor P. C. Claussen provided assistance, gratefully acknowledged, in obtaining a copy of this article); also Kris-Rettenbeck et al., "Homo Viator," p. 15, with further references p. 21 n. 36 and 44.

62. Anthropological evidence from non-European pilgrimage sites provides further evidence that flowers and other naturalia collected at pilgrimage sites have been considered holy. Sites abound in South America, for example, where flowers are picked and sold as devotional objects, according to Professor Luis Millones.

63. Marie-Humbert Vicaire, "Les trois itinérances du pèlerinage au XIIIe et XIVe siècle," in *Le pèlerinage* (*Cahiers de Fanjeaux* 15), Toulouse et Fanjeaux,

1980, p. 18: "On peut définir le pèlerinage de façon tout à fait genérale: une marche pour motif religieux. Comme tel, le pèlerinage est une prise de possession de l'espace dans une intention et par un comportement religieux, une sacralisation de cet espace et des gestes qui s'efforcent de le dominer."

For more on the relation of images and pilgrimage, see Victor Turner and Edith Turner, *Image and Pilgrimage in Christian Culture. Anthropological Perspectives*, New York, 1978.

64. Vienna, Österreichische Nationalbibliothek, Cod. 2730: Thoss, "Georg Hoefnagel," pp. 204ff., ill. 115, 221; idem, *Flämische Buchmalerei. Handschriftenschätze aus dem Burgunderreich*, (exhibition catalogue, Vienna, Österreichische National bibliothek, 1987), no. 84, pp. 130–31, ill. 103.

65. Munich, Bayerische Staatsbibliothek, Clm. 23240: Thoss, "Georg Hoefnagel," pp. 204ff., ill. 214.

66. See further Mary Carruthers, *The Book of Memory: A Study of Medieval Memory Culture*, Cambridge, 1990, pp. 246–48.

67. This point should be emphasized because Wijnands wishes to consider Hoefnagel's collection of drawings of living plants a *herbarium vivum coloribus pictum*, which mimics a *herbarium siccum*. Yet Hoefnagel's plants are, in fact, different from these other examples in that they are shown as alive rather than dried, and in this regard they can be better compared not to the tradition of the herbal but to that of the book of hours. Moreover, the illusionistic devices found in this sort of book antedate the origins of the *herbarium siccum*. (The Hours of Philip of Cleves must date from the 1480s at the latest.)

68. For a treatment of the origins of *Stammbücher* in this regard, see Peter Amelung, "Die Stammbücher des 16./17. Jahrhunderts als Quelle der Kultur- und Kunstgeschichte," in *Zeichnung in Deutschland. Deutsche Zeichner 1540–1640*, ed. Heinrich Geissler (exhibition catalogue, Stuttgart, Staatsgalerie, 1979–1980), 2, pp. 211–22, with extensive references. Hulse, *The Rule of Art*, pp. 41ff., regards emblem books as having replaced books of hours.

69. For Hoefnagel's beliefs, see Vignau-Wilberg Schuurman, *Emblematischen Elemente*; Hendrix, "Joris Hoefnagel and the *Four Elements*"; and chap. 3 below.

CHAPTER 2

1. For the importance of the perception of light and shadow in painting, see Ralph M. Evans, *An Introduction to Color*, New York, 1948, pp. 92ff.; for problems of transmitting perceived into painted light, see E. H. Gombrich, *Art and Illusion*, especially the chapter "From Light to Paint." Wolfgang Metzger, *Gesetze des Sehens*, Frankfurt a. M., 1953, discusses the role of shadows in perception; Rudolf Arnheim, *Art and Visual Perception*, London, 1969, pp. 300ff., discusses their role in giving clues to the source of light and to the third dimension.

2. This subject was treated in the M. Phil. thesis that provided the basis for the initial publication of this chapter, "Theories of Light in Renaissance Art and Science 1400–1600, London, 1972; this thesis also contained a discussion of the relation of theory to painters' practice, including that of Van Eyck and Campin and offered a bibliography of previous works. Paul Hills, *The Light of Early Italian*

Painting, New Haven, Conn., and London, 1987, presents a general treatment of the topic and further bibliography.

For a discussion of light in art theory, see Moshe Barasch, *Light and Color in the Italian Renaissance Theory of Art*, New York, 1978; this work complements the detailed examination in idem, "Licht und Farbe in der italenischen Kunsttheorie der Cinquecento," *Rinascimento* 11, 1960, pp. 267–360. See also Jonas Gavel, *Colour. A Study of Its Position in the Art Theory of the Quattro- & Cinquecento* (Stockholm Studies in the History of Art, 32), Stockholm, 1979. Additional bibliography is provided in Marcia Hall, ed., *Color and Technique in Renaissance Painting*, Locust Valley, N.Y., 1987, which also contains a number of pertinent essays.

A fundamental bibliography, with discussion, of perspective and related issues is available in Luigi Bagnetti, *De naturali et artificiali perspectiva—bibliografia ragionata delle fonti teoriche e delle ricerche di storia della prospettiva (Studi e Documenti di Architectura*, no. 9–10, March 1979). The most thorough treatment of perspective, light, and color in European art and art theory from the fifteenth century is now given by Martin Kemp, *The Science of Art. Optical Themes in Western Art from Brunelleschi to Seurat*, New Haven, Conn., and London, 1990.

3. Giovanni Battista Armenini, *De' veri precetti della pittura*, Rome, 1587, reprinted New York, 1971, pp. 80f; Giorgio Vasari, *Le vite de' più eccelenti pittori, scultori ed architettori*, ed. Gaetano Milanesi, 7, Florence, 1881, pp. 663, 685, et passim; Cristoforo Sorte, *Osservationi nella pittura*, Venice, 1580, pp. 111ff. For the general concern of Renaissance art with problems of light effects in painting, see E. H. Gombrich, "The Leaven of Criticism in Renaissance Art," pp. 33–34; the painting of night scenes, a growing concern in sixteenth-century writing on art, is discussed in Renate Breustedt, "Die Entstehung und Entwicklung des Nachtbildes in der adendländischen Malerei und seine Ausbreitung in den Niederlanden," Dissertation, Göttingen, 1966.

4. Roland Rood, *Color and Light in Painting*, New York, 1941, pp. 20ff, 30, 61ff. develops the concept of inhibition in perception of shadows.

5. It has been shown experimentally that over the range of differences in illumination to which the eye adapts, some observers will tend to look at surfaces and others at light intensities. Thus some observers will notice the differences in illumination within a scene and perceive the shadow as a dark object, something solid and opaque within the visual field; others will look into a shadow, as if at an object through some liquid, and notice the qualities of the objects in more detail; others will concentrate on focusing attention on the object within the shadow to the extent that the shadow disappears. See Rood, *Color and Light in Painting*, pp. 61ff.; Evans, *Introduction to Color*, pp. 162f.

6. Experiments in which subjects were shown shadows of objects but not the objects themselves demonstrate that when the outlines of shadows were sharp and the brightness contrast high, the shadows were perceived as things; when the outlines were unclear and the brightness contrast low, the shadows were perceived as blurs or spots on a screen. See M. D. Vernon, *A Further Study of Visual Perception*, Cambridge, 1951, p. 43.

7. For a discussion of the ambiguities of interpretation that can arise from the perception of shadows and conventions for representing them, see Gombrich, *Art and Illusion*, pp. 267–70, and Metzger, *Gesetze des Sehens*, pp. 377ff.

8. Cennino D'Andrea Cennini, *Il libro dell'arte*, ed. and trans. Daniel V. Thompson Jr., New Haven, Conn., 1933, chap. 8, p. 6. For the application of this principle in painting, see Eduard Flechsig, "Die Lichtführung, ein nicht beachtes Hilfsmittel der Forschung," *Zeitschrift für Kunstgeschichte* 8, 1939, pp. 41–51.

9. Cennini, *Libro dell'arte*, ed. cit., chap. 7, p. 5; Paolo Pino, *Dialogo di pittura*, Venice, 1548, fol. 18r.

10. See Paris, Bibliothèque Nationale, MS. Ashburnham 2038, fol. 33r, quoted in *The Literary Works of Leonardo da Vinci*, ed. Jean Paul Richter, London, 1970 (3rd ed.), 1, no. 515 (hereafter Richter). Translations of Leonardo are taken from Richter.

11. Vasari, *Vite*, ed. cit., 1, pp. 176f.; 7, pp. 490ff.

12. Carlo Ridolfi, *Le Meraviglie dell'arte ovvero le vite degli illustri pittori Veneti e dello stato*, ed. Dietrich von Hadeln, Berlin, 1924, 2, pp. 14–15.

Edward J. Olszewski, "Distortions, Shadows, and Conventions in Sixteenth Century Italian Art," *artibus et historiae* 11, 1985, pp. 101–24, assembles much visual and textual evidence for the copying of shadows as a workshop practice, and argues that the distortions thereby observed stimulated formal inventiveness, in particular the taste for figural elongation. As Olszewski also suggests, however, p. 10, "The artists in the studio, therefore, as they work under conditions of artificial light, can only observe distortions in the shadows cast by their models." For this reason it would be difficult to develop from this sort of observation of models a procedure for shadow projection of regular solids. Indeed the use of shadow projection for the construction of anamorphic images is discussed by Jurgis Baltrušaitis, *Anamorphic Art*, New York, 1977, pp. 30–32, 79–82; Kim H. Veltman, in collaboration with Kenneth D. Keele, *Studies on Leonardo Da Vinci I: Linear Perspective and the Visual Dimensions of Science and Art*, Munich, 1986, pp. 144–46; and George Bauer, "Experimental Shadow Casting and the Early History of Perspective," *Art Bulletin* 69, no. 2, p. 215.

13. Giovanni Paolo Lomazzo, *Trattato dell'arte della pittura, scultura, ed archittetura*, Milan, 1585, pp. 211, 228. (This edition, to which reference is made in this book, has identical pagination with the rarer first edition of 1584.) Lomazzo could have known Geminos's definitions from the Latin translation of Conrad Dasypodius, printed as a work of Hero of Alexandria on the terms of geometry, in *Oratio Cunradi Dasypodii de Disciplinis mathematics. Eiusdem Hieronis [sic] Alexandrini Nomenclaturae vocabulorum geometricorum translatio. Eiusdem Lexicon mathematicum ex diversis collectum antiquis scriptis*, Strassburg, 1579, fol. 17v. Geminos's definition is not, however, identical with Lomazzo's; see n. 29 below.

14. Lomazzo, *Trattato*, pp. 254f. Lomazzo's discussion of perspective is handled in Kemp, *Science of Art*, pp. 83–84.

15. Leon Battista Alberti, *On Painting and On Sculpture*, ed. and trans. Cecil Grayson, London, 1972, p. 47.

Ackerman, "Alberti's Light" (now in *Distance Points*, pp. 59–99), especially pp. 15–17, acknowledges its indebtedness to the previous presentation of this chapter.

Barasch, *Light and Color*, p. 20, however, suggests that Alberti's observations are based on workshop practice, and relates this distinction to a contemporary differentiation between rational (natural) illumination and irrational light effects. Olszewski, "Distortions," pp. 107–8, 124 n. 30, follows Barasch.

16. Alberti, *On Painting*, p. 63.

17. Ibid, p. 73.

18. Bibliothèque Nationale, MS. Ashburnham 2038, fol. 17v (Richter, 1, no. 661); Pino, *Dialogo*, fol. 21v. For the history of the legend, see Kurz and Kris, *Die Legende vom Künstler*, Vienna 1934, p. 79. Gavel, *Colour*, p. 57, also discusses this subject.

For the story of the representation of the legend in art, see Robert Rosenblum, "The Origin of Painting: a Problem in the Iconography of Romantic Classicism," *Art Bulletin* 39, 1957, pp. 279–90.

19. For the meaning of σκιαγραφία in antiquity, see Richard Schöne, "Σκια-γραφία," *Jahrbuch des Deutschen Archaeologischen Instituts* 27, 1912, pp. 19–23; and Ernst Pfuhl, "Skiagraphy," ibid., pp. 227–31.

20. For the history of the sundial, see Hermann Diels, "Die antike Uhr," in *Antike Technik*, Leipzig, 1920; for shadows and the σκαφή, see the remark by Albert Lejeune, *Euclide et Ptolemée, deux stades de l'optique géométrique grecque*, Louvain, 1948, p. 62.

21. The altimetric procedure is Proposition 18 of Euclid's *Optics*. On Thales and attempts at altimetric measurement, see Sir Thomas Heath, *A History of Greek Mathematics*, 1, Oxford, 1921, pp. 129–30, and 2, pp. 1–15. Eratosthenes' calculations are described by Vitruvius in bk. i, chap. 6, of his *De architectura* (*Vitruvius on Architecture*, ed. and trans. Frank Granger, Cambridge, Mass., 1931, pp. 58ff.), where, in a passage that seems to anticipate later discussions of the shadows caused by light coming from different parts of the sky, he tries to determine the points of the compass on the basis of cast shadows. Aristarchus's treatise *On the Sizes and Distances of the Sun and Moon*, ed. Sir Thomas Heath, *Aristarchus of Samos, the Ancient Copernicus*, Oxford, 1913, is based implicitly on the assumption that the sun's rays are parallel to each other. A good general treatment of ancient astronomy is D. R. Dicks, *Early Greek Astronomy to Aristotle*, London, 1970.

22. *Claudii Ptolemaei Opera Astronomica Minora*, ed. J. L. Heiberg, Leipzig, 1907; Heath, *History of Greek Mathematics*, 2, pp. 286–93.

23. On the astrolabe, see Henri Michel, *Traité de l'astrolabe*, Paris, 1947, particularly pp. 27–29; and Lejeune, *Euclide et Ptolemée*, p. 62.

24. In his work on optics, *Questiones de Perspective* [sic] begun c. 1390, Biagio Pelacani da Parma (Blasius Pelicanus Parmensis) says that Ptolemy "made a treatise about the projection of bodies on a plane, which doctrine he took from the knowledge he had about shadows," published in Graziella Federici Vescovini, "Le questioni di perspectiva di Biagio Pelacani," *Rinascimento* 1, 1961, pp. 242–43. I have also consulted two of the available manuscripts for Pelacani's treatise: Florence, Biblioteca Laurenziana, Plut. 18–29, and MS. Ashburnham 1042, where his complete remarks on shadows can be found. The passage quoted is located on fol. 143v of MS. Ashburnham 1042.

Subsequently Kim Veltman, "Ptolemy and the Origins of Linear Perspective," in Marisa Dalai Emiliani, ed., *La prospettiva Rinascimentale, codifcazioni & trasgressioni*, 1, Florence, 1980, pp. 403–7, has also stated that shadow projection was used in the production of the astrolabe.

25. Nicephorus Gregoras defines painting as the delineation of a sphere on a flat plane in his *Astrolabica*, a Byzantine work in the Ptolemaic tradition. He may

be connecting painting with Ptolemy's methods of stereographic projection when he says, "Just as painters seek to imitate objects exactly . . . so too the geometricians and astronomers delineate on a flat plane solid objects, such as octahedrons and cubes and all spherical bodies, like the stars, the heavens, and the earth" (quoted in Cyril Mango, ed. and trans., *Art of the Byzantine Empire, Sources and Documents*, Englewood, N. J., 1972, p. 254).

26. According to Serenus, Peithon had defined parallel lines by means of a "more reasonable" example, stating that they are the lines formed on walls or the ground by the shadows of columns opposite burning torches or lamps. Peithon's argument had apparently been received with ridicule, and Serenus's defense of him is not entirely intelligible; it may be that his text is corrupt, or that both Peithon and he were wrong. See Serenus of Antinöe, *Le livre du cylindre et le livre de la section du cone*, ed. and trans. Paul Ver Eecke, Paris, 1969, p. 54.

27. Ibid., Propositions xxix and xxx, pp. 58, 63. Serenus admits that the outlines of the shadows will not seem parallel, and states that he is assuming that the source of light is a point, which of course could hardly produce parallel shadows.

28. Ibid., Proposition xxx, p. 64; for Serenus, see also Lejeune, *Euclide et Ptolemée*, p. 62, and Heath, *History of Greek Mathematics*, 2, p. 521.

At the end of *De Statua*, ed. cit. Grayson, pp. 138–39, Alberti compares the sections of a human body to the sections of a cylinder seen in shadow projection. While noting, p. 142, that this passage "has the air of an afterthought," Grayson also remarks that "the content of this addition is of particular importance for the painter who represents a section of a body on canvas." Alberti's remarks also closely recall the passage in Serenus, and in view of this fact, it would seem reasonable to investigate the possibility that the tradition continued for the use of shadow casting in projective geometry. Bauer, who deserves credit for calling attention to Alberti's passage, "Experimental Shadow Casting," p. 211, argues, however, that Alberti's text "offers a rare glimpse of the experiments that preceded and led to the formulation of Renaissance perspective."

29. *Damianos Schrift über Optik, mit Auszügen aud Geminos*, ed. Richard Schöne, Berlin, 1897, p. 26. Geminos's definitions read: ἕτερον δὲ τὸ τε θεωροῦν τὰ συμβαίνοντα περὶ τὰς τοῦ ἡλίου ἀκτῖνας ἔν τε κλάσει καὶ φωτισμοῖς αὐτοῖς καὶ σκιαῖς οἷον ὁποία τις ἡ διορίζουσα γραμμὴ τὴν σκιὰν ἐν ἑκάστῳ σχήματι γίνεται. For more on Geminos and ancient theories of light in general, see Arthur Erich Haas, "Antike Lichttheorie," *Archiv für Geschichte der Philosophie*, 20, 1906–1907, pp. 345–86.

30. *Euclidis Optica: Opticorum Recensio Theonis*, ed. J. L. Heiberg, Leipzig, 1895, pp. 144–47.

31. See Lejeune, *Euclide et Ptolemée*, p. 62, for this last point about *umbra* and *penumbra*. Both geometric optics and astronomy depend logically upon the notion of clearly defined lines, whether of luminous rays or of shadows' outlines.

32. For the Arabic traditon of "book of shadows" and "authors of shadows," I rely on the discussion of A. I. Sabra, *The Optics of Ibn Al-Haytham*, London, 1989, 2 (*introduction, commentary, glossaries, concordance, indices*), p. xlviii.

The text of Al-Biruni is available in a translation with commentary by E. S. Kennedy, *The Exhaustive Treatise on Shadows by Abu Al Rayhan . . . al-Biruni*, Aleppo, 1976, 2 vols.; the pertinent comments in his dedication appear in 1, p. 1; see also ibid., 2, p. 1, for a commentary on these remarks.

33. The present summary of Al-Haytham's treatise derives from the translation available in Eilhard Wiedemann, "Über eine Schrift von Ibn Al-Haitam, 'Über die Beschaffenheit des Schattens,' " *Beiträge zur Geschichte der Naturwissenschaften, Berichte der Physikalisch-medizinisch Sozietät in Erlangen* 39, 1907, pp. 226–48. To avoid confusion, I should state that I had previously translated the title of this work as "On the Nature of Shadows," but I am now following the authority of A. I. Sabra in this matter.

While Sabra, *The Optics of Ibn Al-Haytham*, p. xlviii, acknowledges the clear relation of this treatise to astronomy, he also, ibid., p. xlix, makes the point that it belongs to the field of optics; in his article on "Ibn Al-Haytham" in the *Dictionary of Scientific Biography*, 6, p. 195, Sabra also includes this treatise under "Minor Optical Works."

34. "Alkindi, Tideus, und Pseudo-Euklid: Drei optische Werke," ed. Axel Anthon Bjørnbo, *Abhandlungen zur Geschichte der mathematischen Wissenschaften* 24, 3, 1912.

35. *Tractatus de multiplicatione specierum*, in *The Opus Majus of Roger Bacon*, ed. John Henry Biggs, 2, Oxford, 1897, pp. 494ff.

36. *Vitellionis Thuringopoli. Libri X*, ed. Frederick Risner, Basel, 1572; bk. 2, Theorems ix, xff. discuss shadows; Witelo's original theorems are xxi and xxxii.

37. David C. Lindberg, ed. and trans., *John Pecham and the Science of Optics*, Madison, Wis., 1970, pp. 101–3.

38. *Lorenzo Ghiberti's Denkwürdigkeiten*, ed. Julius von Schlosser, 1, Berlin, 1912, pp. 56–58; see Gezienus Ten Doesschate, *De Derde Commentaar van Lorenzo Ghiberti in Verband met de Middleeuwsche Optiek*, Dissertation, Utrecht, 1940, and "Over de Bronnen van de 3de Commentaar van Lorenzo Ghiberti," *Tijdschrift voor Geschiednis* 47, n.d., pp. 432–38, for the question of Ghiberti's use of sources.

39. Lindberg, *John Pecham*, pp. 29ff., discusses the popularity of the treatise.

40. Vescovini, *Studi sulla prospettiva medievale*, pp. 243–45.

41. Biblioteca Laurenziana, MS. Ashburnham 1042, fols. 54v, 57v, 58, 59, 59v.

42. Ibid., fol. 143v.

43. See Vescovini, *Studi sulla prospettiva medievale*, p. 243n., for Pelacani's popularity in the fifteenth century.

Bauer, "Experimental Shadow Projection," argues that Pelacani's description is evidence for the experimental demonstration of perspective images through shadow projection, and as such provided a "simple three-dimensional model for visualizing the abstract geometry of central projection," and therefore contributed to Alberti's construction of a perspectival system. Following Vescovini, Veltman, "Ptolemy and the Origins," also calls attention to the importance of this passage and thus of shadow projection for perspective.

Veltman, *Studies on Leonardo da Vinci*, p. 144, also echoes the argument here that Alberti "does not illustrate the principles involved" in the "potential link betwween shadows and perspectival drawing," nor do his "younger contemporaries, Filarete, Piero della Francesca, and Francesco di Giorgio." Given Pelacani's earlier discussion, his additional thesis can, however, hardly be accepted that "Alberti is probably the first to make explicit the potential link between shadows and perspectival drawing." In light of the arguments for the difficulties of observation presented here, of Olszewski's discussion of this material pertaining to the work-

shop situation in the sixteenth century, and of Bauer's notions of experimentation, Veltman's suggestion that Alberti did not demonstrate a procedure for shadow projection is also implausible because, as Veltman says, later (sixteenth-century!) engravings show that "such experiences (of seeing bodies with cast shadows) would have been commonplace."

44. There has been much discussion of the question of Leonardo's sources. See first the concise statement in Richter, 1, p. 26 n. 3, where passages in Leonardo's manuscripts that reveal a knowledge of earlier sources are given. For general discussions of the question, see Edmondo Solmi, "Le fonti dei manoscritti di Leonardo da Vinci," Supp. 10, *Giornale storio della letteratura italiana*, Turin, 1908, and Eugenio Garin, "Il problema delle fonti di Leonardo," in *La cultura filosofica del Rinascimento italiano*. A concise summary of the sources of Leonardo's optics is given by Martin Kemp, " 'Il concetto dell'anima' in Leonardo's Early Skull Studies," *Journal of the Warburg and Courtauld Institutes* 34, 1971, pp. 120–21. Leonardo's familiarity with Peckham's treatise has been proved by its presence in Leonardo's library, the list of whose contents are published in Ladislao Reti, "The Two Unpublished Manuscripts of Leonardo da Vinci in the Biblioteca Nacional of Madrid," *Burlington Magazine* 110, 1969, pp. 81–89. A. M. Brizio, "Razzi incidenti e razzi refressi," *Lettura Vinciana*, 1963, demonstrates Leonardo's use of Witelo in his discussion of the subject. For an acute appraisal of Leonardo's relationship to his sources on optics, see V. P. Zubov, *Leonardo da Vinci*, trans. David H. Kraus, Cambridge, Mass., 1968, p. 140. This subject, along with many other aspects of the relation of Leonardo's art and thought to that of his predecessors, is also a theme of Martin Kemp's excellent *Leonardo da Vinci. The Marvellous Works of Nature and Man*, London, Melbourne, and Toronto, 1981.

45. Bacon says that solar rays and shadows are not parallel, but seem so to the judgment of the senses; see *De multiplicatione specierum*, ed. cit., 2, pp. 494ff. For Leonardo, Paris, Institut de France, MS. F, fols. 8v, 6r, ed. Charles Ravaisson-Mollien, *Les manuscrits de Léonard de Vinci* (hereafter referred to as Ravaisson-Mollien), 1881 et seq., 4; Richter, 2, no. 881 and 882.

46. In Windsor 12604r (Richter, 1, no. 575) Leonardo says that all light comes from a point; he illustrates this idea here. Other related drawings are in Paris, Institut de France, MS. G, fols. 6r and 19v (Ravaisson-Mollien, 5; Richter, 1, no. 455, 465); see also Paris, Institut de France, MS. I, fol. 37v (Ravaisson-Mollien, 4), where the sun is also represented as a point source.

47. Institut de France, MS. F, fol. 3r and following (Ravaisson-Mollien, 4).

48. Institut de France, MS. C, fol. 3r (Ravaisson-Mollien, 3; Richter, 1, no. 219).

49. Bibliothèque Nationale 2038, fols. 28v and 33r (Ravaisson-Mollien, 6; Richter, 1, no. 555 and 551).

50. Amedeo Agostini, *La prospettiva e le ombre nelle opere di Leonardo da Vinci*, Pisa, 1954, assembles many of Leonardo's observations on cast shadows. Cf. also Veltman, *Studies in Leonardo da Vinci*, pp. 303ff.

51. Leonardo's illustration is reproduced in *Il Codice Atlantico di Leonardo da Vinci nella Biblioteca Ambrosiana di Milano*, ed. Giovanni Piumatti, Milan, 1894, fol. 37r (hereafter referred to as Cod. At.). For the history and illustration of architectural interior drawing, see Wolfgang Lotz, "Das Raumbild in der italien-

ischen Architekturzeichnung der Renaissance," *Mitteilungen des Kunsthistorischen Instituts in Florenz* 7, 1956, pp. 193ff. (also as "The Rendering of the Interior in Architectural Drawing of the Renaissance," in *Studies in Italian Renaissance Architecture*, Cambridge, Mass., and London, 1977, pp. 66–73).

A drawing by Cronaca of the interior of Sto. Stefano Rotondo, Rome, in which shadows are indicated in a contradictory manner, is illustrated in Richard Krautheimer, *Studies in Early Christian, Medieval, and Renaissance Art*, New York, 1969, fig. 26.

52. Cod. At., fol. 250r (Richter, 1, no. 111).

53. Institut de France, MS. A, fol. 42v (Ravaisson-Mollien, 1; Richter, 1, no. 525).

54. Institut de France, MS. C, fol. 9r (Ravaisson-Mollien, 3).

55. Hans Schuritz, *Die Perspektive in der Kunst Albrecht Dürers*, Frankfurt a. M., 1919, p. 14. As discussed above, subsequent scholarship has shown that this idea is adumbrated, as it were, by Pelacani and Alberti. See also Decio Gioseffi, s.v. "Perspective," in *Encyclopedia of World Art*, New York, Toronto, etc., 1966, 11, col. 185–86.

56. Institut de France, MS. C, fol. 5r (Ravaisson-Mollien, 3; Richter, 1, no. 215). For a demonstration that foreshortening shadows shows they can be treated by perspective, see R. Arnheim, *Art and Visual Perception*, p. 309. See also Bauer, "Experimental Shadow Casting," p. 215.

57. Schuritz, p. 14, interprets a drawing of Leonardo's (MS. C, fol. 22r; Ravaisson-Mollien, 3) as being a demonstration of shadow projection: he seems, however, to be reading Dürer's method into Leonardo. The drawing he describes has no clear point source indicated for the light, and the light rays are drawn in the most summary way. They do not clearly pass through the edges of the object casting the shadow, nor do they clearly define the boundary of the shadow where they intersect on the plane. In fact, in the context Schuritz mentions, Leonardo is not concerned with the practical problem of shadow projection.

58. Institut de France, MS. E, fol. 32r (Ravaisson-Mollien, 3; Richter, 1, no. 162), and fol. 32v (Richter, 1, no. 159); see also *Leonardo da Vinci, Treatise on Painting*, ed. Philip McMahon, Princeton, 1956, no. 613.

59. Windsor, Royal Library, inv. no. 19076r (Richter, 1, no. 292); see also, for the date of the manuscript, Kenneth Clark and Carlo Pedretti, *The Drawings of Leonardo da Vinci in the Collection of Her Majesty the Queen at Windsor Castle*, 3, London, 1969, pp. 31f. For the idea that Leonardo took his studies of light outdoors after 1505, see the discussion of Maria Rzepińska, "Light and Shadow in the Late Writings of Leonardo da Vinci," *Raccolta vinciana* 19, 1962 pp. 259–66.

60. MS. G, fol. 37r (Ravaisson-Mollien, 6; Richter, 1, no. 49).

61. Alberti, *On Painting*, ed. cit., p. 91; Armenini, *De' veri precetti*, p. 85; for Leonardo and the question of *sfumato*, see E. H. Gombrich, "Blurred Images and the Unvarnished Truth," *British Journal of Aesthetics* 2, 1962, pp. 170–79.

62. *Treatise on Painting*, ed. cit., no. 136. Rzepińska discusses some aspects of this problem in "Przesten, Linia w Teorii Malarskiej Leonarda da Vinci," and in "Dwa Studia a Teorii Malarskiej Leonarda da Vinci," *Rocznik Historii Sztuki* 7, 1969, pp. 7–27, and 3, 1962, pp. 7–43 (both with French resumés). She tends, however, to ignore the importance of this problem in Leonardo's writings in

order to demonstrate, somewhat incorrectly I believe, a major shift in his theory toward the study of kinetic properties of shadows.

63. London, British Library, MS. Arundel 263, fol. 188r (Richter, 1, no. 231).

64. Cod. At., fol. 148v (Richter, 1, no. 194).

65. Institut de France, MS. E, fol. 32r (Ravaisson-Mollien, 3; Richter, 1, no. 162).

66. Ibid., fol. 31v (Ravaisson-Mollien, 3; Richter, 1, no. 197).

67. Institut de France, MS. G, fol. 3v (Ravaisson-Mollien, 3; Richter, 1, no. 118).

68. Bibliothèque Nationale 2038, fol. 30r (Richter, 1, no. 196).

69. Albrecht Dürer, [Die] Underweysung der Messung mit dem Zirkel und richtscheyt, in Linien, ebnen unnd gantzen Corporen [sic], Nuremberg, 1525, fol. 81v; the pertinent text from Dürer is given in Appendix 1A.

70. Erwin Panofsky, Dürers Kunsttheorie, Berlin, 1915, pp. 26ff.

71. Dürer, Underweysung der Messung, fols. 82r and 82v.

72. For Dürer's näherer Weg, see Panofsky, Dürers Kunsttheorie, pp. 30ff., and "Die Perspektive als Symbolisches Form," Vorträge der Bibliothek Warburg, 1924–1925, Leipzig, Berlin, 1927, pp. 322f.

73. Dürer, Underweysung der Messung, fol. 87r.

74. Erwin Panofsky, The Life and Art of Albrecht Dürer, Princeton, 1955 (3rd ed.), pp. 253–55.

75. According to B.A.R. Carter, the näherer Weg has the practical disadvantages of doubling the angle of vision and causing marginal distortions; see article "Perspective," Oxford Companion to Art, Oxford, 1970, p. 853.

76. Oxford Companion to Art, p. 853; Schuritz, Die Perspektive in der Kunst Albrecht Dürers, p. 35 and passim, first pointed out the inconsistencies in Dürer's perspective construction and handling of shadows.

77. Erwin Panofsky, The Codex Huygens and Leonardo da Vinci's Art Theory (Studies of the Warburg Institute, 21), London, 1940, pp. 60–62, figs. 49–51. For the authorship of the Codex Huygens, see S. Marinelli, "The Author of the Codex Huygens," Journal of the Warburg and Courtauld Institutes 44, 1981, pp. 214–29. The writings discussed in this section are treated along with others in Kemp, Science of Art, pp. 74–91, 111ff.

78. On Barbaro's use of Dürer, see Panofsky, Codex Huygens, pp. 185ff., and Rudolf Wittkower, Architectural Principles in the Age of Humanism, London, 1962 (rev. ed.), p. 66.

79. Daniele Barbaro, La pratica della prospettiva, Venice, 1568, pp. 173, 175.

80. Although he does not say why, Barbaro has evidently observed one of the most extreme of all perceptual ambiguities. Since we expect to see objects illuminated from above and from the left, objects seen with illumination from below are perceived with their features reversed in depth. For this phenomenon, see Evans, Introduction to Color, p. 151, and Metzger, Gesetze des Sehens, pp. 377ff.

81. Barbaro, Pratica della prospettiva, p. 176.

82. Ibid., p. 177; Barbaro's use here of the term luogo determinato may betray an Albertian influence.

83. Ibid., p. 177; on the paintings of the Rosa, see Juergen Schulz, "A Forgotten Chapter in the Early History of Quadratura Painting: The Fratelli Rosa,"

Burlington Magazine 103, 1961, pp. 90–102, and *Venetian Painted Ceilings of the Renaissance*, Berkeley, Calif. 1968, p. 45.

84. Barbaro, *Pratica della prospettiva*, p. 178 ill.

85. Guidiubaldi e Marchionibus Montis [Guidobaldo Marchesi del Monte], *Perspectivae libri sex*, Pesaro, 1600, p. 172.

86. Ibid., p. 245. It should be noted that Guidobaldo's consideration of cast shadows in terms of the planes, sections, and elevations of projective geometry is not, strictly speaking, a branch of *perspectiva artificialis* in Alberti's sense, since the eye is not assumed.

87. Ibid., pp. 246ff. For more on Guidobaldo's shadow projection, see Kemp, *Science of Art*, pp. 90–91.

88. Salomon de Caus, *La perspective avec la raison des ombres et des miroirs*, London, 1611, fols. 42–43.

89. Ibid., fol. 44v.

90. Ibid., fol. 51v.

91. See M. Luckiesh, *Light and Shade and Their Applications*, New York, 1916, pp. 41ff., for a study of shadows cast by light entering through a window.

92. Samuel Marolois, *Perspective contenant la théorie practique et instruction d'icelle*, Amsterdam, 1628, p. 7.

93. Ibid., pp. 49ff., figs. 201–33.

94. Ibid., p. 49.

95. Karel van Mander, *Het Schilder-Boeck . . .* , Amsterdam, 1618 (2nd ed.; 1st ed. 1604), fol. 13r. Van Mander mentions a number of contemporary works in this context. One of them, a representation of Plato's cave by Saenredam, is discussed in P. J. Vinken, "H. L. Spiegel's Antrum Platonicum: A Contribution to the Iconology of the Heart," *Oud Holland* 75, 1960, pp. 125–43.

96. *Francisci Aguilonii* [François Aguilon], *Opticorum libri sex*, Antwerp, 1613, p. 362.

97. Ibid., p. 427. The relation of Rubens to Aguilon is discussed by Julius S. Held, "Rubens and Aguilonius: New Points of Contact," *Art Bulletin* 61, no. 2, 1979, pp. 257–64, correcting Michael Jaffé, "Rubens and Optics: Some Fresh Evidence," *Journal of the Warburg and Courtauld Institutes* 34, 1971, pp. 362–66.

98. Aguilon, *Opticorum libri sex*, pp. 423, 674ff.

99. Ibid., p. 683. The Latin text for this passage is given in Appendix 1B.

100. Pietro Accolti, *Lo inganno degl'occhi: prospettiva pratica*, Florence, 1625, pp. 95f; see Appendix 1C for the complete Italian text of this passage. For more on Accolti, see Kemp, *Science of Art*, pp. 134–36, and for the transmission of Leonardo, Carlo Pedretti, *The Literary Works of Leonard da Vinci: A Commentary to Jean Paul Richter's Edition*, Oxford, 1977, I, pp. 35, 47.

101. Ibid., p. 135.

102. Ibid., pp. 138–43.

103. Ibid., p. 111.

104. Ibid., pp. 108–10.

105. See Elizabeth Cropper, "Poussin and Leonardo: Evidence from the Zaccolini Mss," *Art Bulletin* 62, no. 4, 1980, pp. 570–83.

106. P. A. Barca, *Avvertimenti, e regole circa l'architettura civile, scultura, pittura, prospettiva, et architettura militare*, Milan, 1620, p. 30.

107. J. A. Dubrueil, *La perspective practique*, Paris, 1642: see, for example, p. 137; Samuel van Hoogstraten, *Inleyding tot de Hooge Schoole der Schilderkonst: Anders de Zichtbaere Werelt*, Rotterdam, 1678, p. 269.

108. Hoogstraten, *Inleyding tot de Hooge Schoole*, p. 270.

109. A. Bosse, *Manière universelle de M. Desargues pour practiquer la perspective par petit pied par le Géometral*, Paris, 1647 (2nd ed.), pp. 177–78. Bosse says [author's translation] Dubrueil "placed the site of such a light at a finite distance which in the practice of painting is something badly understood and faulty."

110. Schuritz, *Die Perspektive in der Kunst Albrecht Dürers*, p. 14, mentions this point in discussing why Leonardo and Dürer misunderstood the nature of the sun's rays and failed to formulate a system of solar shadow projection: he does not, however, develop this argument.

111. See Carter, "Perspective," *Oxford Companion to Art*, p. 851, for a concise exposition of Desargues's role in the history of perspective, and also Kemp, *Science of Art*, pp. 120–24.

112. A. Bosse, *La manière universelle de M. Desargues lyonnois pour poser l'essieu & placer les heures & autres aux cadrans du soleil*, Paris, 1643.

113. Bosse, *Manière . . . pour practiquer la perspective*, pp. 177–78, indicates that Dubrueil pirated Desargues's ideas when he speaks of "un certain livre intitulé perspective practique où cette manière universelle est copieé, & falsifieé sous la figure mesme de l'exemple original de M.D. et après deguisé 7 proposée en autre endroit sous d'autres exemples et prétextes ridicules [*sic*]." Desargues himself protested against Dubrueil's theft of his ideas in a number of *affiches* posted in Paris; for them, see G. Desargues, *Oeuvres*, ed. M. Poudra, Paris, 1864, I, pp. 497ff.

114. Bosse, *Manière . . . pour practiquer la perspective*, pp. 296ff. The preface to Bosse's book by Desargues states that Bosse has faithfully represented his ideas: see Desargues, *Oeuvres*, ed. cit., I, pp. 486ff.

115. Carter, "Perspective," *Oxford Companion to Art*, p. 851.

116. Ibid., p. 849.

117. Joshua Kirby, *Dr. Brook Taylor's Method of Perspective Made Easy*, Ipswich, 1754, pt. 2, p. 65.

118. Ibid., pt. 2, p. 65, and pt. 1, pp. 56–57.

119. Ibid., pt. 1, p. 60.

120. Ibid., pt. 1, p. 57.

121. Ibid., pt. 1, pp. 58ff.

122. Dubrueil, *Perspective practique*, p. 130. Taylor also seems to have thought that this was a matter better left to the painter's discretion than to the rule book.

123. Francesco Maria Grimaldi, *Physico-Mathesis de lumine*, Bologna, 1665, Proposition I, pp. 1ff.

124. Carl Goldstein, "Studies in Seventeenth Century Art Theory and Ceiling Painting," *Art Bulletin* 47, 1965, pp. 231–56, discusses Bosse's influence on the academy and academic painting.

125. Kirby, *Taylor's Method*, pt. 1, p. 57. Twentieth-century textbooks demonstrating methods of shadow projection originally worked out during the period 1450–1650 include Guido Hauck, *Lehrbuch der Malerischen Perspektive, mit Einschluss der Schattenkonstruktion*, Berlin, 1910, pp. 274ff.; John Holmes, *Architec-*

tural Shadow Projection, London, n.d. (1929); Joseph D'Amelio, *Perspective Drawing Handbook*, New York, 1964, pp. 87ff.; Nigel V. Walters and John Bonham, *Perspective for Artists*, London, 1970, pp. 64–77; Claudius Coulin, *Step by Step Perspective Drawing for Architects, Craftsmen, and Designers*, trans. John Yarborough, New York, 1972, pp. 38f.

For more on Kirby, Taylor, and in general the later history of perpsectival theory, see Kemp, *Science of Art*, pp. 148ff.

CHAPTER 3

1. For Dürer's nature studies, see Fritz Koreny, *Albrecht Dürer und die Tier- und Pflanzenstudien der Renaissance* (English trans., 1988), with further references. Koreny, p. 14, specifically uses the words "conquest of reality" and links Dürer with the Netherlandish tradition. For more on the tradition of nature studies in relation to Dürer, see the essays edited by Koreny, *Albrecht Dürer und die Tier- und Pflanzenstudien der Renaissance. Symposium, op.cit.*

2. The discovery that Hoefnagel had copied Dürer's nature studies was first noted in an unpublished paper of 1983 by M. L. Hendrix, later incorporated in her "Joris Hoefnagel and the *Four Elements*," pp. 118ff., especially pp. 121–22. This observation was first published by Hendrix, "Joris Hoefnagel's 'The Four Elements,' " in *FMR America*, no. 9, p. 82, ill. p. 84. Copies of Dürer's hare appear on fol. 47r of Hoefnagel's "Terra," and of Dürer's stag beetle on fol. 5r of "Ignis." Koreny, *Dürer und die Tier- und Pflanzenstudien der Renaissance*, pp. 124, 138, has confirmed these observations. This chapter does not deal with the problem of attribution of the stag beetle that Koreny, ibid., pp. 120–21, has reopened for consideration because it is not pertinent to what Hoefnagel and other sixteenth-century artists would have thought of the original study.

3. Renaissance theories of artistic imitation have occasioned an extensive scholarly literature. Good introductions, with many further references, are provided by G. W. Pigman, III, "Versions of Imitation in the Renaissance," in *Renaissance Quarterly* 33, 1980, pp. 1–32; Thomas M. Greene, *The Light in Troy. Imitation and Discovery in Renaissance Poetry*, New Haven, Conn., and London, 1982; H. J. Lange, *Aemulatio Veterum sive de optimo genere dicendi*, Frankfurt a. M., 1974. Some useful additional references are provided by Jeffrey M. Muller, "Rubens's Theory and Practice of the Imitation of Art," *Art Bulletin* 64, 1982, pp. 229–47.

4. See especially for this subject Jan Białostocki, "The Renaissance Concept of Nature and Antiquity," reprinted in *The Message of Images. Studies in the History of Art*, Vienna, 1988, pp. 64–68, 246–48.

5. For the extreme version of the opinion that the northern naturalistic tradition is distinctly different, see Alpers, *The Art of Describing*. David Summers, *The Judgment of Sense. Renaissance Naturalism and the Rise of Aesthetics*, Cambridge, etc., 1987, p. 3 and n. 2, represents the point of view cited here.

6. Hans Kauffmann, "Dürer in der Kunst und im Kunsturteil um 1600, in *Vom Nachleben Dürers. Beiträge zur Kunst der Epoche von 1530 bis 1650, in: Anzeiger des Germanischen Nationalmuseums*, 1940–1953, pp. 18–60, and especially for the doctrine of imitation, p. 30.

7. Pertinent examples of the productive reception of Kauffmann's thesis include Koreny, *Albrecht Dürer*; E. Fučíková, "Umělcí na dvoře Rudolfa II a jejich vztah k tvorbě Albrechta Dürera," *Umění* 20, 1972, pp. 149ff (see especially p. 166); and Kaufmann, "Hermeneutics in the History of Art: Remarks on the Reception of Dürer in the Sixteenth and Early Seventeenth Centuries," in *New Perspectives on the Art of Renaissance Nuremberg. Five Essays*, ed. Jeffrey Chipps Smith, Austin, Texas, 1985, pp. 22–39. This is, however, only a sampling, and I think that it is safe to say that not only the present author, in other works (*L'école de Prague*; *School of Prague*), but many other scholars who have worked on art in Central Europe c. 1600 have followed Hans Kauffmann's lead in applying distinctions gained from Italian art theory to art in Prague and elsewhere in Central Europe.

8. Bernhard Decker, "Dürer-Nachahmungen und Kunstgeschichte . . . ein Problem am Rande," in *Dürers Verwandlung in der Skulptur zwischen Renaissance und Barock*, ed. Hans Beck, Frankfurt a. M., 1981/1982, p. 388: "sie sagt aber nichts über Dürer-Nachahmugen, die sich auf keine akademische Lehrmeinung stützen könnten."

9. Decker, ibid., p. 466: "im Interesse des Bündnisschlusses mit dem absolutistischen Souverän." While Decker is dealing with a different category of Dürer imitations, his generalizations are more sweeping. Koreny, *Albrecht Dürer*, gives the most recent full bibliography of discussions of the issue.

10. The more comprehensive approach to academic ideas urged here is elaborated in my "The Eloquent Artist." For further aspects of the background to this discussion, with additional references, see Cynthia E. Roman, "Academic Ideas of Art Education," in *Children of Mercury. The Education of Artists in the Sixteenth and Seventeenth Centuries*, Providence, R.I., 1984, pp. 81–95. Also pertinent to this theme are essays by Jochen Becker, "Zur Niederländischen Kunstliteratur des 16. Jahrhunderts: Domenicus Lampsonius," *Nederlands Kunsthistorisch Jaarboek* 24, 1973, pp. 45–61, and "Zur Niederländischen Kunstliteratur des 16. Jahrhunderts: Lucas de Heere," *Simiolus* 6, 1972–1973, pp. 113–27. See now for these issues, Walter S. Melion, *Shaping the Netherlandish Canon: Karel van Mander's Schilder-Boeck*, Chicago and London, 1991, 129ff., with a discussion (173f.) of the circle of Abraham Ortelius that is directly pertinent to this chapter.

11. Hoefnagel's poems appear on fol. 55r of the album of Johannes Radermacher, Album Amicorum Joanni Rotarii (*sic*), Centrale Bibliotheek, Rijksuniversiteit, Ghent, MS. 2465. I have read the word *sunt* in line 14 as a correction from *sicut*. My roughly literal English translation follows:

<div align="center">

On Albrecht Dürer. To Show Honor
by Georg Hoefnagel

</div>

To the genius of Dürer, who never made a foolish effort
(Whom none has equaled in drawing, and few in coloring)
It was not enough to have consummated the arts of peace,
But having attacked the affairs of war
He so perfected each Pallas
That from them he bore on his head a double crown.
As a German he taught the Germans how to wage war,

And an art that had previously been without norms and diffuse,
he reduced to certain
Principles, to unfold its precepts hereupon in beautiful order.
You might believe that you were watching Socratic Euclid teaching
In a great assembly, while Megara admired his Mathematics
Discussing how from a point it swelled into such a great boundary-line
Often likewise Dürer is said to have given the fatherland sure
Counsels in doubtful matters. So that
In one citizen the people of Nuremberg possess all things
Which, while they pertain to an individual, are outstanding
enough signs for praise* to others.
*encomia
 On the Image of Melanchthon
Whoever wishes to depict piety in a famous face
He will gain all approval, in painting one Philip.

On fol. 59r of the album notations appear in two different hands, both of them
also to be distinguished from the script in which the poems discussed in this
essay, and the group to which they belong, fol. 54r–59v, are written:

Viviani poema quadam/
met brief Samuel Rademachers vom 13 April 1603

Neither can be identified with Radermacher's hand, and there are several reasons
why I cannot doubt Hoefnagel's authorship of the poems on Dürer. First,
the indication that the poems in the group (fol. 54r–59v) are by Vivianus is,
strictly speaking, not consistent with an inscription on fol. 57r, which reads
Iohannis Viviani et Jacobii Susii and thereby lists Susius as a joint author. Second,
as visible in figure 35, the way in which *Georgij Hoefnagel* is set off in its own
line in the manuscript strongly suggests that, as with the inscription *Iohannis
Viviani et Jacobii Susii*, Hoefnagel is to be taken as the author, just as the reading
of the genitive here may imply; because the name is separated from *in gratiam* it
would not seem to be intended to be read with this phrase, thus ruling against a
reading to the effect that the poems were written for Hoefnagel. Third, poems
written by Vivianus on behalf of or for others, such as Clusius, as on fol. 54v,
employ a different form of inscription. Fourth, the poems on fol. 55r indicate
that the author had a close involvement with the visual arts and artists himself.
Fifth, as related below, Hoefnagel is known to have been a good Latinist and a
good poet (see also the poem in French below), and there is no reason to doubt
that he could have written these works, which in any event are not comparable in
style to other poems by Vivianus. Finally *poema* in the note on Radermacher is
singular.

12. Dürer's works are respectively, in this regard, his *Underweysung der Mes-
sung mit dem Zirkel*, Nuremberg, 1525 (for which see also chap. 2 above); *Etliche
Underricht zu Befestigung der Stett, Schloss und Flecken*, Nuremberg, 1527; and *Vier
Bücher von menschlicher Proportion*, Nuremberg, 1528. For the background to
Nuremberg city politics mentioned here, see in general G. Strauss, *Nuremberg in
the Sixteenth Century*, Bloomington, Ind., and London, 1966; for Dürer's social
position in Nuremberg, see Jane Campbell Hutchinson, *Albrecht Dürer. A Biogra-*

phy, Princeton, 1990. The late Walter Strauss pointed out to me the reference to the *Grösseren Rat*.

13. For the contributions to Radermacher's album and their significance, see in general F. van Ortroy, "Jean Rademacher (ou Rotarius), in *Biographie Nationale publiée par l'Académie Royale des Sciences, des Lettres et des Beaux Arts de Belgique*, Brussels, 1905, 18, col. 541–43; E. de Busscher, *Recherches sur les peintres et sculpteurs à Gand au XVIe, XVIIe et XVIIIe siècles*, Ghent, 1866, pp. 35, 193–94 (as cited by Yates below); P. de Kejser, "Marnix als Psalmenvertaler," in *Marnix van Sinte Aldegonde. Officieel Gedenkboek*, Brussels, 1969, pp. 370–71 (as cited by Yates); F. A. Yates, *Valois Tapestries*, pp. 27, 30, 65–66; J. A. van Dorsten, *The Radical Arts. First Decade of an Elizabethan Renaissance*, Leiden and London, 1970, pp. 37–38, 53–54.

14. The poem for Clusius appears on fol. 54v of the first folio of the gathering in which Hoefnagel's poem is located, that on the *Theatrum* of Ortelius on the recto of the fifth folio, and the poem by Vivianus on the recto and verso of the first folio. The response by Lipsius appears in *Justi Lipsi Epistolarum Selectarum Centuria Prima*, Antwerp, 1605, pp. 5–6. For the transmission of the poems from Samuel to Johannes Radermacher, see n. 11 above.

15. For Radermacher's (and Hoefnagel's) circle in England, see Yates, *Valois Tapestries*, p. 27; Van Dorsten, *Radical Arts*, pp. 38, 52–54; H.E.M.N. Mout, *Bohemen en de Nederlanden in de zestiende eeuw*, Leiden, 1975, pp. 76, 107; Alastair Hamilton, *The Family of Love*, Cambridge, 1981, pp. 112–13.

16. The works to which I refer here are discussed further below; they are respectively *Patientia* (Rouen, Bibliothèque Municipale), figs. 38 and 39, and a painted allegory of poetry and painting (Rotterdam, Museum Boymans-van Beuningen), fig. 42. For these works, see further R. van Roosbroeck, *Patientia. Politieke Emblemata door Joris Hoefnagel 1569*, Antwerp, 1935; Vignau-Schuurman, *Die Emblematischen Elemente*, 2, pp. 113–14, 118.

17. K. van Mander, *Het Schilder-Boeck*. . . , Haarlem, 1604 (1st ed.), fol. 262r, 263r.

18. Hoefnagel's *praeclara . . . insignia laudem* echoes Cicero's *praeclarae laudis insignia*, *Ars Poetica* (Oratio in Pisonem) 9:26. For Hoefnagel's echoes of Horace, see the text below.

19. The classic account of this conception remains Rensselaer W. Lee, *Ut pictura poesis: The Humanist Theory of Painting*, New York, 1967 (rev. ed.) For the pertinence of this theory to painting and drawing in Central Europe, see my "The Eloquent Artist," pp. 136f and in general *The School of Prague*; also *Drawings from the Holy Roman Empire*, p. 23, and the Excursus to chap. 4 below.

20. For this distinction in Latin and in the vernacular, see Baxandall, *Giotto and the Orators*, especially pp. 15–17.

21. See Jan Białostocki, "Vernunft und Ingenium in Dürers kunsttheoretischem Denken," *Zeitschrift des deutschen Vereins für Kunstwissenschaft* 25, 1971, pp. 107–14.

22. Lambert Lombard's letter of 27 April 1565 is printed in G. Gaye, *Carteggio inedito d'artisti dei secoli xiv. xv. xvi. pubblicato ed illustrato con documenti pure inediti*, Florence, 1846, 3, p. 177.

23. The distinction between *disegno* and *colore*, or *colorito* had become commonplace in Italian writings on art by the mid-sixteenth century. See, for example, the

remarks of Ludovico Dolce, most conveniently available in Mark Roskill, *Dolce's Aretino and Venetian Art Theory of the Cinquecento*, New York, 1968, pp. 116–17; Roskill, pp. 25–26, discusses the implications of Dolce's remarks for art criticism.

The secondary literature on the subject is quite large: a preliminary orientation is offered by the works cited in chap. 2, n. 2. See further Maria Rzepińska, *Historia Koloriu*, Cracow, 1983 (2nd ed.), pp. 273ff., and David Rosand, *Painting in Cinquecento Venice. Titian, Veronese, Tintoretto*, New Haven, Conn., and London, 1982, pp. 14–22.

It is also noteworthy that among Netherlandish writers Hoefnagel precedes Van Mander's discussion of the issue in chap. 12 of his theoretical "Grondt," for which see Hessel Miedema, ed. and trans. *Karel van Mander, Den Grondt der edel vrij Schilder-const*, Utrecht, 1973, vol. 1, pp. 252ff.

24. For the learned artist, see Lee, *Ut pictura poesis*, pp. 41–48; this account can be supplemented by Evonne Levy, "Ideal and Reality of the Learned Artist: The Schooling of Italian and Netherlandish Artists," in *Children of Mercury*, pp. 20–27. For the comparable idea in literature, see August Buck, "Der Begriff des 'poeta eruditus' in der Dichtungstheorie der italienischen Renaissance," in *Die humanistische Tradition in der Romania*, Bad Homburg v. d. H., Berlin, Zurich, 1968, pp. 227–43.

25. For Dürer's impact on later German treatises, see Schlosser, *La letteratura artistica*, pp. 276ff. I interpret this issue somewhat differently, however, in *Drawings from the Holy Roman Empire*, pp. 21 and 30 n. 95. For Michelangelo on Dürer, see most recently David Summers, *Michelangelo and the Language of Art*, Princeton, 1981, pp. 384–85, with further references. See also the notes to chap. 2.

The remarks by Lombard, paraphrased above, are printed in Gaye, *Cartegio inedito*, p. 177, as follows:

[Dürer] trovò una via piu gagliarda et non tanto secca, accompagnata di geometria, d'optica, regola et proportione alle figure veramente debbiamo rendergli immortali gratie della bona via per intrare nella perfettione dell'arte, havendo egli sudato per questo effetto tanto nello scrivere quanto nell'operare. (Dürer found a way for rendering figures that was more striking and not so dry, and was accompanied by geometry, optics, rule and proportion; we ought to thank him eternally for the good manner of entering into the perfection of art, since he sweated for this effect as much in writing as in working.)

26. For Minerva (Pallas) in allegories of the arts, see in general Anton Pigler, "Neid und Unwissenheit als Widersacher der Kunst," *Acta Historiae Artium* 1, 1954, pp. 215–35; and Hanna Peter-Raupp, "Zum Thema 'Kunst und Künstler' in Deutschen Zeichnungen von 1540–1640," in *Zeichnung in Deutschland. Deutsche Zeichner 1540–1640*, Stuttgart, 1980, 2, pp. 223–30; for the images discussed here, see especially my "The Eloquent Artist," pp. 124f.

27. See Ellenius, *De Arte Pingendi*, Uppsala and Stockholm, 1960, p. 77. This phrase is also used by Anthony Grafton, "The World of the Polyhistors: Humanism and Encyclopedism," *Central European History* 18, 1985, p. 34.

28. For this conception see especially H. Koller, ἐνκύκλιος παιδεία in *Glotta* 34, 1955, pp. 174–89, and J. Koch, ed., *Artes Liberales. Von der Antiken Bildung zur Wissenschaft des Mittelalters*, Leiden and Cologne, 1959.

29. For this notion, see the Introduction above, and especially Joan [Kelly] Gadol, *Leon Battista Alberti. Universal Man of the Early Renaissance*, Chicago, 1969.

30. For the problem of the interpretation of civic virtue as an educational ideal of Renaissance humanism, see the debate occasioned by Baron, *The Crisis of the Early Italian Renaissance*, to which the fullest response is Seigel, *Rhetoric and Philosophy in Renaissance Humanism*, especially pp. 245–54. See also Eugenio Garin, *L'educazione in Europa 1400–1600* (2nd. ed.) Bari, 1976, and for the Netherlands P.N.M. Bots, *Humanimus en Onderwijs in Nederland*, Utrecht and Antwerp, 1955. More recently these issues have been reconsidered critically by Anthony Grafton and Lisa Jardine, *From Humanism to the Humanities*, Cambridge, Mass., 1986.

31. For the association of Lipsius with circles with which Hoefnagel was also involved, see Van Dorsten, *Radical Arts*, p. 29; Mout, *Bohemen en de Nederlanden*, pp. 107, 111–15; Hamilton, *Family of Love*, p. 112. For Lipsius and military matters, see G. Oestreich, "Der römische Stoizismus und die oranische Heeresreform," in *Geist und Gestalt des frühmodernen Staates*, Berlin, 1969, pp. 11–34. For Lipsius, Neostocism, and his later circles, see most recently Mark Morford, *Stoics and Neostoics. Rubens and the Circle of Lipsius*, Princeton, 1991.

32. Renaissance arguments on the social status of painting are, of course, closely connected with those on its intellectual status; this point is made most clearly by Anthony Blunt, *Artistic Theory in Italy 1450–1600*, Oxford, 1940, pp. 48–57. The significance of the honor granted Dürer in being a member of the Nuremberg Council is stressed by Jeffrey Chipps Smith, *Nuremberg, A Renaissance City 1500–1618*, Austin, Texas, 1983, p. 96. For biographical information about Dürer and his reputation, see Hutchinson, *Albrecht Dürer*.

33. Eugene F. Rice, Jr., *The Renaissance Idea of Wisdom*, Cambridge, Mass., 1958, pp. 149ff.

34. For the background to this transformation in relation to discussions of politics, see H. Wansink, *Politieke Wetenschapen an de Leidse Universiteit 1575–1650*, Utrecht, 1981; Oestreich, "Justus Lipsius als Theoretiker des neuzeitlichen Machtstaates," in *Geist und Gestalt*, pp. 35ff.

35. As discussed most completely in Wansink, *Politieke Wetenschapen*.

36. For this work, see Roosbroeck, *Patientia*, and Vignau-Schuurman, *Emblematischen Elemente*, 1, pp. 243–45. Karel G. Boon, "*Patientia* dans les gravure de la Réforme aux Pays-Bas," *Revue de l'Art* 56, 1982, pp. 9–10, 22 n. 30, and fig. 3, emphasizes the association of patience and hope in Hoefnagel's treatise and relates it to the Calvinist acceptance of the decisions of God, which would have been an appropriate message for Radermacher as a member of the consistory of the reformed comunity of London. Patience is, moreover, also a virtue stressed in Seneca's *De Constantia*.

37. Gerszi, "Die Humanistischen Allegorien der Rudolfinischen Meister," in *Actes du XXIIe Congrès International de l'histoire de l'art Budapest 1969*, Budapest, 1972, 1, pp. 755–62.

38. For Hermathena in Rudolfine art, see Gerszi, ibid., p. 760; Vignau-Schuurman, *Emblematischen Elemente*, 1, pp. 194–98; Jaromír Neumann, "Rudolfínské Umění I," *Umění* 25, 1977, pp. 424–25, and idem, in *Die Kunst der Renaissance und des Manierismus in Böhmen*, Hanau, 1979, p. 184; and my "The Eloquent Artist," pp. 124–30, *L'école de Prague*, pp. 96, 99, 140, 299, 302, and *The*

School of Prague, pp. 91f., where Spranger's painting is illustrated as color plate 8 and discussed at length as cat. no. 20.50, pp. 265–66.

39. Gerszi, "Humanistischen Allegorien," pp. 758–59; Vignau-Schuurman, *Emblematischen Elemente*, pp. 194–98; and *L'école de Prague*, p. 140. See also Jeffrey M. Muller, "The Perseus and Andromeda on Rubens's House" *Simiolus* 12, 1981/1982, pp. 141ff.

40. See in general the discussion of Hoefnagel's imagery in Vignau-Schuurman, *Emblematischen Elemente*; for piety in his allegory for Radermacher, ibid., 1, 291.

41. Cf. Theodore de Beze, *Icones, id est verae imagines virorum doctrina simul et pietate illustrantum . . .*, Geneva, 1580. A useful summary of material on Dürer's portrait of Melanchthon is presented in *Albrecht Dürer 1471–1971*, (exhibition catalogue, Nuremberg, 1971), pp. 209–10. A more comprehensive account of portraits of Melanchthon is offered by Sybille Harksen, "Bildnisse Philipp Melanchthons," in *Philipp Melanchthon 1497–1560*, Berlin, 1963, pp. 270–87.

42. Mout, *Bohemen en de Nederlanden*, p. 100.

43. For the position of Melanchthonianism in Germany at this time, see G. Zschäbitz, "Die Auswirkungen der Lehren Philipp Melanchthons auf die fürstenstaatliche Politik in der zweiten Hälfte des 16. Jahrhunderts," in *Philipp Melanchthon*, pp. 190–226, with references to earlier literature; R.J.W. Evans, *Rudolf II and His World*, pp. 92–93.

44. See Yates, *Valois Tapestries*, and Evans, *Rudolf II and His World*, pp. 93ff. for this group and its origins.

45. Van Dorsten, *Radical Arts*, p. 60 n. 40, and Yates, *Valois Tapestries*, p. 28, plate 18b.

46. For Lipsius in this regard, see Mout, *Bohemen en de Nederlanden*, pp. 94ff; Hamilton, *Family of Love*, pp. 97–102. J. L. Saunders, *Justus Lipsius, The Philosophy of Renaissance Stoicism*, New York, 1955, provides details on the biography of Lipsius. See also Yates, *Valois Tapestries*; Van Dorsten, *Radical Arts*; and most recently Morford, *Stoics and Neostoics*.

47. Cf. Hamilton, *Family of Love*; see also H. de la Fontaine Verwey, "The Family of Love," *Quaerendo* 6, 1970, pp. 252ff.

48. For Melanchthon's importance as an educator, see the classic book by Karl Hartfelder, *Philipp Melanchthon als Praeceptor Germaniae* (*Monumenta Germaniae Paedagogica* 7), Berlin, 1889, and more recently, F. Hofmann, "Philipp Melanchthon und die zentralen Bildungsprobleme des Reformationsjahrhunderts," and E. Neuss, "Melanchthons Einfluß auf das Gymnasialschulwesen der Mitteldeutschen Städte im Reformationszeitalter," in *Philipp Melanchthon*, pp. 83–109, 110–38, with citations of other literature since Hartfelder.

49. *Albrecht Dürer 1471–1971*, ex. cat., Nuremberg, 1971, p. 209.

50. For Melanchthon's rhetorical treatise in relation to the visual arts in Central Europe and its impact in Rudolfine Prague, see my "The Eloquent Artist," pp. 131–32, 145 n. 40, 146 n. 59.

51. Ibid. pp. 125f.

52. For the education of artists see, in general, *Children of Mercury*; for the role of imitation, see Pigman, "Versions of Imitation." For education in the Netherlands see Bots, *Humanimus en Onderwijs*; and in Germany, G. Mertz, *Das Schul-*

wesen der deutschen Reformation im 16. Jahrhundert, Heidelberg, 1902, and idem, *Über Stellung und Betrieb der Rhetorik an den Schulen der Jesuiten*, Heidelberg, 1898, as well as Friedrich Paulsen, *Geschichte des gelehrten Unterrichts*, 1, Leipzig, 1919.

53. See J. A. Emmens, "Apelles en Apollo," in *Kunsthistorische Opstellen* 1, Amsterdam, 1981, pp. 5ff., especially pp. 48ff.

54. See further the translation and discussion in Roosbroeck, *Patientia*, and in Vignau-Schuurman, *Emblematischen Elemente*, 1, p. 256.

55. See, in general, Mario Praz, *Studies in Seventeenth Century Imagery*, Rome, 1964 (2nd ed.).

56. The sources of Hoefnagel's inscriptions are listed and interpreted in Hendrix, "Joris Hoefnagel," especially pp. 266ff.

57. Speaking of the man who desires to lead *sanctum vitae institutum*, Melanchthon (in "De laude vitae scholasticae oratio," in *Opera...*, ed. C. C. Bretschneider, Halle, 1834) says that among other things he should "inquirat rerum naturam, morborum remedia, causas mutationum in natura, motus et effectus coelestes," cited according to Philipp Melanchthon, *Glaube und Bildung. Texte zum christlichen Humanismus*, ed. Günther Schmidt, Stuttgart, 1989, p. 210.

58. Rosalie Colie, *Paradoxia Epidemica. The Renaissance Tradition of Paradox* (reprint), Hamden, Conn., 1976, pp. 285f., has associated Renaissance still lifes, including Hoefnagel's, with Epicureanism.

59. For this last question, see the sources cited in n. 3, and Panofsky, *Idea*, especially pp. 19ff.

60. As pointed out by Saunders, *Lipsius*, pp. 84–85.

61. For the reception of Seneca, see Winfried Trillitzsch, *Seneca im Literarischen Urteil der Antike*, 2 vols., Amsterdam, 1971, 1, pp. 221ff. on Erasmus and Seneca. Karl Alfred Blüher, *Séneca en España. Investigaciones sobre la recepción de Séneca en España desde el siglo XIII hasta el siglo XVII* (rev. ed.), trans. Juan Conde, Madrid, 1983, treats the subject more broadly than the title suggests. See also Henry Ettinghausen, *Francisco de Quevedo and the Neostoic Movement*, Oxford, 1972. For the revival of Stoicism in general, see Léontine Zanta, *La renaissance du Stoicisme*, Paris, 1914.

62. See Jean-Claude Margolin, *L'idée de nature dans la pensée d'Érasme* (*Vorträge der Aeneas-Silvius-Stiftung an der Universität Basel* 7), Basel and Stuttgart, 1966.

63. See for these points G. M. Ross, "Seneca's Philosophical Influence," in C.D.N. Costa, *Seneca*, Cambridge, 1974, pp. 116–65, especially, for the points mentioned, pp. 148, 149.

64. Kris, "Hoefnagel und der wissenschaftliche Naturalismus," p. 247, first pointed to the importance of this motto. For a more recent discussion of the significance of Hoefnagel's mottoes, see Hendrix, "Joris Hoefnagel," pp. 28–34.

65. This text can be found most easily in the edition of Abraham Ortelius, *Album Amicorum*, ed. J. Puraye, Amsterdam, 1969, p. 16:

> Si de nature Dieu est le pere,
> Et si d'amour nature est mere,
> Si du scavoyr el'est maistresse.
> Aussi des arts: mon Ortel qu'est-ce?
> Que je vous doibs? fors ung'bon coeur?
> Coeur vray d'amis non de flatteur.

Pour suivre dieu et la nature.
Et pour monstrer l'affection pure.
(N'ayant aultre), j'emploie aussi
L'art dont nature m'at enrichi
Nature seulle, seulle nourrice
De bons espricts, abhorrant vice.

66. For this album, see H. C. Rogge, "Het Album van Emanuel van Me-teren," *Oud Holland* 15, 1897, pp. 159–92; Yates, *Valois Tapestries*, p. 27; Vignau-Schuurman, *Emblematischen Elemente*, 1, p. 6; see also ibid., p. 222

67. Hendrix, "Joris Hoefnagel," provides the most complete account of Hoef-nagel's career in relation to the creation of his manuscripts on the "Four Elements."

68. Kauffmann, "Dürer in der Kunst und im Kunsturteil," p. 30.

69. Koreny, *Dürer und die Tier- und Pflanzenstudien*, p. 126; see also pp. 124, 138; see Hendrix, "Joris Hoefnagel," pp. 121–22.

70. For these distinctions about academies, see especially "The Eloquent Artist."

CHAPTER 4

1. Gregorio Comanini, *Il Figino, overo del fine della pittura*, Mantua, 1591, pp. 43, 44. A convenient edition of this work is available in Paola Barocchi, ed., *Trattati d'arte del Cinquecento*, Bari, 1962, vol. 3. The translation presented here is that offered in Pietro Falchetta, ed., "Anthology of the 16th Century Texts," in *The Arcimboldo Effect. Transformations of the Face from the Sixteenth to the Twentieth Century*, Milan, 1987, pp. 189, 190.

The image of *Earth* has been illustrated frequently, including in the previously published version of this essay; a good color illustration can be found in *The Arcimboldo Effect*, p. 92. Regrettably the owner would not allow an illustration to appear again here.

2. Roberto Longhi, "Un momento importante nella storia della 'natura morta,' " *Paragone* 1, 1950, pp. 34–39; Charles Sterling, *La nature morte de l'anti-quité à nos jours*, Paris, 1952 (1st ed.), p. 38.

3. Cf. *Stilleben in Europa* (exhibition catalogue, Baden-Baden and Munster, 1979–1980), pp. 154, 155, passim; John T. Spike, *Italian Still Life Paintings from Three Centuries*, Florence, 1983, p. 13.

4. Comanini, *Il Figino*, p. 49; G. P. Lomazzo, *Trattato dell'arte della pittura, scoltura, et architettura*, Milan, 1585, p. 349 (Lomazzo's writings are now con-veniently available in an edition with commentary by Roberto Paolo Ciardi, *Gian Paolo Lomazzo. Scritti sulle arti* [*Raccolta Pisana di saggi e studi*, 34], Florence, 1973, 1974, 2 vols.); Paolo Morigia, *Historia dell'antichità di Milano*, Milan, 1592, p. 566.

5. Pellegrino Antonio Orlandi, *Abecedario pittorico*, Florence, 1731 (3rd ed.; 1st ed. Bologna, 1704), p. 195; Luigi Lanzi, *Storia pittorica della Italia*, Florence, 1882 (5th ed.; 1st ed. 1796), pp. 180–81.

6. F. C. Legrand and F. Sluys, "Arcimboldo meneur de jeu dans le cortège de son temps," in *Les Beaux Arts* 17, 13 February 1955, p. 4; Geiger's book is entitled

I dipinti ghiribizzosi di Giuseppe Arcimboldi, Florence, 1954; Paul Wescher, Review of Geiger, ibid., and Legrand and Sluys, *Arcimboldo et les Arcimboldesques*, in *Burlington Magazine* 98, 1958, p. 29.

7. Sterling, *Nature Morte*, p. 38; Longhi, "Un momento importante," pp. 34–39. Longhi also associates Arcimboldo's painting with a curiosity cabinet; this association recalls the remarks of Julius von Schlosser in *Die Kunst- und Wunderkammer der Spätrenaissance*, Leipzig, 1908, p. 88, of Arcimboldo's "curious" paintings. For a critique of this view, see my "Remarks on the Collections of Rudolf II; the *Kunstkammer* as a Form of *Representatio*," *Art Journal* 38, no. 1, 1978, pp. 22–28, and chap. 7 in this book.

8. Cf. Maurice Rheims, "The Prince of Pictorial Whims," pp. 111–18, and Pontus Hulten, "Three Different Kinds of Interpretation," pp. 20–22, in *The Arcimboldo Effect*; the review is Charles Hope, "Sight Gags," *New York Review of Books* 34, no. 14 (24 September 1987), pp. 41–44.

9. Maiorino, *The Portrait of Eccentricity*, especially pp. 50–52. It should be understood that the literature on Arcimboldo has continued to grow, and that references here are meant to be representative; I have not thought it necessary to include every notice that responded to or ignored the earlier publication of this essay.

10. Comanini, *Il Figino*, p. 51, compares Arcimboldo's metamorphoses (*trasformazioni*) to dream images and, p. 42, calls him a *dotto Egittio* who has presented an image beneath the veil of fruits.

These two paragraphs summarize some of the arguments in "The Allegories and Their Meaning" (author's own title: "Fantasy and Allegory in Arcimboldo's Art"), in *The Arcimboldo Effect*, pp. 89–108, where further references are given. There the point is made, p. 104, that "fantasy and allegory are inextricably connected in his art." To these arguments may be added the realization that a painting of *Janus* described by Lomazzo incorporated what Renaissance writers and artists understood to be a hieroglyphic image of a serpent biting its tail, here symbolizing the year (*Idea del tempio della pittura*, Milano, 1590, p. 154): "Vi ha dipinto ancora un Giano, representando in lui l'anno istesso, facendolo in profillo in sembianze di state con una testa di dietro, che significa il vero, et in serpe al collo che si prende la coda in bocca, accenando con ciò d'essere l'anno. Che parimente è un quadro, et è posto con gli altri in questo Imperial Museo." The significance of this choice of subject is discussed further in the Excursus to chapter 4.

11. "Allegories and Their Meaning," p. 104, quoting David Summers, *Michelangelo and the Language of Art*, p. 456.

12. Comanini, *Il Figino*, pp. 44–48.

13. Sven Alfons, *Giuseppe Arcimboldo* (*Tidskrift för Konstvetenskap* 31), Malmö, 1957, pp. 142ff., 157ff.; Pavel Preiss, *Giuseppe Arcimboldo*, Prague, 1967, pp. 17ff; Evans, *Rudolf II and His World*, p. 174.

14. In contradiction, most clearly, of A. Ferrari-Bravo, *Il Figino del Comanini: teoria della pittura di fine '500*, Rome, 1975, who speaks, p. 67, of "il suo isolamento culturale."

15. The idea that Arcimboldo's pictures are *scherzi* or *bizarrie* is often expressed, as in the standard survey by S. J. Freedberg, *Painting in Italy, 1500 to 1600*, Harmondsworth, 1971 (1st ed.), p. 410.

16. For the "rediscovery" of Arcimboldo as the grandfather of fantastic art and surrealism in the twentieth century, see Paul Wescher, "The 'Idea' in Arcimboldo's Art," *Magazine of Art* 43, 1950, pp. 3–9; G. R. Hocke, *Die Welt als Labyrinth*, Hamburg, 1957, p. 150ff., was the first to compare Rudolf's Prague to Kafka, and developed the notion that Arcimboldo is a forerunner of surrealism; see also Arnold Hauser, *Mannerism*, London, 1965, p. 237. This thesis has remained current: it supplied one of the organizing principles for an exhibition and was thus repeated in many essays in *The Arcimboldo Effect* whose publication accompanied a major Arcimboldo exhibition.

17. The association of the legendary *Sonderling der Kaiserburg*, the supposedly mysterious melancholic, Emperor Rudolf II, with Arcimboldo has been an irresistible source of misinterpretation. Among the interpretations in popular writing are Hans Holzer's association of the portrait of Rudolf II with the emperor's interest in the hermetic science of alchemy (in *The Alchemist, the Secret Magical Life of Rudolf von Habsburg*, New York, 1974, p. 42); that of F. Würtenberger (*Der Manierismus, Der europäische Stil des sechzenten Jahrunderts*, Vienna and Munich, 1962, p. 205), who argues that the picture reflects the emperor's love for horticulture; and that of Görel Cavalli-Björkman, in *Prag um 1600. Kunst und Kultur am Hofe Rudolfs II*, Freren, 1988, p. 225, cat. no. 111, who interprets it as a symbol of human inconstancy (*Unbeständigkeit*), referring to the emperor. Geiger, *Dipinti ghiribizzosi*, p. 77, who first identified the picture as a portrait on the basis of a poem in Comanini, *Il Figino*, interpreted it as Rudolf's joke on himself.

18. "Ad Sacrum Caesarem Invictissimi et clementissimi Imperatoris Maximiliani secundi semper Augusti et Maiestatem, Baptistae Fonteij Primionis, In quatuor temporum, et quatuor elementorum ad humanam effigiem a Josepho Arcimboldo caesareo pictore expressorum Caesari ipsi dicatam Picturam Carmen cum Distichis, et Diuinatio, cui titulus Clementia est. Viennae Austriae tertio calendas Januarias Anno Domini 1568," Vienna, Österreichische Nationalbibliothek, Handschriftensammlung (hereafter ÖNB), Cod. 10152.

The text of this poem is given in Appendix 2, where the annotations indicate marginal references and variations found in the second version in Cod. 10206 (for which see the next note). Since a transcription of the poem is available in the appendix, in this chapter and its notes I have written out in full all standard Latin abbreviations.

19. "Baptistae Fonteii Primionis, De Quatuor Elementis, et Quatuor Anni Temporibus Humanam Formam Induentibus. Ante Triennium ab Autore propter Arcimboldi Picturam, Suae Caesareae Maiestati Poema Dicatum Nunc Correctum, et ad Pompae Europae Patrocinatores, Equitesque cum Ipsorum ordine Traductum Divinatur Quid sit in Causa Ipsorum Metamorphoseos, et Asseritur Esse Clementiam Austriae Domus," ÖNB, Cod. 10206, fols. 50r–59v; "Ad Invictissimum Imperatorem Maximillianum Secundum Austrium. Pro Josepho Arcimboldo caesareo Pictore, Picturae grillum offerente, auxiliumque petente," ibid., fol. 163v.

20. Francesco Porzio, *L'universo illusorio di Arcimboldi*, Milan, 1979, pp. 22–23, 47 n. 22, correctly identifies Fonteio with Fontana and provides biographical information related to his family and work in Italy. A basic source for information

on Fonteo is Fedele Savio, "Giovanni Battista Fontana o Fonteio," *Archivio storico lombardo* 3, 1905, pp. 342–75.

21. The basis for this information is given in my "Arcimboldo's Serious Jokes," pp. 69–70 n. 30, with further references.

22. Ioannis Baptistae Fonteii Primionis, "De Risu, sive quod risus sit virtus, Dialogus Ioanni Michaelio Frangipani Veneto penes Caesarem oratori dicatus . . . anno 1570," ÖNB, Cod. 10466; fol. 2v–3r give information about Fonteo's travels with the court. For this treatise, see "Arcimboldo's Serious Jokes," pp. 69–74.

23. Joannes Baptista Fonteius, *De Prisca Caesiorum Gente . . . commentariorum libri duo*, Bologna, 1582; *Vita di suor Paola Antonia de Negri milanese*, Rome, 1576. Porzio, *L'universo illusorio*, loc. cit., draws conclusions about Fonteo's conversion and whereabouts in Italy.

24. Milan, Biblioteca Ambrosiana, Cod. V, 35 sup.; unfortunately this manuscript contains no further biographical information about the author himself.

25. For the possible connection of Arcimboldo and Borromeo, see my "A Tapestry Design by Giuseppe Arcimboldo, *Burlington Magazine* 130, 1988, pp. 428–30, and "Le opere di Arcimboldo a Monza e la carriera iniziale dell'artista," *Studi Monzesi* 3, 1988, pp. 5–17 (also ibid., as "Arcimboldo's Work in Monza and the Artist's Early Career," pp. [1]–[8]). For the evidence that Arcimboldo was in Milan in 1576 or 1577, see Robert Miller, "Note su Giuseppe Arcimboldo, Giuseppe Meda, Giovanni Battista della Rovere detto il Fiammenghino ed altri pittori milanesi," *Studi Monzesi* 5, 1989, pp. 3–7 (also ibid., as "Notes on Giuseppe Arcimboldo, Giuseppe Meda, Giuseppe Battista della Rovere detto il Fiammenghino, and other Milanese Painters, pp. 8–24, especially pp. 5–6, 11, and doc. 14, pp. 22–23).

26. In describing the festival of 1571 designed by Arcimboldo held to celebrate the marriage of Archduke Charles, Lomazzo says (*Idea del tempio della pittura*, Milan, 1590, p. 155): "E tutte furono inuentioni, e capricci di questo raro pittore (Arcimboldo), ancora che un certo Fonteo introdotto dall'Arcimboldo, che gli diede il carico di fare cartelli, non si vergogno' in una sua compositione di farsene egli inuentore." I have briefly discussed the problem of interpretation of Fonteo's claim for the dating of his collaboration with Arcimboldo in "Arcimboldo's Serious Jokes."

A copy of the cartel dated 28 August 1571 exists in the Haus-, Hof-, und Staatsarchiv, Vienna, Ältere Zeremoniellakten, I. This document is signed on succeeding folios: at the bottom "JO/SE/PH/VS/AR/CIM/BOL/DUS/PIC/TOR/FA/BRI/CA/TOR," and at the top "IO/BAP/FON/TE/IVS/PRI/MI/O/CO/OR/DI/NA/TOR."

A version of the cartel without the signatures is also to be found in ÖNB, Cod. 10206, fols., 72r–82r. The document has been published in Karl Vocelka, *Habsburgische Hochzeiten 1550–1600, Kulturgeschichtliche Studien zum manieristischen Repräsentationsfest*, Vienna, Cologne, and Graz, 1976, pp. 168–83, lacking mention, however, of the inscription with Fonteo's name on the copy in the Haus-, Hof-, und Staatsarchiv. For the distribution of the cartel at the festival, see Cod. 10206, fol. 9v.

27. For a discussion and the identification of this drawing, see my *Variations on the Imperial Theme*, pp. 59–61. The drawing is best illustrated on unnumbered

pages at the back of Roland Barthes, *Arcimboldo*, with an essay by Achille Bonito Oliva, Milan and Paris, 1980. This is the same sheet mentioned in passing by Ciardi, *Lomazzo. Scritti*, 1, p. 362 n.11, and thus vaguely associated with Arcimboldo, as illustrated in G. and A. Nerman, *Catalogo di vendita di disegni antichi*, Florence, 1967, p. 20, no. 10.

28. "Simplex Constitutio Rationum huius Defensorum Argumenti, ante illud tempus a Fonteio ad Serenissimum Archiducem Carolum nomine Arcimboldi perscripta," in Vienna, ÖNB, Cod. 10206, fol. 63r–65v.

29. For the view of *concettismo* as a poetic of correspondence, see Joseph Anthony Mazzeo, "Metaphysical Poetry and the Poetic of Correspondence," *Journal of the History of Ideas* 14, 1952, pp. 221–34.

Freedberg, *Painting in Italy*, p. 410, and Jacques Bousquet, *Mannerism, The Painting and Style of the Late Renaissance*, New York, 1964, p. 231, have also referred to Arcimboldo's paintings as conceits.

Subsequently Barthes, *Arcimboldo*, has extended this argument considerably. Barthes argues, pp. 15–16, that "his painting has a linguistic foundation, his imagination is poetic in the proper sense of the word: it does not create signs, it combines them—deflects them—exactly what a craftsman of language does." See Maiorino, *The Portrait of Eccentricity* for more discussion of this line of interpretation.

30. Information on particular details of these paintings, varying versions, and dates are given in *The School of Prague*, cat. no. 2.1–2.7, 2.11–2.14. The firmest point for dating these paintings are the dates 1563 on the versions of *Summer* and *Winter* and of 1566 on *Fire* in Vienna. Regardless of their exact date of execution, the symbolism in the paintings demonstrates that they were made for Habsburgs, as discussed here.

31. The marginal note in Cod. 10206, fol. 50v, in reference to the lines next quoted in the text of this chapter, reads: *datum est initio anni 1569.* It is possible that the 100 Thaler that Arcimboldo received on 31 May 1570 was in response to this gift; see W. Boeheim, "Urkunden und Regesten aus der K. K. Hofbibliothek," in *Jahrbuch der Kunsthistorischen Sammlungen des Allerhöchsten Kaiserhauses* 7, 1887, pt. 2, reg. no. 5191.

One example out of many of a New Year's gift to Rudolf II is Iacobus Vivarius, *Strena Anni Domini 1596 ad Invictissimum Romanorum Imperatorem Semper Augustum Rudolphum II*, Cologne, 1595; see fol. 2r, which states: *Accipis ergo Xenion quod fecimus anno Nunc ineuente nouo de consuetudine prisca.* Tycho's planned New Year's gift for 1598 is discussed in Victor E. Thoren, *The Lord of Uraniborg*, Cambridge, etc., 1990, pp. 383–84. A cup presented to Rudolf II as a New Year's gift by the Jewish community is recorded in the 1607–1611 inventory of the imperial *Kunstkammer*, Bauer and Haupt, "Inventar," p. 85, no. 1583.

32. ÖNB, Cod. 10206., fol. 50v:

> Non tamen absisto quandoquidem, optime Caesar
> Ad Dominum vacua non licet ire manu:
> Et quoniam Regi decet signa clientes
> Debita Nascentis xenia ferre suos
> His ego mutatis uenereor te partibus Anni

Atque elementorum promptus imaginibus
Haec fero mirificas cupiens animare figuras

Cod. 10152, fol. 2r: Haec fero caesaraeas cupiens animare tabellas.

33. A marginal note in ÖNB, Cod. 10206, fol. 54v, says: "In pompa ut propo-
nebatur Hyems, sed uisum est suae Maiestati ut post ponaretur, et recte."

After mentioning Fonteo's claim to have been the inventor of this tournament,
held in 1571 (see n. 26 above), Lomazzo, *Idea*, p. 155, says of Maximilian II: "Di
che ne e rimase meravagliato l'Imperatore quando l'intese, poi che egli sapea
benissimo, che l'inuentione era stata dell'Arcimboldo il qual con lui spesso ne
havea discorso."

34. ÖNB, Cod. 10206, fol. 153v:

. . . sed quoniam multis impedijs et sine cuiusque auxilio constitutus his
uacare non poterat, hunc quasi supplicens libellum Suae Maiestati in tabella
proposuit, in qua adumbrata et omnia erunt dispersim, quae collocata, et
ordinata Picturae tamque suam filiam loquentem, et ordinata Picturae
tamquam foeminae imaginem effecissent, indicunt igitur ipsam tamquam
suam filiam loquentem, et orantem ut uelit auxilio sublevare pictorem, quae
eam cupit parere, ut possit caesareos uultus adire, et uenerari, hoc est ipsius
thalamo confecta disponi.

The idea that *grilli* is a joking name comes ultimately from Pliny, for which point
see the next note.

35. Pliny's lines read: "idem (Antiphilus) iocoso nomine Gryllum de ridiculi
habitus pinxit, unde id genus picturae grilli vocantur"; Pliny, *Natural History*, ed.
and trans. H. Rackham, Cambridge, Mass., and London, 1952, 9, 344 (bk. 35,
114); Fonteo's comparison of Arcimboldo to ancient artists occurs in the text and
marginal notes on fol. 51v, ÖNB Cod. 10206; the notes read:

Polygnotus insignis inuentione colorum
Pyrrhus pictor insignis inuentione linearum
Gyges ingignis inuentione umbrarum
Josippus Arcimboldus insignis inuentione gryllorum siue chymerarum

Gombrich discusses the application of "Pliny's sobriquets" to living artists in
"The Renaissance Theory of Art and the Rise of Landscape," reprinted in *Norm
and Form*, London, 1966, pp. 112ff. His remarks on the obscurity of Pliny's refer-
ences and use of them to justify paintings are on p. 113; Gombrich, (pp. 112ff.,
151 n. 20) mentions the application of *grilli* to Hieronymus Bosch and A.
Brouwer. For the term *grilli* and its implications, see also Barry Wind, "Pitture
Ridicole: Some Late Cinquecento Comic Genre Paintings," *Storia dell'arte* 20,
1974, p. 20 and n. 26, and more recently the thorough treatment by Horst Bre-
dekamp, "Grillenfänge von Michelangelo bis Goethe," *Marburger Jahrbuch für
Kunstwissenschaft* 22, 1989, pp. 169–80.

36. ÖNB, Cod. 10206, marginal note on fol. 153v: "Volebat pictor Picturae
imaginem, per grillum ut solet exprimere, hoc est, ex instrumentis et rebus ad
ipsam pertinentibus conficere."

37. Ibid., fol. 51r, and marginal note; Cod. 10152, fol. 2v.

38. On Arcimboldo's sources, see Legrand and Sluys, *Arcimboldo et les Arcimboldesques*, pp. 71ff.; Geiger, *Dipinti ghiribizzosi*, p. 81; Alfons, *Arcimboldo*, pp. 9ff. and passim; Preiss, *Arcimboldo*, p. 32; John Shearman, *Mannerism*, Harmondsworth, 1967, p. 304; and for other, more recent references, the Excursus to this chapter.

39. At dinners of the Compagnia del Paiuolo and the Compagnia della Cazzuola in Florence, Giovan Francesco Rustici, Andrea del Sarto, and Domenico Puligo made compositions out of food; see Giorgio Vasari, *Le vite de' più eccelenti pittori, scultori ed architettori*, ed. G. Milanesi, Florence, 6, 1881, pp. 609ff., 614ff. (I owe this reference to E. H. Gombrich).

For actual examples of elaborate table compositions, see Stefan Bursche, *Tafelzier des Barock*, Munich, 1974.

40. W. Deonna, "Unité et diversité," in *Revue Archéologique*, 1914, pp. 39–58, discusses *grilli* as composite gems; Adolf Furtwängler, *Die Antike Gemmen*, 3, 1900, p. 353, and Wolfgang Bingsfeld, *'Grylloi,' Ein Beitrag zur Geschichte der antiken Karikatur*, Ph.D. diss., Cologne, 1956, argue against the identification of *grilloi* with gems. The point, however, is not whether the identification is correct, but that it is a traditional notion, as all parties agree. There are many such *grilloi* or composite gems still in the collection of the Antikensammlung of the Kunsthistorisches Museum, Vienna; with the help of identification supplied to me by Dr. Erika Zwierlein-Diehl, who was preparing a catalogue of antique gems in Vienna at the time I was writing the original version of this article, I studied these gems. Unfortunately no gem has a provenance that can be secured beyond the nineteenth century.

41. ÖNB, Cod. 10206, fol. 56v; Cod. 10152, fol. 9r; a marginal note on fol. 56v of Cod. 10206 says: "Antiqui pictores nescierunt simili picturae effectus." Another marginal note on fol. 51v of Cod. 10206 says: "non legimus apud antiquos concinnatos fuisse huiusmodi picturas."

The comparison with Apelles, given a different twist in this context is also a Renaissance topos; see Rona Goffen, "Icon and Vision: Giovanni Bellini's Half-length Madonnas," *Art Bulletin* 57, 1975, p. 508, for references to further literature. In Rudolfine art, paintings of Apelles before Alexander, such as that of Joos van Winghe (Kunsthistorisches Museum, Vienna), may be meant to bring praise to the emperor as well as to the artist.

42. ÖNB, Cod. 10152, fol. 9r; Cod. 10206, fol. 56v:

> Ipsa monet pictura nouis exculta tabellis,
> Quales nec pinxit, magnus nec sciuit Apelles;
> Tales hoc miti uos Caesare dicite dignas.

43. *Fire* is signed in the bottom right-hand corner "Josephus Mlnensis. F."; on the reverse is marked IGNIS 1566. *Water* is marked on the back AQUA. *Summer* is signed on the collar "GIVSEPPE ARCIMBOLDO. F." and dated on the shoulder 1563; on the back is written 1563 AESTAS. *Winter* is signed in the bottom right-hand corner GIVSEPPE ARCIMBOLDO. F.; on the reverse is written 1563 HJEMS. (See further the *Katalog der Gemäldegalerie*, Kunsthistorisches Museum, Vienna, 1965, 1, pp. 4–5, for this information.)

44. Lomazzo, *Idea*, p. 154: "Oltra di cio v'Ha rappresentato le quatro stagioni formate in figura d'huomo con le cose di ciascuna stagione come la Primavera di fiori, la State di spiche, & legumi, & l'Autunno di frutti, & l'Inverno in forma d'arbore. Che tutti sono dipinti in tanti quadri."

45. ÖNB, Cod. 10206, fol. 58v:

Hyems trunco salicis per uetusto adumbriam rustici apparentiam effingit.
Veris caput ex floribus et eorundem florum herbis conflatur.
Aestas a cistis spicisque et fructibus hominis personam imitatur.
Autumnus ex pomis uarijs humanum uultum refert.

46. Ibid., fol. 58v, 54r:

Aqua uariorum piscium collocatione hominem se repraesentat.
Ex piscibus omnigenis contexitur caput Aquae.

47. Ibid., fol. 59r: "Ignis ex fomilibus, sulphureis, candelis scilecibus, ac humanam faciem colligit."

48. Ibid., fol. 59r: "Aër omni genere volucrum confictarum vultum hominis exprimit"; fol 54r: "Ex auibus omnigenis contexitur caput Aeris."

49. Geiger, *Dipinti ghiribizzosi*, pp. 66–67, fig. 80; Alfons, *Arcimboldo*, p. 48. For Fonteo, ÖNB, Cod. 10206, fols. 59r and 53v; the allusion is on fol. 56r (Cod. 10152, fol. 8v). For the text of Fonteo's marginal note, see also n. 67 below. This is not to state that the painting formerly in the Wenner-Gren Collection is actually by the artist, but that it replicates the original work: see further *The School of Prague*, cat. nos. 2–7.

50. Jurgis Baltrušaitis, "Têtes composés," *Médecine de France*, 1951, quoted in Alfons, ibid., p. 145; *loc. cit.*, pp. 147–48 for identification with Maximilian II; Preiss, *Arcimboldo*, p. 19; Comanini, *Il Figino* (see trans. in *The Arcimboldo Effect*). Fučíková's opinion is given in *Dějiny Českého Výtvarného Umění*, Prague, 1989, 2, 1, p. 184. For Lomazzo, see *Trattato*, p. 349: "ne quali compose, & furnò la figura del Fuogo come con membri di luci, folgori di torchie, di candellieri, & d'altri membri conuenienti al fuoco; l'aria d'vccelli che volano per l'aria tanto perfettamente che le membra paiono tutti conformi de l'aria, L'aqua tutti i pesci, & ostriche del mare, cosi ben composte che veramente l'acqua pare che sia posta in figura, & il quarto elemento de la terra, & di diruppi di sassi, di cauerne, di tronchi, & di animali terrestri."

51. For Fonteo's remarks, see the marginal notes in ÖNB, Cod. 10206, fol. 59r, 54r, and text on fol. 56v (in Cod. 10152, fol. 9r).

52. Wescher, Review, *Les Beaux Arts*, also recognized the possibility that the painting could be *Earth* because of the similarity of dimensions. In addition, Geiger, *Dipinti ghiribizzosi*, p. 48, fig. 29, brings up another Arcimboldesque painting close to the one formerly in Graz, which he compares to a print by Heinrich Göding; however, he adheres to Lomazzo's identification.

The slight differences may result from variations in time of execution, histories of condition, and hence conservation treatment, or, granting the possibility that the surviving version of *Earth* may even have belonged to one of the other multiple series executed by the artist, intended audience. In any case, it replicates the original composition, if it is not the very work in question, as seems most likely.

53. Johannes Sambucus, *Arcus Aliquot Triumphal. et Monimenta Victor Classicae, in Honor Invictissimi ac Illustriss. Iani Austriae*, Vienna, 1572, fig. 3.

54. ÖNB, Cod. 10206, fol. 50v–51r; Cod. 10152, fol. 2r–2v, ll.

55. Cod. 10206, fol. 52vff., with marginal notes; Cod. 10152, fol. 4rff. The use of the epithet "Dominus" for the emperor is an inheritance from Roman law, revived in imperialist thinking, that styles the emperor "Dominus Mundi," Lord of the World; see for this point Frances A. Yates, *Astraea*, pp. 5f. Clemency, a traditional virtue of the Habsburgs, is also that by which Maximilian's supposed namesake, the Roman Aemilianus, took the throne of empire.

For Maximilian's clemency, see, for example, the marginal comments on Cod. 10206, fol. 52v, and the explanation of the contents on fol. 8r, which states: "Primum . . . diuino, quid sit cur elementa, et Tempora effigiem humanam induerint; atque aio in causa esse Clementiam Maximiliani Caesaris, et totius inclytae Austriae domus."

Given the popularity of Stoicism at the time, as discussed in chap. 3, it may also be significant that Seneca wrote an essay on clemency (*De Clementia*), which gained an imperial association by the fact that he addressed it to the Emperor Nero.

56. For a clear exposition of the principles of this system of thought, see Joseph A. Mazzeo "Universal Analogy and the Culture of the Renaissance," in the *Journal of the History of Ideas* 15, 1954, pp. 299–304, and "Poetic of Correspondence," pp. 221–34; see also Jean Seznec, *The Survival of the Pagan Gods*, trans. Barbara F. Sessions, New York, 1953, p. 49, with an accompanying outline on p. 47.

Wescher, "The 'Idea' in Arcimboldo's Art," p. 8; Alfons, *Arcimboldo*, pp. 157–61, 171–76; and Preiss, *Arcimboldo* pp. 17–19, had all previously discussed the application to Arcimboldo of this kind of thinking about the universe. A work by a humanist with connections to Rudolfine Prague, which draws out the parallels between the microcosm and the body politic is Caspar Dornavius, *Menenius Agrippa, hoc est corporis humani cum republica perpetua comparatio . . .* , Hanau, 1615.

57. Alfons, *Arcimboldo*, pp. 142ff., 175; Preiss, *Arcimboldo*, p. 17; Evans, *Rudolf II*, p. 174; Comanini, *Il Figino*, pp. 44–48.

58. ÖNB, Cod. 10152, fol. 6rff.; Cod. 10206, fol. 53vff. The quotation is from a marginal note on fol. 53v in Cod. 10206. Hocke, *Die Welt als Labyrinth*, pp. 153f., has suggested that Arcimboldo's paintings exhibit a *discordia concors* or *concordia discors* while, however, in my opinion misinterpreting its significance. See ÖNB, Cod. 10206, fol. 8r, where Fonteo says: "ac sicuti elementa, et Tempora se praebant concordia, societatemque ineunt, sic regna mundi unanimi consensu imperium acceptura sanguinis Austrii."

Leo Spitzer, "Classical and Christian Ideas of World Harmony. Prolegomena to an Interpretation of the Word 'Stimmung,' " *Traditio* 2 and 3, 1944, pp. 307–64, 409–64, provides a comprehensive discussion of this widespread belief in world harmony, which in the form of Kepler's *Harmonia Mundi* obviously also appeared at the imperial court.

59. ÖNB, Cod. 10152, fol. 6rf.; Cod. 10206, fol. 53vff. The linking of the Moon with *Earth* and *Autumn* is unusual.

60. ÖNB, Cod. 10152, fol. 3rff.; Cod. 10206, fol. 58vff.

61. The anti-Turkish prophecies are drawn out at length in ÖNB, Cod. 10152, fol. 5r–6r, ll; the prophecies on Habsburg rule are most specifically stated on fol. 10vff. and in Cod. 10206, fol. 58rff. The quotation is from a marginal note on fol. 59r of Cod. 10206 (see the notes to Appendix 2): "Sicuti elementa et Tempora arte sunt apud Caesarem, natura sunt suis in locis, ac terminis, non aliter, qua ipsa referunt aetates humanas, in Austria domo erunt pueri, iuvenes, uiri, ac senes, semper, qui aut imperent, aut imperaturi sint."

The allegorical use of the four seasons to express the idea of eternity is discussed in Barbara Maurmann-Brinder, "Tempora Significant. Zur Allegorese der vier Jahreszeiten," in *Verbum et Signum*, I, *Beiträge zur mediävistischen Bedeutungs-Forschung*, ed. H. Fromm, W. Harms, U. Ruberg, Munich, 1975, pp. 69–191, with a bibliography on the iconography of the seasons on pp. 73–74nn. For the ages of man, see Erik Dal, in collaboration with Povl Skarup, *The Ages of Man and the Months of the Year*, Copenhagen, 1980; Elizabeth Sears, *The Ages of Man. Medieval Interpretations of the Life Cycle*, Princeton, 1986; J. A. Burrow, *The Ages of Man*, Oxford, 1986; Mary Dove, *The Perfect Age of Man*, Cambridge, 1986.

62. The inscription on the verso of a version of *Spring* (Madrid, Academia di Bellas Artes di San Fernando; *The School of Prague*, cat. no. 2.3) is illustrated in *The Arcimboldo Effect*, p. 99; it reads: "LA PRIMAVERA/Va accompagnata con l'Aria ch'una testa di uccelli."

63. A marginal note on fol. 57v of Cod. 10206 reads: "De Nuptiis Serenissi-marum Maximiliani Secundi Imperatoris Filiarum quarum altera Regi Hispania-rum, altera Regi Galliarum desponsata est, cecinnisset autor, si adiutus id pro dignitate facere potuisset." The epithalamial verses are found *loc. cit.*, and on fol. 10r of Cod. 10152, e.g., ll.: "O hymenaee hymen repetens, o hymen hymenaee." On Habsburg and dynastic marriages at this time, see Vocelka, *Habsburgische Hochzeiten*.

64. Johannes Sambucus, *Emblemata cum aliquot nummis antiqui operis*, Antwerp, 1564, p. 240.

65. Dionysius of Halicarnassus, *The Roman Antiquities* 4:59–61, ed. E. Cary, London and Cambridge, Mass., 2, 1939, p. 457ff.; T. Livy, *Ab Urbe Condita* 1:55, ed. B. O. Foster, London and Cambridge, Mass., 1939, pp. 190ff.

66. ÖNB, Cod. 10152, fol. 4v, contains remarks about the vacant thrones: Cod. 10206, fol. 53r marginal notes that run:

Caput humanum inventum a fabricatoribus capitolij portendit, romanos potituros hominum imperio.
Capita elementorum, et Temporum humane effigie oblata Maximilliano Imperatori portendit cunctis seculis Mundi fore ut humanibus pareat Austriacis, et ab ijs temperetur.

For the story of the Capitoline, see further Fonteo's comment on fol. 8r: "Dein-ceps Diuino quid omnis ferant elementorum, ac Temporum humani uultus atque aio, quemadmodum hominis caput inuentum a capitolinae arcis fabricatoribus, Imperium orbis portendisse, sic fore ut ab Austrigenis humanissime Terrarum orbis, qui constat ex elementis, regatur omnibus annis, qui constat ex quattuor Temporibus."

67. A marginal note on fol. 56r of ÖNB, Cod. 10206, explains the lines on the peacock and eagle: "Alludit ad aquilam et instans pauoninas Austrorum."

68. Ibid. fol. 56v: "Torques uelleris aurei constat ex scylicibus, et ferris excudentibus Ignem alternatim positis quale gestamen elementis ignis additum cognouit."

69. Alfons, *Arcimboldo*, p. 48; see also n. 61 above.

70. Comanini, *Il Figino*, p. 48, thought that the lion and the fleece "dimostrano, che per mezo della fortezza, & delle fatiche, s'acquista l'honore, & la gloria."

71. A print after Leoni's bust of Charles V is illustrated in L. O. Larsson, *Adriaen de Vries*, Vienna and Munich, 1967, fig. 93; see ibid., p. 48, for an interpretation of the relief bust of Rudolf II, which also mentions the physiognomic parallels on which it is based, similar to those out of which *Earth* is composed. The Habsburg-Hercules comparison is discussed in Guido Bruck, "Habsburger als 'Herculier,' " *Jahrbuch der Kunsthistorischen Sammlungen in Wien* 50, 1953, pp. 191–98, and also in William C. McDonald, "Maximilian I of Hapsburg and the Veneration of Hercules: On the Revival of Myth and the German Renaissance," *Journal of Medieval and Renaissance Studies* 6, 1976, pp. 139–54.

72. ÖNB, Cod. 10206, marginal note on fol. 56v.

73. The *Verzeichnis der Gemälde* of the Kunsthistorisches Museum, Vienna, 1973 (ed. Klaus Demus), p. 8, had previously mentioned that the *Feuereisen* is a Habsburg emblem.

74. For this painting and the related works in the series, see most completely my "Arcimboldo au Louvre."

The references to Maximilian II in the Vienna version clinch the notion that the work was done for the imperial court. Given the date of the painting, 1563, and the fact that Maximilian II was not yet emperor in this year, it is even possible that the artist made it with the intention of bestowing his gift at a later date. Ferdinand I (ruler until 1564) was already noticeably in failing health from early 1563, the earliest time at which Arcimboldo could have arrived at court: see further for Arcimboldo and Ferdinand I Wolfgang Hilger, *Ikonographie Kaiser Ferdinands I.*, Vienna, Cologne, and Graz, 1969, pp. 86, 87, 111ff.

75. See ÖNB, Cod. 10152, 7rff.: "Idem Caesar honos, idem dignissimus autor,/Qua sese latis Romana potentia Terris/Inijceret, cana renouanda exordia Bruma/Esse sui posuit rectis rationibus Anni."

These and other lines in this codex (on fol. 7r and in Cod. 10206, fol. 54vff.: "Iure caput tuus [*sic*]. o Caesar, praeponit Apelles") also leave no doubt that *Winter* is the imperial head. See further n. 33 above.

Fonteo's remark on the Romans making winter the beginning of the year is on fol. 7v, of ÖNB, Cod. 10152, to which the marginal note in ÖNB, Cod. 10206, fol. 55r, is: Hyems caput Anni penes Romanos Imperium autores.

Fonteo further develops a discourse on which is the primary element: Cod. 10152, fol. 8r; Cod. 10206, fol. 55r.

76. Cf. for example, Alfons, *Arcimboldo*, pp. 42–43, 85; Preiss, *Arcimboldo*. pp. 9–10.

77. [Zirfeo], *Ordenliche Beschreibung; Des gewaltigen treffenlichen und herrlichen Thurniers zu Ross und Fuss . . . zu Prag . . . den der anwesenden Chur und Fürsten zu*

Ehren, n.p. [Prague], 1570, fol. 16r; a discussion of this festival is to be found in my *Variations on the Imperial Theme*, pp. 28-33.

78. The most complete source of information on the 1571 festival is Fonteo, ÖNB, Cod. 10206. For discussions of the festival, see Alfons, *Arcimboldo*, pp. 74-85; Vocelka, "Studien," pp. 78-89; Hans von Zwiedeneck, "Die Hochzeitsfeier Erzherzogs Karls II. mit Maria von Baiern," *Mittheilungen des Historischen Vereines für Steiermark* 47, 1899, pp. 193-213; and for more of the interpretation given here, *Variations on the Imperial Theme*, pp. 33-43.

The prophecy on Lepanto is made in the title of Fonteo's compilation: "Baptistae Fonteii Primionis Evropalia, hoc est Species Dignita, significatio, solennis eius Pompae, quam Maximillianus Secundus, Imperator inuictissimus, cum illustri Europae ostentatione ijs produxit ludis, quos egit summo, incredibilique splendore, atque apparatu, dum Sereissimi Archiducis Caroli fratris nuptialem celebritatem ornandum amplificandamque suscepit, diuinoque simul praesagio foederatae aduersus Barbaros militiae fortunatos gloriosos exitus, et Triumphum portendisse uisus est, die ipso quadragesimo ante magnam uictoriam naualem." Other specific prophetic utterances are made on fol. 38v.

79. ÖNB, Cod. 10206, fols. 150r, 152r-152v:

Dietro alli Venti, ueniva un Padrino uestito da femina, sopra un Cauallo bianco apomelato con le crine negre, la testera guarnita di uelluto uerde con guarnitione di spighilia d'oro, la Croppera di coramo messo à oro, et argento tratagliato nelli contorni, et dipinto a ghiribizzo d'animali. . . . La quale per corrispondenze fu giudicata esser la Terra.

A venti succedeva il Padrino uestito da femina con ueste longa, et sopra uestina di tela d'argento con guarnitione di passamani, At Alamani d'argento, con conciatura di testa fatta di veli bianchi i fogia d'unde d'argento. La Mascherà grave, pallidetta congimessi tanto quanto nel rosso. Cavalcava in cauallo morello scuro. La testera di uelluto bianco guarnita di spighilia d'argento. Il Pettorale, et la croppera di corame margelato dipinto, à pesci, con taglij similmente pescificati. Onde s'auuiserro i spettatori ch'esser dovesse L'Acqua elemento.

80. On the French ballet as an "imperial" expression, see especially Yates, *Astraea*, pp. 165-67; on Spenser, see pp. 69-74.

81. On imperial imagery in the sixteenth century, see in general *Astraea*; for the revival of the imperial ideal with Charles V, pp. 1-29, "Charles V and the Idea of the Empire."

82. Sambucus, *Arcus* . . . , fol. 6r, fig. 3.

83. Comanini, *Il Figino*, p. 45: "Et che direste di quella testa fatta di più teste d'animali tutti diuersi, la quale gli compose in Germania, & fù dall' Imperadore mandata ne gli anni à dietro alla Cattolica Maestà di Spagna." See further *The School of Prague*, cat. no. 2.3, for the possible identification of this series.

84. For details concerning the series done for August of Saxony, see my "Arcimboldo au Louvre." A 1610 inventory of the Dresden collection lists four gifts from Maxmilian II to August that can be identified with Arcimboldo's paintings, "Inventarium über die Churfürstliche Sächssische Kunst-Cammern [*sic*] . . . ," Dresden, 1610, fol. 296r (Staatsarchiv Dresden, on deposit in the Staatliche

Kunstsammlungen Dresden, Grünes Gewölbe). For the participation of August in the 1570 festival, see ÖNB, Cod. 10206, fol. 59v, 1611; for Arcimboldo's, *Ordentliche Beschreibung*, fol. 15r.

The 1621 inventory of the imperial collections in Prague lists seventeen paintings by Arcimboldo; see Heinrich Zimmermann, ed., "Das Inventar der Prager Schatz- und Kunstkammer," in *Jahrbuch der Kunsthistorischen Sammlungen des Allerhöchsten Kaigerhauses*, 25, 1905, pp. xxff. Eight paintings that may have been made by Arcimboldo are listed in a 1613 inventory of the collection of Prince Karl von Liechtenstein cited in Geiger, *Dipinti ghiribizzosi*, p. 127. See now Herbert Haupt, *Fürst Karl I. von Liechtenstein. Obersthofmeister Kaiser Rudolfs II. und Vizekönig von Böhmen. Hofstaat und Sammeltätigkeit. Edition der Quellen aus dem liechtensteinschischen Hausarchiv (Quellen und Studien zur Geschichte des Fürstenhauses Liechtenstein)*. Vienna, Cologne, Graz, 1983, vol. 1, pt. 2, p. 186, no. 257-259. Comanini, *Il Figino*, pp. 52f., indicates that there were many imitations of Arcimboldo's work during his lifetime. See further for Arcimboldesque paintings Legrand and Sluys, *Arcimboldo et les Arcimboldesques*, pp. 87f., and "Some Little-Known 'Arcimboldeschi,' " *Burlington Magazine* 96, 1954, pp. 210–14.

85. The tapestries are described in André Félibien, "Les quatre elements peints par Mr. LeBrun et mises en tapisseries pour Sa Majesté" and "Les quatres series peintes par Mr. Le Brun et mises en tapisseries pour Sa Majesté," in *Recueil de descriptions de peintures*, Paris, 1689, pp. 95–141, 143–93. The quotations are taken from pp. 102, and 145–46:

> Si les Philosophes ont écrit que l'Amour a débrouillé le cahos, & mis tous les Elemens dans leur place, on peut dire avec plus de verité que *Sa Majesté* a mis par son heureux Mariage la paix dans son Estat, & qu'Elle a comme changé tous les Elemens qui estoient dans une confusion horrible, durant les cruelles guerres dont il a esté affligé si longtemps.
>
> . . . ayant peint dans ce rare ouvrage le changement que *Sa Majesté* a, s'il faut ainsi dire, apporté dans les Elemens, en changeant le mauvais usage qu'on en faisoit, & de quelle sorte elle les a reduits dans cette disposition qui a produit par la Paix des effets si extraordinaires, il estoit besoin de representer encore par d'autres peintures ces effets merveilleux, dont l'on n'avoit figuré que la cause. Pour faire voir que Sa Majesté ayant donc mis comme un nouvel ordre dans les Elemens a aussi rendu les Saisons plus belles et plus fecondes, ou plutost a remplé nos jours de bonheur, et comblé nos années de sortes de bien.

Series of these tapestries are to be found among other places in the Mobilier National, France.

86. See Comanini, *Il Figino*, p. 31, for his friendship with Arcimboldo and the indication that the painting was still in Milan when the poem was written; Geiger, *Dipinti ghiribizzosi*, p. 78, suggests that the poem accompanied the picture to Bohemia.

87. See Giacomo Berra, "Allegoria e mitologia nella pittura dell' Arcimboldi: La 'Flora' e il 'Vertunno' nei versi di un libretto sconosciuto di rime," in *ACME. Annali della Facoltà di Lettere e Filosofia dell'Università degli Studi di Milano* 41, fascicle 2, 1988, pp. 11–39. Berra's discovery contains much other important material

on Arcimboldo's paintings that helps support the interpretation presented here; for our differences, see the Excursus to this chapter.

88. The parts of the poem referred to here are in *Il Figino*, pp. 33, 43, 41f, 34f.

89. *Il Figino*, p. 42.

90. Lomazzo, *Idea*, p. 157, comments that His Majesty [Rudolf II]" con lettere mostra di starla [the painting of Vertumnus] aspettando con estremo desiderio."

91. Fonteo, for example, says of Maximilian (ÖNB, Cod. 10152, fol. 2r; Cod. 10206, fol. 50v): "Cuius quae satagunt agnoscere sceptra, beatas/Cernimus esse vrbes, cernimus esse viros."

92. Ovid's account of a golden age appears in bk. I of the *Metamorphoses*; 11. 113ff. relate the coming of the seasons with the silver age (Ovid, *Metamorphoses*, ed. F. J. Miller, Cambridge, Mass., and London, 1944, p. 10). On the connection of the golden age and the imperial theme, see Yates, *Astraea*, pp. 30ff. and passim. Fonteo himself prophesies the return of the golden age with the reign of Rudolf II in ÖNB, Cod. 10206, fol. 24v.

A similar use of Vertumnus (this time with Pomona) in connection with the idea of a golden age that will return under the beneficent rule of the Medici occurs in Pontormo's painting at Poggio a Caiano; see Kurt W. Forster, *Pontormo*, Munich, 1966, pp. 43f.; Matthias Winner, "Pontormos Fresken in Poggio a Caiano. Hinweise zu seiner Deutung," *Zeitschrift für Kunstgeschichte* 35, 1975, pp. 153–97; and Janet Cox-Rearick, *Dynasty and Destiny in Medici Art*, Princeton, 1980.

93. For the relation of wit to fantasy, see in general the discussion in Summers, *Michelangelo and the Language of Art* and *The Judgment of Sense*, and also Martin Kemp, "From 'Mimesis' to 'Fantasia': The Quattrocento Vocabulary of Creation, Inspiration and Genius in the Visual Arts," *Viator* 8, 1977, pp. 347–98. The quotation is taken from Mazzeo, "Poetry and the Poetic of Correspondence," p. 223.

94. This paragraph summarizes some of the arguments in my "Arcimboldo's Serious Jokes," where further references to the primary and secondary sources can be found.

95. Besides Fonteo, see, for example, the usage in the title of Caspar Dornavius, *Amphitheatrum Sapientiae Socraticae Joco-Seriae . . .* , Hanau, 1619, and in the works of the imperial physician Michael Maier, *Lusus Serius*, Oppenheim, 1616, and *Jocus Severus*, Frankfurt a. M., 1617.

EXCURSUS TO CHAPTER 4

1. In addition to the references in chap. 4 to earlier discussions and possible sources, including ancient gems, Porzio, *L'universo illusorio di Arcimboldi*, p. 14, deals with the claim that Arcimboldo's inventions had no precedents and, pp. 14–26, offers an extensive summary of Arcimboldo's sources. Porzio, p. 14, ill. p. 15, mentions Indian miniatures as a source for Arcimboldo. In an unpublished lecture (Newberry Library, Chicago, 1976) E. A. Maser also suggested that Indian miniatures might be a source for Arcimboldo.

More recent literature on the question includes Jurgis Baltrušaitis, "Prima dell'Arcimboldi: mostri e bizzarrie medievali," pp. 7–22; Francesco Porzio, "Arcimboldi: un imprevedibilie erede di Leonardo"; and Maurizio Calvesi, "Le fonti dell'Arcimboldi e il verde sogno di Polifilo," pp. 38–51, in *Arcimboldi e l'arte delle meraviglie (Art et Dossier)*, 1987; Berra, "Allegoria et mitologia," and Raymond B. Waddington, "Before Arcimboldo: Composite Portraits on Italian Medals," *The Medal* 14, 1989, pp. 13–23.

2. Comanini, *Il Figino*, p. 32 (most easily available in Barocchi, *Trattati d'arte del cinquecento*, Bari, 1962, 3). The discovery of a compendium of poems on Arcimboldo assembled by Giovanni Filippo Gherardini, by Berra, "Allegoria e mitologia," has confirmed a suggestion first made by Geiger, *Dipinti ghiribizzosi*, p. 78, that the poem accompanied the painting when it was sent to Bohemia. Berra indicates that there are slight variations in the versions of Comanini's poem, as published by the author himself and in Gherardini's gathering, including the lines here quoted: cf. Berra, ibid., p. 23.

3. Alfons, *Arcimboldo*, p. 136, mentions Propertius's poem in relation to the etymology of the name Vertumnus, citing his information, however, by reference to secondary sources, p. 190 n 255; Alfons does not discuss its significance for the painting. More characteristic of the art-historical literature is his remark that Vertumnus would have been a well-known figure (*välbekant gestalt*) for Rudolf II because the emperor owned a series of tapestries depicting Ovid's tale of Vertumnus and Pomona. For references that relate Ovid to the painting of Vertumnus, see chap. 4 above, and Porzio, *L'universo illusorio*, pp. 39–41; Jaromír Neumann, in Jirina Hořejší et al., *Die Kunst der Renaissance und des Manierismus in Böhmen*, Hanau, 1979, p. 197; and also the reference to Vertumnus and Pomona in Barthes, *Arcimboldo*, pp. 36, 108–10.

The suggestion made in chap. 4 that the image of Rudolf II as Vertumnus evoked the return of a golden age, especially as discussed by Ovid, *Metamorphoses* I:89ff., has also been picked up by subsequent studies, e.g., Jaromír Neumann, "Rudolfínské Umění," p. 438. Only after the initial publication of the earlier version of this Excursus did the importance of Propertius become recognized, as by Berra, "Allegoria e mitologia."

4. Editions of Propertius already published in the fifteenth century start with ones published by F. de Montibus in Venice, 1472, as well as an edition published in the same year in Venice by Vindelinus de Spira, which accompanied the works of Tibullus, Catullus, and Statius. Later editions, published alone or with the works of other poets, appeared in Venice in 1475; in Rome and Vicenza in 1481; in Rome (ed. A. Volscus [Volsco]) in 1482; in Brescia in 1486; in Bologna (ed. P. [F.] Beroaldo, with commentary) in 1487; in Venice in the same year; in Venice in 1488, 1491, and 1493; another edition appeared in Venice in 1500. Many more editions were published in the sixteenth century.

5. For fifteenth-century commentaries on Propertius, see Donatella Coppini, "Filologi del Quattrocento al lavoro su due passi di Properzio," *Rinascimento*, 2nd series, 17, 1976, pp. 219–30; *eadem*, "Il commento a Properzio di Domizio Calderini," *Annali della Scuola Normale Superiore di Pisa, Classe di lettere e filosofia*, 3rd series, 9, pp. 1119–73; see also the brief comments by Antonio La Penna,

L'integrazione difficile. Un profilo di Properzio, Torino, 1977, p. 274; see also the next note.

6. *Sex. Propertius*, com. A. Muret, Venice, 1558; *Catulli, Tibulli, Properti Nova Editio*, ed. Joseph Scaliger, . . . *Eiusdem in eosdem Castigationum Liber*, Paris, 1577. For Scaliger's edition of Catullus, Tibullus, and Propertius, see Anthony Grafton, *Joseph Scaliger*, Oxford, 1983, pp. 161–79, which also gives the background to the edition, bibliographic references, and, pp. 35–37, discusses earlier commentaries on Propertius.

7. Lipsius's emendations to Propertius are found in his *Antiquarum Lectionum Commentarius*, Antwerp, 1575, passim, as in his *Variarum Lectionum Libri IV*, Antwerp, 1569, passim. Morford, *Stoics and Neostoics*, p. 33, notes Lipsius's intention to publish a commentary on Propertius, and elsewhere, pp. 92, 144, points out his earl y interest in the Roman elegist. It is also worth noting that Lipsius, *Antiquarum Lectionum*, pp. 84–86, also places a poem in the mouth of Vertumnus, undoubtedly in the wake of his reading of Propertius.

8. For the fortunes of Propertius in the poetry of the fifteenth and sixteenth centuries, see La Penna, *L'integrazione difficile*, pp. 263–82.

9. Hans Belting, *Bellinis Pietà. Ikone und Bilderzählung in der venezianischen Renaissance*, Frankfurt a.M., 1985, pp. 29–31, discusses Giovanni Bellini's use of Propertius I, 21 in a painting of the 1470s.

10. The "etiological" character of the elegies of the fourth book is mentioned widely in the scholarly literature on Propertius, as is their "archaeological" aspect. See, for example, H. E. Butler and E. A. Barber, eds., *The Elegies of Propertius*, Oxford, 1933, p. lxvi, and in reference to Propertius IV, 2, also p. 333; G. Dumézil, "Propertiana," *Latomus* 10, 1951, pp. 293ff.; E. Pasoli, "De Properti libro quatro," *Euphrosyne*, n.s. 1, 1967, p. 3; and especially Jean-Paul Boucher, *Études sur Properce. Problèmes d'inspiration et d'art*, Paris, 1965, pp. 147ff. For Lipsius and the Vertumnus elegy of Propertius, see n. 7 above.

11. Johannes Annius, "*[Comentaria] Super Vertunnianam Propertii*" [sic], in *Commentaria . . . super opera diversorum auctorum de antiquitatibus loquentium confecta*, Rome, 1498, fol. Fi–Fvi. (Two editions were published in Rome in that year and one in Venice.) References to Vertumnus, outside of this commentary, are perhaps more easily found in the 1552 edition of Nanni's work, *Berosi sacerdotis chaldaici, Antiquitatum Italiae ac totius orbis libri quinque, Commentarijs. . .* , Antwerp, 1552, e.g., pp. 22, 37.

12. Cf. C. R. Ligota, "Annius of Viterbo and Historical Method," *Journal of the Warburg and Courtauld Institutes* 50, 1987, p. 53.

13. Editions of Nanni's text were published in Paris in 1512 and 1515; in Rome in 1530; in Antwerp in 1545; in Basel in 1550; in Lyon in 1552, 1554, and 1560; in Venice in 1585; and in Heidelberg in 1598–1599.

Anthony Grafton has informed me that Nanni's construction of the text of Propertius had become part of the "vulgate" edition of his corpus by the mid-sixteenth century, and could thus have been used by scholars such as Muret and Scaliger even when they were not aware that the readings they were adopting were Nanni's; for the background to Scaliger's edition, see Grafton, *Scaliger*. It is amusing to note in this regard that in two instances when Scaliger tries to estab-

lish new readings, for Propertius IV, 2:30, and IV, 2:35 (*Castigationum Liber*, p. 230), he actually approximates Nanni (e.g., compare Scaliger's *subisse* to Nanni's *subiisse* in line 30).

14. For Nanni's importance for mid- and late sixteenth-century writers, see Grafton, from whom this phrase is taken: "Traditions of Invention and Inventions of Tradition in Renaissance Italy: Annius of Viterbo," in *Defenders of the Text*, pp. 76–103. For more on Nanni, see also idem, *Forgers and Critics. Creativity and Duplicity in Western Scholarship*, Princeton, 1990.

15. Postel's connection with the imperial court is demonstrated in chap. 5; Pancirolli's discussion of silk manufacture, a topic also important to Arcimboldo, in chap. 6.

Postel's use of Nanni is evident in his *De Etruriae regionis quae prima in orbe Europaeo habitata est originibus*, Florence, 1551, e.g., pp. 19–20, 55–56. For Postel and Nanni, see further Grafton, "Traditions of Invention," pp. 94–95. Lazius's use of Nanni is demonstrable in his *De gentium aliquot Migrationibus, sedibus fixis, reliquis linguarumque initiis et immutationibus ac dialectis Libri XII*, Frankfurt a.M., 1600, pp. 14–15, where he cites works concocted by Nanni for Berosus and Fabius Pictor in reference to the equation of Noah and Janus.

For Pancirolli's use of Nanni (he cites another of Nanni's spurious inventions, Flavius Vopiscus, for which see Grafton, ibid., pp. 95–96), see chap. 6, n. 43.

16. The importance of Propertius for Renaissance mythography is demonstrated by Vincenzo Cartari, *Imagini delli dei de gl'antichi, [sic]*, Venice, 1571, pp. 269ff. [reprint, 1976]; Venice, 1677 [reprint Graz, 1963], pp. 145ff., and many other editions [1st ed. Venice, 1556], to be discussed below.

For the use of Nanni in another Renaissance handbook on mythography, see Lilio Gregorio Giraldi, *De Deis Gentium*, Basel, 1548 (reprint ed. New York and London, 1976), pp. 213–14. While Giraldi ridicules Nanni's conflation of Vertumnus and Janus, discussed here, in the next breath he also uncritically accepts the texts Nanni had fabricated for Berosus, on which Nanni had supposedly in part based this equation.

17. As Grafton, *Scaliger*, especially pp. 35–37, suggests, etiological and archaeological interests are also commonly expressed in commentaries on Propertius, even if it cannot be said that they are evident in Scaliger's own scant remarks on Propertius IV, 2.

18. For the relation of Arcimboldo to the ideal of the learned artist, see my "The Eloquent Artist," pp. 123–24, and for this notion in Prague in general *L'école de Prague*, pp. 32–34, 87–92, and *The School of Prague*, passim.

19. For Arcimboldo's journey, see the documents published most conveniently in Geiger, *Dipinti ghiribizzosi*, pp. 124–25. A letter of September 1582 from Rudolf II in Augsburg to Raimund Dorn in Kempten regarding Arcimboldo's journey to purchase "antiquiteten und Kunststuck" [sic] was published first in Heinrich Zimerman, ed., "Urkunden, Akten und Regesten aus dem K.K. Ministerium des Innern," *Jahrbuch der Kunsthistorischen Sammlungen des Allerhöchsten Kaiserhauses* 5, 1887, pt. 2, p. cclxxiii, reg. no. 4565.

20. For the relation of Rudolfine painting to elegy and epigram, see "*Éros et poesia*: la peinture à la cour de Rodolphe II," *Revue de l'art* 28, 1985, pp. 29–46. It

may also be noted that this relationship seems to apply to the Latin poems, as distinct from the Italian sonnets, on Arcimboldo's paintings written by his Milanese contemporaries, which Berra, "Allegoria e mitologia," has uncovered.

21. Barthes, *Arcimboldo*, pp. 15–16; see chap. 4, n. 29.

22. Berra, "Allegoria e mitologia." Berra argues that Arcimboldo also employed as a visual source an illustration of Vertumnus provided in the 1571 edition of Cartari's *Imagini*, fig. 4, but the wreath of fruit seen in this image is preceded by the similar fillet-like headdresses in Arcimboldo's even earlier versions of the seasons and elements, as remarked above.

In view of the wide-scale reception and continuing importance of Nanni's text, and its direct use by authors at the imperial court, as demonstrated in this Excursus, Berra's observation that there are more copies of editions of Cartari than of editions of Nanni to be found in present-day libraries in Milan does not hold much force.

23. Nanni (Annius), *Super Vertunnianam*, fol. Fir. The association of Vertumnus with Janus may have been given authority by their conjunction in Horace's *Epistles* I, 20:1 ("Vertumnum Janumque, liber spectare rideris").

For the importance of Nanni's equation of Janus and Vertumnus, see also Ligota, "Annius of Viterbo and Historical Method," p. 53.

24. See chap. 4, n. 10 above for Lomazzo's text on the lost painting of Janus. In his poem on Arcimboldo's paintings of the seasons and elements, ÖNB, Cod. 10152, fol. 9v, Fonteo writes: "Eccontra effoetam non curat Libera Brumam/ Nubere prudentisque uetat sapientia Jani." The association of Janus with the god of wine, Liber, may depend upon Nanni's etymology of Janus from Iain in his commentary on Propertius, *Berosi Chaldaei . . .*, p. 402: "Quare Ianus non spectat ad originem Latinam vel Graecam, sed ut ait Berosus Scythicam, qui vti Hebraei vinum dicunt Iain, & ab eo Ianum. Ergo quem Latini a vino viniferum, & Graeci ab oeno oenotrium, eundem Scythae atque Hebraei a Iain, id est, vino vocant Ianum, id est, vinosum, & de his duabus rationibus vitae subditur his verbis."

25. For a discussion of these "Roman" elements, see Boucher, *Études sur Properce*, pp. 147ff., and Pasoli, "De Properti libro quatro," pp. 14ff.

26. In particular, Pasoli, ibid., especially p. 20.

27. See "Ad Antonium Canisianum de Primordiis Urbis Florentiae," in *Christophori Landini Carmina Omnia*, ed. Alexander Perosa, Florence, 1939, pp. 86–91; Landino's use of Propertius in this poem is pointed out by La Penna, *L'integrazione difficile*, p. 271.

28. Introductions to the background to the extensive Renaissance debate on the *paragone* can be found in the discussions by John White, "Paragone. Aspects of the Relationship between Sculpture and Painting," in Charles S. Singleton, ed., *Art, Science and History in the Renaissance*, pp. 43–109, and Summers, *Michelangelo and the Language of Art*, pp. 269–78, with further references. Other useful literature on the subject includes Leatrice Mendelsohn, *Paragoni: Benedetto Varche's Due Lezzioni and Cinquecento Art Theory*, Ann Arbor, Mich., 1982, and Peter Hecht, "The Paragone Debate: Ten Illustrations and a Comment," *Simiolus* 14, 1984, pp. 125–36, with further references.

29. See Bernhard Schnackenburg, "Beobachtungen zu einem neuen Bild von Bartholomäus Spranger," *Niederdeutsche Beiträge zur Kunstgeschichte* 9, 1970, pp.

155–58. It is also interesting to note that in a bronze *Apollo*, of approximately the same date as Arcimboldo's painting, Adriaen de Vries also created a *paragone* with ancient sculpture: see my "A Drawing by Adriaen de Vries in Gdańsk," *Biuletyn Historii Sztuki* 46, 1984 (published 1986), pp. 203–9.

30. Lomazzo, *Idea del tempio della pittura*, p. 157, as in chap. 4, n. 90.

CHAPTER 5

1. In addition to the previously known accounts and the documents connected with Paulus Fabritius that are discussed at length in this chapter, another hitherto unknown description of the event was made by one D[ominus?] l'Abbé. This description is contained in a letter of 7 August 1577 to the archbishop of Prague, now located in Prague, Státní Ústřední Archiv, APA I C 71 Recepta, Kart. 710, 1577, VII–VIII, fol. 123a–c. A transcription of the part of the letter containing the description is published in Appendix 3, A.

I am grateful to Robert Lindell for providing me with a copy of this document, which was not published in the earlier version of this essay. This account specifically describes the location of one arch as being on the Graben.

2. K. van Mander, *Het Schilder-Boeck*, Haarlem, 1604 (1st ed.), fol. 272r.

3. This entry is treated in H. Blaha, "Öesterreichische Triumph- und Ehrenpforten der Renaissance und des Barock" unpublished Ph.D. dissertation, Vienna, 1950, especially pp. 16, 51; my *Variations on the Imperial Theme*, pp. 10, 128 n.3, with references to earlier literature. Subsequent references to this entry include K. Vocelka, *Die politische Propaganda Kaiser Rudolfs II. 1576–1612* (Veröffentlichung der Kommisssion fur die Geschichte Österreichs 9), Vienna, 1980, pp. 138–39; and H. Lietzmann, *Das Neugebäude in Wien. Sultan Süleymans Zelt—Kaiser Maximilians II. Lustschloss. Ein Beitrag zur Kunst- und Kulturgeschichte der zweiten Hälfte des sechzehnten Jahrhunderts*, Munich and Berlin, 1987, pp. 154f., both with additional references.

Among other details determined by the document discussed in this essay is the exact date of the entry, 17 July 1577, not 20 July, as frequently given in previous literature, e.g. in my *Variations on the Imperial Theme*, p. 10. I also wish to rectify the mistaken identification of Monmacher (Manmacher) as Hans, *recte* Mathias.

The entry has also received some attention from music historians, as some of the music played by instrumentalists stationed on the arch has been identified and published: see Albert Dunning, *Vier Staatsmotetten des 16. Jahrhunderts* (*Das Chorwerk*, 120), Wolfenbüttel, 1976. I am grateful to Robert Lindell for this reference.

4. See most recently for this event Lietzmann, *Neugebäude*, p. 154.

5. Vienna, Niederösterreichisches Landesarchiv, Ständearchiv A 9/26, fol. 10r–21r. This text is printed in Appendix 3, B.

6. In addition to previously published documents, discussed below, and others published in Appendix 3, these include other material in the Niederösterreichisches Landesarchiv, Ständearchiv, Vienna, and in the Wiener Stadt- und Landesarchiv, Oberkammeramtsrechnungen, Vienna.

7. Österreichische Nationalbibliothek, Handschriftensammlung (hereafter ÖNB), Cod. No. 8805. This text is printed in Appendix 3, D.

8. For Mathias Monmacher (Manmacher), see especially Lietzmann, *Neugebäude*, pp. 140f.

9. For Georg Haas, see Emmerich Schaffran, "Georg Haas, Hoftischler in Wien, und sein Musterbuch," *Unsere Heimat, Monatsblatt des Vereines fur Landeskunde und Heimatschutz von Niederösterreich und Wien*, n.s. 7, 1934, pp. 139–58.

10. The pertinent documents are printed in Appendix 3, E. Some of these documents, but not all the material mentioning Fabritius, were published by K. Uhlirz, "Urkunden und Regesten aus dem Archive der k.k. Reichshaupt- und Residenzstadt Wien," *Jahrbuch der Kunsthistorischen Sammlungen des Allerhöchsten Kaiserhauses* 18, 1897, pt. 2, reg. no. 15821.

11. For these citations, see more fully Appendix 3, E.

12. J. E. Schlager, *Wiener-Skizzen aus dem Mittelalter, Neue Folge*, Vienna, 1839, p. 159: "1578. Dem H. Doctor Paul Fabricius, so die Ehrenporten 1577 druken lassen, und dem Ersamen rath dedicirt, für mehrere Exemplar . . . 33fl." Schlager's source cannot be located in the Vienna archives, nor can the work by Fabritius to which he refers be found there or in the Vienna libraries; no similar volume is recorded in the *Verzeichnis der im deutschen Sprachgebiet erschienenen Drucke des XVI. Jahrhunderts*, 6, 1986. No print of the arch survives either.

A description of the suburban arch is, however, to be found in Paulus Fabricius, *Ad nobilem virtute, eruditione et autoritate praeclarum virum D. Jacobem Monaw epistola quae et descriptionem portae gratulat. suburbane Vienn. Aust. Imp. majesti. positae . . . et carmen nuptiale continet*, Görlitz, 1580. A copy of this rare work is located in the library of Wrocław University, Poland (sig. no. 441769).

13. Delfino's report is found in a letter of 27 July in the Archivio Segreto Vaticano, Nunziatura di Germania, 74, fol. 153rff., and quoted in part by Maurice Vaes, "Le séjour de Carel van Mander en Italie, 1573–77," in *Hommage à Dom Ursmer Berlière*, Brussels, 1931, p. 239, n. 5. The part of the letter dealing with the entry is published in Appendix 3, C.

14. See *Rudolpho II. Augusto &c. Austriae Archiduci serenissimo. etc. a Paulo Fabricio Laubensi Lusacio, Caesaris Mathematico, Med: Doctore, Academiae Viennensis nomine ac iussu, Scriptae Gratulationes publicae. I. Cum Rex Hungarorum. II. Cum Et Bohemorum Rex crearetur Conorareturque. III. Cum ad Romani Imperii Maiestatem Rex Augustus eveheretur et inaugurararetur. Nunc simul impressae & Reverendissimo Principi, ac Domi., Domino Martino Episcopo Wratislaviensi. etc. ab autore dedicatae*, 1576 (Vienna ÖNB 741729-C). Fabritius's dedication on fol. 1r is indicated as being at: Viennae Calend. Ianu. Anno 1576 (1 January 1576).

15. E. Zinner, *Die Entstehung und Ausbreitung der Coppernicanischen* [sic] *Lehre*, Vaduz (reprint), 1978, and Thomas Kuhn, *The Copernican Revolution*, New York, 1957, present clear expositions of Copernicus's teaching and its reception. For this subject, see also Hans Blumenberg, *The Genesis of the Copernican World*, trans. Robert M. Wallace, Cambridge and London, 1987, and the essays in Jerzy Dobrzycki, *The Reception of Copernicus's Heliocentric Theory*, Dordrecht and Boston, 1973.

16. As many historians of science have pointed out, the promulgation of Copernicus's theory did not exclude the possibility that all or part of the Ptolemaic system might be retained. For some thinkers, Copernicus might have represented

an improvement upon but not a full replacement of Ptolemy. For the response to Copernicus and the efforts to reconcile it with previous systems, see, beside the treatments cited in n. 15, the interesting essay by Robert S. Westman, "Three Responses to the Copernican Theory: Johannes Praetorius, Tycho Brahe, and Michael Maestlin," in Westman, ed., *The Copernican Achievement* (UCLA Center for Medieval and Renaissance Studies, 7), Berkeley, Los Angeles, and London, 1975, pp. 285–345.

In any case, for an observer on earth, the Ptolemaic description of the motion of the heavens, as represented on a traditional celestial globe, might still have been regarded as adequate, and this may explain why Fabritius continued to employ such a globe in connection with Ptolemy.

17. Th. von Oppolzer, *Syzygien-Tafeln für den Mond, Publikationen der Astronomischen Gesellschaft* 16, Leipzig, 1885.

18. For Fabritius's clock design, see the text printed in Appendix 3, F, and n. 31 below. For more on Emmoser, see Bruce Chandler and Clare Vincent, "To Finance a Clock. An Example of Patronage in the 16th Century," in *The Clockwork Universe. German Clocks and Automata 1550–1650*, eds. Klaus Maurice and Otto Mayr, New York, 1980, pp. 103–13.

My suggestion about Emmoser's involvement remains necessarily speculative, and, according to John Leopold and Clare Vincent, the necessary expertise involved in the construction of rotating spheres is not that great. As noted below (see n. 41 and the Appendix 3, F), Fabritius himself had also invented clocks. Still, I am not aware of other workmen in Vienna who could have manufactured the kind of device described in this paragraph, and I find the hypothesis about Emmoser's involvement worth considering.

19. J. von Aschbach, *Die Wiener Universität und ihre Gelehrten 1520 bis 1565*, Vienna, 1888, pp. 113f., 344, makes the point about the group of celebrities, partly inside and outside the university, which he says formed a kind of "court academy." Lietzmann, *Neugebäude*, p. 161, also says that this group *gehörten einer Hofakademie* (belonged to a court academy), but it should be noted that there was no formally established academy in Vienna at that time.

20. In addition to Aschbach, *Wiener Universität*, for the circle of humanists around the court of Maximilian II, see Evans, *Rudolf II and His World*, pp. 118–27, 129, and especially idem, *The Making of the Habsburg Monarchy 1550–1700*, Oxford, 1979, pp. 24–38. As is suggested in this chapter, however, a thorough study of the court (and the culture) of Maximilian II carried out in a manner similar to that of Evans's treatment of "Rudolf II's world" seems a desideratum. At the time this book went to press, Howard Louthan was at work on a dissertation at Princeton University that may serve toward this end.

21. A poem by Fabritius in honor of Matthioli is included in the collection *Oratio et Carmen de Carolo V Caesarae Mortuo* . . . , Vienna, 1558, p. F 2r. Evidence for Fabritius's friendship with Clusius, including their joint ascent of the Etscher (Oetscher), is discussed below. Letters from Fabritius to Blotius attesting to their friendship may be found in the collection of the the latter's correspondence located in the ÖNB, Handschriftensammlung, Vienna, Cod. 9737, z 15, fol.II/224, and z 18, fol. 230. He may also have been friendly with the historian

Wolfgang Lazius, on whose death he wrote an epitaph, printed in Diomedes Cornarius Zwiccaviensis, *Oratio in funere Doctoris Wolfgang Lazii Viennensis*, Vienna, 1565, cited in Aschbach, *Wiener Universität*, p. 214 n. 1.

22. Vienna, ÖNB, Cod. 8805; see Appendix 3,C. The best biography of Fabritius is offered by Aschbach, *Wiener Universität*, p. 187 n. 2, who mentions this document in passing, although not with an entirely correct description.

23. For Widman Stadius (Johann Albrecht Widmanstetter), who served as superintendent of the University of Vienna during the 1550s, see Aschbach, ibid., pp. 53, 245. For an introduction to Postel, see W. J. Bouwsma, *Concordia Mundi: The Career and Thought of Guillaume Postel (1510–1581)*, Cambridge, Mass., 1957, and for his activity in Vienna, Aschbach, ibid., pp. 243ff.

24. For instructions on church burial and Fabritius's behavior in this regard, see the document printed by R. Kink, *Geschichte der kaiserlichen Universität zu Wien*, Vienna, 1854, 1, pt. 2, p. 189, no. lxv. From this sort of evidence Aschbach, *Wiener Universität*, p. 122, argues that Fabritius was a Protestant.

25. A *Schmähschrift* by Fabritius on Flacius Illyricus and his followers (*De Infami Cuculo, Flacio Illyrico Huiusque Improbissimo Genere, Germaniam Gregatim more Locustarum Pervolante*, n.p. [Vienna?], 1568, is found bound into a volume in Wolfenbüttel, Herzog August Bibliothek, 95.10.2 Quodl. in Folio, fol. 309v–310r. Fabritius's attack on the Flacists as cuckoos fouling a nest may be a response to the publication of a Flacist confesssion in Austria in 1566, one sign of the many controversies between followers of Melanchthon and Flacius Illyricus. The best source for this aspect of religious history in Austria remains Bernhard Raupach, *Evangelisches Oesterreich, das ist, Historische Nachricht von den vornehmsten Schicksalen der Evangelisch Lutherischen Kirchen in dem Ertz-Hertzogthum Öesterreich*, Hamburg, 1732, pp. 79ff. See also in general Wilhelm Preger, *Matthias Flacius Illyricus und seine Zeit*, reprint, Hildesheim and Nieuwkoop, 1964.

Fabritius's letter to Blotius of 4 December 1576, ÖNB, Handschriftensammlung, Cod. 9737 z 15, fol. II/224, may refer to suspicions about his religious convictions, when Fabritius remarks: "Fabricius equidem sum, non Oedipus. Hoc ideo dico, quod non satis intelligam quorsum quaedam dicantur: (non enim quae dicuntur non intelligo). Veruntamen cum hic nihil sit quod vel religionem vel publicum statum possit offendere, sane ipse autor suae siue fame siue infamiae periculo haec publicet."

26. This paraphrases Robert S. Westman, "The Melanchthon Circle, Rheticus, and the Wittenberg Interpretation of the Copernican Theory," *Isis* 66, no. 232, June 1975, p. 174, who offers a cogent summary of the problem. A positive reassessment of the long-standing issue of Melanchthon's attitude toward Copernicanism is also presented by Bruce Moran, "The Universe of Philip Melanchthon: Criticism and Use of the Copernican Theory," *Comitatus* 4, 1973, pp. 1–23, and by J. R. Christianson, "Copernicus and the Lutherans," *Sixteenth Century Journal* 4, 1973, pp. 1–10. John Dillenberger, *Protestant Thought and Natural Science*, New York, 1960, provides a good introduction to the question of Melanchthon's attitude toward science.

27. See, for example, Lynn Thorndike, *A History of Magic and Experimental Science*, vol. 5, New York, 1941, pp. 378–407; Blumenberg, *Genesis of the Copernican World*, pp. 316–19, and especially Westman, "The Melanchthon Circle,"

pp. 165–93, with references to earlier literature. See also Westman, "Three Responses." See further J. V. Field, "A Lutheran Astrologer: Johannes Kepler," *Archive for History of Exact Science* 31, 1984, pp. 190–272, especially pp. 219–24.

28. In this regard the figures in Melanchthon's circle who were concerned with what we now call botany and zoology should be brought into account: see Thorndike, *History*, pp. 390ff. For more on Hoefnagel in this regard, see chap. 7 below.

29. See especially Victor E. Thoren, *The Lord of Uraniborg. A Biography of Tycho Brahe*, Cambridge, etc., 1990, pp. 11 and passim; Westman, "The Melanchthon Circle," p. 170, adduces parallels between Melanchthon's and Kepler's writing,

30. The astronomical (including astrological) publications of Fabritius are listed (though not completely) in E. Zinner, *Geschichte und Bibliographie der Astronomischen Literatur in Deutschland zur Zeit der Renaissance*, n.p. [Berlin], 1941, pp. 222, no. 2110; 224, nos. 2143, 2144; 228, nos. 2187, 2188; 233 n. 2279a; 240, no. 2931a; 242, no. 2415; 253, no. 2620a; 257, no. 2673; 260, no. 2732; 262, no. 2771; 263, no. 2771a; 265, no. 2820; 272, nos. 2925a and b; 278, no. 3035b; 280, no. 3073b; 287, nos. 3183a and b; 289, nos. 3220a and b; and 297, no. 3376. Manuscript treatises on astronomy (astrology) by Fabritius are listed in Aschbach, *Wiener Universität*, pp. 192 and 193, nn. 2 and 3. The manuscripts cited by Aschbach are now mainly to be found in the ÖNB, Handschiftensammlung, Vienna, e.g., cod. ser. nov. 3827 and 2635; cod. n. 10985, 10963, 8017, 10711, 8278, 10693, 10693.1, 11139, 10751, 10752*, 10760, 1061, and 12448*. Fabritius's comments on the comet of 1558 are included in his *Descriptio Cometae qui flagruit Anno MDLVIII Menso Augusti*, published together with his *Oratio & Carmen de Carolo V Caesare Mortvo*, Vienna, 1558.

31. Brahe's comments on Fabritius's treatment of the nova appear in the third part of his *Astronomiae Instauratae Progymnasmata*, ed. J.L.E. Dreyer, *Tychonis Brahe Dani Scripta Astronomica*, vol. 3, Copenhagen, 1916, pp. 43–44. Brahe calls Fabritius *eruditissimus ille inprimisque praestans vir.*

32. See Zinner, *Geschichte*, p. 26, and Aschbach, *Wiener Universität*, p. 192, for discussions of Fabritius's work in this context. Fabritius's treatises related to this subject are Vienna, ÖNB, Handschriftensammlung, Cod. 10711 and 10693.

33. See Owen Gingerich and Robert S. Westman, *The Wittich Connection: Conflict and Priority in Late Sixteenth-Century Cosmology*, Philadelphia, 1988 (Transactions of the American Philosphical Society), pp. 8–9, 20–22.

34. For Brahe's receipt of a copy of this treatise, see Zinner, *Coppernicanischen Lehre*, pp. 294–96, and J.L.E. Dreyer, *Tycho Brahe. A Picture of Scientific Life and Work in the Sixteenth Century*, New York (reprint), 1963, pp. 82f. Dreyer, p. 83, n. 2, discusses the further fate of Brahe's copy of Copernicus's manuscript, "De Hypothesibus Motuum Coelestium Commentariolus." More recently Hayek's meeting with Brahe in Regensburg and his transmission of the *Commentariolus* is discussed in Thoren, *Lord of Uraniborg*, pp. 97–99; Thoren, passim, provides further information on Brahe's continuing contact with Hayek, and on the more recent literature on both Hayek and the *Commentariolus.*

35. See J. L. E. Dreyer, ed., *Tychonis Brahe Dani Opera Omnia*, vol. 7, Copenhagen, 1924, p. 147, letter of Hayek to Brahe of 7 November 1588: "A FABRICIO

Vienna illum accepi, te salvere iubet." Hayek's and Brahe's regrets about Fabritius are expressed respectively in letters of 30 May and 1 November 1589, ibid., pp. 182, 213.

36. See T. Hagecius (ab) Hayek, *Dialexis de Nouae et prius incognitae Stellae inusitatae Magnitudinis 7 splendidissimi luminis apparatione . . . accesserunt aliorum quoque doctissimorum virorum de eadem stella scripta . . .*, Frankfurt a. M., 1574, including *Stellae nouae uel nothae potius, in coelo nuper exortae, & adhuc lucentis, authore Paulo Fabricio med. Doct. & Caesaris Mathematicus.*

37. G. Eder, *Catalogus Rectorum & Illustrium Virorum Archigymnasii Viennensis . . .*, Vienna, 1559, p. 86.

38. See Aschbach, *Wiener Universität*, p. 191 n. 1, who, besides the *Encomion Sanitatis*, Vienna, 1557 (an extract of which is published here in Appendix 3, F), otherwise notes, n. 3, just a series of unpublished "Visitationes et ordinationes" for the Vienna hospitals (these are to be found in the ÖNB, Handschriftensammlung). A *Carmen recitatum sub finem oratoris, cum titulo Doctoratis in Medicina ornaretur* is included in *Oratio & Carmen de Carolo V . . .*, p. F 3.

The connection between medicine and astrology is an ancient one: for a general introduction to the history of medicine, touching on this question among many others, see Nancy G. Siraisi, *Medieval and Early Renaissance Medicine. An Introduction to Knowledge and Practice*, Chicago and London, 1990.

39. For Fabritius's interests in chorography, see Aschbach, *Wiener Universität*, p. 193 and n.2, mentioning his expedition on the Etscher (Oetscher).

40. Clusius mentions their ascent of the Oetscher in his *Rariorum Stirpium per Pannoniam . . .*, Vienna, 1583, p. 557, cited in Aschbach, *Wiener Universität*, p. 121 n. 1. and pp. 190f. no. 5; see also pp. 193f. n. 2; see also Evans, *Rudolf II*, p. 120. Fabritius's major botanical work is his *Catalogus Stirpium circa Viennam nascentium*, Vienna, 1557. This text is referred to by Fabritius in his *Encomium Sanitatis*; see Appendix 3, F. See further Aschbach, ibid., p. 191 n. 1.

41. Such a clock is described in the dedication to the *Encomium Sanitatis*: see Appendix 3, F.

42. Brahe's poetry is assembled in the exemplary edition of *Carmina* by I.L.E. Dreyer and Joannes Raeder, *Tychonis Brahe Scripta Varia*, vol. 9, Copenhagen, 1927, pp. 171–215. For Kepler as humanist and poet, see Grafton, *Defenders of the Text*, pp. 178–203.

43. See the poem *Sac. Caes. Maiestatis Consiliario Aulico Viro amplissimo Domino IOHANNI TVNNERO V. I. Doct. Domino et amico observando*, dedicated on 8 April 1573, in Hayek, *Dialogus*, pp. 135f. This work has not been noticed by previous bibliographers of Fabritius, including Zinner, *Geschichte*.

44. It should be noted, however, that although they are cited by Aschbach, *Wiener Universität*, several of Fabritius's poetic works, among them the *Historia de divo Abrahamo*, the *Oratiuncula pro defensione fidei Christianae*, as well as the *Tagus*, mentioned below, may have been known to him from earlier bibliographic references: these works are not to be located in any libraries in Vienna. Aschbach seems to rely solely on M. Denis, *Die Merkwurdigkeiten der k.k. Garellischen offentl. Bibliothek am Theresiano*, Vienna, 1780, pp. 284, 285, 294, 298, 299, 302, 303. Denis also seems to supply the basis for other early references to these works in J. C. Adeling, *Fortsetzung und Ergänzungen zu Christian Gottlieb Jöchert, Allgemeinen Gelehrten Lexicon*, Leipzig, 1787, vol. 2, p. 990f. A copy of the *Tagus*,

Vienna, 1571, is located in Wolfenbüttel, Herzog August Bibliothek, 202.1.Quodl.(20). The *Oratiuncula pro defensione fidei Christianae*, Vienna, 1557, is published with Fabritius's *Tityrus*, also in the Herzog August Bibliothek, 56.1 Poetica (9).

45. *Oratio et Carmen de Carolo V Caesare Mortuo* . . .

46. *Triumphus Ferdinando I. Ro. Imp. Augustiss. Archigymnasi Viennensis nomine pro felicibus Imperii Auspiciis*, cited in Aschbach, *Wiener Universität*, p. 171. A poem in honor of Ferdinand I is also included with the *Oratio et Carmen de Carolo V* . . . , pp. C 4 verso ff.

47. These poems, one of them dedicated to Carolus Clusius, are published by Aschbach, *Wiener Universität*, pp. 190f. n. 5 and pp. 286f. n. 1. For more on this garden, see Lietzmann, *Neugebäude*, pp. 29–31, where the correct location of this place is established as on the Prater, not, as often in the literature reviewed by Lietzmann, in Kaisers-Ebersdorf.

48. Aschbach, *Wiener Universität*, p. 160, records one such congratulatory publication containing pieces by Elias Corvinus and Fabritius that was written on the occasion of Rudolf II's election as king of the Romans. Aschbach does not, however, cite the extensive compendium of *Scriptae gratulationes*, including poems on Rudolf's coronation as king of Hungary, of Bohemia, and as Holy Roman Emperor, mentioned in n. 14 above. An earlier version of the poem on the Hungarian coronation had been published by Fabritius in Vienna in 1572: *Rvdolpho Serennissimo Hvngariae Regi, etc Archidvci Avstriae, etc . . . In solenni inauguratione Coronam et insignia regni accipienti*. A copy is located in Wolfenbüttel, Herzog August Bibliothek, 36.1 Poetica (16).

49. J. A. von Bradish, "Dichterkrönungen in Wien des Humanismus," *Journal of English and Germanic Philology* 36, no. 3, 1937, pp. 367–83, gives an account of the festivities presided over by Fabritius.

50. For a survey of these entries and tournaments, see my *Variations on the Imperial Theme*; see also chap. 4 above.

51. See further chap. 4, and the Excursus to it, in this book. For a more recent review of the problem of Arcimboldo's collaboration with humanists, see my "Arcimboldo's Serious Jokes."

52. The theme of the intelligibility of Renaissance entries and festivals is discussed most cogently by D. J. Gordon, "Roles and Mysteries," reprinted in *The Renaissance Imagination. Essays and Lectures by D. J. Gordon*, collected and edited by S. Orgel, Berkeley, Los Angeles, and London, 1980, pp. 2–23. Gordon points out, pp. 10–11, that the issue of comprehensibility creates a problem of interpretation that has engaged scholars since Burckhardt and Warburg.

53. A similar point may be made about paintings Arcimboldo created for Maximilian II and Rudolf II: for this argument see my "Arcimboldo's Serious Jokes." Not only the unlearned may have had trouble identifying the subject matter of Renaissance festivals. It is interesting to note that L'Abbé, whose account otherwise seems trustworthy, identifies the horse that Fabritius specifically says is Pegasus with the "Capitoline Horse," presumably that on which the figure of Marcus Aurelius sits. Perhaps the type of horse may have been similar, but an image of Pegasus would presumably have been winged.

54. For this sort of terminology, see *The School of Prague*.

55. For this argument, see most fully my "*Éros* et *poesia*: la peinture à la cour de Rodolphe II."

56. Fabritius's description of his collaboration with Spranger and the devices the artist used give more evidence suggesting that other rhetorical and poetic devices may have been consciously transferred to painting. Of course the possible appearance of visual elements comparable to such figures as anaphora, as I have discussed in "Éros et *poesia*," would not be the same as verbal usages, but then neither is pictorial antithesis the same as its verbal equivalent. In "Éros et *poesia*," as well as *The School of Prague*, p. 62, when I talk of pictorial "equivalents" in the use of various devices, I speak not merely about formal devices but of the way they convey meaning—in a manner analogous to, although obviously not identical with, those of rhetoric and poetry. The existence of Fabritius's text suggests that we should be more open to finding actual textual evidence for a point of view that will involve an effort, as I have elsewhere suggested (in "The Eloquent Artist"), at saying what has deliberately gone unsaid in the construction of a stylistics.

Nevertheless, in her review of *The School of Prague*, Inemie Gerards-Nelissen, in *Simiolus* 20, 1990/1991, pp. 75–79, charges my interpretation with formalism and suggests that my argument for the applicability of poetic terminology is based solely on Pontanus. Yet my approach is certainly not inappropriate to the theory of the time, and here I would merely quote a passage from *The School of Prague*, p. 55, that seems to have been overlooked by Gerards-Nelissen: "Late sixteenth-century poetics characteristically conceived of works of literature as typifying genres, and brought painting into its account. Julius Caesar Scaliger's *Poetices Libri Septem*, arguably the most important poetic treatise of the second part of the century, has been described as 'formalistic' in the way it applies rhetorical analyses to the problem of the definition of genres. Scaliger also made extensive comparisons of poetics to painting. Scaliger was but one of many writers who made these connections: . . . his follower Pontanus wrote the era's most extensive comparison of painting, poetry and rhetoric, and Pontanus also considered the definition of genres at length. In a similar manner, sixteenth- and early seventeenth-century art theory implicitly recognized the significance of genre in relation to the question of artistic decorum."

As I suggested, much as in the instance of Cartari discussed in the Excursus preceding this chapter, Pontanus stands for a larger phenomenon, for which Fabritius provides more evidence. I made reference to Pontanus specifically because, among the writers on the question, he is one figure, like Fabritius, who can be specifically tied to a court artist. I am grateful for Gerards-Nelissen's supporting reference to similar passages in Comanini, but Comanini's treatise was not published until after many of the pictures I am describing by Spranger actually had been painted.

57. For this aspect of the iconography of the print, see chap. 3, above, where further references are indicated.

58. For convenient editions of the text of the poem by Sabinus, see *Renaissance Latin Verse. An Anthology*, edited and compiled by A. Perosa and J. Sparrow, Oxford, 1979, p. 451, and *Lateinische Gedichte Deutscher Humanisten*, ed. and trans. H. C. Schnur, Stuttgart, 1966, pp. 358–59.

59. For this symbolism, see Jerzy Kowalczyk, "Odezwa, Sygnet i Berło.

Ideologia i symbole Akademii Zamojskiej," in *W krgu kultury dworu Jana Zamoyskiego*, Lublin, 1980, pp. 160–86, 298–302 (notes).

60. For more on this notion, see chap. 4 and the Excursus above, and *The School of Prague*, pp. 43–54.

61. The metaphor of "interdisciplinary pollination" is employed by A. Grafton, *Defenders of the Text*, in reference to Kepler.

CHAPTER 6

1. Museum of Fine Arts, Boston, William A. Sargent Fund, 1950. Full description of the drawings, with transcription and translation of all of Arcimboldo's texts, is given in Hugh Macandrew, *Italian Drawings in the Museum of Fine Arts, Boston*, Boston, 1983, cat. no. 8, pp. 12–17. According to a manuscript note inserted in the volume containing the drawings (cited in Macandrew, p. 15), the book was given by Hoffmann to his wife, Margareta von Harrach, and thence through the line of the counts Harrach.

The drawings were first published and their date and function established by Henry Preston Rossiter, "Ornament from a Sixteenth-Century Library," *Bulletin of the Museum of Fine Arts, Boston* 48, 1950, pp. 46–52.

The ideas presented in this chapter were first sketched out in my *Drawings from the Holy Roman Empire*, cat. no. 47, pp. 134–37, with references that supplement those given by Macandrew.

2. Hoffmann and his family are studied most completely in Klaus Eckart Ehrlicher, "Ein steirisches Adelsgeschlecht in Böhmen und Mähren. Hoffmann Freiherren zu Gruenpüchel und Strechau," *Bohemia. Zeitschrift für Geschichte und Kultur der böhmischen Ländern* 21, 1980, pp. 59–83; for Ferdinand Hoffmann himself, see pp. 63f. A thorough biography of Hoffmann, which would help elucidate some of the themes of this paper, is still a desideratum.

3. The text published here follows the transcription published by Macandrew, *Italian Drawings*, with certain emendations, including some of the missing letters, which are noted in brackets. As will be noted, the interpretation of some passages herein also differs in parts from the translation provided by Macandrew. My own more literal translation follows:

> To the most illustrious Lord, Baron Lord Ferdinand Hoffmann, President of the Chamber of His Holy Imperial Majesty:
>
> Knowing how much painting is to the taste of every most noble lord, and how much your very illustrious Lordship delights in it, and how it has truly seemed worthy to every great prince, and knowing how your Lordship is about to have some rooms painted in his castle, it seemed to me that I could present some invention made thus in a rough design, having not had the time to do the aforesaid sketches with that diligence that is fitting, and so much the more so as I find myself very busy with works for his Holy Imperial Majesty my Lord [i.e., Rudolf II].
>
> I will tell how the ancients were the first inventors of grotesques, which, however, were not named grotesques by those ancients, but by the moderns, for this reason, that in Rome, as almost every day they are discovering different buildings underground, these inventions are found within caves

[grottoes], and when painters have taken them [i.e., the inventions] from these caves in drawings, they have given them the name grotesque. One sees that the ancients did not do this by chance, nor added figures nor animals in the said grotesques, but intentionally . . . so that I have thought from this that the moderns could similarly place weaving inside the spaces [i.e., the interstices of the grotesques] in the manner that the ancients placed altars, sacrifices, or some other thing therein, so if one had the intention, one could place some form of manufacture.

I demonstrate in the present sketches what the manufacture of silk is, and because this is less well known in Germany, I have thought of having this [form of manufacture] placed as first, as one can make [paint] in another chamber the manufacture of wool, and in another chamber one could have made [painted] the manufacture of cloth, or we mean the origin of linen, how first flax is gathered and then how cloth is made step by step.

The Most Affectionate Servant of Your Most Illustrious Lordship,
Giuseppe Arcimboldo.

4. Rossiter, "Ornament," p. 48, compares the Boston drawings to Arcimboldo's festival designs.

Preiss, *Giuseppe Arcimboldo*, Prague, 1967, p. 11, connects the Boston drawings with the Leonardesque tradition of the artist as a *uomo universale* and mentions the "modern" character of their portrayal of workers. Porzio, *L'universo illusorio*, p. 38, also says that they are permeated "da un vago sentore realistico e popolaresco." The correct reference for the drawing of a peasant woman, which Preiss, p. 12 and fig. 48, compares to them is Madrid, Biblioteca Nacional, 7239, pen and brown ink, blue wash, 180 x 254 mm., signed: Giuseppe/Arcimboldo/Mediolanonsis f. [sic].

Preiss, p. 11, and in Emanuel Poche and Pavel Preiss, *Pražské Palace*, Prague, 1977, p. 129, relates the Boston drawings to grotesque decorations. See, however, more recently Preiss, *Italší umělci v Praze. Renesance Manyrismus Baroko*, Prague, 1986, pp. 115–22, following more closely the ideas suggested in the earlier version of this chapter.

Alfons, *Arcimboldo*, p. 118, connects Arcimboldo's proposal with the development of the silk industry and efforts to introduce it into Lower Austria (*Niederösterreich*); in this context he refers to an article by Anton Schachinger, "Die Entwicklung der Maulbeerbaum und Seidenkultur in Wien und Niederösterreich bis in die Mitte des 19. Jahrhunderts," *Jahrbuch für Landeskunde von Niederösterreich*, n.s. 27, 1938, pp. 147ff. According to Schachinger, pp. 147–48, however, while a privilege to establish silk manufacture was granted in 1569, no permanent form of sericulture was established in the region until the early seventeenth century, when Karl von Liechtenstein introduced silk-making into his estates, which lay on the border between the Austrian and Bohemian lands (between Lower Austria and Moravia).

Alfons remarks, p. 119, that Hoffmann was well chosen to receive this proposal and compares their type of subject matter to Agostino Gallo's *Le venti giornate dell'agricoltura*. Again the comparison of Gallo's work, for which I have also consulted the 1566 edition published in Venice, *Le dieci giornate della vera agricoltura*

e piacerii della villa, must be considered a general rather than specific comparison, without reference to sericulture.

Macandrew, *Italian Drawings*, p. 17, compares Arcimboldo's designs with a contemporary set of illustrations by Stradanus, discussed further below, and with an eighteenth-century account preserved in Lucca.

5. See chaps. 4 and 5 above, and for further dimension of the atmosphere in Prague, also my "The Eloquent Artist."

6. The edition by H. M. Hubbell of *De Inventione*, Cambridge, Mass., and London, 1976, pp. xx–xxii, provides an extensive bibliography on the treatise; for the *Ad Herennium*, see the introduction in the excellent edition by H. Caplan, Cambridge, Mass., and London, 1968.

7. Guarino's and Fazio's uses of the term are cited by Baxandall, *Giotto and the Orators*, pp. 101 and 103, which traces the early development of humanist criticism of a painting.

See, in general, for the subject of "invention," particularly in respect to dialectic in this period, Cesare Vasoli, *La dialettica e la retorica dell'Umanesimo. 'Inventione' e 'Metodo' nella cultura del XV–XVI secolo*, Milan. 1968.

8. See *Alberti On Painting and Sculpture*, ed. cit., pp. 94–98; also Leon Battista Alberti, *On Painting*, trans. John R. Spencer, New Haven, Conn., 1966, pp. 90–91.

9. Roskill, *Dolce's Aretino and Venetian Art Theory*, p. 116 (with English trans. on p. 117), and further discussion of invention on pp. 118ff. Dolce's contributions to rhetoric and poetics are discussed in Bernard Weinberg, *A History of Literary Criticism in the Italian Renaissance*, Chicago, 1961 (reprint 1974), 1, pp. 101–2, 127, 143–44, 174, 420–44. See also ibid., 2, p. 1125.

Lee, *Ut pictura poesis*, Appendix 2, pp. 70–71, first pointed to Dolce's text and its Renaissance antecedents and parallels. Summers, *Michelangelo and the Language of Art*, p. 73, also mentions Dolce's text, and pp. 69, 125–26, discusses its further ramifications. For the broad application of "invention" and its meaning in the Cinquecento, see, e.g., an article by R. Scorza, "Vincenzo Borghini and Invenzione, The Florentine Apparato of 1565, *Journal of the Warburg and Courtauld Institutes* 44, 1981, pp. 57–75; the decorations Scorza discusses were for the celebration of the marriage of Rudolf II's aunt.

10. Lomazzo, *Idea*, pp. 154–55.

11. See for this point the discussion of texts gathered by Summers, *Michelangelo and the Language of Art*, pp. 68–70, 125–26, and especially p. 492 n. 65. See also E. H. Gombrich, "Leonardo's Method for Working Out Compositions, reprinted in *Norm and Form*, pp. 58–63.

12. Giuseppe Banfi, *Vocabolario Milanese-Italiano*, Milan, n.d., p. 425. According to Macandrew, *Italian Drawings*, p. 17, Valerio Lucchesi has also noted that the artist's diction and frequent dropping of the double consonant demonstrated his North Italian background.

13. Summers, *Michelangelo*, pp. 124–26 and 490–92; Nicole Dacos, *La découverte de la Domus Aurea et la formation des grottesques à la Renaissance*, London and Leiden, 1969, pp. 124–26.

14. For this tradition, see H. W. Janson, " 'The Image Made by Chance' in Renaissance Thought," in *De Artibus Opuscula XL. Essays in Honor of Erwin Panofsky*, New York, 1961, pp. 254–66, with further references, and also Gombrich, *Art and Illusion*, ed. cit., pp. 181–202.

15. For remarks on Botticelli, see Leonardo da Vinci, *Treatise on Painting*, eds. A. Philip McMahon and L. H. Heydenreich, Princeton, 1956, 1, p. 59, no. 93; for the comments on Piero di Cosimo, Giorgio Vasari, *Le vite de' più eccellenti pittori . . .* , ed. Milanesi, 4, Florence, 1879, p. 134. Anton Francesco Doni, *Disegno del Doni partito in più ragionamenti, ne quali si tratta della scoltura et pittura . . .* , Venice, 1549, fol. 22r; G. Armenini, *De' veri precetti della pittura*, p. 193; these texts are also conveniently cited by Dacos, *Découverte*, pp. 124–26.

16. McMahon and Heydenreich, eds., *Treatise*, pp. 50–54, no. 76; see the discussion of this passage by Gombrich, *Art and Illusion*, pp. 188–89 (whose translation I have used). Gombrich cites his "Conseils de Leonard sur les esquisses de tableaux," *Études d'art*, 1954, pp. 8–10; see also idem, "Leonardo's Method," pp. 60–61. Leonardo's advice is to look

> in alcuni muri imbattrati di varie machie, o pietre di varii misti, se harai a inventionare qualche sito, potrai li vedere similitudini de diversi paesi hornati di montagne, fiumi, sassi, alberi, pianure grande, valli e colli in diversi modi; anchora vi potrai vedere diverse battaglie et atti pronti de figure strane, arie di volte e abitti, et infinite cose.

17. Gombrich, "Leonardo's Method," p. 61.
18. Gombrich, *Art and Illusion*, p. 189.
19. Vasari, *Vite*, ed. Milanesi, Florence, 1878, p. 174:

> Gli schizzi, chiamiamo noi una prima sorte di desegni che si fanno per trovar il modo delle attitudini, ed il primo componimento dell'opra; e sono fatti in forma di una macchia, ed accenati solamente da noi in una sola bozza del tutto. E perché del furor del artefice sono in poco tempo con penna o con altro disegnatoio o carbone espressi, solo per tentare l'animo di quel che gli sovirene, percio si chiamano schizzi. Da questi dunque vengono poi rilevati in buona forma i disegni.

20. See the discussion of drawing in relation to the furor of the inventive imagination in Summers, *Michelangelo and the Language of Art*, pp. 67–69, with further references.

21. Arcimboldo's festival drawings are discussed in my *Variations on the Imperial Theme*, pp. 51–57; the function of the sheets to which the Boston drawings are here compared is established on pp. 54–55. See for illustrations of these drawings Andreas Beyer, *Giuseppe Arcimboldo Figurinen Kostüme und Entwürfe für höfische Feste*, Frankfurt a. M., 1983. For Vasari's further desciption of types of drawings, see Vasari, *Vite*, ed. Milanesi, 1, pp. 174–77. Rossiter, "Ornament," p. 49, also notes the preliminary yet "decorative" character of Arcimboldo's Boston drawings.

22. Porzio, *L'universo illusorio*, p. 38.

23. For this point about grotesques as a product of the *ingenium* and furor, see the remarks by R. P. Ciardi in the introduction to his edition of G. P. Lomazzo, *Scritti sulle arti*, 1, p. lxxvii; and also David Summers, "Michelangelo on Architecture," *Art Bulletin* 54, 1972, especially pp. 150ff.

24. For Doni and Armenini, see the references in n. 15 above; for Lomazzo, *Trattato dell'arte della pittura, scoltura, et architettura*, especially in ed. Ciardi, 2, p. 367.

25. B. Cellini, *Vita*, ed. P. D'Ancona, Milan, 1926, as cited by Dacos, *Découverte*, 3: "Queste grottesche hanno acquistato questo nome dai moderni per essersi trovate in certe caverne della terra in Roma dagli studiosi."

26. Ligorio's text on *grottesche* is printed in full in Dacos, *Découverte*, pp. 161ff.; the definition of grotesques is on p. 161: "Grottesche, sono dette la sorte dell'antiche pitture dalli nostri moderni, et l'hanno denominate dalle antiche et artificiose grotte, dipinte, cioè da quelle delle crypte, et dalli cryptaportichi di che furono pitte di diverse fantasticarie, con vaghi colori, dicose molto studiose."

27. Ligorio's text reads: "Tutte erano simboli . . . come per mostrare nel figurato le cose morali, le cose certe, e false, le vere." For the full text of this passage, see Dacos, ibid., pp. 161–62; see also pp. 181–82.

28. For Arcimboldo and hieroglyphs, see chap. 4, n. 10, Berra, "Allegoria e mitologia," p. 29, and my "Arcimboldo's Serious Jokes."

29. Lomazzo, *Trattato*, in *Scritte sulle arti*, p. 367: "il pittore esprime le cose ed i concetti, non con le proprie ma con altre figure." See also Lomazzo, *Trattato*, p. 369: "Queste grottesche, non solo siano cosi dette dalle grotte, ma perche a proposito venivano fatte non altrimente che ennimi, o cifre, o figure egizie, dimandate ieroglifici, per significare alcun concetto o pensiero sotto altre figure, come noi usiamo negli emblemi e nelle imprese."

30. Dacos, *Découverte*, p. 129. Ligorio's ideas on grotesques are also discussed by David R. Coffin, "Pirro Ligorio and Decoration at Ferrara, *Art Bulletin* 37, 1955, pp. 182–85; for Ligorio's views on the arts and their background in arguments such as those of G. A. Gilio, see idem, "Pirro Ligorio on the Nobility of the Arts," *Journal of the Warburg and Courtauld Institutes* 27, 1964, pp. 191–210. For Ligorio and Lomazzo on grotesques, see also Summers, *Michelangelo and the Language of Art*, pp. 496–97, n. 106.

31. Summers, "Michelangelo on Architecture," p. 152. The debate over the interpretation of Horace's (*Ars Poetica* [*Ad Pisonem*], lines 1–11) and Vitruvius's (*De Architettura Libri Decem*, 7.5:3–5) dicta on license in poetry and painting are discussed ibid., pp. 150–54. See also Dacos, *Découverte*, pp. 120–35. For the history of the modern idea of the grotesque—not exactly consonant with Renaissance usage, as noted by Summers, p. 152 n. 33—see Wolfgang Kayser, *The Grotesque in Art and Literature*, New York (new ed.), 1981.

32. This account of the debate among Barbaro, Paleotti, and Danti follows Summers, "Michelangelo on Architecture," pp. 150–53, and Dacos, *Découverte*, pp. 123–24, 128–34, who makes the point about the shift in issues of debate; the original texts are cited by both Summers and Dacos.

33. For this possible meaning of "intention," see Summers, *Michelangelo*, pp. 212–13, 517–18 n. 30, with further references.

34. Cf. Lomazzo, *Rime . . . nelle quali ad imitazione de i Grotteschi usati d' pittori, hacantato le lodi di Dio, e de le cose sacre, di Prencipi, di Signori, e huomini letterati, di pittori, scoltori, e architetti . . .* , Milan, 1587, p. 529 on Arcimboldo; *Libro di Sogni*, ed. Ciardi, 1, pp. 1–240. Ciardi's commentary makes apparent the interconnection of these two works and, p. 1 nn. 1 and 2, the dreamlike nature of many of the *rime*. The *Rime* also indicate the meaningful nature of grotesques for Lomazzo.

35. Lomazzo, *Rime*, p. 529. For the conjunction of *grilli* with inventions and *bizarrie*, see also ibid., p. 418:

"Si chè ad ogni modo ha da seguier ognuno il grillo delle sue invenzioni e disporle segundo gl'ordini proporzionati e naturali lasando a dietro le invenzioni e bizarie de gl'altri." See also the further conjunction of these ideas with grotesques in idem, *Rime*, p. 5: "Gl'humori, le inuentioni, & fantasie, Et gli strani pensieri, & le chimere, Sono nel sesto con le grillerie."

Irving Lavin, "Bernini and the Art of Social Satire," in idem, ed., *Drawings by Gianlorenzo Bernini from the Museum der Bildenden Künste, Leipzig, German Democratic Republic*, Princeton, 1981, p. 54 n. 61, has called attention to the first of these passages and has further, pp. 45–46, discussed the history of the term *grillo* with references to earlier literature on the subject, p. 54.

36. For Fonteo's use of the term *grillus* and its antecedents, see chap. 4 above.

37. See chap. 4, nn. 35 and 36 above. As is argued in chap. 4, regardless of whether or not Fonteo's original poems on Arcimboldo's paintings were composed ex post facto, his use of the term *grillus* was most likely known and approved by the painter. Fonteo's description of Arcimboldo's paintings as *grilli* or chimeras is particularly pertinent in the present context, for it is this invention that was not known to the ancients.

38. Lomazzo's text is discussed above. For Doni, *Disegno del Doni*, fol. 22v, where after speaking of "mille bizarrie, & altretante confusioni nel capo" as "fantasie, castelli in aria, & sogni," he calls *grottesche* "queste chimere dipinte." For Armenini, see *De' Veri Precetti*, p. 193. D. Barbaro, ed. and trans., *I dieci libri dell'architettura di M. Vitruvio*, Venice, 1567 (1st ed. 1556), p. 321, comments thus on grotesques: "Certo si come la fantasia nel sogno ci rappresenta confusamente le imagini delle cose, & spesso pone insieme nature diverse; cosi potemo dire, che facciono le Grottesche, le quali senza dubbio potemo nominare sogni della pittura."

39. For the relation of grotesques as *fantasie* to classical proscriptions, see Dacos, *Découverte*, pp. 122–29, and Summers, "Michelangelo on Architecture," pp. 151–53.

For Fonteo's allusion to the Horatian topos of ridiculous creatures, see *De Risu*, ÖNB, Cod. 10466, fol. 130r: "Risus unicus, admonet. . . . Pictorem, ne Humano capiti cervicem equinam, iungatur Tigribus agnos."

40. Emanuele Tesauro, *Il Cannochiale Aristotelico* (Turin, 1670 [5th printing]), ed. August Buck, Bad Homburg v.d. H., Berlin, Zurich, 1968, p. 85: "Tutti i Pittori le lor capricciose & crottesche inuentiue chiamano GRILLI." Lavin, "Bernini and the Art of Social Satire," p. 54 n. 61, also calls attention to this passage.

41. My "Arcimboldo's Serious Jokes" amplifies this argument.

42. Michel N. Benisovich, "The Drawings of Stradanus (Jan van der Straeten) in the Cooper Union Museum for the Arts of Decoration, New York," *Art Bulletin* 38, 1955, p. 251 n.6, suggests that Arcimboldo's Boston drawings are done in the "spirit of scherzi di fantasia," a statement meant as an unfavorable comparison with Stradanus's designs.

43. Heinrich Salmuth, ed. and trans., *Guidonis Pancirolli Rerum Memorabilum . . .* , Frankfurt a. M., 1646 (Amberg, 1599 [1st ed.]), pp. 306–7; Salmuth also

gives the sources of this legend such as Flavius Vopiscus, *In Vita Aureliani*. See the Excursus to chap. 4, n. 15.

In his proem, p. 2, Salmuth indicates he heard Pancirolli lecture in Padua in 1587 and 1588.

44. Summers, "Michelangelo on Architecture," p. 152 n. 33, and Dacos, *Découverte*, p. 122, who is cited in agreement by Summers; Dacos points out that "Le débat [over grotesques] soulève en effet le problème complexe de le rupture avec la tradition classique et de l'expression libre de l'imagination."

45. For this distinction and the subject of imitation in general, see the important comprehensive study of Pigman, "Versions of Imitation in the Renaissance."

46. For the knowledge of ancient grotesques and their treatment during the Renaissance, see, besides Dacos, *Découverte*, eadem, *Le Loggi di Raffaello. Maestro e bottega di fronte all'antico*, Rome, 1977, with extensive illustrations. See also Dacos, *Découverte*, figs. 3, 180.

47. Eugenio Garin, *L'educazione in Europa*, Bari, 1957, p. 275.

48. Lee, *Ut pictura poesis*, pp. 16–23, discusses the Horatian restriction in regard to art criticism and theory.

49. H. R. Jauss, "Ästhetische Normen und geschichtliche Reflexion in der 'Querelle des Anciens et des Modernes,' " in Charles Perrault, *Parallèle des anciens et modernes en ce qui regarde les arts et les sciences*, Munich, 1964, pp. 48–50, 53. Jauss is, to be sure, not the only scholar to have made this point. See also the references cited in the preceding and following notes.

50. H. R. Jauss, "Literarische Tradition und gegenwärtiges Bewusstsein der Modernität, und Schegels und Schillers Replik auf die 'Querelle des Anciens et des Modernes,' " in *Literaturgeschichte als Provokation*, Frankfurt a. M., 1970, pp. 11–106, traces the transformation of the seventeenth-century *querelle*. That *querelle* is studied most fundamentaly by Hubert Gillot, *La Querelle des anciens & modernes en France*, Paris, 1914. See also Jauss, "Ästhetische Normen," pp. 48–64, for citations of further literature.

51. August Buck, *Die "Querelle des Anciens et des Modernes" im Italienischen Selbstverständnis der Renaissance und des Barocks (Sitzungsberichte der wissenschaftlichen Gesellschaft an der Johann Wolfgang Goethe Universität Frankfurt am Main 11, no. 1)*, Wiesbaden, 1973, p. 6. Frank E. Manuel, *Shapes of Philosophical History*, Stanford, 1965, pp. 64–66, makes the same point.

52. Tacitus, *Dialogus de Oratoribus*, ed. William Peterson, Cambridge, Mass., and London, 1958, pp. 7–8.

53. E. R. Curtius, *European Literature and the Latin Middle Ages*, trans. Willard R. Trask, London, 1953, pp. 251–55.

54. For ancient ideas of nature and history, and the ideas stemming from them, see J. B. Bury, *The Idea of Progress and Growth*, New York, 1932; Ludwig Edelstein, *The Idea of Progress and Classical Antiquity*, Baltimore, 1967; C. R. Dodds, *The Ancient Concept of Progress and Other Essays on Greek Literature and Belief*, Oxford, 1973, pp. 1–25; and Manuel, *Shapes of Philosophical History*, p. 24 (and for the Renaissance, pp. 46–49). Edelstein, ibid., pp. 35, 39, 75, 111, speaks of the first *Querelle des anciens et des modernes* of the fifth century B.C. The Renaissance view of the decay of the world is the subject of Victor Harris, *All Coherence Gone*, Chicago, 1949.

55. For this *locus classicus* in Priscian, its recurrence in the Middle Ages, and its relation to the topos of "dwarfs standing on the shoulders of giants," see H. Silvestre, "Quanto iuniores, tanto perspicaciores, Antécédents à la querelle des anciens et des modernes," in *Recueil commémoratif du Xᵉ anniversaire de la faculté de philosophie et lettres* (Publications de l'Université Lovanium de Kinshasa), Louvain and Paris, 1961, pp. 231–55.

56. The origins and appearance of this topos are discussed extensively, with reference to earlier literature on the subject, in Robert K. Merton, *On the Shoulders of Giants, A Shandean Postscript*, New York and London, 1965.

57. August Buck, "Aus der Vorgeschichte der 'Querelle des Anciens et des Modernes' im Mittelalter und Renaissance," *Bibliothèque d'Humanisme et Renaissance* 20, 1958, especially pp. 520–35.

58. Cf. Buck, ibid., pp. 535–41; Buck, *Die "Querelle"*; Giacinto Margiotta, *Le origini italiane de la Querelle des Anciens et des Modernes*, Rome, n.d. (1953); Hans Baron, "The *Querelle* of the Ancients and the Moderns as a Problem for Renaissance Scholarship," reprinted in *Renaissance Essays from the Journal of the History of Ideas*, eds. Paul O. Kristeller and Philip P. Wiener, New York and Evanston, Ill., 1968, pp. 95–114; C. Vasoli, "La première querelle des 'anciens' et des 'modernes' aux origines de la Renaissance, in R. R. Bolgar, ed., *Classical Influences on European Culture A.D. 1500–1700*, Cambridge, London, New York, and Melbourne, 1976, pp. 67–80. Vasoli, *La dialettica*, pp. 9–27, also relates the quarrel to dialectic.

59. Weinberg, *History of Literary Criticism*, 2, p. 1112; see also pp. 662–63, 712–13, 808–9, 874.

60. Cf. Alberti, *On Painting and on Sculpture*, ed. Grayson, pp. 32–33; *On Painting*, trans. Spencer, pp. 39–40. The relation of Alberti's argument to the *querelle* of ancients and moderns is pointed out by Buck, "Aus der Vorgeschichte," p. 537; idem, *Die "Querelle,"* p. 10; Vasoli, "La première querelle," p. 72; and Baron, "The *Querelle*," p. 111. Baron, p. 110, also calls attention to a similar passage about the visual arts in Giannozzo Manetti's *De Dignitate Hominis*.

In his prefatory letter to Brunelleschi and elsewhere, Alberti also claims that the moderns in several regards have surpassed the ancients. This claim is an application of the humanist commonplace that the moderns had surpassed the ancients, a topos that Filippo Villani had already applied to painting, as noted by Baxandall, *Giotto and the Orators*, p. 72. See also Curtius, *European Literature*, pp. 162–66, for this topos of surpassing the ancients. It should be noted, however, that Alberti's claims for Brunelleschi's architecture regard it tellingly as a stunning feat of engineering; for the implication of this point, see the works cited in n. 63 below.

The remarks of Ugolino Verino are found in his epigram, "De pictoribus et sculptoribus florentinis, qui priscis grecis equiperari possint," Florence, Biblioteca Laurenziana, Plut. 39, Cod. 40, III, fol. 26v, quoted in Herbert P. Horne, *Botticelli, Painter of Florence*, intro. John Pope-Hennessy, Princeton, 1980 (1st ed., 1908), p. 306; see also pp. 304–5, 364, doc. no. lviii.

61. See, for example, Vasari, *Vite*, ed. Milanesi, 1, pp. 92, 95; 4 (1879), pp. 1, 11, 13; 7 (1881), pp. 135f. In making reference to Vasari, Baron, "The *Querelle*," p. 104, and Buck, *Die "Querelle,"* p. 17, note, however, that his cyclical view of art history may imply a coming decline in art. See also for these issues, Max

Imdahl, "Kunstgeschichtliche Exkurse zu Perrault's 'Parallèle des Anciens et des Modernes,'" in Perrault, *Parallèle*, ed. cit., particularly pp. 65–66.

62. The phrase *scavoir inventer* [*sic*] is found in Perrault, *Parallèle*, p. 101. The importance of this principle is emphasized by Jauss, *Ästhetische Norman*, p. 49; see also pp. 50, 53ff.

Perrault's poem *Le siècle de Louis le Grand* adumbrates the arguments found in his lengthy *Parallèle*; for the poem, see ibid., pp. 170ff.

63. For earlier views of the "progress" of the sciences and technology and their relation to the "quarrel of the ancients and moderns," see Bury, *Idea of Progress*, pp. 50ff; Richard F. Jones, *Ancients and Moderns. A Study of the Background of the Battle of the Books*, St. Louis, 1936; Paolo Rossi, "The Idea of Scientific Progress," in *Philosophy, Technology and the Arts in the Early Modern Era*, trans. Salvator Attanasio, ed. Benjamin Nelson, New York, Evanston, Ill., and London, 1970, pp. 63–99, with further references.

See also, and in regard to the material of the previous note, Paul Oskar Kristeller, "The Modern System of the Arts," reprinted in *Renaissance Thought, II. Papers on Humanism and the Arts*, New York, Evanston, Ill., and London, 1965, pp. 193–95.

64. See in general for this subject E. H. Gombrich, "The Leaven of Criticism in Renaissance Art," pp. 111–31. See also Summers, *Michelangelo and the Language of Art*, pp. 60–70.

65. Salmuth, ed., *Pancirolli Rerum Memorabilium . . .* , pt. 2, is entitled "Nova Reperta, sive Rerum Memorabilium Recens inventarum & veteribus plane incognitarum Liber," and is devoted to these "new discoveries." Perrault clearly was familiar with Pancirolli's ideas, as he quotes him in *Parallèle*, p. 120.

66. Dornavius, *Felicitas Seculi*, fol. D1v–D2r, also cited, with incorrect foliation, by Evans, *Rudolf II*, p. 187 and n. 2.

67. Cf. *Rerum Memorabilium*, pt. 2, pp. 303ff: "De Textis Sericis."

68. Günther Thiem, "Studien zu Jan van der Straet, gennant Stradanus," *Mitteilungen des Kunsthistorischen Institutes in Florenz* 8, 1958, p. 91, has established the dating of the drawings for the *Nova Reperta* series as c. 1550.

The engravings of the *Nova Reperta* series are reproduced by Bern Dibner, ed., *New Discoveries. The Sciences, Inventions and Discoveries of the Middle Ages and the Renaissance as Represented in 24 Engravings Issued in the Early 1580's by Stradanus*, Norwalk, Conn., 1953. The engraving of *Ser, Sive Sericus Vermis* bears the inscription "Joan. Stradanus invent. Joan. Galle Excud." Yet there has been some disagreement, if not confusion, about the attribution and dating of the engravings. While Dibner, perhaps from reading the inscription as *excudit* on the print, says that seventeen of the series were engraved by Johannes Galle, three by Hans Collaert, and one by Theodor Galle, F. W. H. Hollstein, ed., *Dutch and Flemish Etchings, Engravings, and Woodcuts ca. 1450–1700*, 7, Amsterdam, n.d., p. 87, attributes ten plates to Theodor Galle and ten to Hans Collaert, as does Thiem; Hollstein, *Dutch and Flemish Etchings*, 4, Amsterdam, n.d., p. 213, also, however, attributes the same series to *Ph.* Galle and Hans Collaert; Leo van Puyvelde, *The Flemish Drawings in the Collection of His Majesty the King at Windsor Castle*, New York, 1942, p. 24, no. 157, notes that one of the series is by Adriaen Collaert. While Dibner dates the series to the early 1580s, Thiem notes that Hans Collaert

was born in 1566 and Theodor Galle in 1571, and E. H. Gombrich, *Kunst und Fortschritt, Wirkung und Wandlung einer Idee*, Cologne, 1978, p. 80, figs. 46, 47, dates them c. 1600. Gombrich also discusses the prints in connection with the development of the idea of progress.

The reference to Stradanus in *Drawings from the Holy Roman Empire*, p. 136, should be to Johannes, not Jacobus, Stradanus.

69. For this series see Puyvelde, *Flemish Drawings*, pp. 24–25, nos. 159–63, and Benisovich, "The drawings of Stradanus," p. 251. Benisovich notes, p. 250, that the frontispiece of the *Nova Reperta* series is inscribed *Th. Galle sculpsit, Philippe Galle excudit.* See also Macandrew, *Italian Drawings*.

70. Van Mander, *Het Schilder-Boeck*, Haarlem, 1604, fol. *IIIv, IIIr. For the theme and these allegories in relation to Van Mander's and other texts, see the introduction and first chapter in *The School of Prague*; also, "The Eloquent Artist," pp. 124–30. See also Hanna Peter-Raupp, "Zum Thema 'Kunst und Kunstler' in Deuschen Zeichnungen 1540–1640," in *Zeichnung in Deutschland; Deutsche Zeichner 1540–1640*, 2, Stuttgart, 1980, pp. 223–30.

71. Hope, "Sight Gags," p. 43, suggests that Arcimboldo's proposal for grotesques is banal, but given the highly unusual choice of subject for this type of decoration, and Arcimboldo's lengthy explanation of the process of manufacture, this characterization seems to go wide of the mark.

72. Cf. Evans, *Rudolf II and His World*, pp. 133–34. Brno (Czechoslovakia), Universitní Knihovna, MK 51 (1.215), MK 4 (1.214).

73. For the identification of these manuscripts, see Eliška Fučíková, "Einige Erwägungen zum Werk des Jacopo und Ottavio Strada," *Leids Kunsthistorisch Jaarboek* 1, 1982, pp. 340, 341, 351 n. 8, 352 nn. 11, 12. The list of manuscript copies of Strada's *Symbola Romanorum Imperatorum . . .* , expanded by Fučíková, p. 351 n. 8, can be further increased. The original manuscripts by Giulio et al. have been published by Beket Bukovinská, Fučíková and Lubomír Konečný, "Zeichnungen von Giulio Romano und seiner Werkstatt in einem vergessenen Sammelband in Prag," *Jahrbuch der Kunsthistorischen Sammlungen in Wien* 80, 1984, pp. 61–186.

74. An example of this *ex libris* is pasted in Hoffmann's copy of Strada's *Simbola*, Brno, Universitní Knihovna, MK 51.

75. For this series, see *Drawings from the Holy Roman Empire*, p. 160, no. 58, and further Fučíková, "Zur Konzeption der rudolfinischen Sammlungen," in *Prag um 1600. Beiträge zur Kunst und kultur am Hofe Rudolfs II.*, Freren, 1988, p. 61.

76. Jaromír Neumann, "Rudolfinské Umění II," *Umění* 26, 1978, p. 312, says that it was Hoffmann's *nedostatečný zájem* (insufficient interest) that caused them not to be executed.

77. For De Vries's work in Prague, consult the discussion in *The School of Prague*, p. 291. I am grateful to Sue W. Reed of the Museum of Fine Arts, Boston, for supplying me with the following list of contents of the collective volume from Hoffmann's library into which the Arcimboldo drawings are bound:

1. Dietrichs de Bry (Söhne), *Architectura et perspectiva Etlicher Staedt Kirchen Schloesser und Haeusser*, Frankfurt a.M., 1602.

2. Hans Lencker, *Perspectiva* . . . , Nuremberg, 1571.

3. Sambucus, *Arcus aliquot Triumphal. et Monimenta victor classicae in Honorem . . . Jani Austriae* (see chap. 4 above).

4. Gabriel Krammer, *Architectura. Von den Fünf Seulen sambt Iren Ornamenten* . . . , Prague, 1602.

5. Jans Jakob Ebelmann, six etchings of wardrobes, c. 1600.

6. Jacob Floris, *Compertimenta pictoriis flosculis manubiisque bellicis variegata*, Antwerp, 1567.

7. Nicolas de Bruyn, nine engravings of heroes.

8. Crispin van de Passe, *The Four Elements* (engravings).

9. Crispin van de Passe, eight emblems (dated 1601) (engravings).

10. Marcus Gerards, *The Four Continents* (engravings).

11. Hans Vredeman de Vries, *Grottesco: in diversche manieren*...(16 engravings with title page).

12. Hans Vredeman de Vries, grotesque borders, 16 engravings.

13. Joseph Boillot, *Artifices de feu & divers Instruments de guerre* (Strassburg, 1603).

14. Arcimboldo's drawings.

78. See chap. 4, n. 29 above. Neumann, "Rudolfínské Umění I," pp. 483–89, and in idem, et al., *Die Kunst der Renaissance und des Manierismus in Böhmen*, Hanau, 1979, pp. 196–97, relates Arcimboldo's paintings to conceptism and interprets them under the rubric of "mannerism."

79. See E. H. Gombrich, "The Renaissance Conception of Artistic Progress and Its Consequences, reprinted in *Norm and Form*, particularly p. 9, where the idea of a *dimostrazione* is discussed.

80. See Van Mander, *Het Schilder-Boeck*, fol. 271v, for the desription of Spranger's activity in Rome. The association of Spranger with the ideal of working *uyt den geest* is discussed in "The Eloquent Artist," pp. 119 and 140 n. 3, with further references.

81. This criticism of "mannerism" as "conceptism" briefly recapitulates the arguments made in "The Problem of 'Northern Mannerism.' "

It should also be noted, in reference to the connection of French classicism with the seventeenth-century *querelle*, that the contemporary artistic forms praised by Perrault are those associated with the court of Louis XIV, and the setting for the dialogue that constitutes his *Parallèle* is indeed Versailles (cf. the description in Jauss, ed., *Parallèle*, p. 128), and that Perrault's brother was the classicist architect and theorist Charles.

82. The argument for a kind of rhetorical decorum in painting at Prague is advanced in "The Eloquent Artist," pp. 133–37; cf. also *The School of Prague*, chap. 4.

83. See "The Eloquent Artist," p. 135, for an example of ornamental "elocution" in Rudolfine painting; see also *The School of Prague*, passim. The argument about invention here is intended to stress invention of new subject matter, as distinct from the invention of new treatments of traditional subject matter, discussed by Gombrich, "Artistic Progress," p. 9; see also n. 80 above.

84. Comanini, *Il Figino*, p. 35.

85. *Felicitas Seculi*, fol. 1r. Dornavius's familiarity with Prague is further demonstrated by his remarks on fol. C 3v. For Heintz, see Jürgen Zimmer, "Josephus Heintzius—architectus cum antiquis comparandus: Příspěvek k poznání rudolfínské architektury mezi let 1590–1612," *Umění* 17, 1969, pp. 217–40.

86. Hendrix, "Joris Hoefnagel and the Four Elements," first suggested that Hoefnagel had set up a rivalry with his predecessors, including ancient painting.

87. The importance of Rudolfine Prague for the development of mechanical and technical inventions in relation to the "new science" has still not received the full attention it deserves. In the meantime, see Evans, *Rudolf II and His World*, pp. 188–89, and passim, with further references. See also Klaus Maurice, "Jost Bürgi, or On Innovation," in *The Clockwork Universe. German Clocks and Automata 1550–1650*, eds. Klaus Maurice and Otto Mayr, New York, 1980, which, p. 87, stresses the importance of Rudolf II's patronage in promoting astronomical knowledge and inspiring mechanical inventions.

88. These activities are mentioned by Comanini, *Il Figino*, and Lomazzo, *Idea*, who mentions that Arcimboldo's *acutissimo ingegno (Idea*, p. 155) "ritrovò artificii di passar fiumi espeditamente, ove non fossero ponti ne si havessero navi."

89. This point is suggested by Thoren, *The Lord of Uraniborg*, p. 467.

90. As mentioned in a letter of Tycho to Johann Gerhart Herwart von Hohenburg, 18/28 August 1600, in Dreyer, ed. *Opera*, 8, p. 358, also noted in Thoren, *The Lord of Uraniborg*.

91. Hoffmann's role in procuring instruments for a pump, with Bürgi's manufacture, for Brahe and Kepler is established in Johannes Kepler, *Gesammelte Werke*, ed. Max Caspar, 14, Munich, 1949, pp. 98, 470.

92. Evans, *Rudolf II and His World*, p. 187, notes Kepler's interest in water machines and suggests that Bürgi assisted him.

93. See a letter of 13 December 1599 from Hoffmann to Kepler, printed in Kepler, *Werke*, 14, p. 98; and a letter to David Fabritius of February 1604, Kepler, *Werke*, ed. Caspar, Munich, 1951, p. 27: Utor Sextante et Quadrante parvo ex Hoffmanni liberalitate. See also a letter of 18 December 1604 to the same recipient, ibid., p. 78.

94. Evans, *Rudolf II and His Time*, p. 153, mentions and gives references in Kepler, *Werke*, ed. cit., 14, letters nos. 155–57, 160, for the connection between Kepler and Hoffmann, and suggests that Hoffmann served as intermediary between Kepler and Brahe. Hoffmann's involvement with the two is also indicated in Brahe's correspondence, ed. Dreyer, *Opera*, 8, pp. 244–45, 247–48, 254–56, 341. See also Thoren, *The Lord of Uraniborg*, pp. 440, 451, 459, 466.

95. Kepler, *Werke*, ed. cit., Munich, 1938, 1, p. 307. Evans, *Rudolf II and His World*, p. 187, cites part of Kepler's remarks, but not the passage to which reference is made here: "Praxin verò sic peculiariter sibi possidet; ut habitura sit posterior aetas, quem in hic genere Coryphaeum celebret, non minorem quàm DVRERVM in pictoria, cujus crescit occulto, velut arbor, aevo fama."

I would like to distinguish between Kepler's discussion of Dürer's fame in *genere pictoria* and his use elsewhere, in his treatment of optics, of the terms *imago* and *pictura*; for these latter conceptions, see T. Kaori Kitao, "*Imago* and *Pictura*: Perspective, Camera Obscura and Kepler's Optics," in Dalai Emiliani, ed., *La prospettiva Rinascimentale*, 1, pp. 499–510. For another comment on the meaning of

pictura in this context, see the essay by A. T. Grafton and the author, "Holland without Huizinga," Review of Alpers, *The Art of Describing*, in *Journal of Interdisciplinary History* 16, 1985, pp. 253–65.

96. For the importance of Prague in the development of new genres, see *The School of Prague*.

In her review of *The School of Prague*, Gerards-Nelissen, rev. cit., p. 79, seems to misunderstand this point, calling this sort of argument "modern formalist"; this overlooks the innovation implicit in the creation of new genres. Her contrast between Arcimboldo as "the only artist" who might "really be considered modernist and innovative" and "painters such as von Aachen, Spranger and Savery," who "tended more to base their inventions on existing examples than to break with the past, let alone reject it," also misstates the case, ignoring the actual possibility for innovation and invention that existed at the end of the sixteenth century. In differentiating Arcimboldo from other court artists, this distinction overlooks the multitude of sources, visual and textual, discussed in the previous literature as well as in the text and notes in chap. 4 and its Excursus, that exist for this artist. Isolating Arcimboldo also misrepresents the complicated relation to the past involved in his modern stance, which, as discussed in this chapter, has many parallels to other contemporary phenomena.

CHAPTER 7

1. Erwin Panofsky, "Galileo as a Critic of the Arts: Aesthetic Attitude and Scientific Thought," *Isis* 147, 1956, pp. 9–10; Panofsky's essay represents a revision of his booklet *Galileo as a Critic of the Arts*, The Hague, 1954.

2. "Considerazioni al Tasso," in *Le Opere di Galileo Galilei*, 9, Florence, 1932 (reprint), p. 69:

> Mi è sempre parso e pare, che questo poeta sia nelle sue inventioni [*sic*] oltre tutti i termini gretto, povero e miserabile; e all'opposito, l'Ariosto magnifico, ricco e mirabile; e quando mi volgo a considerare i cavalieri con le loro azzioni e avvenimenti, come anche tutte l'altre favolette di questo poema, parmi giusto d'entrare in uno studietto di qualche ometto curioso, che si sia dilettato di adornarlo di cose che abbiano, o per antichità o per rarità o per altro, del pellegrino, ma che però sieno in effetto cosellini, avendovi, come saria a dire, un granchio petrificato, un camaleonte secco, una mosca e un ragno in gelatina in un pezo d'ambra, alcuni di quei fantoccini di terra che dicono trovarsi ne i sepolcri antichi di Egitto, e cosi, in materia di pittura, qualche schizetto di Baccio Bandinelli o del parmigiano, e simili altre cosette; ma all'incontro, quando entro nel *Furioso*, veggo aprirsi una guardaroba, una tribuna, una galleria regia, ornata di cento statue antiche de' piu [*sic*] celebri scultori, con infinite storie intere, e le migliori, di pittori illustri, con un numero grande di vasi, di cristalli, d'agate, di lapislazari e d'altre gioe, e finalmente ripiena di cose rare, preziose, maravigliose, e di tutti eccellenza.

The translation used here is that of Panofsky.

For the situation of Galileo's remarks in the literary quarrel over Ariosto and

293

, *A History of Literary Criticism in the Italian Renaissance*, 2, pp.

Galileo as a Critic," pp. 9–10.

Schlosser, *Die Kunst- und Wunderkammer der Spättrenaissance. Ein*
hichte des Sammelwesens, Braunschweig (2nd ed.), 1978 (1st ed.,
, p. 203: according to Schlosser, the "klaren, bei allem Tempera-
nen und praktische Sinn des Volkes, bei dem die Mathematik als
nationᵤ ssenschaft angesprochen werden darf" could be contrasted with "die
romantische Hexen- und Teufelsküche, wie die ganze spukhaft Abenteuerlichkeit
des Nordens."

5. I have in mind here such works as Alpers, *The Art of Describing*, and Michael
Baxandall, *The Limewood Sculptors of Renaissance Germany*, New Haven and Lon-
don, 1980.

6. As a result, Schlosser's distinctions have been specifically criticized by Bar-
bara J. Balsiger, " 'The Kunst- und Wunderkammern': A Catalogue Raisonné of
Collecting in Germany, France and England, 1565–1750," unpublished Ph.D.
dissertation, University of Pittsburgh, 1970; Bauer, "Die Kunstkammer Kaiser
Rudolfs in Prag," p. xv; Giuseppe Olmi, "Dal 'teatro del mondo' ai mondi in-
ventariati. Aspetti e forme del collezionismo nell'età moderna," in P. Barocchi
and G. Ragionieri, eds. *Gli Uffizi. Quattro secoli di una galleria*, Florence, 1983, p.
243; and Antoine Schnapper, *Le géant, la licorne, la tulipe. Collections françaises au*
XVIIe siècle, Paris, 1988, pp. 12–13.

A good (though by no means complete) bibliography of works on collecting in
early modern Europe, giving some idea of the volume of publications since
Schlosser and Panofsky, is contained in Oliver Impey and Arthur MacGregor,
The Origins of Museums. The Cabinet of Curiosities in Sixteenth- and Seventeenth-
century Europe, Oxford, 1985, pp. 282–312. This bibliography is complemented
by those of Elisabeth Scheicher, *Die Kunst- und Wunderkammern der Habsburger*,
Vienna, Munich, and Zurich, 1979, and Adalgisa Lugli, *Naturalia et Mirabilia. Il*
collezionismo enciclopedico nelle Wunderkammern d'Europa, Milan, 1983; see also
more recently *Schatzkästchen und Kabinettschrank. Möbel für Sammler*, Berlin, 1989.

7. Gabriel Kaltemarckt's *Bedenken wie eine Kunst-cammer aufzurichten seyn*
möchte of 1587, his conceptualization of how a *Kunstkammer* should be formed,
demonstrates that the divisions made between types of princely collections did
not exist for him: see Barbara Gutfleisch and Joachim Menzhausen, " 'How a
Kunstkammer Should Be Formed': Gabriel Kaltemarckt's Advice to Christian I
of Saxony on the Formation of an Art Collection, 1587," *Journal of the History of*
Collections 1, 1989, pp. 3–32. Kaltemarckt points to Italy in general as a model and
specifically, pp. 27–28, as a source for works of art. He also explicitly elides the
distinction beween picture galleries and *Kunstkammers*, saying, p. 11, that princely
Kunstkammers should contain first, sculpture, second, paintings, and only third,
wondrous (*wunderbarliche*) naturalia, in their original form or shaped into vessels.

It is also important to note that although he says that objects in the last category
are obtainable in Germany and Italy, Kaltemarckt's proposal for a *Kunstkammer*,
in fact, concentrates on the first two, especially sculpture.

8. The conflict between Kaltemarckt's and Galileo's writings indeed suggests
the variety of interpretations that may be read from contemporary sources. Dif-

ferences of opinion about the meaning of the *Kunstkammer* do not seem to be either alleviated by an accumulation of information unavailable to earlier interpreters or independent of a hermeneutic outlook or interpretive strategy ("theory") that valorizes some sources rather than others and interprets them differently. However, the first point, about increased information, is made by, among others, Alfons Lhotsky, "Die Geschichte der Sammlungen," *Festschrift des Kunsthistorischen Museums*, Vienna and Horn, 1941/1945, p. 239. The latter point, about interpretation being independent of theory, is made by Schnapper, *Le géant*, p. 13, who, while deliberately eschewing theory, seems to suggest that the only possible choice for an interpretation of collecting based on some theory, which he rejects, would have been "neo-Marxist" (!).

9. Schnapper, "The King of France as Collector in the Seventeenth Century," *Journal of Interdisciplinary History* 17, 1986, p. 188, notes the difficulty of resolving questions of interpretation and even suggests the need for recognizing the importance of the different conditions and temperaments involved in the history of collecting. In spite of these cautious remarks, Schnapper goes on to generalize about the relation of collecting to patronage by referring to the French situation, despite the fact that his own arguments would seem to point to the thesis that they would have depended upon situations different from circumstances elsewhere.

It does seem to be the case that collections that at first appear to have similar contents were regarded differently at different times and places. Giuseppe Olmi ("Dal 'teatro del mondo' ai mondi inventariati," pp. 233–69, and also "Alle origini della politica culturale dello stato moderno: dal collezionismo privato al *cabinet du roy*," *La Cultura* 16, 1978, pp. 471–84) has described how the relation of collecting to the development of the history of science and the role of the state, in fact, changed during the seventeenth century, a point ignored by Schnapper. One of the conclusions of this essay is that a reconsideration of the earlier *Kunstkammer* suggests a way in which Krzysztof Pomian's (for which see n. 13 below) and Schnapper's theses, while probably misapplied to the princely *Kunstkammer* in Central Europe, c. 1600, may well reflect the changed circumstances for collecting and display, most particularly in the region, some time thereafter.

10. Gerard l'E. Turner, "The Cabinet of Experimental Philosophy," in *The Origins of Museums. The Cabinet of Curiosities in Sixteenth-and Seventeenth-Century Europe*, eds. Oliver Impey and Arthur MacGregor, Oxford, 1983, p. 214.

11. For the political argument, see, for example, my *Variations on the Imperial Theme*; "Remarks on the Collections of Rudolf II: The *Kunstkammer* as a Form of *Representatio*," *Art Journal* 38, 1978, pp. 22–28; and *The School of Prague*, pp. 11–17; and Scheicher, *Die Kunst- und Wunderkammer der Habsburger*. For the relation to science, see, for example, S. A. Bedini, "The Evolution of Science Museums, *Technology and Culture* 6, 1965, pp. 1–29; Eliška Fučíková, "The Collection of Rudolf II at Prague: Cabinet of Curiosities or Scientific Museum?"; Michael Hunter, "The Cabinet Institutionalized: The Royal Society's 'Repository' and Its Background"; and Turner, "The Cabinet of Experimental Philosphy," all in *The Origins of Museums*, pp. 47–53, 147–58, 214–22.

12. Schnapper, "The King of France as Collector in the Seventeenth Century," p. 185f.; see also *Le géant*, pp. 12, 13f.

13. See the essays collected in Krzysztof Pomian, *Collectionneurs, amateurs et curieux. Paris, Vènise: XVIe-XVIIIe siècles*, Paris, 1987. See also the critique of Giuseppe Olmi, "Science-Honour-Metaphor: Italian Cabinets of the Sixteenth and Seventeenth Centuries," in *The Origins of Museums*, pp. 5–16, who, however, notes the historical development in collections in this context.

Even though he criticizes certain aspects of Pomian's definition of collecting (cf. *Le géant*, pp. 7f), Schnapper also employs the word *cabinet des curiosités* and curiosity cabinet for the *Kunstkammer*: in general he, in fact, seems to adhere to Pomian's notion of these collections as assemblages of the curious. For a critique of my interpretation of Rudolf II's *Kunstkammer*, which instead calls into account Tennyson and British collections of the nineteenth century, see Nicholas Penny, "The Curiosities of Art and Nature," *Times Literary Supplement*, 24–30 March 1989, pp. 313–14.

The remarks of Francis Haskell, "Introduction," in Francesco Solinas, ed., *Cassiano del Pozzo. Atti del Seminario Internazionale di Studi*, Rome, 1989, p. 9, seem to indicate a favorable reception to Pomian's and Schnapper's theses. (I am grateful to Jonathan Brown for calling my attention to this reference.)

14. Certainly Schnapper's words of caution about simple or overinterpretations are well taken, but to emphasize France, and to ignore that conditions might be different in an area like Central Europe, where the entire cultural and social organism was determined by the existence of multiple polities totally unlike the French situation, would seem to represent even more of a misinterpretation. It is obviously also anachronistic to bring into account notions of an English curiosity cabinet of the nineteenth century, as Penny has done.

15. This is also perhaps one reason why, although it is not germane to his subject of French collecting, Schnapper criticizes the interpretation of Rudolf II's collection. For Prague, see in general *The School of Prague*.

16. As, for example, Jürgen Freiherr von Kruedener, *Die Rolle des Hofes im Absolutismus* (Forschungen zur Sozial- und Wirtschaftsgeschichte 19), Stuttgart, 1973, and Hubert Ch. Ehalt, *Ausdrucksformen absolutistischer Herrschaft. Der Wiener Hof im 17. und 18. Jahrhundert* (Sozial- und wirtschaftshistorische Studien 14), Munich, 1980, both with further bibliography.

17. Most importantly from Norbert Elias's now classic *The Court Society*, trans. Edmund Jephcott, New York, 1983. While Elias's work was based on seventeenth-century France, it is not dealt with directly by Schnapper, even though the latter raises the possibility of a social historical approach, if only to dismiss it.

18. Ehalt and Kruedener, as cited in, n. 16, as well as the works cited in n. 11, with further bibliography.

19. Schnapper, "The King of France as Collector," especially pp. 187, 200–201.

20. Examples of this sort of collecting are so manifold, from the time of the dukes of Berry, whose patronage activities hardly seem distinguishable from their collecting, that it seems almost superfluous to name them; for a notable counterexample to Schnapper's thesis, see Steven Orso, *Philip IV and the Decoration of the Alcazar of Madrid*, Princeton, 1986.

For a more complete view of the interrelationship of patronage and collecting at the early modern courts, see Martin Warnke, *Hofkünstler. Zur Vorgeschichte des modernen Künstlers*, Cologne, 1985, especially pp. 224ff.

21. For much information on this theme in general, see Warnke, *Hofkünstler*, pp. 240ff., 286ff., and passim.

In reference to the Habsburg courts, this is one of the themes of Lhotsky's "Die Geschichte der Sammlungen," where a vast amount of material is gathered demonstrating the interconnection of the Habsburgs' patronage of court artists with the development of the court collections. In a 1963 lecture Erwin Neumann also specifically emphasized that the work of the the court artists was one of the sources of Rudolf II's *Kunstkammer*; see Bauer, in "Die Kunstkammer Kaiser Rudolfs in Prag," p. 19.

22. *The School of Prague*, pp. 21, 120–21 n. 50.

23. This is one of the reasons for the so-called "Dürer-Renaissance," c. 1600. For aspects of this subject, see chap. 3 above, and especially Gustav Gluck, "Fälschungen auf Dürer's Namen aus der Sammlung Erzherzog Leopold Wilhelms," *Jahrbuch der Kunsthistorischen Sammlungen des Allerhochsten Kaiserhauses* 28, 1909–1910, pp. 1–35; Kauffmann, "Dürer in der Kunst und Kunsturteil"; *Dürer-Renaissance*, Munich, 1971; Fučíková, "Umělcí na dvoře Rudolfa II"; Hans Georg Gmelin, "Dürerrenaissance um 1600," *Im Blickpunkt* 7, 1979; Gisela Goldberg, "Dürer-Renaissance am Münchener Hof," in *Um Glauben und Reich: Kurfürst Maximilian I*, 2, pt. 1: *Beiträge zur Bayerischen Geschichte und Kunst 1573–1657*, Munich, 1980, pp. 318–23; "Zur Ausprägung der Dürer-Renaissance in München: *Münchener Jahrbuch der bildenden Kunst* 31, 1980, pp. 129–76.

24. Gutfleisch and Menzhausen, "How a Kunstkammer Should Be Formed," p. 28: because of the superiority of Florentine sculptors in copying ancient works, Kaltemarckt suggests that Florence is highly preferable to Rome, where the art of ancient sculpture is concerned.

25. This point can obviously be made in regard to the collecting of copies of ancient sculpture through the ages, for which see Francis Haskell and Nicholas Penny, *Taste and the Antique*, New Haven and London, 1981.

For specific examples of copies of paintings, see the many references in the 1621 inventory of the Prague collections, in Zimmermann, "Das Inventar der Prager Schatz- und Kunstkammer vom 6. Dezember 1621," pp. xiiiff.

26. See Bruce T. Moran, "Wilhelm IV of Hesse-Kassel: Informal Communication and the Aristocratic Context of Discovery," in Thomas Nickles, ed., *Scientific Discovery: Case Studies (Boston Studies in the Philosophy of Science* 60), Dordrecht, Boston, and London, 1978, especially pp. 70–73. Moran's work on this and similar subjects often derives ultimately from his "Science at the Court of Hesse-Kassel: Informal Communication, Collaboration and the Role of the Prince-Practitioner in the Sixteenth Century," unpublished Ph.D. dissertation, University of California, Los Angeles, 1978.

27. Schnapper, "The French King as Collector," p. 186 (who in this context is also criticizing Alpers, *Art of Describing*), claims that "there is no proof (if anything the opposite) that Rudolf II built his collection to celebrate his glory and his power," but has offered no support for this argument; Penny, "Curiosities of Art and Nature," also does not.

28. See the edition by Gutfleisch and Menzhausen, art. cit., *e.g.*, p. 4.

29. See Herbert Brunner, ed., *Schatzkammer der Residenz*, Munich, 1970 (3rd ed.), pp. 7–18, for the founding documents of the Munich *Schatzkammer*; see also

Renate von Busch, *Studien zur süddeutschen Antikensammlungen des 16. Jahrhunderts*, Ph.D. dissertation, Munich, 1975.

30. See the discussion in Lhotsky, "Geschichte der Sammlungen," pp. 285ff.

31. Cited by Rudolf Distelberger, "The Habsburg Collections in Vienna during the Seventeenth Century," in *The Origins of Museums*, p. 40, and also by Lhotsky, "Geschichte der Sammlungen," p. 302; the original document was published by H. Zimmermann, "Acten und Regesten aus dem Archiv des k.k. Ministeriums des Inneren, *Jahrbuch der Kunsthistorischen Sammlungen des Allerhöchsten Kaiserhauses* 7, 1888, pt. 2, p. lxii, reg. no. 4701.

32. Moran, "Wilhelm IV of Hesse-Kassel," pp. 67–96, and idem, "Science at the Court of Hesse-Kassel," p. 71.

33. For this topic in general, see Warnke, *Hofkünstler*, pp. 261–69. Warnke makes the point , p. 269, that "Der Einsatz der Maler und der Malerei im zwischenhöfischen Verkehr war eine der geschichtlichen Voraussetzungen dafür, dass Staaten und Nationen sich auch durch ihre Kunst und Kultur nach aussen repräsentiert fühlten."

This topic is adumbrated specifically in relation to the Habsburgs in *Variations on the Imperial Theme*; see also my "Die Kunst am Hofe Rudolfs II in Bezug auf das Salzburg Wolf Dietrichs," in *Fürsterzbischof Wolf Dietrich von Raitenau. Gründer des barocken Salzburg*, Salzburg, 1987, especially p. 188.

Personal reports of as yet unpublished research by Dr. Thomas Fröschel of the University of Vienna on the topic of Rudolf II's diplomacy is bearing out the importance of gift giving and receiving in this sort of relationship.

34. While Penny, "Curiosities of Art and Nature," p. 313, accepts the notion that banquets "were the occasion for redundant ostentation," he has objected to what he calls the misinterpretation of evidence from Prague, where, in *The School of Prague*, pp. 11–12, figs. 9, 10, I compared the illustration of a festival of the Golden Fleece in 1585 to a similar representation of a *Schauessen* at the court of the dukes of Berry. Yet it should be emphasized that in the mid-sixteenth century the Habsburg court took over Burgundian ceremonial (see Oskar Freiherr von Mitis, "Vom burgundischen Hofe Ferdinands I in Österreich . . . ," in *Festschrift Oswald Redlich (Jahrbuch für Landeskunde von Niederösterreich, 1928)*, pp. 153ff.), among its aspects the tradition of the ruler receiving gifts on 1 January. This custom is probably the reason why there are extraneous precious objects in an illustration of a January feast at the Berry court (for which see, in comparison to a 1585 feast at the Prague court, *The School of Prague*, figs. 9 and 10). For the custom of New Year's gifts at the Prague court, see chap. 4 n. 31 above. The connection between earlier Berry/Burgundian traditions and the world of Rudolf II is also evident in the Prague 1585 feast because at that event the court was celebrating a ritual that can be tied to a specific Burgundian knightly order, induction into the order of the Golden Fleece.

Furthermore, a later image of a Habsburg *Schauessen* also showing a credenza with precious vessels, from the reign of the Emperor Charles VI in the eighteenth century, demonstrates the continuation of this tradition and supports this interpretation of the Rudolfine image. Significantly, the annual day set aside for such a public *Schauessen* at the court of Charles VI was Saint Andrew's Day, the saint's day of the patron of the Golden Fleece, with which such ceremonies were evi-

dently associated. See Ehalt, *Ausdrucksformen*, fig. 10, and related texts. It should further be noted that the description accompanying the depiction of the 1585 imperial banquet (*School of Prague*, fig. 10) specifically calls it a *Schauessen*.

An even later illustration of a "Freij Taffel der *Nieder Österreichischen* Dreij Obern herrn Ständten" included in Georg Christoph Kriegl, *Erb-Huldigung, Welche der . . . Frauen Mariae Theresiae . . . Als Ertz Herzogin zu Oesterreich von Denen gesammten Nider-Oesterreichischen Ständen . . . abgeleget den 22. Novembris Anno 1740*, Vienna, 1740 depicts another *Schauessen* at which a banquet table is laid out with plates that are not being used, but are intended for show. According to the files of the George R. Gardiner Museum, Toronto, where this book opened to this illustration was on display in 1992, this plate may be derived from Ludwig von Gülich, *Erb-Huldigung Josepho I . . . als Ertz-Hertzogen zu Oesterreich*, Vienna, 1705.

35. In contradiction to Penny's remarks that objects placed on sideboards at banquets, as in the images illustrated in *The School of Prague*, figs. 9 and 10, were used for service rather than show, Howard Coutts, in a letter to the *Times Literary Supplement* of 5 May 1989, p. 485, gives further evidence supporting the point repeated here. Coutts concludes that, in any case, "Since the function of elaborate meals in the early modern period was as much for the display of wealth as the satiation of appetite, there would have been no inherent contradiction in the dual function of the sideboard as a place of display of lavish plate and a serving table for wines and spirits."

36. Werner Schade has kindly mentioned to me the existence of an unpublished late sixteenth-century drawing in the Graphische Sammlung, Dresden, which depicts a ceremonial granting of the *Kurwürde* to a Saxon elector, where the event is shown taking place in Prague, in a setting where works of art are prominently displayed. Ceremonies of *gésine*, the lying in of a newborn infant at the French and Burgundian courts, involved a similar display of objects: see for example the account of the ceremony attending the birth of Mary of Burgundy in 1485 in Victor Gay, *Glossaire Archéologique du Moyen Age et de la Renaissance*, Paris, 1887, 1, pp. 774–75. (I am grateful to Elizabeth H. Beatson for this reference.)

37. See especially Schnapper, "Collections of the Kings of France"; Penny, "Curiosities of Art and Nature"; and Eliška Fučíková, "Die Kunstkammer und Galerie Kaiser Rudolfs II als eine Studiensammlung, in *Der Zugang zum Kunstwerk: Schatzkammer, Salon, Ausstellung, "Museum"* (*Akten des XXV. Internationalen Kongresses für Kunstgeschichte, Wien, 1983, 4*), Vienna, Cologne, and Graz, 1986, pp. 54–55.

38. This transformation is theorized and described by Jürgen Habermas, *Strukturwandel der Öffentlichkeit. Untersuchungen zu einer Kategorie der bürgerlichen Gesellschaft*, Darmstadt and Neuwied, 1962.

39. For the fame of Rudolf II's collections, see the references, including Van Mander, cited in my *The School of Prague*, pp. 3f.

In a review of *The School of Prague*, in *Renaissance Quarterly* 43, 1990, p. 190, Joaneath Spicer comments on the debate over Rudolf's collections as a form of representation, arguing that despite the existence of "few contemporary references to visits by ambassadors or other princes to whom such symbolism might have been directed," the thesis about collecting "is essentially correct, not only

because the fame of the collections abroad was perhaps as important as the reality."

40. *Iani Gruteri Corpus Inscriptionum* . . . , Amsterdam, 1707 (1st ed. 1606), dedication, fol. A2 recto and following:

IMPÆ CAESÆ RVDOLPHO II PARENTI PVBLICO PIO FELICI PERPETVO AVGVSTOÆ DÆNÆMÆQÆ EIVS IANVS GRVTEVS;

Abunde constat rerum quaque rarissima ita & ubique, & semper, Principum virorum, tanquam peculiaria, ut etiam apud privatos nata aut inventa, statim tamen tacità destinatione eisdem transcriberenter. . . . (fol. A4) Vtroque certe tam pulchre hactenus lita ut GERMANIA tota . . . ispsamet in medio posita & coronata flammis tam feralibus, non modo restet incolumis, sed Phoenicis instar, reddità quasi Iuventute reflorescat. Quo ipso, quamuis ita demearis omnium opinionem, ut toto passim orbe agas in ore, in oculis, in animis omnium: instas tamen eidem famae, tibique clauis trabalibus deuincis ideoque, etsi diuina virtute tuae ac felicitatis opera, egregiis artificum monumentis, publice priuatimque prodeant ducta caelo, pigmento, auro, delectaris quidem hac turoum pietate. Interim haud dissimulas, nihil istorum perenne; non laureas, non arcus, non triumphos, non statuas; sed quotidie, uel terraemotu, uel incendio, uel hostili impetu, uel aeuo denique prolixiore obsolescere delectabilem istium oculorum florem: ut contra ipsa gliscere vetustate auctoritatem ingeniorum, ac quicquid sibi adplicuerunt reddi magis ac magis sacrum & venerabile; adeo quidem ut omne quod hodieque in rerum natura notitiae est & nominis, id disciplinis istis liberalioribus jure acceptum feras.

I am grateful to Anthony Grafton for mentioning this passage to me.

41. The Swedish could certainly have learned in many ways about the treasures in Prague while their armies were in Germany. Yet it is also interesting to note that there is certainly evidence that the fame of artists at the Prague court had also spread directly to Scandinavia, where they had already had an impact on developments in Denmark. For this point see my review, "Christian IV. The 19th Art Exhibition of the Council of Europe, Denmark 1988," *Kunsthistorisk Tidskrift, 58, 1989,* pp. 20–21.

42. Fučíková, "Die Kunstkammer und Galerie Kaiser Rudolfs II. als eine Studiensammlung," p. 55, argues specifically that "das offizielle Hofzeremoniell hat die Besichtigung der Sammlungen nicht einbezogen." Part of the problem may be in the definition of a state visit. During the late sixteenth century such occasions included many activities that we would regard as recreations or diversions, such as jousting, feasting, and hunting.

43. This we learn from the visit of the French King Henry III to Vienna in 1574. According to a dispatch of 28 June 1574 of Vincenzo Tron to Doge Alvisio Mocenigo describing the visit of King Henry III of France (published in Hans von Voltellini, "Urkunden und Regesten aus dem K. und K. Haus- Hof- und Staats-Archiv in Wien, *Jahrbuch der kunsthistorischen Sammlungen des Allerhöchsten Kaiserhauses* 15, 1894, pt. 2, reg. no. 11916, quoting Dispacci di Germania, Senato III [Secreta], 4), Maximilian II entertained his visitor with hunts, visits to the gardens, and two days of showing him *molte cose belle et singulari, cioe pitture, orologhi,*

instumenti d'ogni sorte et cose cussi fatte (many beautiful and rare things, such as paintings, clocks, instruments of every kind, and other finely made things).

44. When I searched for them, I discovered that Archduke Maximilian III Habsburg, Cardinal d'Este, Duke Christian II of Saxony, and Maximilian I of Bavaria were all taken to the collections in the palace, as well as to the gardens and other places of interest. For references to these visits, see my *"Kunstkammer* as a Form of *Representatio,"* pp. 22, 27 n. 4; visits by commoners are cited on p. 24 n. 2. For a more recent publication on the visit of Jacques Esprinchard, see also the account published in Eliška Fučíková, *Tři francouzští kavalíři v rudolfinské Praze, Jacques Esprinchard, Pierre Bergeron, François de Bassompierre*, Prague, 1989, pp. 26ff.

45. See *"Kunstkammer* as a Form of *Representatio,"* pp. 22, 27, nn. 2, 3, for information in this regard. Such signs of favor indeed seem to have been a fairly regular occasion, whether or not scholars have yet uncovered more than a few concrete examples of such events. More work needs to be done in this regard in the study of other collections: the guest books associated with collections and other *alba amicorum* would be a place to start. Of course, as Fučíková, "Die Kunstkammer . . . als eine Studiensammlung," p. 55, notes, specific interests in encouraging gifts to collections do not exclude other motivations in this instance; for more on this point, see Warnke, *Hofkünstler*, pp. 122–33 and passim.

While other visits of ambassadors to courts formed part of the diplomacy of the day, ambassadors are not the same as princes. One should not therefore expect that court protocol would determine that they received the same treatment as princes. A state visit seems to have been one of a prince. For this reason, reference to visits by ambassadors who did not see the imperial collections, e.g., those of Pierre Bergeron, for which see most recently Fučíková, *Tři francouzští kavalíři*, pp. 38ff., do not seem relevant to the argument pursued here.

46. Quoted in Vincenzo Promis, ed., "Ambasciata di Carlo Francesco Manfredi di Luserna a Praga nel 1604," *Miscellanea di storia italiana edita per cura della regia deputazione di Storia patria* 16, ser. 2, 3, 1877, p. 583. Although cited in my *"Kunstkammer* as a Form of *Representatio,"* p. 27 n. 3, and p. 22, since this source has not subsequently been consulted, and the regularity of visits has been challenged (e.g., by Penny, "Curiosities of Art and Nature," p. 313), these remarks deserve quotation here.

47. Promis, "Ambasciata," p. 584; see p. 594 for the other visit to the collections.

48. The first quotation comes from an as yet unpublished lecture by Fučíková. "The Arrangement of Rudolf II's Collection," Princeton, October 1990; the reference to the comments of the cardinal as banal comes from Schnapper, p. 187 n. 5. The reason for repeated references to this text is that it was used in a key passage negatively by Von Schlosser: for this point, see my *"Kunstkammer* as a Form of *Representatio,"* p. 23; Bauer, "Das Kunstkammerinventar," p. xiv, had already pointed to the importance of Schlosser's use of this text, corrected it, and regarded Alessandro d'Este's judgment as "sicherlich sehr kompetenten."

49. Philipp Hainhofer, merchant, collector, and traveler, and an exceedingly well-informed observer, remarked (Oskar Doering, ed., *Des Augsburger Patriciers*

Philipp Hainhofer Reisen nach Innsbruck und Dresden [*Quellenschriften für Kunstge-schichte und Kunsttechnik des Mittelalters und der Neuzeit*, n.s. 10], Vienna, 1901, p. 216) of the lower story of the Dresden *Lusthaus* that "Diser saal sihet hüpsch perspectivisch aus, vnd ainer antiquario gleich."

Although apparently overlooked in the literature on German collecting, this observation should probably be taken into account when considering the design of the Prague *Neu Saal* and of the antechamber to the collections, which had perspective paintings by the Vredemann de Vries. There may even have been some programmatic decoration that was deemed appropriate to spaces connected with collections.

The treatment presented here contradicts the interpretation of the latest comprehensive study of the Dresden collections, Gerald Heres, *Dresdener Kunstsammlungen im 18. Jahrhundert*, Leipzig, 1991, especially p. 30, which surprisingly does not take the *Lusthaus* into account.

50. See the essays by Elisabeth Scheicher, "The Collection of Archduke Ferdinand II at Schloss Ambras: Its Purpose, Composition and Evolution"; Joachim Menzhausen, "Elector Augustus's Kunstkammer: An Analysis of the Inventory of 1587"; and Lorenz Selig, "The Munich *Kunstkammer*, 1565–1807," all in *The Origins of Museums*, pp. 29–38, 69–75, 76–89; see also Elisabeth Scheicher, "Zur Entstehung des Museums im 16. Jahrhundert. Ordnungsprinzipien und Erschliessung der Ambraser Sammlung Erzherzog Ferdinands II," in *Der Zugang zum Kunstwerk*, pp. 43–52 and Fučíková, review of *The School of Prague, Burlington Magazine* 1042, January 1990, p. 40.

Schnapper's expression of doubts, "The French King as Collector," to the effect that "many seventeenth-century inventories and descriptions impose an order on a collection, the actual presentation of which was completely different because of the practical necessities of placing objects primarily according to size—in contrast to the more or less logical order of the written accounts," does not seem to take cognizance of these essays.

For Prague, see *The School of Prague*, as well as the limiting remarks in a review of the same by Fučíková, *Burlington Magazine* p. 40.

51. Fučíková, "Die Kunstkammer und Galerie Kaiser Rudolfs II. als eine Studiensammlung," and *eadem*, "The Collection of Rudolf II at Prague: Cabinet of Curiosities or Scientific Museum?" In her review in *Burlington Magazine*, p. 40, Fučíková, referring to this last essay, remarks, "Nothing in the display of the collections was intended to impress the visitor with the unlimited power and wealth of the Emperor and his family."

52. Penny, "Curiosities of Art and Nature," p. 313. See similarly Haskell, "Introduction," p. 9.

53. See, for example, Penny, ibid., p. 314, and especially Fučíková, "Die Kunstkammer und Galerie Kaiser Rudolfs II. als eine Studiensammlung," p. 55, and Review, *Burlington Magazine*, p. 40.

54. This point is exemplified by Rudolf's failure, for example, to acquire the Isenheim altarpiece: see Andrée Hayum, *The Isenheim Altarpiece. God's Medicine and the Painter's Vision*, Princeton, 1989, p. 11.

55. See William B. Ashworth, Jr., "Remarkable Humans and Singular Beasts," in Joy Kenseth, ed., *The Age of the Marvelous*, Hanover, N.H., 1991, pp. 113–14 ff.

56. This point was disseminated by Luigi Salerno, "Arte, scienza e collezioni nel Manierismo," *Scritti in onore di Mario Salmi*, 3, Rome, 1963, pp. 193–214, and has become a commonplace of the literature on collecting.

In "The Factual Sensibility," a review of *The Origins of Museums*, in *Isis* 79, 1988, pp. 452–67, Lorraine P. Daston has challenged what she calls the "reigning interpretation of this deliberate hodgepodgery, expressed most often in connection with Rudolf II's collection at Prague as intended to represent the universe in microcosm." Daston states that "this view has some textual backing in the Flemish physician Samuel Quiccheberg's sketch of a 'theatrum sapientiae,' but is belied by the contents of the collections themselves. Far from recreating the entire universe by token or in miniature, Rudolf II's vast collection was almost wholly devoid of exotica and naturalia."

These objections are, however, not based on the primary sources, including a reading of the inventory of Rudolf II's collection, which clearly contains many items of the sorts Daston denies were present. Instead, Daston's argument is directly founded on a misreading of an essay in *The Origins of Museums*, p. 44, that does not pertain to Rudolf II's Prague in any instance. The passage Daston cites from Rudolf Distelberger, "The Habsburg Collections in Vienna during the Seventeenth Century," explicitly does not discuss the collections of Rudolf II in Prague, but rather the Habsburg treasury of the later seventeenth century: this represents a much different type of collection and pertains to a different era as well.

57. Samuel Quiccheberg, *Inscriptiones vel tituli theatri amplissimi . . .* , Munich, 1565. For the relation of Quiccheberg's ideas to German collections, see first Rudolf Berliner, "Zur älteren Geschichte der allgemeinen Museumslehre in Deutschland, *Münchener Jahrbuch der bildenden Kunst* 5, 1928, pp. 324–52; E. M. Hajos, "The Concept of an Engravings Collection in the Year 1565: Quicchelberg, 'Inscriptiones vel tituli theatri amplissimi,' " *Art Bulletin* 40, 1963, pp. 151–56; idem, "References to Giulio Camillo in Samuel Quicchelberg's 'Inscriptiones vel tituli theatri amplissimi,' " *Bibliothèque d'Humanisme et Renaissance* 25, 1963, pp. 207–11, was first to point out this connection.

For the relation of Camillo and Quiccheberg to Italian as well as German collecting, see especially Olmi, "Alle origini della politica culturale dello stato moderno," p. 478; idem, " 'Dal Teatro del mondo' ai mondi inventariati," pp. 243–44; idem, *Ulisse Aldrovandi. Scienza e natura nel secondo Cinquecento*, Trento, 1976, pp. 78ff.; Lina Bolzoni, " 'L'invenzione' dello Stanzino di Francesco I," in *Le arti del principato mediceo*, Florence, 1980, pp. 255–99.

58. Besides the sources cited above, see Laura Laurencich-Minelli, "Museography and Ethnographical Collections in Bologna during the Sixteenth and Seventeenth Centuries," in *The Origins of Museums*, pp. 19–28; Giuseppe Olmi, *Scienza e natura nel secondo Cinquecento* [*Quaderni di Storia e Filosofia della Scienza* 4], Trento, 1976, pp. 78ff, and also my *"Kunstkammer as a Form of Representatio"*; Scheicher, *Die Kunst- und Wunderkammer der Habsburger*, pp. 68–69. This is but a sampling of a widely expressed view.

59. *"Kunstkammer as a Form of Representatio."*

60. For the pertinence of these beliefs, particularly to the notion of the "theater of the world," see Yates *The Art of Memory*; eadem, *Theatre of the World*, Chicago, 1969; Paolo Rossi, *Clavis Universalis*, Milan, 1960.

61. Scheicher, *Die Kunst- und Wunderkammer der Habsburger*, pp. 37–38, in treat-

ing the fifteenth-century princely collection as a *Zeugnis universalen Herrschaft-sanspruchs*, points to the ancient and medieval precursors to such cosmic decoration associated with the Burgundian collections.

62. See Bolzoni, "Invenzione," and also Scott Schaeffer, "The Studiolo of Francesco I de' Medici in the Palazzo Vecchio in Florence," unpublished Ph.D. dissertation, Bryn Mawr, 1976.

63. For the *Antiquarium*, see Von Busch, "Studien." Lorenz Selig, "Munich *Kunstkammer*," pp. 83–84, points out that an interest in the products or lands of Bavaria was also evident in the Munich *Kunstkammer*.

64. This description is based on Hainhofer's account in Doering, ed. cit., *Hainhofers Reisen*, pp. 215ff. See also Walter Bachmann, "Nossenis Lusthaus auf der Jungfernbastei in Dresden," *Neues Archiv für sächsische Geschichte* 57, 1936, pp. 1–29.

65. See my *"Kunstkammer* as a Form of *Representatio,"* and *The School of Prague*, pp. 291, 262, cat. no. 20. 41.

In the light of Spranger's Hermathenic fresco in the Prague castle (*The School of Prague*, cat. no. 20.41), it is important to note that there is no great distinction to be drawn in Prague between overtly political messages and other sorts of imperial allegories glorifying the ruler's "wisdom and intellect," in contrast with the argument of Fučíková, Review, in *Burlington Magazine*, p. 40. The manner in which Rudolfine allegory assumes the traditional expression of allegories of virtue into imperial panegyric is discussed in my "Empire Triumphant: Notes on an Imperial Allegory by Adriaen de Vries," *Studies in the History of Art* 8, 1978, pp. 63–78; see also *The School of Prague*, p. 58. Lubomír Konečný, "Hans von Aachen and Lucian: An Essay in Rudolfine Iconography," *Leids Kunsthistorisch Jaarboek* 1, 1982, p. 244, makes some confirming comments in this regard.

66. I believe that it is for such general kinds of symbolic associations, not merely for some more specific political message, that one must search to find some coherent message in the *Kunstkammer*: cf. my *Variations on the Imperial Theme*.

67. Paintings like Arcimboldo's have been associated with the *Kunstkammer* since Schlosser (*Kunst- und Wunderkammer*, p. 216, ill. pp. 177, 178), and images like them were also criticized in a similar connection by Galileo (see Panofsky, "Galileo as a Critic of the Arts," pp. 9–10, 14). See also Sven Alfons, in "The Museum as an Image of the World," in *The Arcimboldo Effect*, pp. 66–87.

For the interpretation of Arcimboldo's paintings mentioned here, see chap. 4.

68. Penny, "Curiosities of Art and Nature," p. 314.

69. Selig, "The Munich *Kunstkammer*," p. 87, also notes how when in Munich in 1606 objects were removed from the *Kunstkammer* and placed in a more secluded location, they were thus "treated as 'arcana' [*sic*], about whose 'secret contents' only the ruler was informed and over which only he could dispose. Contemporary connoisseurs, including the persevering Hainhofer, had no admission to the *Kammergalerie*."

70. The idea that art could serve a propagandistic aim and at the same time be directed to an elite has, of course, older roots. For a recent interpretation of the court of Maximilian I in this regard, see Jan-Dirk Müller, *Gedechnus: Literatur und Hofgesellschaft um Maximilian I*, Munich, 1982.

71. For the relation of the *arcana naturae* to the *arcana imperii*, see Carlo Ginzburg, "The High and the Low: The Theme of Forbidden Knowledge in the Sixteenth and Seventeenth Centuries," in *Clues, Myths, and the Scientific Method*, trans. John and Anne C. Tedeschi, Baltimore and London, 1989, especially p. 63. For the "mysterious meaning" of Arcimboldo's works, see most recently my "Arcimboldo's Serious Jokes."

This passage responds to Fučíková, Review, in *Burlington Magazine*, p. 40, who states that "like the Emperor's collections the allegories glorifying Rudolf's reign also lacked pomp. . . . Only the allegories of the Turkish wars appear to have a political content, and their format indicates they were not intended for public display but for the seclusion of the Emperor's own collections."

72. Giuseppe Olmi, "Alle origini," p. 476, remarks: "Gli studioli non sono spesso luoghi pubblici, ma ambienti che possono essere pienamente intesi—e nei quali, quindi, si puo penetrare—solo con una adeguata preparazione, solo dopo aver superato, cioè [*sic*], tutte le ardue di una iniziazione quasi venata di misticismo."

73. In supporting the argument advanced here, Spicer, Review, pp. 190f., argues that the "greatest emblematic importance of the collections was to Rudolf himself, underpinning, even defining his sense of self. With a crumbling empire, these encyclopedic collections, this microcosm, may have been of real importance to Rudolf's measure of his control over larger forces." I have made a similar argument in "Empire Triumphant."

74. See Erich Trunz's classic essay of 1931, "Der deutsche Späthumanisumus um 1600 als Standeskultur," in Richard Alewyn, ed., *Deutsche Barockforschung. Dokumentation einer Epoche*, Cologne and Berlin, 1965, pp. 147–81, and also Wilhelm Kühlmann, *Gelehrtenrepublik und Fürstenstaat. Entwicklung und Kritik des deutschen Späthumanismus in der Literatur des Barockzeitalters*, Tübingen, 1982 [*Studien und Texte zur Sozialgeschichte der Literatur*, 3].

75. As Schnapper, "The French King as Collector," p. 187, asks. Schnapper's focus on France again overlooks the fact that the French model does not apply to Central Europe, where there were many princes and many princely collections.

76. *Gesta Grayorum*, London, 1688 (reprint, Oxford, 1914), pp. 34–35.

77. Impey and MacGregor, "Introduction" to *The Origins of Museums*, p. 1.

78. Ibid., p. 1, for the association with a gentleman.

Paolo Rossi, *Francis Bacon. From Magic to Science*, trans. Sacha Rabinovitch, London, 1968 (original edition 1957), pp. 23–24, already recognized the correct context, however. While Impey and MacGregor, "Introduction," p. 1 n. 1, and also Fučíková, "Die Kunstkammer und Galerie Kaiser Rudolfs II. als eine Studiensammlung," p. 58 n. 1, credit G. l'E. Turner with bringing this passage to their attention, Rossi seems to have been the first to bring it into the literature on Bacon and collecting.

79. Fučíková, "Die Kunstkammer und Galerie Kaiser Rudolfs II. als eine Studiensammlung," pp. 53–58. The observations of Fučíková and of Impey and MacGregor serve as an important corrective to Rossi, who believed, pp. 237–38 n 90, that the use of collections as means of scientific research and observation proposed by Bacon was realized "only in France under Louis XVI [*sic* (for Louis XIV?)]."

80. There is a large literature on this subject: for an introduction, with further references, see Roy Strong, *Splendor at Court. Renaissance Spectacle and the Theater of Power*, Boston, 1973; idem, *The Cult of Elizabeth*, London, 1977; D. J. Gordon, *The Renaissance Imagination*, ed. Stephen Orgel, Berkeley, Los Angeles, and London, 1975; Graham Parry, *The Golden Age Restor'd. The Culture of the Stuart Court, 1603–42*, New York, 1985, pp. 40–63.

81. *Gesta Grayorum*, pp. 35–36.

82. Fučíková, "Studiensammlung," and "The Collection of Rudolf II at Prague," argues for the importance of the research and study aspects of the collection over its political significance. See also Beket Bukovinská, "Die Kunst- und Schatzkammer Rudolfs II. Der Weg vom Rohmaterial zum Sammlungsobjekt als ein Erkenntnisprozess," in *Der Zugang zum Kunstwerk*, pp. 59–63, who similarly argues that the "Sammlungsstücke waren viel mehr als bloss Repräsentationsobjekte—ein Mittel, ein Dokument, ein Ergebnis der Erkenntnis, des Eindringens in das Wunder und die Grösse der Natur." This argument does not seem to contradict other possible observations about the collections.

83. Fučíková, "Studiensammlung," p. 54, makes the contrary argument.

84. Rossi, *Francis Bacon*; Yates, *Giordano Bruno and the Hermetic Tradition* (2nd ed.), p. 450; eadem, *The Art of Memory*, pp. 357–61; *The Rosicrucian Enlightenment*, pp. 118–29, and especially "The Hermetic Tradition in Renaissance Science," in *Art, Science and History in the Renaissance*, Baltimore and London, 1968, pp. 255–74. In this last essay Yates provides the most accessible definition of this "tradition." Regardless of debates over the interpretation of the importance of hermetism (or even its definition) in early modern science (for which see the recent overview by Brian P. Copenhaver, "Natural Magic, Hermetism, and Occultism in Early Modern Science," in David C. Lindberg and Robert S. Westman, eds., *Reappraisals of the Scientific Revolution*, Cambridge, etc., 1990, pp. 261–301), Bacon's reference is clear.

85. For this point in general see Rossi, "Mechanical Arts and Philosophy in the Sixteenth Century," in *Philosophy, Technology and the Arts in the Early Modern Era*, p. 2f., and Rossi, *From Magic to Science*, especially pp. 237–38 n. 90, for the importance of collections in this project.

86. The negative connotations of *curiosus* and *curiositas* in the "Golden Ass" (*Metamorphoses*) of Apuleius are abundantly clear: see, for example, bk. I.2.19, and the more extended discussion in bk. XI.23. The connection with magic arts is directly established in this text, as in bk. II.6.1. A similar connotation is present in many other Latin authors, as in Catullus 7.11, Cicero *De Finibus* II.9.28.14, and elsewhere.

87. For this point see William B. Ashworth, Jr., "The Sense of the Past in English Scientific Thought of the Seventeenth Century: The Impact of the Historical Revolution," unpublished Ph.D. dissertation, Madison, Wis., 1975, p. 26 n. 43. It is easy to see how Bacon, whose thought had many points in common with various occult traditions, would have been worried about associations with "occult" curiosity on this score as well.

88. For the vice of curiosity in medieval thought, see E. Peters, "*Libertas Inquirendi* and the *Vitium Curiositatis* in Medieval Thought," in *La notion de liberté au Moyen Age: Islam, Bysance, Occident/The Concept of Freedom in the Middle Ages:*

Islam Byzantium and the West, eds. George Makdisi, Dominique Sourdel, and Janine Sourdel-Thomine, Paris, 1985, pp. 89–98, with further references.

89. For this point see Jean-Claude Margolin, *L'idée de nature dans la pensée d'Érasme*, Basel and Stuttgart, 1966, especially pp. 15, 53 nn. 59–60.

90. As in Melanchthon's *De Orione*, quoted in Westman, "The Melanchthon Circle," p. 170.

91. See n. 2 above for Galileo's comments. Hans Blumenberg, *Der Prozess der theoretischen Neugierde*, Frankfurt a. M., 1973, provides a useful overview of the subject, but conceives of the subject of curiosity in a more general way, to which his treatment of Bacon corresponds.

92. This and the preceding three paragraphs summarize an argument that I made in a lecture delivered at the annual meeting of the Renaissance Society of America, Stanford University, March 1992.

93. For this point see Rossi, "Mechanical Arts and Philosophy in the Sixteenth Century," p. 2f.

The latest information on Palissy is presented in *Bernard Palissy. Mythe et réalité*, Agen, Niort, Saintes, 1990, with a bibiography of almost 700 titles. In "Une vie engageé," ibid., p. 22, Dominique Poulain and Marianne Thauré continue to speak of Palissy's *cabinet de curiosité*, however.

94. For this argument see Rossi, *Philosophy, Technology and the Arts*, and *Francis Bacon*.

95. Fučíková, "Kunstkammer als eine Studiensammlung."

96. For an overview of this subject, see Bruce T. Moran, "Patronage and Institutions: Courts, Universities, and Academies in Germany. An Overview 1550–1750," in Moran, ed., *Patronage and Institutions. Science, Technology, and Medicine at the European Court 1500–1750*, Rochester, N.Y., and Woodbridge, Suffolk, 1991, pp. 169–84.

97. See Moran, "Wilhelm IV of Hesse-Kassel;" "Princes, Machines and the Valuation of Precision in the 16th Century," *Sudhoffs Archiv* 61, 1977, pp. 209–28; "German Prince-Practitioners: Aspects of the Development of Courtly Science, Technology, and Procedures in the Renaissance," *Technology and Culture* 22, 1981, pp. 253–74; "Christoph Rothmann, the Copernican Theory, and Institutional and Technical Influences on the Criticism of Aristotelian Cosmology," *Sixteenth Century Journal* 13, 1982, pp. 85–108; and in general "Science at the Court of Hesse-Kassel."

Moran has extended his discussion to Paracelsianism under Moritz of Hesse in a series of essays, "Privilege, Communication, and Chemistry: The Hermetic-Alchemical Circle of Moritz of Hessen-Kassel," *Ambix* 32, 1985, pp. 110–26; "Der alchemistisch-paracelsische Kreis um den Landgrafen Moritz von Hessen-Kassel (1572–1632), *Salzburger Beiträge zur Paracelsusforschung* 25, 1987, pp. 119–45 (this last source is cited by Jole Shackelford, "Paracelsianism and Patronage in Early Modern Denmark," in Moran, ed., *Patronage and Institutions*, p. 85 n. 3).

98. See Hans Rott, "Ott Heinrich und die Kunst," *Mitteilungen zur Geschichte des Heidelberger Schlosses* 5, 1905, pp. 117f., 224. For fuller discussion of the subject of patronage of instrument-making, see also Moran, "Wilhelm IV of Hesse-Kassel," especially pp. 74–78, "Princes and Machines"; "Princes, Machines and the Valuation of Precision"; and "German Prince-Practioners."

99. See Richard Patterson, "On the Hortus Palatinus at Heidelberg and the Reformation of the World," pt. 1, "The Iconography of the Garden"; pt. 2, "Culture as Science," *Journal of Garden History* 1, 1981, pp. 67–104, 179–202.

100. Quoted in Moran, "German Prince-Practitioners," p. 254.

101. As quoted in a number of places by Moran, e.g., "Princes, Machines and the Valuation of Precision," p. 209.

102. August's lathe survives in the Musée Carnavalet, Paris. For the effect of August's interests on his collections, see especially the interpretation advanced by Joachim Menzhausen, "Elector Augustus's *Kunstkammer*"; also idem, *Dresdener Kunstkammer und Grünes Gewölbe*, Vienna, 1977. See also Heres, *Dresdener Kunstsammlungen*, pp. 30–31.

The topic of courtly practice is discussed by Moran, "German Prince-Practitioners".

103. For Rudolf's patronage of the occult, see Mout, "Hermes Trismegistos Germaniae."

104. Rudolf II's patronage of natural science still deserves a thorough study. A good introduction is now provided by Zdeněk Horský, "Die Wissenschaft am Hofe Rudolfs II. in Prag," in *Prag um 1600. Kunst und Kultur am Hofe Rudolfs II.*, Freren, 1988, pp. 69–74. See also the comment in chap. 6, n. 87 above.

105. For De Boodt, see the important discoveries and treatment in Marie Christiane Maselis, Arnout Balis, and Roger H. Marijnissen, *De Albums van Anselmus de Boodt (1550–1632). Geschilderde natuurobservatie aan het Hof van Rudolf II te Praag*, Tielt, 1989.

106. These possibilities were raised by Ivan Muchka in a lecture delivered in Vienna in February 1989, forthcoming in the *Jahrbuch der Kunsthistorischen Sammlungen in Wien*, 1992.

107. For the Hessian *Kunstkammer*, see Eva Link, *Die Landesgräfliche Kunstkammer Kassel*, s. l., s.d. [Kassel, 1975], and Franz Adrian Dreier, "The *Kunstkammer* of the Hessian Landgraves in Kassel," in *The Origins of Museums*, pp. 102–9, especially p. 106 for the presence of Bürgi's objects.

108. See Menzhausen, "Elector Augustus's *Kunstkammer*" and *Dresdener Kunstkammer und Grünes Gewölbe*; also idem, "The Electoral Kunstkammer," in *The Splendor of Dresden*, [exhibition catalogue], Washington, New York, and San Francisco, 1978, pp. 75–77, where Menzhausen argues that the *Kunstkammer* was at first scientific in nature and later became representational.

109. First noted by Erwin Neumann, "Das Inventar der rudolfinischen Kunstkammer von 1607–11," in *Queen Christina of Sweden: Documents and Studies (Analecta Reginensia 1)*, Stockholm, 1966, pp. 262–65.

110. Fučíková, "Kunstkammer als eine Studiensammlung"; eadem, "The Collection of Rudolf II at Prague"; Bukovinská, "Die Kunst- und Schatzkammer Rudolfs II."

111. For this use of collections, see Olmi, "Science-Honour-Metaphor," but the point is made in regard to other collections by other authors in *The Origins of Museums*. See also Fučíková, *Tři francouzští kavalíři*, p. 22, for the suggestion that De Boodt used the collection for his gemological studies.

112. Johannes Kepler, *The Six-cornered Snowflake*, ed. and trans. Colin Hardie, with essays by L. L. Whyte and B.F.J. Mason, Oxford, 1966, p. 43; the original

text, p. 42, reads: "Vidi enim Dresdae in aede Regia cui Stabulo nomen, exornatum abacum aere argentoso, ex quo quasi efflorescebat dodecahedron avellanae parvae magnitudine, dimidia parte extans."

The place in the palace where Kepler probably saw this object was the *Stall* or *Lange Galerie*, which was the setting for tournaments and other pastimes and thereby attracted much attention: see Fritz Löffler, *Das Alte Dresden. Geschichte seiner Bauten*, Dresden, 1953, p. 23; and most recently, Steffen Delang, "Das Schloss im Zeitalter der Renaissance: Das Renaissanceschloss," in *Das Dresdener Schloss Monument sächsischer Geschichte und Kultur*, Dresden, 1989, pp. 49–52.

113. This point is also made in relation to Christian I of Saxony, the builder of the edifices around the *Stallhof*, by Delang, ibid., p. 51. I have treated relations between Rudolf II and Christian II in *Variations on the Imperial Theme*, pp. 111–13, and the earlier relation between Elector Augustus and Emperor Maximilian II in "Arcimboldo au Louvre."

114. See Bauer, "Kunstkammerinventar," p. xxi.

115. As first observed by Fučíková, *Tři francouzští kavalíři*, p. 22.

116. See, for example, the citations of creatures after the nomenclature of Clusius, "Kunstkammerinventar," reg. no. 238, 245, 257, and passim, or Georg Hoefnagel, reg. no. 230, 231. Fučíková, "The Collection of Rudolf II at Prague," p. 47, also briefly notes that the inventory "often refers to the relevant contemporary scientific literature."

117. For a general consideration of the relationship of nature painting to science in Prague, see *The School of Prague*, pp. 74–89.

118. For this view of Bacon, see Rossi, *Francis Bacon*.

119. For this subject, see most thoroughly William Eamon, "From the Secrets of Nature to Public Knowledge," in *Reappraisals of the Scientific Revolution*, pp. 333–65; see also Carlo Ginzburg, "High and Low: The Theme of Forbidden Knowledge in the Sixteenth and Seventeenth Centuries."

120. A survey of Kepler's activities in Prague is offered by Zdeněk Horský, *Kepler v Praze*, Prague, 1980. This subject is also treated frequently in other literature on Kepler, e.g., the sources cited in n. 127 below. For Kepler and astrology, see Gérard Simon, *Kepler astronome astrologue*, Paris, 1979.

121. Fučíková, "The Collection of Rudolf II at Prague," pp. 52–53, with reference to "Kunstkammerinventar," reg. no. 1292.

122. "Kunstkammerinventar," p. 70:

(reg. no. 1292) "In einem nidern weisen schectelin ein gross auf ener seitten mugelt glass, zu den durchsehenden instrumenten oder *stravederi*, dabey noch 3 kleine, welche der von Taxis Ihr Mt: von Venedig bringen lassen."

(f. 198) STRAVEDERI, INSTRUMENTI IN DIE WEITTEN ZU SEHEN EIN DING, SAMB WERE ES NAHENDT.

(reg. no. 1293) 1–12 Zwelff instrumenta allerley gattungen zum durchsehen in die weitten, je eines besser als das ander, mit leder, theils mit samet überzogen.

123. Kepler, *Dissertatio cum Nuncio Sidereo*, Prague, 1610, in M. Caspar, ed., *Gesammelte Werke*, 4, Munich, 1941, p. 293:

"Fatendum est, me ex eo tempore, quo Optica sum aggressus, creberrimè a Caesare rogatum de PORTAE suprascriptis artificiis, fidem iis ut plurimùm derogasse."

124. Ibid., p.290:

"Tres sunt menses cùm Augustissimus Imperator super Lunae maculis varia ex me quaesivit, in ea constitutus opinione; Terrarum et continentium simulachra in Luna ceu in speculo resplendescere. Allegabat hoc potissimùm, sibi videri expressam Italiae cum duabus adiacentibus insulis effigiem: Specillum etiam suum ad eadem contemplanda offerebat in dies sequentes, quod omissum tamen est. Adeò eodem tempore GALILAEE, Christi Domini patriam vocabulo preferens, Christiani orbis Monarcham (eiusdem irequieti spiritus instinctu, qui naturam detectum ibat) deliciis tuis aemulatus es."

125. Ibid., p. 289: "Addebant Augustissimi Caesaris RVDOLPHI imperia: qui meum de hac materia iudicium expetebat."

126. As demonstrated by his remarks, ibid., p. 294; see also his comments in the introduction to his *Dioptrice*.

127. For a summary of Kepler's intellectual activities, see Max Caspar, *Kepler*, London and New York, 1959; also in particular for astronomy, B. Stephenson, *Kepler's Physical Astronomy*, New York, 1987, and Hallyn, *Poetic Structure*. Galileo's work is most readily accessible in Stillman Drake, trans. and intro., *Discoveries and Opinions of Galileo*, New York, 1957.

128. Kepler, *Narratio de Observatis a Se Quatuor Iovis satellitibus Erronibus*, Frankfurt a.M., 1611, in Caspar, ed. cit., p. 318: "instrumentum fuit nec optimum nec commodissimum, sustentatio instrumenti in situ immoto, et deprehensio quesiti Iouis difficilima."

129. Kepler's letters to Galileo to this effect are reprinted in Caspar, ed., Kepler, *Gesammelte Werke*, 16, Munich, 1954, no. 584, pp. 319f., and no. 597, p. 347f.

130. See Kepler's *Narratio*, pp. 318ff.; the location is derived from the epigrams of Thomas Segethus, ibid., p. 324: "et nos Mediceia videmus astra/Pragae Marmoreum lenis fert ver Molda iugum."

131. See Caspar, "Nachbericht," in Kepler, *Gesammelte Werke*, 4, Munich, 1941, pp. 511ff.

132. See Drake, *Galileo*; Caspar, *Kepler*; and for the original texts, Caspar, ed., Kepler, *Gesammelte Werke*, 16, 4.

133. Kepler, *Werke*, ed. cit., 4, p. 344; the translation is taken from Alan Debus, *Man and Nature in the Renaissance*, Cambridge, etc., 1978, p. 96, which also has a short summary of these developments.

134. See Kepler, *Werke*, ed. cit., 4, pp. 4, 290, 291, 293, 318, 324; 16, pp. 320ff.

135. I take this point on the authority of Albert van Helden, who at the time of writing is preparing a book on the history of the telescope, and to whom I am grateful for discussing with me the issue of dissemination of instruments.

136. Besides the references above to Kepler's astronomical work, the best historical account of his service to Wallenstein is that offered by Golo Mann, *Wallenstein: Ein Leben*, Frankfurt a. M., 1974. For Kepler as Wallenstein's astrologer, see also Martha List, "Das Wallenstein-Horoskop von Johannes Kepler. Zur Geschichte seiner Entstehung," in *Johannes Kepler. Werk und Leistung*, Linz, 1971, pp. 127–38.

137. The story of Wallenstein's architectural patronage in Prague is the subject of a forthcoming book by Ivan Muchka; the present author has also continued research on this topic.

138. According to Owen Hannaway, "Laboratory Design and the Aim of Science. Andreas Libavius versus Tycho Brahe," *Isis* 77, 1986, pp. 585–610, Tycho Brahe, Rudolf's court astronomer, whom we have earlier encountered in these pages, epitomizes the private, aristocratic pursuit of science. Thoren, *The Lord of Uraniborg*, presents a somewhat different interpretation of Brahe's aims and the public nature of his enterprise.

We may note the way Brahe sent around copies of his *Astronomiae instauratae mechanica*, his account of his inventions of astronomical devices, with separate dedications to the various courts of Europe: see Hannaway, ibid., p. 589 and n. 13. He also circulated copies of his star catalogue in manuscript form to those who could understand them. Rather than emphasizing Brahe as an exemplar of aristocratic science per se, the point may be better resolved by reference to the replacement of one court or aristocratic model by another, or by reference to the relatively more public versus relatively more private nature of the enterprise.

139. See Th. H. Lunsingh Scheurleer, "Un amphithéâtre d'anatomie moralisée," in Th. H. Lunsingh Scheuerleer and G.H.M. Posthumus Meyjes, *Leiden University in the Seventeenth Century. An Exchange of Learning*, Leiden, 1975, pp. 217–77; and the essays by Distelberger, "Habsburg Collections," pp. 39–46; Christian Theuerkauff, "The Brandenburg *Kunstkammer* in Berlin," pp. 110–14; H. D. Schepelern, "Natural Philosophers and Princely Collectors: Worm, Paludanus, and the Gottorp and Copenhagen Collections," pp. 121–27; Michael Hunter, "The Cabinet Institutionalized: The Royal Society's Repository and Its Background," pp. 159–68, and William Schupbach, "Some Cabinets of Curiosities in European Academic Institutions," pp. 169–78, and G. Olmi, "Alle origini della politica cultural," all in *The Origins of Museums*. See also Bruce T. Moran, "Patronage and Institutions"; David S. Lux,"The Reorganization of Science 1450–1700, pp. 185–94; Alice Stroup, "The Poltical Theory and Practice of Technology," pp. 211–34, in *Patronage and Institutions*.

It is the point of the present chapter, as of Olmi's "Alle origini" and "Dal 'teatro del mondo,' " that emphasis should be placed on the development of collections during the seventeenth century.

140. For this point see Hans Blumenberg, *Die Lesbarkeit der Welt*, Frankfurt a. M., 1983 (2nd ed.), pp. 68–85.

141. For this view of Tesauro, see Eugenio Donato, "Tesauro's Poetics: Though the Looking Glass," *Modern Language Notes* 78, 1963, pp. 15–20.

142. Olmi, "Science-Honour-Metaphor," pp. 12–13, points to contemporaneous and later seventeenth-century collections in Italy, without recognizing the fundamental point about Tesauro's poetic outlook. At least for the later period, there is no necessary conflict in any instance between the arguments advanced here and those of Olmi to the effect that "other aspects of seventeenth-century museums also make it difficult to justify the view of them as centres of scientific research."

Penny, "Curiosities of Art and Nature," states that "surely in Rudolf's court art we encounter neither miracles nor the detection of hidden 'correspondences' but mere extravagance of simile, the witty conceits of the poetry of the period." This seems to express both a mistaken view of poetry c. 1600, as distinct from later developments, as well as of Rudolfine art and collecting: for a corrective of

the interpretation of poetry, see, for example, Rosamond Tuve, *Elizabethan and Metaphysical Imagery: Renaissance Poetic and Twentieth-century Critics*, Chicago, 1947.

APPENDIX 2

1. Title in Österreichische Nationalbibliothek, Cod. 10206 (hereafter ÖNB, cod. 10206), fol. 50r: BAP. FONTEII PRIMIONIS/ DE QVATUOR ELEMENTIS, ET QVATVOR/ ANNI TEMPORIBVS HVMANAM/ FORMAM INDVENTIBVS./ ANTE TRIENNIVM AB AVTORE PROPTER/ARCIMBOLDI PICTVRAM, SVAE CAES*AREO MA*IES*TA*TI PÖEMA DICATVM./ NVNC CORRECTVM, ET AD POMPAE EURO/PAEAE PATROCINATORES, EQVITESQ*V*E/ CVM IP SORVM ORDINE TRADVCTVM./ DIVINATUR QVID SIT IN CAUSA IPSORVM META-MORPHOSEOS, ET ASSERITVR/ ESSE CLEMENTIAM AVSTRIAE DOMUS./ AD INVICTISSIMVM IMPERATOREM MAXIMILI*ANUM*/*SECVNDUM* AVSTRIVM D*OMINUM* DOMIN*VM* CLEMEN TISSIMVM.

2. Marginal note in ÖNB, cod. 10206, fol. 50v: Appellans Maximilli*ani* Se-*cund*i Imperatoris.

3. Lines added in ÖNB, cod. 10206, fol. 50v: Et quoniam Regi decet Anni signa clientes/ Debita nascentis xenis ferre suos,/ His mutatis ueneror te partibus Anni/Atq*ue* Elementorum promptus imaginibus; with marginal note, datu*m* est initio anni 1569.

4. ÖNB, cod. 10206 50v: Haec fero mirificas cupiens animare figuras.

5. Marginal note in ÖNB, cod. 10206, fol. 51r: deducitur *et* [*et hoc* ?] ad faus-tum omen.

6. Marginal note in ÖNB, cod. 10206, fol. 51r: nempe adducta pietate, et cleme*n*tia Maximiliani *Secund*i Austrij Imp*erato*ris.

7. ÖNB, cod. 10206, fol. 51r.: Josippi.

8. Marginal note in ÖNB, cod. 10206, fol. 51r: appellantur Grilli huius*modi* pictur*ae* Arcimboldian*ae*.

9. Marginal note in ÖNB, cod. 10206, fol. 51v: Propter picturam, in qua caput eleme*ntorum* humana effigie et caput hominis eleme*n*tis qualitates indicans creata [facta ?] aptum est [?].

The following lines are added in cod. 10206, fol. 51v–52r:

> Quare hominum si quid praeclaris artibus usque
> Tangeris et Rerum picta decora iuuant
> Accipe, Pictorum quae praestantissimus ipsa
> [Marginal note: est n*on* notu*m* aut scitu*m* huiusmodi inue*ntum*.]
> Austrigenum famae Tempora, Resque dedit
> Nunc data Fatidicae, mutae cito danda pöesi;
> Prisca Aetas signis anteferenda tuis
> [Marginal note: non legimus apud antiquos concinnos fuisse
> hui*usm*odi picturas.]
> Namq*ue* licet clares auxit Poygnothus Achaeos.
> [Marginal note: Polygnothus insignis inuentione coloru*m*.]
> Picturae studio uersicolore suae,
> Quam modo Daedalei signarat linea Pyrrhi.
> [Marginal note: Pyrrhus pictor insignis inuentione linearu*m*.]

Quam Lydi solers finxerat umbra Gygis.
[Marginal note: Gyges insignis inuentione umbrarum.]
Attamen Humanis oculis quod redditur arte,
 Josippi mirum perficit ingenium.
[Marginal note: Josippus Arcimboldus insignis inuentione gryllorum
siue chymerarum.]
Quod non uulgatisque modis aut cernitur usu
 Trito spectantum pascere corda virum,
Non digiti fingent digitos crinesue capilli
(fol. 52r)Aut oculorum oculi, lumina lumen erunt.
Non elementa dabunt elementum, aut Tempora Tempus.
 Quaelibet e quouis quidlibet efficient.
[Marginal note: Non fit in natura, sed in arte alludit ad opinionem
philosphorum, quodlibet non fieri e quolibet]
Vt neque sic Artem Naturae cedere quam Tu
 Vafra Naturam dixeris arte vehi.

10. Marginal note in ÖNB, cod. 10206, fol. 52r: Vatum, propter oracula pro-
mitenda [?] Imperium Austriacis; exempla, propter rationem.

11. Marginal note in ÖNB, cod. 10206, fol. 52r: propter disticha loquentium
elementum et Temporum subiuncta.

12. ÖNB, cod. 10206, fol. 58v: posse uidebantur.

13. Marginal note in ÖNB, cod. 10206, fol. 58v: Hyems trunco salicis per
vetusto adumbriam rustici apparentiam effingit.

14. Marginal note in ÖNB, cod. 10206, fol. 58v: Aqua uariorum Piscium collo-
catione Hominem se repraesentat.

15. Marginal note in ÖNB, cod. 10206, fol. 58v: Veris caput ex floribus, et
eorundem florum herbis conflatur.

16. Marginal note in ÖNB, cod. 10206, fol. 59r: Aer omni genere volucrum
confictarum vultum hominis exprimit.

17. Aestas a cistis, spicisque et fructibus hominis personam imitatur.

18. Ignis, ex fomilibus, sulphureis, candelis, scilecibus, ac humanam faciem
colligit.

19. Autumnus ex pomis uarijs humanum uultum refert.

20. Terra, cur recte ex animantibus constet.

21. fol. 52v: IN HVMANAM QVATVOR ELEMENTORVM,/ ET QVATVOR ANNI TEM
PORVM EFFIGIEM/ DIVINATIO AD SACRAM CAESAREM MAIESTATEM.

22. Marginal note in ÖNB, cod. 10206, fol. 52v: Diuinatio, cur elementa, et
Temporarum humanos uultus induerunt.

23. In ÖNB, cod. 10206, fol. 52v: fors.

24. Marginal note in ÖNB, cod. 10206, fol. 52v: Metamorphoses Jouis non
habuerunt causam piam, neque honestam.

25. Marginal in ÖNB, cod. 10206, fol. 53r: Clementia Austriaci sanguinis,
quidem [?] perpetua unica [?], omnes virtutes, exteris omnibus antecelluit, et
antecellit.

26. ÖNB, cod. 10206, fol. 53r: tuis.

27. Marginal note in ÖNB, cod. 10206, fol. 53r: Domino, quia Imperium
habet orbis, qui constat ex elementis, et regitur anni Temporibus.

28. ÖNB, cod. 10206, fol. 53r: Sciuisse Humano.

29. Marginal note in ÖNB, cod. 10206, fol. 53r: Caput humanum à fabrica-toribus Capitolij portendit romanos potituros hominum imperio.

30. Marginal note in ÖNB, cod. 10206, fol. 53r: Capita elementorum, et Tem-porum humana effigie oblata [?] Maximiliano Imperatori portendit cunctis seculis mundi fore ut humanibus pareat Austriacis, et ab ijs temperetur.

31. Phrase in parenthesis absent in ÖNB, cod. 10206.

32. ÖNB, cod. 10206: Austrigenae sunt.

33. This and the the the next 28 lines are missing in ÖNB, cod. 10206.

34. Marginal note in ÖNB, cod. 10206, fol. 53v: Sicuti summa concordia os-tenditur in his rerum, atque Temporum capitibus, sic concorditer regna orbis caput submittent Austrigenis.

35. ÖNB, cod. 10206, fol. 53v: Possint, en ultro tibi se concordia flectunt. The order of the lines also differs slightly in this version.

36. Marginal notes to this and the next lines in ÖNB, cod. 10206, fol. 53v: Juno Auris;/ Ops Terrae, domini/ Vulcanus Ignis/ Consus Aquae/ quia se amant, elementorum amicitiam creant.

37. ÖNB, cod. 10206, fol. 54r: En diversa uno coeunt in vertice Rerum.
Again the order of the lines in the two versions differs slightly here.

38. Marginal note in ÖNB, cod. 10206, fol. 54r: Ex piscibus ominigenis con-texitur caput Aquae. Ex auibus omingenis contexitur caput Aeris. Ex animanti-bus terrestribus contexitur caput Terrae.

39. Marginal note in ÖNB, cod. 10206, fol. 54r: Pacis studium uiget in Max-imilliano secundo Imperio.

40. ÖNB, cod. 10206, fol. 54r: Artisque

41. ÖNB, cod. 10206, fol. 54r: Veris Tyndaridae Phryxaeus, et Europaeus. Marginal notes for this and the next three lines: Gemini, aries, Taurus,/Leo, virgo, cancer,/ scorpivs, libra, sagitta,/ capricornus aquarius, Pisces/ signa quatuor temporum.
The previous line is missing here. There are also slight differences in the word order.

42. Absent in ÖNB, cod. 10206, fol. 54v.

43. Marginal note in ÖNB, cod. 10206, fol. 54v: In pompa ut proponebatur Hyems, sed uisum est suae Maiestati ut postponaretur, et rectè.
The next line is lacking in ÖNB, cod. 10206.

44. Marginal note in ÖNB, cod. 10206, fol. 54v: Quae gentes incipiant annum ab Autumno.

45. ÖNB, cod. 10206, fol. 54v: longe.

46. Marginal note in ÖNB, cod. 10206, fol. 54v: Quae gentes incipiant annum ab aestaté.

47. Marginal note in ÖNB, cod. 10206, fol. 54v: Quae gentes incipiant annum a vere.

48. ÖNB, cod. 10206, fol. 55r: placide. Marginal note: Hyems caput Anni penes Romanos Imperij autores.

49. ÖNB, cod. 10206, fol. 55r: Primus Caesar honos, primus dignißimus autor.

50. Marginal note in ÖNB, cod. 10206, fol. 55r: Rationes, cur non temere praeponi uideatur Hyems reliquis Temporibus.

51. Marginal note in ÖNB, cod. 10206, fol. 55r: Proserpina Dea Hyemi;

52. Marginal note in ÖNB, cod. 10206, fol. 55v: Noctes praeponitur a diebus, in diebus nomina à dis.

53. Marginal note in ÖNB, cod. 10206, fol. 55v: Thales praeposuit Aquam caeteris elementis.

54. Marginal note in ÖNB, cod. 10206, fol. 55v: Anaximenes Aërem.

55. Marginal note in ÖNB, cod. 10206, fol. 55v.: Heraclitus Ignem.

56. Marginal note in ÖNB, cod. 10206, fol. 55v: Hesiodus Terram.

57. ÖNB, cod. 10206, fol. 55v: Arcibolus [sic] Terra.

58. Marginal note in ÖNB, cod. 10206, fol. 55v.: Humidus rigor, rigidus humor; Hyemes aqueas, aquis Hyemalibus, hyemeles aquas aqueis hyemibus coniungit.

59. Marginal note in ÖNB, cod. 10206, fol. 56r: Aqua, et Hyemis colligatio huiusmodi est.

60. Marginal note in ÖNB, cod. 10206, fol. 56r: Si Dea hyemis Prosepina est amica Neptuno Deo Aquae, et Hyems erit amica Aquae.

61. Marginal note in ÖNB, cod. 10206, fol. 56r: Veris, et Aëris similitudo qualitatum.

62. Marginal note in ÖNB, cod. 10206, fol. 56r.: Ver producit omnes colores, quos propter aërem cernimus.

63. Marginal note in ÖNB, cod. 10206, fol. 56r.: alludit ad aquilam, et instans [?] pauoninas Austrorum.

64. Marginal note in ÖNB, cod. 10206, fol. 56r: Aestatis, et ignis inter se conuenientia.

65. Marginal note in ÖNB, cod. 10206, fol. 56r: Ex quibus constet caput Ignis elementis.

66. ÖNB, cod. 10206, fol. 56r: Cingereque.

67. Marginal note in ÖNB, cod. 10206, fol. 56v: Torques uelleris aurei constat ex scylicibus, et ferris excudentibus: Ignem alternatim positis: quale gestamen elementis ignis additum cingerit.

68. ÖNB, cod. 10206, 56v: At uerò.

69. Marginal note in ÖNB, cod. 10206, fol. 56v: Leo insigne Regum Bohemorum.

70. Marginal note in ÖNB, cod. 10206, fol. 56v: Antiqui pictores nescierunt simili picturae effectus.

71. ÖNB, cod. 10206, fol. 56v: Ipsa hoc humano testantur corpore clausa.

72. Marginal note in ÖNB, cod. 10206, fol. 57r: Propter ipsorum collocutiones in distichis positas.

73. This line is missing in ÖNB, cod. 10206.

74. Marginal notes to this and next lines in ÖNB, cod. 10206, fol. 57r: Sol conciliat nuptias Aestatis et Ignis. Luna conciliat nuptias Terrae, et Autumni.

75. Marginal note in ÖNB, cod. 10206, fol. 57r: Venus uetat Veris coniugium propter tenerem aetatem.

76. Marginal note in ÖNB, cod. 10206, fol. 57r: Libera uetat Hyemis coniugium propter grauem aetatem.

77. Marginal note in ÖNB, cod. 10206, fol. 57v: Neptunus Aquam, et Juno Aërem rite [?] coniugio precreare faciunt.

78. Marginal note in ÖNB, cod. 10206, fol. 57v: De Nuptiis Serenissimarum Maximiliani Secundi Imperatoris filiarum, quarum altera Regi Hispaniarum, altera Regi Galliarum desponsata sit, cecenisset autor si adiutus id per dignitate facere, potuisset.

79. ÖNB, cod. 10206, fol. 58r: Nunc uti Ver. In ÖNB, cod. 10206, fol. 57v, this line is preceded by a line missing in Codex 10152: Et prius herba fuit messis flauentis aristae. Marginal note on fol. 58r: Sicuti elementa, et Tempora ante sunt apud Caesarem, natura sunt suis in locis, ac terminis, non aliter, qua ipsa referent aetates humanas, in austriae domo erunt pueri, iuvenes, uiri, et senes. semper, qui aut imperent, aut imperaturi sint.

80. ÖNB, cod. 10206, fol. 58r: Austrigenum.

81. Marginal note in ÖNB, cod. 10206, fol. 58r: Conclusio confirmata a gestis hactenus ab Imperatore Maximiliano Secundo.

82. Addition to the end of the version in ÖNB, cod. 10206:

(fol. 59r)
 Conclusio ad Sacrum Caesaream Maiestatem
 Qualiscunque igitur mea Diuinatio, qualis
 Qualis debetur gloria carminibus,
 (Marginal note: Quia propter festinationem non est satis elaborata.)
 (fol. 59v)
 Haec modo grata tuum perundant muner pethis
 Sublimi accedam vertice syderibus.

There follows another epigram seeking aid from Maximilian II.

Index